KU-319-584

THE DISCOVERY OF PAINTING

The Growth of Interest in the Arts in England, 1680 - 1768

NOTTINGHAM UNIVERSITY LIBRARY

IAIN PEARS

Published for the Paul Mellon Centre
for Studies in British Art by
Yale University Press
New Haven and London
1988

cC

Copyright © 1988 by Yale University

All rights reserved. This book may not be reproduced,
in whole or in part, in any form (beyond that copying
permitted by Sections 107 and 1208 or the U.S. Copyright
Law and except by reviewers for the public press),
without written permission from the publishers.

Set on the Apple Macintosh
in Times New Roman, with camera ready pages,
by Pothecary Ltd.

Printed and bound by W B C, Bristol and Cardiff.

Library of Congress Catalog Card Number 88-50426

ISBN 0-300-03829-1

330308

Contents

List of Illustrations

viii

Petworth House. Photo courtesy of the Courtauld Institute, London.
51. Sebastien Bourdon: *Joseph sold by his Brethren*, National Trust, Petworth House. Photo courtesy of the Courtauld Institute, London.
52. David Teniers: *The Archduke Leopold's Gallery*, National Trust, Petworth House. Photo courtesy of the Courtauld Institute, London.
53. and 54. Robert Adam: *Designs for the Parlour at Headfort House*, Center for British Art, Yale University.
55. Thomas Rowlandson: *Tourists in the Grand Room at Wilton House*, Henry E. Huntington Library and Art Gallery.
56. Anon: *Antiquarians*, British Museum, Department of Prints and Drawings.
57. William Humphrey: *The Paintress*, W. S. Lewis Library, Farmington,Connecticut.
58. John Barlow: *The Duchess of Portland*, W. S. Lewis Library, Farmington, Connecticut.
59. Anon: *Connoisseurs*, British Museum, Department of Prints and Drawings.
60. Anon: *A Connoisseur admiring a Dark Night Piece*, British Museum, Department of Prints and Drawings.
61. Anon: *A Collection of Connoiseurs* British Museum, Department of Prints and Drawings.
62. Jonathan Richardson: *Portrait of George Vertue*, National Portrait Gallery, London,
63. B. Reading after Sir Joshua Reynolds: *Portrait of Horace Walpole*, Center for British Art, Yale University.

Acknowledgements

ANYBODY WHO WRITES a work of history inevitably accumulates a large number of debts of gratitude by the time the book is finished; any book which takes as long to complete as has this one collects more than most. For that reason, several people are probably omitted here, either for reasons of space or because they have faded into the mists of the past and their names are now beyond recall to me; they are thanked, nonetheless. My first debt of gratitude is to Francis Haskell, who was splendidly indulgent while he was my supervisor and who has maintained an interest in my project long after any formal obligations ended. Neil McWilliam of the University of East Anglia was also a constant source of advice. Both of these people have read and commented on the varying manuscripts I have produced far more often than was good for them. Margaret Hunt of Amherst College also read the works and saved me from a number of embarrassing errors that would otherwise have gone unnoticed. I have benefited greatly from many long conversations with members of the Department of the History of Art at Oxford, particularly Richard Wrigley, Colin Bailey and Peter Funnell. Archivists and librarians up and down the country and in France and Holland were unfailingly patient, helping to find documents that I could easily have abandoned in despair. Dr W.O. Hassell, formerly of the Bodleian library, Ron Parkinson of the Victoria and Albert Museum, Mr John Guinness and Dr Rosalind Marshall of the Scottish National Portrait Gallery, all provided specific information with ready generosity. Burton Fredericksen and Carol Togneri-Dowd kindly brought me out to California to go through the Getty Provenance Index and Library's now incomparable files on English collectors. I would also like to thank the Duke of Devonshire, the Duke of Marlborough, the Duke of Beaufort, Viscount de L'Isle, the Earl of Leicester, Mrs H.M.C. Jones-Mortimer and Captain James Alston-Roberts-West, as well as the museums and other institutions listed

in the following pages, for their kindness in letting me see and use their manuscripts and pictures. The members of Reuters bureaux in Rome and later back in London were agreeably tolerant and understanding when my mind should, perhaps, have been concentrated on more worldly matters. My parents have been unendingly generous in all ways for many years; without their support, and that of my brother, this book would never have been started and certainly would never have reached its end. The various institutions who have periodically funded me also deserve great thanks; not only Oxford, Yale University and the Getty Foundation, who allowed me the time to finish, but also the Department of Education (and, briefly, the Department of Health and Social Security) who funded me in a now long-past golden age when British governments still thought that history was worthwhile. Thanks also go to John Nicoll and Mary Carruthers of Yale University Press for being willing to publish the book, and for scrutinising the final manuscript with such care. My final thanks go to the dedicatee of this book, Ruth Harris of Smith College, whose friendship, company, advice and example made me realise what good history can be and made the moments when I was not working on it incomparably enjoyable. Equally, her willingness to take on my syntax, punctuation and structure simultaneously was little short of heroic. All these people have contributed greatly to this work and made it better than it would otherwise have been.

IP

Abbreviations

BM. Add. Mss.	British Museum, Aditional Manuscripts
Edwards	Edward Edwards, *Anecdotes of Painters who have resided or been born in England, with Critical Remarks on their Productions* (London 1808)
Hist. Mss. Comm.	Publications of the Historical Manuscript Commission
Lugt	Frits Lugt, *Repertoire des Catalogues de Ventes Publiques interessant l' Art ou la Curiosité,* 3 vols. (The Hague 1938)
PRO	Public Records Office, London
Vertue	ed. K. Esdaile and others, 'The Notebooks of George Vertue', *Walpole Society,* vols. 18, 20, 22, 24, 26, 29, (Oxford 1930-47)

Pictures have that singular Privilige that, though they seem Legible Books, yet they are Perfeck Hieroglyphicks to the Vulgar, and are all alike to them...

William Aglionby, *Painting Illustrated in Three Diallogues (London 1685)*

1

INTRODUCTION

THIS BOOK IS an attempt to chronicle and explain the creation of a new and complex cultural phenomenon which emerged on the English scene in the century or so after 1680. It is entitled the 'discovery of painting' not because an interest in painting was entirely unknown before then, as the courtly collections formed in the 1620s and the 1630s by Charles I, the Earl of Arundel and the Duke of Buckingham demonstrate. Nonetheless, in this earlier period there were few collectors, and the most distinguished of the painters were foreign. Not only was there no 'English School' of painting, there was little sign that anyone particularly wanted one. Only a small number of people wrote about the arts and there were no exhibitions. It was illegal to import paintings for sale, auctions were forbidden in London unless held under the aegis of the Corporation and painters were tied into the essentially artisanal guild of the Painter Stainers' company. The catastrophe of the Civil War made this situation even worse as many of the Englishmen apprenticed to foreign painters lost their masters and the best of the great collections were broken up. Moreover, painting came under a degree of theological disapproval which made the life of many practitioners unhappy and less profitable.

The Restoration, however, saw the beginnings of change. More people went on tour to Europe, following those who, like the diarist John Evelyn, had spent a period in exile during the troubles and absorbed an interest in the arts while out of the country. Collections began to be formed once more while several authors produced works to instruct their countrymen and lament on the poor state of the arts in England. In the 1680s the dam preventing imports burst and London was glutted with paintings trying to find a buoyant market away from war-torn Europe. From then on the formation of an art market was rapid and professional dealers and auctioneers speedily emerged to supply collectors. Painters

made more money, some received knighthoods and all began to com-
plain about their lack of social respectability. Advocates of a new
method of training artists became more vociferous and the presses
poured out dozens of new works on aesthetics, appreciation of the arts
and practical manuals on how to paint. Up to 50,000 paintings flooded
into the country and more than double that amount passed through the
auction houses, with a sizeable number fetching prices that would have
made the fathers and grandfathers of the buyers turn pale with horror.

At the most superficial level this growth of interest can be ascribed to
the greater availability of works of art that resulted from the evolution of
a sophisticated market. However, such an explanation — and similar
reasoning that cites more international stability, greater foreign travel
and increased disposal income — is insufficient to give a comprehensive
account of why the English switched from largely disdaining works of
art to being Europe's most enthusiastic and extravagant collectors.
Merely because works could be collected did not in itself guarantee that
they would be, and this study will attempt to uncover the motivations
that complemented and assured a steady expansion of the market.

Those who wrote on the arts and the social problems of the period
were a diffuse group, ranging from the high aristocracy at one end of the
social spectrum right down to Grub Street hacks at the other. Thus, John
Locke in the 1690s touched on painting because he considered it an
aspect of education and David Hume in the 1730s discussed the topic as
part of moral philosophy. The Earl of Chesterfield in the 1740s mentions
the subject through his concern with good breeding and Samuel
Fawconer in the 1760s because of its relevance to his obsession with
luxury. Equally, writers and satirists from Ned Ward at the start of the
eighteenth century to the host of obscure and frequently anonymous
contributors to the *Gentleman's Magazine*, the *Universal Spectator*,
Appleby's Journal and many others, discussed painting and related
issues because they thought their audience wanted to read about it.

Each author brought his own particular perspective to bear on any one
topic and this was, no doubt, formed from a combination of experiences
ranging from social background, political outlook and financial necessi-
ty. The contributions of all make up the totality of the eighteenth-century
discourse on cultural life. The various analyses on education, taste,
social opportunism, fashion and so on that follow, therefore, attempt to
sketch out the essential features of this discourse without investigating
the authors' pedigrees. Their writings illustrate the links with wider
issues that gave art its new significance in English life, and their state-
ments are quoted because they represent important strands in this
discourse rather than because they contain any great originality.

One final caveat is necessary: references will be made throughout this
book to 'the English' and the term requires some initial clarification.

Essentially, I argue that interest in painting ultimately derived from a process of cultural unification of the upper ranks of English society. The discussions on the subject encouraged the growth of a vision that allowed aristocracy and middling ranks to identify a set of common interests and attitudes. They increasingly saw themselves as the cultural, social and political core of the nation, 'citizens' in the Greek sense with the other ranks of society scarcely figuring in their understanding of the 'nation'. If these groups are referred to in a way which appears to suggest that they were the country, then this is largely because it is how they saw themselves. It is a measure of the importance of the cultural changes in this period that such a self-vision was possible. For exactly the same reason, I mean men when I refer to the 'English'. As will be made clear in later pages, the appreciation of the arts was increasingly considered to be a masculine preserve and professional painting produced only a few examples of female artists. Indeed, the virtual exclusion of women from all but amateur painting served to confirm the seriousness of painting as a topic, and the process by which this was accomplished will be set out in some detail.

Painting moved into the theoretical limelight because of its link to the topic of taste which, as the second chapter will show, demanded and received the attentions of a series of highly gifted writers for a large portion of the eighteenth century. Taste came under such close scrutiny because of its direct relation to some of the most important social issues of the day, above all to a growing unease on the part of many commentators about the source of social authority. This in turn necessitated a long re-examination of the nature of morality and the relationship that existed between individuals and groupings of all sorts.

All ages have their anxieties, but each articulates particular forms which characterise the era. In the first half of the eighteenth century a combination of rapid social change, urban development and redistribution of income focused concern above all on a feeling that old rules and standards of recognition were becoming less effective in ordering society and marking its various boundaries. Such changes manifested themselves mainly in what may be termed a crisis of symbolism, in which previously stable social referents lost their fixity and became more difficult to interpret with confidence, both because they were being challenged by new considerations and because they themselves were undergoing change. Clearly, alarm about such matters was far from new. Sumptuary laws were passed under Elizabeth and complaints about 'new men' were common throughout the fifteenth and sixteenth centuries, but, although the cause of concern was well enough established to be almost traditional, the form and the way it was expressed was novel.

Moreover, it is through both alarm and its source that the historian can penetrate to the underlying reasons for the sudden development of a passionate interest in painting and the particular way in which this enthusiasm was structured.

The fear that a form of social blindness was posing an imminent threat to stability was a constant theme in the literature of the period. In 1735, for example, James Miller sketched out very precisely, if with tongue in cheek, the reasons for the savage lampooning he included in his play *'The Man of Taste'*:

> When what is set up for the Standard of Taste, is but just the reverse of Truth and Common Sense ... when all distinctions of Rank and Station are broke in upon, so that a Peer and a Mechanick ... indulge in the same diversions and luxuries ... shall not fair and fearless Satire oppose this Outrage upon all reason and distinction ...'[1]

Similarly, the *Connoisseur*, a magazine notable for its bitter and frequently unpalatable traditionalism, dealt with the same point twenty years later, demonstrating the distaste that could be aroused by people whose appearance cut across the normal boundaries:

> A desire of grandeur and magnificence is often absurd in those who can afford it; but when it takes hold of those who can scarce furnish themselves with necessaries, their Poverty, instead of demanding our pity, becomes an object of Ridicule ... this endeavour to appear grander than our Circumstances allow, is nowhere so contemptible as amongst those Men of Pleasure about Town, who have not Fortunes in any proportion to their Spirit ...'[2]

Although undoubtedly exaggerated, such frettings — which can be found in abundance up to the 1760s — were indicative of real changes taking place, one of the major causes of which was the rapid rise in the wealth of London. The capital had dominated the country in population terms since the days of its massive Elizabethan growth. The commercial expansion in the decades after the 1688 revolution, however, had a far more distorting impact on the social structure than had been evident from the simple expansion of numbers in earlier periods. By around 1700, London encompassed well over 10 per cent of the population, was the starting and ending point for more than three quarters of the country's foreign trade, and contained a government bloated by years of extraordinary expenditure on war. As a result, it also contained ever larger numbers of merchants and rentiers with surplus funds,[3] and its demands for supplies were fast destroying old trading patterns and creating a truly national market.

One of the most frequently noted side-effects of this growth was the effect it had on traditional patterns of social intercourse, creating new demands and different speeds of interaction. The greater spread of wealth over a wider range of people and the transitory nature of social contact had a slow but unsettling effect. The dynamics of London life meant that associations could not be readily pegged to what were accepted as 'real' indicators of value, such as money, land or title, but instead had to rest on the most insubstantial foundation of manner and appearance. Out of the relatively closed structure of the countryside, where there was a greater chance of knowing the facts of someone's background, city dwellers had no option but to react according to appearances.

By the 1770s the social effects of commercial development could be viewed by some commentators with a degree of detachment:

At the same time that a great proportion of the people are raised to independence, a number of individuals have the opportunity of acquiring very ample fortunes; while on the other hand, many of the old families are, from the same circumstances, reduced to poverty and indigence ... this fluctuation of property, so observable in all commercial countries, and which no prohibitions are capable of preventing, must necessarily weaken the authority of those who are placed in the higher ranks of life ... the hereditary influence of family is therefore diminished.[4]

Many others, however, experienced severe alarm and a deluge of criticism dwelt in great detail on the most minor points of fashion, manners, reputation and customs as a way of getting to grips with the problem. Some of the most censorious, such as Samuel Fawconer in 1765, clearly identified the capital as the main source of changes that were taking place and denounced its insidious impact:

In so large and populous a City, the generality of the Inhabitants must be entire Strangers to each other. And, where the exteriors form our Judgement of the Man, and appearance in the Vulgar Eye passes for the only Criterion of true worth: every one is ready to assume the marks of a superior Condition, in order to be esteemed more than what he really is ...'[5]

In his view, London allowed men to get by on illusion, to substitute appearance for substance and as a result threaten the entire social structure: '... on whatever levelling principle the reasonable distinction of merit and degree is confounded, the order of Government is broken in upon and destroyed.'[6] The real danger, therefore, was not that real

qualities became obsolete or unimportant under the pressure of city life, but rather that they became more difficult to see clearly. Commentators of all social levels who examined this problem — which was a crucial element forming the discourse surrounding taste — were addressing what they considered a serious failure of perception. Nor were the worries confined merely to the writings of a few, possibly slightly hysterical, backwoodsmen from the shires. In 1732, for example, the government revived the Courts of Honour to weed out those who falsely laid claim to coats of arms and other visible symbols of social status. The move was welcomed by the *Universal Spectator* on the grounds that it could help restore the clarity and certainty that was felt to be so lacking: 'It is the General Wish, that these Proceedings may at last terminate in a General Visitation, whereby we may know how to distinguish between the Noble and the Vulgar, the Gentleman and the Upstart'.[7] To emphasise the importance of such knowledge, it went on to draw an alarming classical parallel to emphasise the dangers of the destruction possible when distinctions were allowed to dissolve: 'The antient Greeks and Romans paid great regard to Nobility; but when the levelling Principle obtained ... those States soon dwindled and came to Ruin ...'[8]

The apparent belief that something would indeed be done to combat this problem percolated down the social ranks, producing some odd rumours that were not the less significant for being entirely erroneous. In 1729/30, for example, Viscount Perceval, later the Earl of Egmont, (1683-1748) commented critically in his diaries on the rumour-mongering in the city, saying,

> It makes one melancholy to see the industry of the disaffected to poison the minds of the lower ranks of people ... the shopkeepers are told that the Queen will have the citizens' wives to wear a rose or badge to distinguish them from the gentry and nobility ...[9]

That anxiety about the effects of such matters was no mere snobbery is demonstrated by Samuel Johnson (1709-84), a man whose abilities rather than appearance raised him up from humble beginnings. As he maintained during one of his rare flights into the subject of economics:

> The artful and fraudulent usurpers of distinction deserve greater severities than ridicule or contempt, since they are seldom content with empty praise but are instigated by passions more pernicious than vanity ... The commercial world is very frequently put into confusion by the bankruptcy of merchants, that assumed the splendour of wealth ... [until they] drag down into poverty those whom their equipages had induced to trust them ...[10]

So it should not be imagined that the problem was a simple one of the

established seeking to keep out the *parvenu* or *nouveau-riche*. The attitudes described above were distributed in a more complicated fashion and could happily co-exist in the same person. As will be shown later painters were one of the most perfect examples of newcomers trying to muscle their way into social respectability. Nonetheless, these same painters and their families could be equally condemnatory of what they saw as social climbing in others, criticising the very movements that offered them the repute they craved. In 1773, for example, the wife of Allan Ramsay (1713-84), a man who was certainly not averse to making his fortune as a painter, complained of the 'absurd ambition' of others to appear to 'belong to a rank of life in which fortune had not placed them.'[11]

The greatest desire of many commentators was to establish a satisfactory means of disconnecting worth from appearance. For example, almost everyone disapproved in theory of fashion in clothes as being at best vanity and at worst socially subversive; on the other hand, the awareness that fashion was mere frippery that had nothing to do with substantial virtues did not blind critics to the fact it was a subject to great importance. The Earl of Chesterfield (1694-1773) typifies such a duality between the pragmatic and the ideal in mid-century. For a start, he could never decide what he meant when he talked about 'men of fashion'. At times, the phrase is all but synonymous with fops, people little better than social parasites. Elsewhere, the description sometimes means the best of people, the repository of everything good that society had to offer. His letters constantly highlight this dichotomy and strikingly illustrate the difficulties of sorting out the relationship between the internal and external man. For Chesterfield, fashion was to be determined by rank so that it could act as a social indicator of what people truly were. The gentleman, in other words, had to dress appropriately so that he would receive the treatment to which his gentility entitled him:

> dress is a very foolish thing, and yet it is a very foolish thing for a man not to be well-dressed, according to his rank and way of life ... the difference in this case, between a man of sense and a fop, is, that the fop values himself upon his dress; and the man of sense laughs at it, at the same time he knows he must not neglect it ...[12]

The difficulty was, of course, that if dressing like a gentleman meant that the gentry would be treated correctly, then there was no clear reason why anyone else with sufficient funds should not dress in the same fashion and trick others into paying him more respect than was his due.

The question of fashion in matters of dress attracted the delighted attention of satirists throughout the century and engaged the minds of those who claimed to be more serious critics of society's foibles. The

interest can be understood best if it is seen as only part of a much more wide-ranging concern with education. As will be shown later, in many ways the subject of painting was also an aspect of this more general concern.

Debate on education was imbued with many of the same confusions that afflicted the discussion of clothing, with much of the argument generated not so much by clear-cut differences of opinion as from a simple disagreement over terminology. When using the simple word 'education', for example, a huge range of possible meanings could be involved. On occasion it meant the 'solid matter' of learning — mathematics, history, geometry and the like — which contrasted with mere accomplishments, the frivolous social graces that included deportment, dancing and the art of conversation. Equally, education could be a general term covering the solid and the insubstantial types of learning simultaneously, with both given due importance in the production of a finished gentleman. While there was general agreement about education's value, therefore, this superficial assent disguised differences that were only revealed when the question of definition was brought up.

As Brauer has shown,[13] a substantial transformation of educational theory in this period diluted the seventeenth-century emphasis on élite training. By the 1750s not only were the ends of education — ie. virtue and usefulness — desirable, but learning and the sophistication it produced were becoming attractive possessions in their own right. The external indicators of education were put forward as factors contributing to social cohesion, dampening the passions, creating trust and providing a *lingua franca* of politeness which enabled men to overcome and subdue their differences.[14] However, if the trappings of polite education were a social good in themselves, they were also supposed to indicate the internal quality of gentility, providing signs that others could recognise and allowing them to react appropriately to the 'true' nature of those they met. By knowing what the other person was, social rectitude could be maintained through the deployment of the appropriate responses demanded by relative positions of superiority, inferiority or equality. The value of such signposts for clarifying and making recognisable real social divisions, above all between gentility and the rest, was something explicitly recognised by writers in the period, with some elevating this aspect to such an extent that it almost became the prime reason for education's existence.[15]

However, as with fashion, the entire system threatened to break down if external signs and internal qualities were not rigidly bound to each other. From the beginning of the 'Augustan' period, commentators pondered the question of whether, if a person developed all the polite externals that signified gentility, he was a gentleman as a result. If the appearance and reality of gentility could exist separately, there was a

need to discover how the two were to be distinguished and social bound-
aries maintained. The importance of this question was speedily
recognised, with the possible confusion being seen as either good or bad
depending on the author. In 1747 the educational writer Stephen Philpot,
for example, approached the question from the standpoint of the outsider
and gave instructions on how to acquire the appearances needed to infil-
trate the upper ranks of society. Such externals, he notes, had already
helped to raise 'many a one to great Power and Dignity from very small
Beginnings'. As a result, he stresses the importance of getting such mat-
ters right:

> The neglecting to give Children such Accomplishments as are gener-
> ally necessary to recommend them to the World ... is also one
> frequent cause of their ill-success ... he that will carefully attend to
> the event of things may often see the Man of Parts, Learning and
> Knowledge in his Profession, quite overlooked and disregarded ...
> whilst a Person of not half his Abilities in other respects shall by his
> more polite Behaviour, genteel Address, becoming and decent
> Assurance, be caressed and esteemed, and procure himself many
> Friends and Acquaintances, who will promote him and serve him ...
> when they see a Man well-bred, and polished in his Behaviour, they
> reasonably conclude that he has been well-educated also in all other
> respects ...[16]

While the middling ranks emphasised the importance of appearance
in order to enter higher society, the upper ranks saw it as a means of
staying there. Drawing on a long tradition founded on the idea that a real
aristocrat should also behave like one,[17] apologists for this standpoint
also adopted the more recent emphasis. As Lord Chesterfield put it,

> Know then, that as learning, honour and virtue are absolutely neces-
> sary to gain the esteem and admiration of mankind, politeness and
> good breeding are equally necessary to make you welcome and agree-
> able in conversation and common life ... remember then, that to be
> civil with ease (which is properly called good breeding) is the only
> way to be beloved and well received in company; that to be ill-bred
> and rude is intolerable and the way to be kicked out ...[18]

The difference between these approaches, and the outrage aroused in
polemicists against luxury and laxness like Fawconer, ultimately lies in
disagreement over the definition of the term 'gentility'. In the traditional
interpretation of the word, a gentleman was anyone with the rank of
esquire and up. In this sense, it was the fact of birth that was important,
even though Renaissance theorists had suggested that in ideal circum-
stances a gentleman should have the superior qualities to match his

genealogy. The more recent interpretation, however, took a more flexible approach by suggesting that 'real' gentlemen were those with certain virtues that were not necessarily the exclusive possession of people with a certain level of birth. The very distinct possibility arose, therefore, that a person might be a gentleman and not a gentleman simultaneously, depending on the unit of measurement employed.

Once more, such a dichotomy was far from being the invention of the eighteenth century but instead, as the *Universal Spectator* pointed out, was a question that went back into the mists of antiquity:

> A Brave and Virtuous Father, says Horace, can no more produce a Base and Vicious Son, than a Dove can be the offspring of an Eagle. Juvenal differs from him, where he brings in his Nobilitas sola est et unicum virtus, as commonly translated, Virtue is the only true Nobility.[19]

From the seventeenth century onwards, the emphasis placed on this second interpretation was imbued with an additional fervour. Daniel Defoe (*c*.1660-1731), for example, was particularly keen that the landed gentry should more frequently and enthusiastically acquire the attributes that would complement and strengthen their actual social position.[20] Emphasising the obligation of the gentleman-by-rank to become a gentleman-by-virtue as well was a standard ploy for writers from the Restoration onwards who insisted on the hollowness of the former alone: 'If thou art not as well an inheritor of the Father's and Ancestors' virtue, as Estate, thou art but a titular Gentleman at best ...'[21]

Such a desire to reform the higher orders contained within it an onslaught on the traditional conception of social ranking which, if traceable in embryo back to the sixteenth century, broke out in full and often acrimonious force in the books and magazines of the eighteenth. The sweetly reasonable and cajoling tone adopted by *The Spectator*[22] was merely the more polite face of a fundamental assault on hierarchy by birth, the force of the attack being modified by the attempt not to overthrow but to convert. If gentility by birth did not confer 'true' gentility, which had to be cultivated and earned, then such a view necessarily implied that birth alone was a useless conception.

This interpretation began seriously to question and undermine the aristocracy's right to the automatic respect and deference of others. The implied willingness to write off the fundamentals of the English social structure must, however, be seen in the context of the conciliatory approach adopted by most educational writers. The strident criticisms of Defoe were only an early and extreme stance in a much broader campaign to reform the upper ranks by society by making them accept the values of the polemicists themselves. Such disdain for traditional conceptions can be seen, for example, in magazines like the *Plain Dealer:*

There is a Hobby Horse, in the World, called Nobility by the Right of Birth; which was the invention of industrious policy, to entail and perpetuate Virtue. But like Vinegar, from the finest Wines, it is so changed, by its Putrefaction, that there is not a sharper Curse ... than is inflicted on Mankind by that silly thing, called Pride of Descent ... what a ridiculous Pretence to Reverence is the Accident of having been born, to live lazily — it is insolence, in the highest degree, for a Cypher, of rank and title, to expect Submission, from a Person, who is venerable for his good Qualities, upon no better a Foundation, than because the accomplished Commoner is, perhaps, the Son of an honest Man, who had nothing to depend upon, but his Industry.[23]

Despite their acidity, the commentators generally agreed on the legitimacy of social eminence and hierarchy, even though they insisted that the values on which it was founded were debased: they make no political objection to an aristocracy but instead fervently hope that it makes itself acceptable. Although acknowledging that 'Some I know look upon the institution of Nobility to be one of the grossest impositions upon the common sense of mankind ...' and although accepting that 'many of them [ie. nobles] ... are so barren they are quite incapable of producing anything,' several writers could nonetheless assert that once the aristocracy was reformed it would be a useful if not vital part of society.[24]

In addition, it is notable that the assault on the *de facto* ruling classes as defined by birth emphasised precisely the same moral failures which were used to indict the lower orders. The writers, almost all of them middle-class urbanites, appear to have seen themselves as hemmed in on all sides by turpitude, with both aristocracy and masses equally guilty of ignorance, idleness, lasciviousness and a variety of other sins. In contrast to this vision of moral vacillation and instability, the middling ranks increasingly presented themselves as the real stable base on which social order rested, avoiding the perils posed by both excess wealth and undue poverty. As Goldsmith's *Vicar of Wakefield* summed the view up in 1766:

The order of men which exists between the very rich and the very rabble ... in this middle order of mankind are generally to be found all the arts, wisdom and virtues of society. This order alone is known to be the true preserver of freedom and may be called the People ... [25]

The shift in emphasis towards the training of the young should be seen as part of a considerable campaign to alter the nature and perception of merit in the English social system. 'Solid' education indeed remained the central element of all schooling, but for the well-bred and those aspiring to this status there developed alongside a whole host of secondary aspects which were at least implicit assaults on the notion of

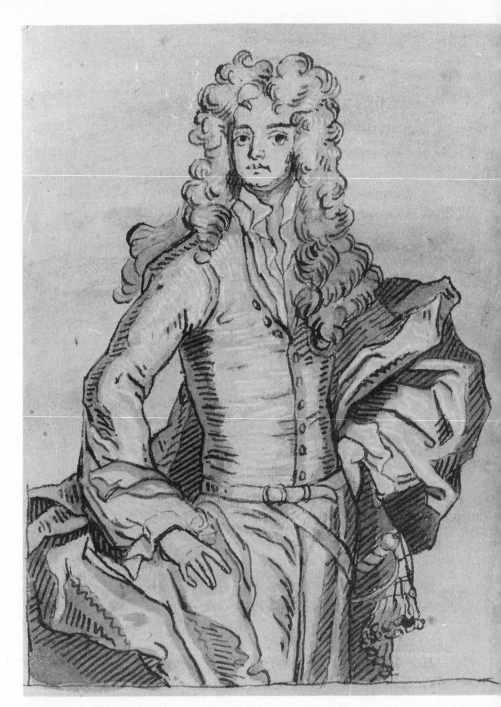

1. Edward (d. after 1723) or Robert (fl 1716) Byng: *Portrait of John Perceval, Earl of Egmont*, pen and ink sketch after Sir Godfrey Kneller (1648-1723).

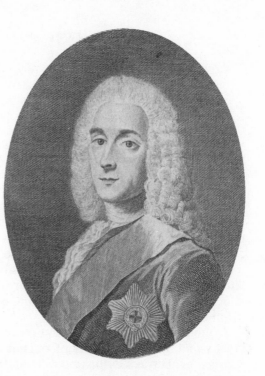

2. Giovanni Vitalba (*c*.1740-*c*.1789)
after William Hoare (1706-99):
Philip Dormer Stanhope, fourth
Earl of Chesterfield.

hierarchy by birth. As with money itself, education was becoming less and less the exclusive possession of the gentleman, as more people from a wider range of classes gained at least some access to the basics of reading, writing, languages and elementary arithmetic. However, if simple possession of knowledge was no longer an effective marker, what the owner did with it could become more important. The correct deployment of education, as with money and social position, won greater attention, with matters like courtesy, decorum, deportment and both actual and emotional charity receiving more emphasis.

There are distinct signs that the campaign for reform had its effect. The aristocracy, caricatured in its seventeenth-century form by the 'Proud Duke' of Somerset (1662-1748), who disapproved of his own daughter sitting down in his presence,[26] began to compete with other ranks on the same ground both metaphorically and literally. The change is perhaps symbolised best by the famous example of Beau Nash's removal of the Duchess of Queensbury's finery at the Bath pump room, which was an unspoken insistence that the nobility appear like everyone else, submit to the same rules and conventions and be judged on their intrinsic merits.[27] To give a small example of the depth of the changes, on 13 January 1746, the Earl of Egmont was to be found

Talking at the coffee house with Mr Atkinson, formerly a citizen and now a rich liner draper, and with Mr Woolaston, of Covetousness,

they instanced Sir Will. Joliffe, now living, formerly a Turkey mer-
chant, who passes to be worth a hundred thousand pound if not two,
and brags that in his whole life he never bought a book, picture or
print ... [28]

The threesome continued to gossip merrily for an hour or two about
numerous acquaintances, sagely agreeing on their shortcomings. Such
an event was clearly nothing unusual; indeed it is likely London was full
of such tablefuls of people. The significance of the little episode, how-
ever, lies in this ordinariness, the fact that, by the middle of the
eighteenth century, it was unremarkable for an earl to meet two com-
moners in a public drinking shop and chatter for an hour or so,
condemning their fellows by reference to absolute moral qualities — in
this case greed. Moreover, these standards were accepted as applying to
all ranks of men and the evidence to support their condemnation was the
reluctance of their subject to spend money on items of education and
culture.

A more substantial demonstration of this attitude is found in the
mushrooming of all manner of organisations which successfully cut
across class barriers by uniting different ranks of men around common
interests. While such bodies as scientific clubs, groups of antiquarians,
charitable bodies or music societies were only ready to take in certain
levels of society and were costly — Vertue complains that his member-
ship fees over the years had been a 'continual expence' — they
nonetheless had a considerable effect in softening barriers.[29] Egmont
exemplifies the way in which such tiny groups participated in transcend-
ing rankings and bringing about this unfreezing. He knew Mr Woolaston
through their mutual involvement in the Georgia Society, forming a
wide range of other acquaintances through his membership of the Royal
Society, Dr Bray's Charity and a singing club. The degree of change
since the protocol-infested seventeenth century was attested to by the
Earl of Chesterfield who, though mindful of the importance and dignity
of rank by birth, also believed that association with the more lowly
members of society could be a privilege, not merely a duty, for the well-
born:

> There are two sorts of good company; one which is called the beau
> monde, and consists of those people who have the lead in courts, and
> in the gay part of life; the other consists of those who are distin-
> guished by some peculiar merit, or who excel in some particular
> valuable art or science. For my own part, I used to think myself in
> company as much above me, when I was with Mr Addison or Mr
> Pope, as if I had been with all the Princes of Europe ... [30]

One of the more important parts of practical education was prolonged

mixing in good company, where the rough edges of character could be rubbed off and the uncut diamond of youth be honed to a shining, flawless example of true breeding. Mingling with others was thus elevated into a central part of the educative process — the idea that the 'world is a great school' attaching itself particularly to social interaction. As the Encyclopaedia Britannica put it, 'nothing renders the mind so narrow and so little ... as the want of social intercourse ...'[31] In 1763 James Nelson saw the prime advantage of the intermarriage of different ranks not in financial but in purely cultural terms as a method of facilitating unified values:

> The principle thing that Men of Trade have to do, is, to keep clear of self-sufficiency; and to avoid that Arrogance and Conceit which Money is apt to create. Their frequent marriages and intermarriages with well-bred people, are some means to effect this, and educating their Children suitably another ... hence appears the necessity of good education and well-educated manners for this class of people: that as they insensibly, as it were, become allied to their betters, they may be taught properly to coincide with them ... [32]

However, such wholesome advice highlighted the problem that there was no clear way of distinguishing the socially cohesive process of learning from the higher-placed from the 'impudent affectation of shew'[33] that unravelled the social fabric.

Emulation, whether it be of manners, interests or of clothes, acts as a form of social referent, a claim to belong to a certain group or to possess a certain type of status. This reference can be either divisive or assimilative, in the former case indicating membership of a group detached from the mainstream of society and in the latter laying claim to be part of it. In the case of eighteenth-century England, as nearly all commentators agreed, fashion was invariably in the second category, with emulation designed to act as a passport to the higher reaches of society. The use of clothing in the manner of the seventeenth century puritans, who adopted an ostentatiously drab exterior to demonstrate their disaffection, seems to have been rare.

Apart from the risk that imitation could be labelled dishonest, aping the well-to-do could be a perilous undertaking — an investment made, like any other, in the hope of a substantial return. Simple examples of this can be found among painters like Arthur Pond (c.1700-58), who spend a small fortune on creating the right impression for clients which he initially could ill-afford;[34] Reynolds, who maintained an aristocratically lavish household complete with gilded coach;[35] and Kneller, who was so carried away that he maintained his extravagance to the bitter end and beyond, going to his grave with a sumptuous and hugely expensive

funeral.[36] In all of these cases the initial investment in carriages, servants and living accommodation was made in the hope that they would serve to attract new and better clients before the funds to pay for them ran out. Equally, Reynolds' cultivation of the educated can be seen as an attempt to gain a suitable reputation by a distinct — if decidedly less expensive — display of socially valued signs.[37] At the same time, there are many instances of the investment not yielding the hoped-for-dividends. The pages of Vertue are full of references to impoverished painters, like Ferg and Vandermijn,[38] and there are some instances, such as with the Italian Andrea Soldi, of a bid for joint social and professional reputation going very badly wrong.[39]

Although emulation of the gentry or urban aristocracy weakened the position of those imitated by blurring the marks of distinction by which they were identified, at another level such behaviour had precisely the opposite effect, as the desire to copy one's superiors is necessarily an acceptance of the fact that they are superior. Such imitation binds the imitator to the imitated in a relationship that confers mutual benefit, with the former possibly gaining the chance of rising in status and the latter being strengthened through recognition as an ideal. Permanent and fairly rapid changes in external signs, of which pure fashion was the simplest example, was built into the nature of the eighteenth-century social structure. However, if fashion was largely determined by ultimate reference to 'real' sources of eminence such as title, position or type of wealth, it was also partially conditioned by the interplay of these with other types.

Fashion on its own could have a distorting effect. For example, an appeal to foreign modes was often effective as a way of seeking prominence as it could suggest access to expensive foreign travel and a knowledge of foreign customs that could by-pass the otherwise insulated national system. Thus, William Kent scraped together enough money to go to Italy and come back with Italian clothes, phrases and a disdain for English provincialism, all traits which indirectly endeared him to the upper ranks as 'Kentino' and helped establish his reputation as an expert in all questions of art and design. However, if the Earl of Burlington was impressed by such a display, others were not, and satirists had a field-day from the early eighteenth century onwards lampooning with both visual and verbal squibs those who were excessively devoted to matters foreign. More sober commentators were often willing to join in,[40] and in a 1756 review of Samuel Foote's *Gentleman returned from Paris*, for example, the *Monthly Review* dourly commented: 'However ridiculous the Hero of this piece may seem, his character, to those who have seen some of our Gallic-Englishmen, will not appear to be greatly exaggerated ...' [41]

The wish to reform the upper ranks of society was not confined to London but was also waged with equal fervour against the large number

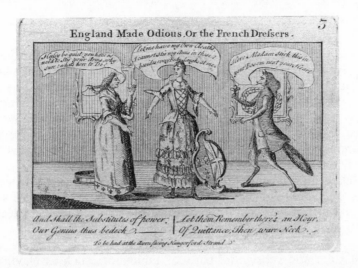

3. Anon: *England Made Odious, or, The French Dressers* (*c*.1756) from *A Political and Satyrical History of the Years 1756 & 1757*, plate 3. A satire on Newcastle and Fox. The artist implies treachery on their part by having Britannia dressed in French clothes. The force of the critique derives from frequent disapproval voiced of Englishmen and women who adopted foreign — and especially French — modes. The preface to the book criticises 'that infatuated Regard which has been fixed to every Thing *French*'.

of country gentry, indicating a general campaign no doubt enlivened by the political divide of court and country.[42] One of the standard sources of humour in the Restoration was the exploitation of the city/country dichotomy, with whole series of effete, cynical, urban wits being contrasted with droves of ignorant, dull and vulgar country gentry on all the London stages. Such a contrast was, of course, far from new, as literary and moral capital had frequently being made out of the comparison from the Roman Empire onwards.[43] What is more significant is that recourse to this traditional ploy became decidedly less frequent as the eighteenth century progressed. Moreover, even when the rustic was pilloried unmercifully, the sarcasm did not derive directly from a crude contrast with the urban style of life, as many of the fops who represent the City are portrayed even less sympathetically. Whereas the squire was a fool and a dolt, the urbanite was cold and exploitative. One was dangerous because he was an idiot, the other because he was calculating and cynical. Each, in other words, was condemned even-handedly by reference to a set of values which criticised both sides as being lamentable and inadequate.

Nonetheless, the rustic gentleman in this period was criticised according to an ideal that was essentially urban in character and derived from a belief in the merits of education, frequent social intercourse and external civility. The lack of such things in the gentry worried urban writers and was, yet again, transformed into a question of perception. Cut off from the stimulus of city life and unable to achieve a balance of cultural

influences, the country gentleman was seen to be more prone than most to the distortions of prejudice, an important problem as they were — and were clearly recognised to be — the political backbone of the nation. Reforming and civilising them was therefore an urgent undertaking both for their own sakes and even more for the national well-being. The boredom of country life and the fear that this encouraged debauchery and vice among the squirearchy was, consequently, a difficulty that had to be tackled speedily.

In this matter, however, writers were often quite clear that it was not simply education that the country gentry lacked. From the late seventeenth century it was acknowledged that the nuts and bolts of learning could be acquired in the provinces quite easily:

> The solid and substantial parts of Education, such as Navigation, Architecture, Heraldry, Fortification, Limning, and the like, I am very confident, they may be acquired with far greater Freedom and Convenience in the Country, than they can be at London; especially by a Gentleman of an Estate that has it in his Power, to choose what kind of Tutors he pleases ...[44]

Rather it was the veneer and sophistication of civilisation that the country could not provide and which was so desperately needed, a complaint where the example of painting frequently makes an appearance as a symbol of what was wrong, with crude artistic tastes — if indeed there were any at all — being held up as a symbol of inadequacy. In 1755, for example, the *Connoisseur* pointed out very clearly the implicit links between art, politics and social stability on the one hand and the pitfalls of country life on the other:

> Nothing is more necessary, in order to wear of any particularities in our Behaviour, or to root out any preverseness in our Opinions, than mixing with Persons of Ages and Occupations different from our own ... the furious Partisan, who has not been weaned from a mad attachment to particular Principles, is weak enough to imagine every Man of a different Way of thinking a Fool and a Scoundrel ... to the same Cause we owe the rough Country Squire, whose ideas are wholly bent on Guns, Dogs, Horses and Game. His Hall must be adorned with Stags Heads, instead of Busts and Statues; and in the room of Family Pictures, you will see Prints of the most famous Stallions and Racehorses ... To this absurd Practice of Cultivating only one Set of Ideas, and shutting ourselves out of any Intercourse with the rest of the World, is owing that Narrowness of Mind, which has ... made Roughness and Brutality the Characteristics of the mere Country Gentleman in Politics and Religion... [45]

Such desires for reform would have had little chance of success had they been formulated in a vacuum, but it is reasonable to see these aims as being only one symptom of a more general change. The political system that emerged from the upheavals of the seventeenth century largely depended on the country as the source of power with the capital as its actual residence. The delicately balanced system meant that access to direct political power required land and influence in the provinces to provide the authority that was exercised both locally through quarter sessions and the like but also through Parliament. At the same time, however, attaining local influence also depended on access to the innumerable advantages offered by London and the government. The result was double edged — entry into the urban political world gave an advantage to those who could identify with it through the adoption of the appropriate demeanour. Similarly, those same external cultural signs, transposed to the provinces, served to indicate that their possessor had access to central government and the wealth of pensions, sinecures and general influence that it commanded. The most obvious and expensive way in which these attitudes were demonstrated to the world was through architecture, the building of a country house in the latest style demonstrating both wealth and sophistication. Other, less expensive, methods of demonstrating the same thing abounded and became apparent in such matters as a subscription to the *Gentleman's Magazine*, conversation that indicated knowledge of the doings of high society, the right fashion in clothes or a collection of pictures.

However, if it was of importance that the country gentry slowly absorb some of the standards of urban culture, the city also remained dependent on the country because of the nature of the political process, and writers felt unable to adopt a purely proselytising tone. The country gentry were frequently disposed to absorb much of what the city had on offer, but the transference was not a simple one-way process. For a long time there existed a considerable hostility on the part of the rural gentry to the city, above all to those of its members seen to be parasitic — the office holders, bond owners, bankers and so on — all of whom grew rich by usury and the careful and manipulative absorption of tax revenue. The more cautious of the polemicists, such as the *Gentleman's Magazine* — the name of whose supposed editor, Sylvanus Urban, epitomised the attempt to reform and unify without giving offence — were at some pains to stress the virtues of the country life and thus temper the force of the attack. In the 1690s, for example, Jeremy Collier had felt obliged to condemn theatrical satires on the country gentry on the grounds that undermining them also undermined authority and hence the good governance of the kingdom.[46] In the same way, *Appleby's Journal* some forty years later roundly criticised those Londoners who 'lavish their stock of ill-nature on that common topic of satyr, rural squires and

Country Hoydens'.[47] It then went on to defend the good sense, religious piety, modesty, sense of obedience and, above all, lack of susceptibility to fashion, which the country life inculcated.

The country gentry were too important to be either totally neglected or condescended to, as ultimately they made up the bulk of the membership of the House of Commons, provided a substantial portion of revenues and governed the provinces. Thus, Robert Walpole demonstrated his remarkable grasp of political reality through his ability to be all things to all men: refined connoisseur and collector of art, patron of painters and architects at one moment, beer-swilling vulgarian muttering about his apple crop the next.[48] Similarly, Addison's Sir Roger de Coverly found it expedient to modify his views depending on where he was: 'I find, however, that the Knight is a much stronger Tory in the Country than in the Town, which, as he told me in my ear, is absolutely necessary for keeping up his interest'.[49] Later in the century, the poor unfortunate painter Thomas Jones found himself subjected to a week's misery of constant horsing and hunting while on a painting trip in Northamptonshire because of 'the shame of being thought such a Poltrone' if he revealed himself a cowardly city dweller.[50]

However, a readiness to meet the countryside half-way and adopt country pursuits — a fairly widespread habit, especially if horses were concerned [51] — was often performed at some cost to the overall reputation for gentility. Such entertainments were sometimes viewed by the more fastidious as being at best on the very borders of polite behaviour:

> There are liberal and illiberal pleasures as well as liberal and illiberal arts ... There are some pleasures which degrade a gentleman as much as some trades do ... driving coaches, rustic sports, such as fox-chases, horseraces, etc, are, in my opinion, infinitely below the honest and industrious professions of a tailor and a shoemaker, which are said to deroger.[52]

As a result of a long-term process of mutual compromise and willingness to adopt what the other had on offer, separate cultural standards were slowly rubbed away and superseded by an increasingly uniform framework of values. The Tory gentleman and rustic squire continued to exist but could no longer remain unaware of or unaffected by the views and opinions of those different from themselves. The march of the landscape garden across the country, fashions in architecture and the appearance of collections of pictures in houses, were all aspects of this unification, as was the attempt to standardise the language that Johnson's dictionary represented.[53]

As a result, even the arch-urbanite and incorrigible cultural snob Horace Walpole began to find the provinces almost tolerable. Campaigning for Parliament in Lynn in 1761, he wrote:

I have bore it all very cheerfully; nay, have sat hours in conversation, have been to hear misses play on the harpsichord, and to see an Alderman's copies of Rubens and Carlo Marat. Yet to do the folks justice, they are sensible and reasonable and civilised. Their very language is polished since I lived amongst them. I attribute this to their more frequent intercourse with the world and the capital.[54]

Walpole's attitude is still imbued with the condescension that only an assumption of cultural superiority can generate, but nonetheless he is judging the inhabitants of Lynn by standards that he would also apply to himself. They are found wanting, and indeed faintly ridiculous, but they are nonetheless both literally and figuratively speaking the same language. The Alderman's knowledge of painting may be slight by his visitor's standards, but both accepted its worth.

This process of mutual accommodation was not, however, either totally smooth or even totally welcomed. Very clearly, one man's civilisation was another's degeneracy and those who saw the countryside as the last bastion of common-sense against the evil spread of luxury through society were dismayed that their champions seemed at times positively eager to surrender to the enemy. Samuel Fawconer, for example, viewed the process that gave Walpole such quiet satisfaction with quite another emotion: 'The present is the Age of Pastime, the Golden Reign of Pleasure ... This Frenzy is not confined to the Metropolis, but overspreads the Face of the Kingdom: every Corner of which abounds with Temples of Pleasure, agreeable to the depraved Tastes of a Luxurious Age' [55] Even more moderate observers later in the century could demonstrate dissatisfaction and a degree of burgeoning nostalgia for what they considered to be fast disappearing local integrity in the face of the unifying onslaught that originated in London. As John Byng put it in 1790:

I am just old enough to remember Turnpike roads few, and those bad; and when travelling was slow, difficult and, in carriages, somewhat dangerous: But I am of the very few (perhaps alone) who regret the times ... when England afforded to the pleasure of the observant traveller, a variety of manners, dress and dialect. In former times I have (gravely and wisely) remarked upon the influx of vice pour'd in upon every corner of the country by the quick and easy communication of travell ... in the days of bad roads, the country could not be stripp'd of its timber, or despoil'd of its honesty, cheapness, ancient customs and civility ... now every abuse and trickery of London are ready to be played off upon you ... [56]

Such steps towards the cultural unification of the upper ranks of society, very incomplete though they were, were nonetheless important as

they created a new and powerful social division. Defined by all the old barriers, of name, wealth, rank, land and so on, and equally conditioned by the new factor of education, this barrier nonetheless overreached all of them. English society showed a remarkable ability to survive not because of any crudities like mass co-optation of the successful but because it allowed a few outsiders to enter the ranks of the respectable by a form of examination, the requirement being to pass through a filter which stopped the unsuitable sneaking through. Money on its own was insufficient and other attributes could ensure, at best, only a temporary entrance. Only if the appropriate values were learnt, absorbed and manifested, internalised to such an extent that they were accepted without reserve, could entry be guaranteed; and there was a quiet assurance that the parvenu would ultimately be detected and exposed:

> A little Observation will enable us to distinguish the well-bred Gentleman from one, whose natural Abilities, and even real Knowledge, as well as outward Appearance, Cloathing and Equipage are by no means Inferior to his. There is an Air or Mien given by good Breeding which comes no other Way.[57]

To accept the values of a society is to resign the right, or even the ability, to challenge them. English society was so constituted as to make acceptance attractive — open only to a few, but open nonetheless. The cultural structure of England provided a new and sophisticated pattern for the recognition and location of one's fellows and at the same time provided a rationale for the existence of differences that were exposed through the contrast of individuals.

If the new attributes based on absolute values led to, and were partially caused by, a discourse between the middling ranks and those above them, then it was necessary that the same weapons of disdain be turned on the middling ranks themselves. The essence of a strong ideology is that it may appeal to utterly 'true' qualities and that its verdict is pronounced on all groups without fear of favour. Thus, it was natural that all ranks were to be examined by these new criteria and — along with dissolute aristocrats, vulgar gentry and ignorant peasants — the ordinary middling type of city dweller became an equally good target for demonstrating the existence of stupidity, ill-breeding and bad taste. The attacks on the 'cits' was, perhaps, even more vitriolic since there was no residual sense of deference and no fear of reprisal. The attack brought to bear all the weapons that snobbery, intellectual superiority and condescension could muster. The cits were pummelled in books, magazines and newspapers throughout the eighteenth century and finally emerged as a stereotype of what the middling ranks could be if not educated properly, becoming the model for disdain of lower middle-class preferences that has lasted well and long.[58]

Alongside all these modifications, views of the lower ranks of society also underwent a subtle change. They were still defined by their position but were increasingly also bracketed by those absences which excluded them from the culture of the upper echelons. Instead of being seen as a different breed of people, answerable to standards other than those which governed the upper ranks, they were drawn into the common system and also assessed by reference to these universals. It was a far more severe form of examination and one which emphasised more strongly the failure of such people to deserve equal treatment. The lower ranks were no longer merely artisans, peasants or whatever, they were above all non-gentlemen, a negative definition that covered them all and unified them into a particular block of society — the mob — identifiable by absences in the same way that gentlemen were located by possession of particular attributes.

The relocation of virtue so that it was defined by social position was a substantial change in the way parts of English society viewed themselves. Previously, of course, universal standards had existed, particularly the quality of being a good Christian. It was perfectly possible for a member of the lower ranks to be a good Christian despite his modest position, and indeed, to a certain extent the further down the social scale one was the easier it was to suffer and to be resigned to one's fate. Anyone throughout the social spectrum had, in theory at least, an equal opportunity to live a life of virtue.

Virtue as defined by culture was, however, a very different matter and depended on the internalisation of certain values inculcated by a social training only participation in the world of the élite could provide. Social movement was consequently narrowed to an individualistic trickle, with virtue amongst the lower orders being defined above all by an individual's ability to rise above his circumstances; not, in other words, to live a virtuous life within his means and rank but to do so rather by overcoming them. Eighteenth century society therefore came to be balanced culturally in a very fine way, with the maintenance of distinction depending on a fundamental contradiction. It required all ranks to stay in their places and accept their lot in life, but simultaneously insisted on the need to break through the barriers to achieve true worth. Social status was essentially founded, therefore, on a sense of failure, of real immobility contrasted with the requirement to rise, and this perspective provided a new way of assessing the lower orders. Men were not responsible for their subordinate position, they were not particularly responsible for their failure to rise above it and they were required for the good of society to stay where they were. Nonetheless this passive position caused them to be condemned. It was a new relationship of contempt, in which a hierarchy under God giving each man a place and a degree of respect was transformed into a hierarchy of the ideal man,

with God's role reduced to being the patron of what man had organised.

Much has been written in recent years about the development of post-Restoration English society, particularly after 1688. Considerable attention has been given to the question of whether the middle classes rose or not, or whether, in complete contrast, the eighteenth century was not the period *par excellence* of aristocratic domination. In fact, both views seem to be justified; the aristocracy ruled all it surveyed, which was most of the country, but it did so, so to speak, under licence. They dominated, but that dominance was itself exploited and made use of; it was slowly, and certainly incompletely, channelled into areas and assessed in ways which were comfortable to the values of those beneath them. The nobility and gentry were at the top of the ladder but what they were seen to be was increasingly an idealised reflection of what those beneath required of them. Those beneath drew comfort from the fact that, whatever the distinctions of rank, the stratospheres of society were populated by people basically just like them, who could be judged by the standards they accepted for themselves and, moreover, who were also to be found manifestly wanting when set alongside the idealised conceptions which embraced them all.

It is rash and dangerous to talk of the 'triumph of the bourgeoisie' in a age when such a term had little meaning. However, the cultural unity that was being formed in this period had many of the characteristics of what might be termed 'bourgeois' ideology. It was meritocratic, divorced from metaphysical hierarchies and grew directly out of a urban and commercial environment. Moreover, it had as its chief propagandists those who, if not 'middle class' in the classical sense, nonetheless came almost exclusively from the 'middling ranks'. England's social stability in the period must therefore be seen in terms of a conjuncture of culture and politics. The resilience of the political and social fabric had less to do with the much examined and frequently exaggerated permeability of the ranks of society than with those ranks being rendered in some respects obsolescent or at least redefined. It was not, therefore, that peace and quiet was assured by a great willingness to recruit from below, to absorb new blood and to co-opt those who might become discontented if excluded. Indeed, there appears to be more evidence to suggest that such practices were fairly rare. The English aristocracy and above all the nobility was, on the whole, quite keen to keep its honours and privileges to itself and fought hard to repel newcomers.[59] For every successful merchant or banker whose family was elevated into the peerage after three generations there were a hundred who remained as rich commoners, able to buy and sell their titular superiors.[60]

Instead, the bitterness and potential violence generated by exclusion was assuaged by the gradual formation of an overarching inclusion within which the innumerable distinctions continued to exist. It was the

triumph of the club and the assembly room; the solution to England's particular problems in the eighteenth century was not simply political, the establishment of a 'Venetian oligarchy' and a parasitism in which those preyed upon were kept quiet by a judicious mix of bribes and coercion; nor was it the result of covering up fundamental differences with a veneer of politeness. Rather it was a cultural answer, the growth of a set of values which reduced the importance of the more sordid details of pensions, sinecures and rotten boroughs and created an interlocking dependency.[61]

The emergence of a growing cultural homogeneity in one sector of society thus paralleled the undermining of popular recreations such as bear-baiting, feast days and wakes which have been the subject of considerable examination in recent years. As Malcolmson has said, 'From the middle of the eighteenth century there are many signs of an increasing willingness among people of authority to intervene against the customary practices of popular recreation. Recreational customs were subjected to a multitude of direct attacks ...' [62] The terms used are significant: the redefinition of cultural values, that is the creation of 'high culture' in its modern form, identified plebian habits as something distinct and redefined them as mere recreation, needing to be suppressed because of their adverse impact on work practices. The upper ranks slowly withdrew from participating in such activities, except for maintaining a token presence as overseers or patrons. As Fielding said:

Whilst the People of Fashion seized places to their own use, such as courts, assemblies, operas, balls, etc; the people of no fashion, beside one Royal Palace, called his Majesty's Bear Garden, have been in constant possession of all hops, fairs revels, etc ... so far from looking on each other as brethren in the Christian Language, they seem scarce to regard each other as of the same species.[63]

Cultural separation consequently became more obvious and permitted 'popular culture' to become clearly branded as merely the occupation of the vulgar in contrast to the more purely intellectual 'pleasures of the understanding' which characterised — ideally at least — the refined, delicate and educated.[64] The crucial step was the emergence of a cohesive and all embracing standard which permitted the condemnation of popular habits as inferior and converted the attempt to destroy them into a duty for the good of those attacked. It was a task which was very far from complete in 1770 but nonetheless much basic work had been done and a new cultural hegemony was held firmly in place. If the English working class had such immense difficulties when it began to be 'made' at the end of the eighteenth century, then much of the responsibility for this must go to the fact that in cultural terms it had been pre-empted.

Those above it had reformed themselves in a novel fashion which had at
its base an essentially cultural identity. Partial, indefinable and arbitrary,
it nevertheless stretched its influence throughout society, binding nobles
and commoners, gentry and traders, city and country, in a mutually
acceptable and recognisable framework of values against which external
pressure was inadequate.

It is as part of this mass of reordering, which stretches from England's
transformation into the most powerful state in Europe to more obscure
shifts in perception and belief, that the growth of interest in painting
must be understood. What painting became and equally what became of
the people who made the paintings, is an integral, and illustrative, part of
the constant flow of tiny alterations that were taking the whole society
into new and uncharted directions. How paintings were acquired and
valued are matters of importance not because the development of such
an interest was of immense significance *per se* but because it can be
used to uncover something of these changes in attitude.

Central to the importance of painting was taste, the body of aesthetic
prescriptions which provided the intellectual framework through which
the works themselves were interpreted. From the moment of its trans-
formation from the borrowed French notion of *goût*, taste was a social
phenomenon that was deeply affected by the attitudes and concerns
outlined in this chapter. Supposed pretension in discernment was
abused mercilessly when identified and pressed into service as yet
another indicator of the absurdities threatening the good order of soci-
ety. The fact that 'Fiddlers, Players, Singers, Dancers and Mechanicks
themselves are all the sons and daughters of taste ...'[65] or that 'We
scarce have a grave Matron at Covent Garden, or a jolly dame at
Stock's Market, but what is elegant enough to have a taste for things
...'[66] was merely one of the more ridiculous indicators of serious perils
that awaited the country if the destruction of perceptual signs contin-
ued unchecked.

2

TASTE

THE DEBATE ON aesthetics that occupied a growing degree of attention in the years towards the middle of the eighteenth century was both long and complicated.[1] It covered several areas; for example, a distinction was made between the nature of beauty, the way beauty was created and the fashion in which men recognised and responded to it. Although the debates on these questions produced a wide variety of different opinions there were two constants which were almost never brought into question. Firstly, beauty was invariably held to exist as an absolute quality and, secondly, the possibility of absolute taste — a perfect perception of beauty — was almost never doubted.

The fixed notion around which all discussions revolved, the idea of beauty itself was debated with relatively little heat. Different formulae were advanced for its composition but these in general took second place to the question of how it was perceived. Equally, the nature of creation was constantly played down after an initial flurry of interest in the late seventeenth century, with the particular problems of the artist or poet being frequently alluded to but rarely succeeding in dominating discussions. Greater concentration on this aspect of aesthetics was largely postponed until well into the later part of the century.

Of far greater moment was perception. The relationship of object and individual was easily the dominant strand of enquiry and the one with which the period's greatest minds felt obliged to come to grips. The subject was, however, of equal fascination for many of the lesser literary figures of the period. While the likes of Locke, Hutcheson and Shaftesbury laid the groundwork for the new interpretation, and men like David Hume and Alexander Gerard built on those foundations, a host of minor commentators such as John Gilbert Cooper, John Gwyn, Marshall Smith and journalists were also eager to make their own views known. The debate was an attempt to hammer out an accepted conceptual

framework that would permit an understanding of the significance of art in the social world. The result was nearly three-quarters of a century of effort, and no small admixture of frustration and pedantry, as writer after writer hurled himself into the melée in the quest to discover what taste was and establish some sort of useful definition for it.

The Moral Background

The first and most obvious link with wider social concerns was the similarity of argument and preoccupation which structured the debates on both aesthetics and morality. The link between the two was provided by the neo-platonic identification, brought up to date through the work of the Earl of Shaftesbury (1671-1713), on the Good and the Beautiful.[2] In the debate over morality eighteenth-century commentators were in essence attempting to place on a more secure footing what they considered to be a dangerously weakened structure of belief. The position of God as the ultimate source of authority on moral matters had become less assured, partly because of perceived difficulties of interpreting God's will. Revealed religion suffered not only from connection with the authoritarianism of Roman Catholicism, but also had the misfortune of association with the Protestant enthusiasts of the Civil War era.[3]

However, if the scriptural and prophetic revelations of God's word that gained currency in the seventeenth century were manifestly unsatisfactory, if not dangerous, this was far from meaning that the need for an ultimate arbiter of morality had disappeared. With no source of authority there were no standards by which the actions of men might be judged, consequently no morality and hence no legitimate basis for civil society. Thomas Hobbes was one of the earliest, and most perceptive, to grasp this prickly nettle and, at least in the opinion of those who came after him, pursued the question to a bitter, dispiriting and essentially amoral conclusion. From the moment he published *Leviathan*, Englishmen of all varieties attempted to refute his argument and substitute a conclusion of rosier hue. [4]

By far the most successful of these was John Locke (1632-1704), whose work set up the parameters within which the enquiry was conducted for much of the next century and also indicated new and fruitful directions for aesthetic theory. Reversing the normal route of investigation, Locke began with the observation that, as men take decisions, the central issue is to determine whether these are arbitrary or subject to absolute assessment. If the latter, the central question became what constituted the solid and immovable plank from which these judgements were formed once revealed religion is deemed inadequate. His way into the topic therefore was not through the metaphysical consideration of

absolute qualities, but rather through an examination of the process of decision-taking.

The difficulty with Locke's description of the build-up of an originally empty mind through association was that it tended towards precisely the opposite conclusion to the one he set out to produce. There was little in the logic of his analysis which would instantly point towards a place for morality. Indeed, it suggested an atomised mankind, each reaching conclusions and decisions which were not susceptible to external judgement. To steer away from

4. George Vertue (1684-1756): *Portrait of John Locke*, pen and ink.

this, Locke made two assumptions. Firstly, that the impressions placed in the mind as a result of external stimuli were accurate and invariable in each individual, and secondly that there was some sort of direction which guided the process of analysis. What exactly he meant by this latter argument is not precisely clear, given his assertion that the mind is initially empty, but the implication would seem to be that it had a latent tendency to interpret the stimuli in a uniform fashion.[5]

If Locke failed to produce a flawless argument — Berkeley (1685-1753) quickly pointed out that there was no evidence that sensations were absorbed accurately, with Bolingbroke (1678-1751) adding that there was no proof of the existence of the moral faculty either [6]— then at least no-one who came after did much better. However, in the attempt to clear up some of the ambiguities left behind him, his pupil the 3rd Earl of Shaftesbury elaborated on the possibility of latent tendencies and put forward — if only in a partial fashion — the notion of an inbuilt moral sense in the mind. This idea became one of the central conceptions of eighteenth century moral thought and also helped lay the ground rules for most of its aesthetic theorising. [7]

Even so, in practical terms it was still far from simple to show tangible connections between the theory of morality and its actual practice. In the case of straightforward religion God was still a central, if now less immediate, pivot around which the entire structure revolved. If He no longer intervened directly through revelation *via* the church, miracles or in any other fashion, He now implanted the moral sense and retired from the scene, and it was this authorship that justified the continuation of notions of good and bad. As the Scottish moral philosopher Francis Hutcheson (1694-1746) put it:

If God therefore was originally Wise and Good, he must necessarily have preferred the present Constitution of our Sense approving all Kindness and Beneficence, to any contrary One; and the Nature of Virtue is thus as Immutable as the Divine Wisdom and Goodness. Cast the Consideration of these Perfections of God out of this Question, and indeed Nothing would remain Certain or Immutable.[8]

If the argument had gone full circle and ended by replacing a God-given tendency for God himself, the basic and practical problem of assessing real human actions and decisions in moral terms was no nearer a solution. Even the question of direct divine intervention was far from simple: 'Whatever God hath revealed is certainly True; no doubt can be made of it. This is the proper Object of Faith: but whether it be a Divine Revelation or no, Reason must judge ...'[9] Even if the existence of the moral faculty was granted, and its presence was in fact disputed only rarely by eighteenth-century commentators, then there was the further problem of how, in turn, it was to be spotted and assessed. As was clear to most writers, while the nature of the mind meant that there ought to be agreement on moral questions, in practice there was little unity to be discerned. The original question consequently reappeared in a slightly different guise: why were there these differences, and how were true assessments of morality to be distinguished from false ones? Hutcheson, a follower of Shaftesbury, concluded that although all people had a moral sense, in many cases it was clearly defective. David Hume (1711-76) on the other hand, took the more charitable view that the differences were a result of incompleteness and that the mind lacked sufficient sensory data of the appropriate kind to be able to reach the right conclusions.[10]

The ultimate conclusion was an unstable élitism which in a paradoxical fashion drew strength from its logical flaws. God's absence meant that judgement of an individual's actions and beliefs was necessarily made by other people, though not other people qualified merely by their nature as human beings but rather by their ability to judge accurately. Thus Adam Smith posited the impartial bystander as the external standard[11] and David Hume, those with sufficient supplies of data to develop their moral faculties.[12]

The character of moral philosophy in the eighteenth century is thus of a very distinct type. Nearly all of those who wrote on it recognised the flaws inherent within their words, and were aware of the recourse, in arguments that accepted the need for proof and demonstration, to things which could not be shown to exist. Their arguments were transitional, attempting to substitute new absolutes for the old and inadequate ones, while their own logic impelled them towards a relativist and a totally different world view.

Taste

As is clear from reading even a few of the tracts on taste which poured
from the presses in the first half of the century, one of the dominant and
most curious characteristics was the degree to which the authors were
generally content merely to reiterate what had gone before. Following
the pattern laid down for morality, the discussion of taste was divided
into two main parts, comprising the nature of perception and the innate
sensibilities of the mind.[13] Out of the meeting of the two came judge-
ment, which enabled the individual to assess quality. However, the
precise content of the word 'taste' was always subject to variation. For
some, such as Alexander Pope and Alexander Gerard, it was the prod-
uct of the meeting of innate tendencies and refined judgement.[14] For
others, like John Gilbert Cooper and the *Encyclopaedia Britannica*, it
was the instantaneous sentiment of beauty alone.[15] For others still, such
as the anonymous authors of *A Discourse concerning the Propriety of
Manners, Taste and Beauty*, and the *Female Spectator*, taste lay solely in
refined assessment.[16] In general, however, nearly all the writers were
agreed that taste stemmed from two factors, acting either alone or in
combination, even if they rarely agreed on the precise mixture.

No matter how taste was defined, the assumption that the appreciation
of aesthetic properties was a unified field necessarily led to a search for
the common denominators which would isolate and identify the basic
standards. Drawing on Locke's methodology, aesthetics grew away from
external metaphysical explanations of beauty, a line of research quickly
seen as scarcely susceptible to empirical demonstration, and instead
turned almost completely to the individual. The essence of the change
was to generate the view either that beauty had no independent existence
outside the mind, or that its existence was irrelevant. Thus, following
Berkeley, it was argued that beauty lay not in the object itself but rather
in the act of perception. Hutcheson, perhaps, summed up the idea most
succinctly, saying: 'The word beauty is taken for the idea raised in us,
and a sense of beauty for our power of receiving this idea ...'[17]

From that point the essence of the argument was to say that there was
a standard because all men were built more or less the same and there-
fore have minds which are predisposed to interpret external stimuli in a
similar fashion. In other words, the same object will trigger the same
reactions and what one person finds beautiful, others should find beauti-
ful as well. Again, however, the existence of innumerable differences of
opinion forced writers to confront the fact that this was patently not the
case:

> The great variety of Taste, as well as of opinion which prevails in the
> world, is too obvious not to have fallen under everybody's attention

... we are apt to call barbarous whatever departs widely from our own taste and apprehension; but soon find the epithet of reproach retorted on us ... [18]

Opposed to this fact, however, was another basic observation which was that the nature of man created the need for such external standards: 'It is natural for us to seek a standard of Taste; a rule by which the various sentiments of men may be reconciled; at least a decision afforded confirming one sentiment, and condemning another.' [19] Hume refused to adopt the easy solution of relying on the wisdom of common sense by pointing out that this can exist in different forms, some of which are clearly erroneous. Common sense, for Hume as well as for others, was valid as an argument for judgement only if it was *correct* common sense, a conclusion which provided no resting place but instead impelled the seeker forward in the search of the proof needed to decide which was indeed correct.

If common sense, pure and simple, was deemed insufficient as the ultimate source of standards, so another potential absolute, the essentially seventeenth century notion of rule,[20] was also both tested and found wanting. The idea of rule had, in fact, been under attack long before the beginning of the eighteenth century, and the most devoted of its English disciples, such as John Dryden, would cheerfully admit to frequent transgressions. Like common sense, it was perceived only as a medium: rules could be proven wrong and therefore could not, in themselves, constitute the absolute source. For Addison, for example, 'the Production of a great Work of Genius, with many Lapses and Inadvertencies, are infinitely preferable to the Works of an Inferior kind of Author, which are scrupulously Exact and Conformable to all the Rules...'[21] However, if straightforward adherence to an established canon of rule fell into disrepute, then this did not mean that the idea itself disappeared. Rather, gaining pleasure by a work which disobeyed them merely proved that the rules were wrong and that the work would conform to them if the correct ones were identified: 'If [parts of a poem] are found to please, they cannot be faults, let the pleasure they produce be ever so unexpected and unaccountable.'[22]

The conclusion which resulted from the twin observations that both absolute standards and differences of taste existed was necessarily that some people were capable of judging better than others, so that it became natural to search for a way of deciding between various opinions. In some cases the return to the metaphysical external was immediate, as in the case of Hutcheson, the *Investigator* and the *Discourse on ... Taste*. [23] This external — generally described as being God or Nature or both — was, however, equally inadequate as a solution. If absolute standards existed and men were equipped to recognise those standards,

then plainly a divergence of opinion indicated that some people functioned better than others. The only way to decide who in fact was better at perceiving beauty was to see whose mind functioned closest to Nature's or God's intentions, an argument which took the problem straight back to the beginning again. As with moral philosophy, the way out of the conundrum was ultimately found by having recourse to people themselves, although in a very cir-cumscribed form. The impartial bystander therefore finds his aesthetic equivalent in a similarly vague, but human-based, notion of the absolute, what Gerard called 'the unperverted sentiments of mankind'.[24]

Again, Hume was typical in his recourse to such an explanation as well as in the significance he attached to taste and its importance for social assessment. From the starting-point of saying that 'a delicate Taste of wit or beauty ... is the source of all the finest and most innocent enjoyments of which mankind is susceptible ...', he goes on to posit the possibility of perfection in such matters, a conclusion which was an inevitable result of the assertion that absolute standards do exist.[25] The importance of such a belief is that, as there cannot be infinite or even different types of perfection, all questions of choice were placed firmly within a single structure which did not allow the existence of separately valid preferences. Consequently it elaborated a method of linking and comparing individuals and of placing them in a hierarchy. In sum, it was a system which legitimated types of value judgement, of saying that one person was better or worse than another.

Moreover, the introductory reference to pleasure gives the argument added importance because of the Lockean view that the impulse to moral action was an affair of psychology, whose fundamental cause is man's reception of differing degrees of pleasure and pain. Moral action was pleasurable and hence anything which refines the ability to distinguish degrees of pleasure and pain contributed to an ability to act with rectitude. If pleasure was desirable, refined pleasure was therefore virtually a duty to society. Hence a 'delicate taste of wit or beauty' was not merely something which contributed to the pleasure of the individual but can equally be seen as an exercise of social responsibility. It was an indication of virtue, and hence equally of the superiority of one man over another. The conversion of a preference into a virtue, and moreover into a quantifiable virtue, was thus almost complete. Paralleling many of his contemporaries, Hume stressed the importance of simple familiarity:

... nothing tends to increase further and improve this talent, than practice in a particular art, and the frequent survey or contemplation of a particular species of beauty. In a word, the same address and dexterity which practice gives to the execution of any work, is also acquired by the same means in the judging of it.[26]

This initial assertion suggests that he implicitly accepted Pope's notion that the 'seeds of taste' were in everyone and that no one was inherently incapable of being a judge of art. Good judgement was the result of effort, not a capability that one may or may not possess at birth. The doctrine is important as it means that it can become a status symbol in a way that something like physical beauty cannot. If good taste was the result of human agency and its presence or absence is the result of individual effort, then that individual may be judged on his willingness or refusal to acquire it. If, on the other hand, its presence was simply an accident of birth, then it would be inherently unreasonable to attack those not well endowed.[27]

Having established this point, Hume expands the argument to erect an inherently élitist structure of judgement around it. As educated people were best able to appreciate works of art, it was only their opinions which were worthy of attention: 'One accustomed to see, and examine, and weigh the several performances, admired in different ages and nations, can alone rate the merits of a work exhibited to his view, and assign its proper rank among the productions of genius.'[28] However, there was a potential trap which lay in wait even for the educated, and this was the notion of prejudice:

> ... to enable a critic the more fully to execute this undertaking [ie. of judgement] he must preserve his mind free from prejudice, and allow nothing to enter into his consideration, but the very object which is submitted to his examination ... when any work is addressed to the public, though I should have a friendship or enmity with the author, I must depart from this situation, and considering myself as a man in general, forget, if possible, my circumstances. A person influenced by prejudice complies not with this condition, but obstinately maintains his natural position ... by this means his sentiments are perverted ... so far his taste evidently departs from the true standard, and of consequence loses all credit and suthority.[29]

Appreciation, therefore, could be conditioned by knowledge or prejudice. Both were seen to operate independently of each other; there is no suggestion, for example, that knowledge in itself is a way of controlling prejudice. The fundamental problem remains, however, of deciding when an opinion is based on the one or the other.

The passions were very different to prejudice, the former being a non-volitional attitude of mind, the other a wilful imperfection. The practical difference was that the inclinations of the passions operated separately from the intellect proper and could be controlled and potentially overridden by rational evaluation, whereas prejudice contaminated and distorted clarity of perception.[30] Hume's willingness to bring this distinction

into the discussion, a rarity amongst his fellow writers, enabled him to dismiss the question of variation. Differences of opinion in taste stem either from imperfections or idiosyncrasies in individuals, preventing them from reaching a perfect degree of objectivity. Such an argument is however essentially circular; a variation of taste is either legitimate or illegitimate, and Hume provides no way of telling one from the other except by referring to what 'we' already know and understand. If the individual accepts fundamental norms which distinguish him from the 'common audience' — such as the value of artistic appreciation or the desirability of strictly defined notions of a fitting education — then his claim that he assesses in terms of passion rather than prejudice is inherently more convincing.

Consequently this doctrine, put forward throughout the period with varying degrees of sophistication, indicates the belief that particular, socially-formed tastes should be recognised as absolute preferences, with those who fail to accept them liable to castigation as inferior. To taste correctly was largely a question of removing hindrances or of absorbing enough sensory data in all forms to overrule the prejudices and allow innate mental faculties to function correctly. Only the educated person could manage this and consequently only he displays 'natural' taste. The idealised figure of the gentleman thus enters into a new relationship with the rest of society. The education and refined ideal becomes the norm of behaviour to which all others must aspire. Most fail to attain this normality not because of any inherent inability but because of a wilful refusal to try. The tastes of that overwhelming majority who fall outside the accepted parameters of accurate perception are consequently a form of deviance, a manifest fault rather than a valid and acceptable difference.

In their musings on taste in the first half of the eighteenth century, authors saw a need to find a source of authority. How they attempted to achieve this was closely linked to the attitudes laid out in the first chapter. The debate on taste, through its close links with morality, education and notions of perception, impinged on basic questions of social relationships, altering the legitimation of the socially eminent and the way in which their position was viewed. The essence of, and justification for, such eminence slowly became more firmly founded on a theory of cultural superiority which had at its core all the elements that gave dynamism to the question of aesthetic preference. Dominance came to be justified by the possession of objectivity, an attribute identified with clarity of perception which, far from being the prerogative of the ever more dubious quality of birth, was instead a universal attribute that was simply more likely to be possessed by those with the good fortune to be both wealthy and well-born. Taste was the product of education in its widest sense; as the author of *A Discourse concerning the Propriety of Manners, Taste*

and Beauty put it: 'Propriety and delicacy of Taste is merely the effect of Culture ... An extensive knowledge of the beautiful is only acquired by a polite and virtuous Education ...'[31] This, in turn, was equally seen by many as the qualification for ruling:

> The Education of the Gentleman ... [is] of all others the most important to the Publick ... Gentlemen [are] born to be Legislators, to be the Bulwarks of our Constitution, to fill up the Posts which require Wisdom, Conduct, and the most improved Abilities ... if their Education is defective or bad, the whole Constitution is affected by it ...[32]

Possession of taste not only indicated education and hence virtue but also implied and signified the fitness of its possessors to rule. If the complex web of beliefs that made up the doctrine was challenged, then the entire structure that supported the social fabric could rapidly begin to unwind as well, for if the quality of perception was relative then no man's opinion could be assessed and hence no man could be trusted. According to the *Encyclopaedia Britannica*, such a possibility was dangerous: 'It is a common Saying, that there is no disputing about Tastes, and if by the Taste here be understood the Palate ... the Maxim is just ... but the Maxim is false and pernicious when applied to ... intellectual Taste ...'[33] As mentioned, such a negative assertion was in fact noticeable mainly by its absence, with few except satirists ever advocating the notion of relativity in a concrete form.

Taste and the People

The social conditions that aided the emergence of this definition of taste necessarily had implications for the way in which parts of the social structure related to each other. If, on the one hand, it spread an all-encompassing umbrella over those groups with education who accepted its doctrine, then it also included the rest of society as well. Taste, through painting and all its other various forms, thus had a double-edged and contradictory role. It served to identify and separate those who accepted it from those who did not, erecting a hierarchy of value as it did so. As the writer on painting, Marshall Smith, put it in the 1690s:

> They whose Minds are fortunate enough through these Exomations, with what Contempt may they look on those muddy and fulsome Pleasures which most of Mankind, and are known to be Pleasures only by name, not only being Narrow, Forced and Feigned, but proditonous and exitial instead of being beneficiall to Human Existence ... without a Judgement of [painting] he shall be the Jest of

those whose greater Skill will not excuse their ill-Manners therein. [34] (*sic*).

Even if Smith scarcely reaches the heights of literary lucidity his meaning is clear enough: taste and knowledge of painting will separate the possessor from the rabble through his association with minority interests. It will bolster his social position through distinguishing him from the common ruck of mankind.

Well into the eighteenth century this idea was maintained and taken further. Setting out his programme for encouraging the visual arts in England, John Gwyn in 1749 insisted that of all the population, the common mass were the only ones who had nothing whatsoever to do with painting: '... none are left out but the mere servile and Labouring Order of People, to whom, no other Knowledge is necessary but their Duty to God, their Superiors and one another ...' [35]

Equally, however, there was a strain of opinion which did not restrict the impact of painting to a limited notion of the 'public' but instead stressed that mankind as a whole would be bettered if everybody possessed taste as then all would be wise, objective and sensible. Painting was of importance as it could serve as a medium for educating the people and raising them higher towards perfection. In the late seventeenth century, for example, William Aglionby thought that painting would cure men of tendencies to lust and gluttony, Smith that it 'Incourages to vertue, [and deters] from vice'. [36] Once more, this tendency reaches its height with Richardson, who expands the idea into a much more substantial programme. Pointing out that gentlemen of means have a great deal of time on their hands, and that whatever else, painting is an innocent occupation whose pursuit would leave little time for vice and debauchery, he expands on Aglionby's theme and insists both that the enthusiasts for painting would be reformed by the subtle effects of pictures, and through them the lower orders would be improved as well:

Our walls like the Trees of *Dodona's* Grove speak to us, and teach us History, Morality, Divinity; excite in us Joy, Love, Pity, Devotion, etc. If Pictures have not this good effect, it is our Fault in not Chuseing well ... If Gentlemen were Lovers of Painting ... This would help to Reform Them, as their example, and influence would have the like Effect upon the Common People. [37]

Through the mediation of the gentleman, therefore, the effects of art percolate down the social scale and improve the totality of the nation. However, if the didactic potential of painting were exploited to meet the frequently and explicitly articulated need to bring responsibility to the lower orders, then the distinctions its natural exclusivity proffered would

have been compromised. Such a paradox was perfectly reflected in a similar duality in the nature of taste: if the essence of taste was the objectivity that education alone could confer, what possible effect could paintings have on the masses who were, almost by definition, brutish and ignorant?

Such a conundrum vividly highlights the double nature of the eighteenth century conception of art as cause and effect of virtue, objectivity and education. It is frequently implied that the ameliorative capacity of art is dependent on a certain predisposition inculcated by a prior education and that it acts as an accelerator to virtue but not as its initial source. Such a viewpoint relates to a strand of social philosophy which parallels the aesthetic and moral debates examined earlier.

As is well known, one of the eighteenth century's most idiosyncratic developments was the conception of the natural man, the noble savage whose characteristics reach their apogee in the writings of Rousseau. At first sight the distance between this figure and the equally idealised gentleman could not be greater, since the one benefits from all the sensations that an advanced society can produce, while the other profits just as much from having avoided them. In fact, the presence or lack of cultural artifacts disguises a fundamental similarity between the two types, which is the absence in both of prejudice. Both, consequently, have the ability to perceive, and hence act, with objectivity. By virtue of his direct communion with uncorrupted nature the noble savage attains a harmonious mental balance that is reproduced in society only by gentlemen who are shielded from distortions by a carefully regulated education. Gentleman and Savage were consequently united in their distinction from the rest of mankind as both were unique in their immunity to the abnormalities that existence in an imperfect society implied. The philosophical savage was, therefore, an important ideological balance which helped to legitimate both the gentleman and the value system he embodied.

Variations in the ability to appreciate the arts becomes more understandable in this light. The initial state of the mind was one predisposed to the objectivity essential for correct functioning: the 'seeds of Taste' gave all human beings the potential to comprehend the arts. However, in the majority of cases the developing mind progressively became less capable of seeing and assessing correctly due to the inappropriate and distorting sensations to which it was subjected. For the overwhelming majority, therefore, art was either partially or totally incomprehensible as their minds were incapable of reproducing an exact image of the object. The mental vision of the object was instead distorted by the play of prejudices which prevented the link being made between the direct representation of the scene portrayed and the natural beauty in which that image was cast.

A distinction made with some frequency was that between natural sentiment and the explicit recognition of that sentiment. This returns us to the difference indicated above between sensual or instinctive perception of beauty and intellectual perception. It was generally held that true penetration into the absolute nature of things, and consequently the derivation of all the benefits this conferred, was not possible without the intellectual and conscious recognition of what beauty was, how it was constituted and how the individual was responding to it. Without this recognition, the sensation of beauty would be a transient phenomenon, a sensation of pleasure which could not be mentally assimilated and applied. Pleasure was in this sense divorced from the learning process and hence of no significance beyond itself. George Stubbes perhaps sums up this attitude most concisely:

> Original Beauties, which are purely Intellectual, can only be discovered by the Understanding: and it may be justly inferred that the sensible Beauties, corresponding to these Originals, from whence they are copied, can only be rightly discerned by the same Faculty, which alone is capable of comparing them ... and perceiving their Excellence ... The rude Surprise of gazing Ignorance, new to these Arts, and discerning little of their Beauty, soon vanishes and the pleasing Wonder is succeeded by Indifference.[38]

The moral content of a picture was seen to consist of two parts. Firstly, there was intellectual beauty, the impression formed in the mind by a beautiful object and its connection with nature, and the conditioning of the mind through association to correct interpretation and hence to moral behaviour. Secondly, however, there was a more direct content, where the moral impact was gained by the direct imitation of the deeds represented. Thus a visual representation of a noble or heroic deed, an act of kindness or holiness, indicated to the viewer the existence and importance of such actions. If the deed was portrayed in a way which arrested the viewer by triggering instant sensual responses, then his attention would be secured for long enough to register the action represented. Even though the mass of people was incapable of appreciating the intellectual beauty of a work, this secondary factor meant that they were nonetheless susceptible to its artistic representation and hence painting could indeed play a didactic role. Moreover, in certain cases people were granted a partial ability to perceive with accuracy, particularly when their own experience gave them insights into the painter's intentions. The painter Joseph Highmore (1672-1780), for example, makes this point quite specifically:

> ... every man is a Judge of the Representation, in proportion as he is of the Original Subject; a Sailor, for instance, is a better Judge of the

5. John Oliver (1616-1701): *(Colonel Charteris) Contemplating the Venus of Titian* (*c.*1700). Colonel Charteris ultimately provided a satisfying illustration for contemporaries of the connection between sensuality and disorder. Seen here as the epitome of how not to appreciate painting, he later increased his reputation as one of the great rakes of the period. His end was the sort that even Hogarth might have had trouble dreaming up, and indeed, Charteris appears as one of the onlookers in *The Rake's Progress*. In the 1730s, he was arrested, charged and convicted of rape after kidnapping and asaulting a country girl. He narrowly escaped the gallows but died in 1732.

> principle Circumstances which enter into the Composition of a
> Seapiece, than the best Painter in the World, who was never at Sea ...
> Children, Servants, and the lowest of the People are Judges of
> Likeness in a Portrait ... [39]

If painting was to have a beneficial effect it had to be presented in a fashion which made this possible and it was understood that the mere existence of good intentions on the part of the artist was not, in itself, sufficient to evoke a correct response from the viewers. That a variety of reactions might ensue from a single visual image was an inevitable result of the psychological approach to taste. Consequently, an evil effect might be derived not from the painting itself but from the mental distortions it stimulated in an unbalanced or inadequately equipped mind. Such a possibility became an important preoccupation and the misuse or misinterpretation of a work of art was deemed to be a significant sign that distinguished the true lover of art from the false one. Not only is there a striking early visual image of this, in John Oliver's print of a Titian (see Plate 5) with a man leering in an obscene fashion at the woman represented from behind a curtain, it also occurs in all forms of literature. In Bramston's 'Man of Taste' for example, the point is made through sculpture:

My Taste in Sculpture from my choice is seen,
I buy no Statues that are not obscene ... [40]

and Richardson brings in the question of idolatry, distancing himself from such falsity and making clear the difference between the painting and its effects:

I plead for the Art, not its Abuses ... if when I see a *Madonna* tho' painted by *Rafaelle* I be enticed and drawn away to Idolatry ... *May my Tongue cleave to the Roof of my Mouth, and my Right Hand forget its Cunning* If I am its Advocate as t'is Instrumental to such detested purposes ...[41]

Such sentiments appear frequently in the literature on painting throughout this period. The insistence that, as Wills put it, 'Painting [is] innocent in itself' assuming that it was done in good faith, reoccurs again and again.[42] The constant return to this refrain, however, necessitates a brief examination of the intellectual and practical context of these ideals in order to analyse the way the didactic purpose of art was understood and put into effect.

Taste, People and Religion

The constant reiteration of the essential moral neutrality of painting, and its potential for both good and evil dependent on the attitude of those who looked at it, was a necessary outcome of the barriers which inhibited the acceptance of many forms of visual representation. The impact of the Reformation and of puritanism on painting is outside the scope of this chapter but it is important to emphasise that suspicion towards art was a deep-rooted and still prevalent tradition.[43] The extreme puritanical attitude towards the arts consisted of two very distinct aspects. Firstly there was the simple moral approach which attacked the theatre, dancing and such like as encouraging lax behaviour. Secondly, there was the more overtly theological strain, which condemned paintings in particular because of the ungodly nature of images. By far the most concise statement of this attitude was made at the high tide of puritanism in 1641 by George Salteran, who made his views unmistakably plain. Calling Tertullian and the Homilies to his aid, he maintained that the very act of looking at pictures was by definition idolatrous:

Yea, Thou worshipped them, which makest them, because now they may be worshipped; yea thou worshippeth them thyself, to them thou offerest up thy Spirit and thy Soule, namely thy Wit, thy Labour, thy Skill ... he Worshippeth them who maketh them, he Worshippeth them who Setteth them up in an high Place of Honour ... [44]

Reaction in the post-Restoration period opposed such dogmatism very strongly. One of the more fervent responses came in the 1680s from the playwright Robert Wolseley, who came close to emptying painting of all potential for either good or evil by an almost exclusive concentration on technique as its essential element:

> There has not been a very famous painter in the world who has not made either pictures or drawings of men or women in postures or with parts obscene, not one of any note but like my Lord Rochester he has been guilty of barefaced bawdry ... Will [Rochester] say that these great masterpieces of genius and skills that have been orna- ments for the closets of Princes, are poor pretences to painting, because they are obscene ...? 45

In contrast, the psychological and empirical approach which devel- oped at the end of the seventeenth century countered the puritans by completely undercutting the bases of their arguments. The insistence that painting was, within certain limits, neutral and innocent, capable of good or evil depending on the attitude of the viewer, introduced a new ele- ment into the debate which the older puritanical tradition failed to answer. The battle was far from being abstract or merely theological. Rather the intellectual arguments were brought forward to deal with what was clearly a deep-seated feeling in the English about the dangers of painting which, although on the defensive, was very far from dead.

Even though the art market meant that a large proportion of works coming into the country were of Catholic subject matter the profound English suspicion of Catholicism necessarily involved a considerable distaste for many of the paintings.46 Although an unprejudiced gentle- man might, according to Hume, be able to penetrate to the inner good- ness of the work, the prejudiced multitude were seen to be in some danger. For many, as for John Gilbert Cooper (1723-69), such works could be unacceptable and evil:

> ... as long as superstition uses Art like a Magician's Wand to delude the multitude with her fairy Creations, and Luxury allures her to rebel against Virtue, the Productions must necessarily be Monstrous; Disgust every undistempered Mind; and only suit that Incongruity from whence they sprung [*sic*] of Priestcraft and Licentiousness.47

Until the Hanoverian Succession was secure, the political situation in England was such that the merest suspicion of Catholicism was enough to cause problems. The possibility that certain types of pictures might be either an indication, or a cause, of Catholicism was strong enough to make collectors occasionally restrain their enthusiasms. The Duke of Shrewsbury (1660-1718) certainly felt this way, and while in his

idiosyncratic self-imposed exile in Rome in the early years of the eighteenth century his letters home emphasise the concern. Shrewsbury had dallied with Catholicism in his youth and while in Rome married an Italian countess. Combined with his long residence in the city and political importance, this made him a perfect target for rumours that he had secretly embraced the Roman faith. He repeatedly and truthfully denied the speculation, but nonetheless the suspicions seem to have affected his new-found love of painting. On a request from Lord Somers (1651-1716), for example, he went searching for pictures for the latter's collection and on 5 July 1704 he wrote to say that he had found some, including a Madonna and Child by Rubens. However, despite its merit as a painting, Shrewsbury was dubious: it was, he maintained, 'less fit for England, because, without knowing why, they have crowded in a fryar, an improper person, and little thought of in our Lady's time'. [48]

Even later there seems to have been a tendency to exercise caution when dealing with religious topics, with most collectors acquiring only pictures which represented safe and straightforward Biblical subjects. For example, the financier Arthur Moore possessed some sixty pictures in 1710, [49] with only three religious paintings. Only one of these, however, was a non-Biblical scene — representations from the Bible being more acceptable than scenes of Catholic saints and martyrs drawn from less reputable sources — and this was swapped for a landscape soon after his inventory was drawn up. One of the most glaring exceptions to this general pattern was the engraver Robert Strange (1721-92), whose collection in the 1760s was over half composed of religious subjects, a very substantial number indeed being non-Biblical. However, this is perhaps the exception which proves the rule: Strange was not only a Catholic but also a fervent Jacobite whose connections with the 1745 rebellion haunted him throughout his career.[50]

Of all the doubts attached to painting the question of pictures in churches was the most difficult to overcome. Both theoreticians and painters were not only willing, but even eager, to see a return of altarpieces and other decorations. As far as painters were concerned this desire was tinged with self-interest: churches were still the supreme social institution in the country and the use of paintings would have ensured an exposure - and hence a reputation - for the artists that even the most popular exhibition could never have approached. In addition, they would have opened up a new, and potentially highly lucrative, market for history paintings on a grand scale, which it was generally agreed was so noticeably and damagingly absent. John Gwyn again expressed this entirely self-centred notion concisely:

... in order to raise the Art [ie. of painting] to the utmost degree of perfection in England, it is sincerely to be wished, that the narrow

Notion of banishing Works of this nature from places of Public Worship was entirely exploded ... if this miserable, mean-spirited Prejudice was once overcome, England might in time, in its Churches and Painters, vie with Rome itself ... [51]

Uppermost in the minds of most theorists, however, was the didactic potential of painting. If art did have the ability to inculcate a tendency towards virtue in the masses, then it was clear that there should be no enmity between it and the church, which was in theory dedicated to the same end. The idea that the painter 'may assistant be unto the priest' was consequently a notion that slowly increased in popularity.[52]

The relationship posited in this formula was an idealisation which presupposed the willingness of men to defer to the superior knowledge and attainments that the painter was supposed to embody. However, such an idea of mass education was on occasion rudely destroyed by the masses themselves, who frequently showed themselves highly resistant. It was not simply that painters were distrusted, the church itself was also constantly suspected of harbouring subversive Jesuits ready to lead the English astray, and the local population was willing to react violently to defend themselves and their religion against possible threat.

Largely because of concern about popular protests, one of the painters' favourite projects thus made very little progress throughout the century. In 1683/4, for example, the Vicar of Moulton in Lincolnshire was persuaded to install some paintings of the Apostles in his church, a deed which instantly stirred the ire of the parishioners. When all the pictures had been hung, they reported the matter to the local bishop so forcefully that they were granted their case. Writing in a letter that he had no objection to paintings generally, Bishop Barlow made it clear that he was less certain about their use for religious purposes, and agreed with the parishioners in condemning 'The setting up of so many images, as (I believe) no Church in England has seen since before the Reformation'.[53]

Such a reaction should not be regarded as merely the unusual fervour of a backward provincial region, as the arguments of Bishop Barlow of Lincoln were revived in full force in London in 1714 when an altarpiece was put up in Whitechapel Church. The furore this caused was considerable and involving several public disturbances in the area. When, for example, the assistant of the curate in question died two years later, the event was still of sufficient importance to prompt the mob to turn out for the funeral and jeer at the corpse.[54] In this particular case, however, the objections were slightly different. The parishioners were no longer primarily opposed to all paintings in church but rather were taking very direct action to ensure that the image came up to their standards of appropriateness and decorum, a role of implied judgement which

6. William Kent (1684-1758): *Altar
Piece for St Clement Danes*, 1725,
oil on canvas (destroyed).

reversed the assumed relationship between the painter and the mass of
mankind. The objection seems to have been generated by the fact that
the painting had been commissioned by one Dr Walton, who was strong-
ly suspected of being a covert Jesuit. Moreover, it was believed that the
painting was a slanderous attack on the respectable and devoutly
Protestant dean of Peterborough, Dr Kennet, as in order to gain revenge
for a quarrel, Walton was supposed to have insisted that the figure of
Judas Iscariot in the work bore the good doctor's likeness.

Another case — although it is far from being the last to take place —
confirms the transference of the debate to the question of appropriate-
ness, with parishioners once again insisting on their right to judgement.
This incident is the more celebrated one of the altarpiece painted by
Kent for St Clement Danes (Plate 6), which was lampooned mercilessly
by Hogarth on the grounds of its artistic incompetence.[55] Hogarth's

7. William
Hogarth (1697-
1764):
*Satire on Kent's
Altar Piece*,
October 1725.

protest (Plate 7) was, however, out of step with that of his compatriots, whose outrage stemmed more from what the picture represented than from technical matters. The same procedure occurred as had been witnessed at Moulton: public protests, an appeal to the bishop, followed by the forcible removal of the offending object. The events at Whitechapel a decade earlier were alluded to by the author of a pamphlet on the subject in the attempt to establish Kent's painting as an integral part of a more widespread Catholic conspiracy: 'Nor is this the first Attempt which has been made on the Peace of our Truly Apostolic Church by Popish Emissaries, non-Jurors, and other its open and secret Enemies; for the Altarpiece of Whitechapel is yet fresh in everybody's Memory ...[56]

As the author makes clear, it is not the fact of a picture being present but rather its subversive content which caused the unrest. Writing to the bishop after the work's removal, the author roundly applauds his 'last Injunction to remove that ridiculous superstitious piece of Popish Foppery from our Communion Table; this has gained you the Applause and Goodwill of all honest Men, who were scandalised to see that Place defiled with so vile and impertinent a Representation'.[57] The picture was claimed to be an attempt to bring the church into disrepute and to seduce the parishioners away from the true religion by showing an angel with the features of the Princess Sobieski, here identified as no less than 'a pensioner to the whore of Babylon'. The author finally attempts to prove his point by casting scarcely-veiled aspersions on the fidelity of both Kent and his patron to the Anglican cause:

> When your Lordship shall examine, who is the Painter, and of what Principle? How long had he been from the Court of Rome, before he painted that Picture? ... when you shall further enquire after the Person who employed him, whether he be a Protestant, or if he call himself so, whether his Children were not sent abroad to popish Seminaries of Education ... [58]

Theological objections from within the church hierarchy appear to have been finally laid to rest in the second half of the eighteenth century, helped along the way by William Hole's immensely detailed listing of authorities to prove that the presence of pictures in church was acceptable.[59] Even so, and despite the willingness of the artistic community to give its services free, this did not clear the way for approval of the 1773 scheme to decorate St Paul's Cathedral.[60] Only in the 1780s when George III wanted to employ West on St George's Chapel at Windsor — and took the trouble to square it with the Anglican authorities before work commenced — did the church give an overt blessing to such projects, although the fact that Windsor was essentially a private chapel may well have made the theologians more amenable. [61] Elsewhere, the constant danger of church decoration being interrupted either from interfering parishioners or zealous bishops, helped to ensure that very few projects were undertaken.[62]

Such problems bring to light another level of the omnipresent uncertainty about the nature of authority in both artistic and other matters. It was an essential part of the theory of taste that only the unprejudiced had a sufficiently balanced perception to have legitimate authority in deciding the goodness or badness, the appropriateness or otherwise, of a painting. Those who lacked these qualifications had no legitimate right to impose their own preferences, but instead were to receive with total passivity such images considered suitable by those able to judge.

Such an opinion, implicit in the writings of the early eighteenth century, became much more explicit from the 1750s onwards. The requirement and justification for the educated classes to provide leadership in such matters and to take decisions for the good of the lower orders thus became more overtly articulated and formed a bridge between aesthetic theory and more generalised notions of the position, duties and authority of the upper ranks of society as a whole. By emerging in this way, the idea absorbed and strengthened an attitude about the nature of the relationship between the assorted social orders which was posited upon a conception of an organic dependency, a structure of mutual responsibilities and obligations. The assumption of the absolute nature of taste, and consequently the false nature of preferences outside the social élite, legitimated and indeed necessitated this role of leadership while also strengthening an essentially paternalistic attitude towards the lower orders.

Such a disdainful view of the lower orders was not a particularly new phenomenon. What was very different, however, was the way this conclusion was reached, and the implications that it had for the place of the arts in society. The essence of the claims of superiority lay not in any belief in a pre-ordained chain, stretching from God downwards, but instead was a psychological and essentially intellectual legitimation of the social order. The most cogent and direct statement of the general view of the abilities of the lower orders was put forward by William Shenstone, who vociferously asserted that whatever the opinions of the masses in aesthetic matters, they are bound to be either wrong or only accidentally correct:

> ... I think moderately speaking, the Vulgar are generally in the wrong. If they happen to be otherwise, it is principally owing to their implicit Reliance on the Skill of their Superiors: and this has sometimes been strangely effectual in making them imagine they relish Perfection. In short, if they ever judge well, it is at the time they least presume to frame Opinions for themselves. It is true they will pretend to taste an Object which they know their Betters do. But then they consider some Person's Judgement as a certain Standard or Rule ... [63]

The blindness of the lower orders in matters of aesthetics was an aspect of their equal lack of perception in question of politics. The essence of appreciating works of art was to see through to the truth and distinguish between the false and the worthy. One of the grand theories which accounted for the obstreperousness of the lower orders was that an inability to perceive correctly made them easily led astray by their uncontrolled passions. If the eighteenth century was the Age of Taste to some historians, then to many contemporaries it was, rather, the Age of

Riot, the calm and civilised surface of society being frequently and loudly ruptured by the incursions of the mob. To the alarmed readers of the deeds of country rioters, or people who were themselves robbed, pick-pocketed or stoned by urban riff-raff, unruly behaviour demonstrated the degree to which the lower orders were corrupted, their perceptions perverted by their living conditions. Because of this, they were easy prey for demagogues and trouble makers who could exploit their inability to see their own and the general good. As one contributor to the *Gentleman's Magazine* put it in 1757:

> ... If I may guess at the true Cause of Riots in other Parts of the Kingdom ... I may confidently affirm, that some Persons of Figure and Influence are always acting behind the Scenes, and that the real Mob are only the Tools of those who are led by either Principle or Interest, to wish for a general Confusion ... [64]

The theoretical connection that the element of perception created between the arts and social unrest was indicated by Joseph Highmore in 1766 when discussing judgement:

> How few have either the natural or acquired Abilities, or are in a situation to judge for themselves? The Bulk of Mankind are, having always been, and necessarily must be, led or directed. What is called the Universal Consent of Mankind is nothing; there is no such thing; a very few influencing Multitudes, even without their perceiving it ... [65]

The purpose of paintings changed in this period from being primarily a duty to serve God to being one of serving society. This reorganisation gave society the right and the duty to monitor and control their production. If, as will be shown in later chapters, the social élite increasingly came to accept, and even to insist upon, their duty to encourage works of art for the general good, then a parallel of this was the possibility of prohibiting works as well, to determine by both positive and negative means that the flow of images perceived by members of society was of a beneficial nature. Censorship is, of course, something that governments have traditionally viewed as their right, but it is the nature of censorship and the justifications put forward for it which are of crucial importance. Censorship to prevent criticism or to safeguard the secrets of government, or even interference to bolster the doctrinal purity of a church, provided a justification for a relatively limited degree of control. Censorship on moral grounds, to direct the aspirations and thoughts of men, was an aim of much greater extent. It potentially expanded the right to interfere from a fairly specifically defined type of image to all images and moreover increased the right to observe and check from a limited number of locations to an infinitely large number.

The English system of government in the eighteenth century was, however, woefully ill-equipped to act on such a legitimation. Except perhaps in the control of the theatre, it failed to achieve much until the passing of the obscenity laws in the nineteenth century. Nonetheless, the doctrine of taste did encourage the desire to stop what many considered an unending flood of 'prints and pictures, which greatly tend to the corrupting the morals of Youth'.[66] This belief helped to forge a link between straightforward aesthetics and the views of those influenced by such bodies as the Society for the Reformation of Manners.

As the principal Improvement in polite and common Education, is received from books, from the same Source it is that our Morals are corrupted; and it is the most shameful Odium which can be possibly thrown on a Nation, that it abounds with Writings calculated to serve the cause of Vice, and depreciate every Virtue ... at every corner, and in every Bye Alley ... we see exposed to Sale, on Windows and Stalls, Pamphlets with the most immodest titles and Impure pictures, which a Messalina would blush to meet with ... At the entrance of every public place of Resort, Agents of Iniquity post themselves with these devilish Instruments of Temptation... [67]

The idea of taste, consequently, was neither a neat array of received opinion, nor was it a body of ideas that confined itself strictly to the sphere of aesthetics. Rather it was an evolving subject that bound the question of artistic perception to far weightier matters and gave the visual arts a significance they could not otherwise have attained. Moreover, the relative absence of government censorship did not mean that no limitations on production were imposed. If the notion of taste was vague it was nonetheless immensely powerful, absorbed and adopted by artists and public alike. The firmly held ideas on beauty and its perception meant that there was little point and little desire to stray too far beyond the bound of acceptability. Collections which displayed intense sexual desires and interests were tantamount to admitting the equal possession of bad taste and consequently of not being socially respectable. Such ideas were far more effective in stemming the flow of immorality than either the enthusiasms of the Society for the Reformation of Manners or the occasional descent of government agents. Equally, for an artist to paint such works was virtually an admission that he was a bad painter and, moreover, damaged his profession's increasing claims to be a useful part of English society.

3

THE ART MARKET

The Sources of Paintings

THE PERIOD BETWEEN 1680-1760 saw the virtual invention of the English art market as in effect before this time there was no permanently established commercial system which dealt with the distribution or redistribution of works of art. The limited number of transactions virtually precluded this and the small resale market that did exist was dominated either by private deals or by foreign agents. Buyer and seller generally did their business personally and it was rare for a middle man to be called in except, perhaps, to give an estimate of the value of the goods being exchanged.[1] Foreigners were generally used for purchases of works from abroad if a more professionalised approach was necessary, the best example of this being the part played by foreign dealers in the purchase of the Gonzaga collection for Charles I.[2]

The first time that something approaching a real market structure can be seen in England is with the disposal of Charles I's pictures after 1649, which caused the appearance of a second level of distributors in transactions. This, however, was something of an accident: Charles' pictures were made over to his various creditors, who then resold them to recuperate their debts.[3] The volume of business generated by the sale was unprecedented and the indications it gave for the future proved somewhat premature. It was not until the number of pictures being exchanged increased permanently and on a more stable basis that a real English art market emerged, something which took a further three decades.

The supply of paintings on the English market in the late seventeenth century came from two main sources. Firstly there was the production of new works by living artists, a separate and only partially commercialised sector which will be examined in following chapters. The other, and more important, source was the resale of extant works, this latter

section being numerically much larger. An Englishman would have found it fairly difficult to acquire a painting before the 1680s even if he had had both the money and the inclination to buy. Had he lived in London, he could perhaps have bought one at a print or book shop, as did Pepys, for example.[4] Alternatively, he could have commissioned a work from one of the many artists working in the city. However, problems would have begun to appear had he wanted a good painting as that, almost by definition, meant a foreign one. As most of the polemicists were forever complaining, there were few good paintings in England in the first place, [5] and consequently many less on sale. Antwerp and Amsterdam were still the European centres for the art market and the few high quality paintings in England tended to be shipped there — remnants of the Arundel collection, for example, were sold in Amsterdam in 1684, as the bulk of the paintings from the Buckingham collection had been sold in Antwerp in the 1650s.[6]

For an Englishman to build up a good collection of paintings in this early period meant, therefore, that he had to buy them abroad. It has been suggested that it was economic adjustments that made this a practical possibility, with the rapid advance in England's wealth and the slow decline of Italy's not only putting an increasing number of paintings on sale but also making the English more capable of outbidding competitors.[7] Although this is undoubtedly true, such long-term changes in fact merely opened up the possibility that paintings would begin to flow northwards, rather than creating the certainty that they would do so. Before any large scale trading could begin to take advantage of economic change there were still many obstacles that needed to be overcome.

The first problem inhibiting the growth of a substantial art market in England was bureaucratic, in that it was technically illegal to import paintings into the country at all. Although the law was far from being enforced rigorously (one of the most notable seventeenth-century lawbreakers in this respect was Charles I), the government did remember it occasionally, and frequently enough to make importing pictures less than tempting.[8] In the Restoration period, however, the relaxation of the law became as official as was possible without a statutory change. By 1672 the Treasury board was instructing the customs commissioners that 'as for pictures and gilt leather, where they are not brought in for sale, but only for the private use of gentlemen, you are to represent the particular cases unto us, so if we think fit, they may be permitted to pay customs *ad valorem*'.[9]

Even so, the arbitrary responses of officialdom still posed problems both for the private collector and for the potential merchant. On 19 June 1685, for example, the Earl of Peterborough had a trunk of pictures confiscated by the customs and only managed to retrieve them with some

difficulty.[10] If members of the aristocracy occasionally had to wait several months before they could claim their possessions then lesser mortals found things even more complicated. One Anthony Holzafell, a French Protestant artist who later worked as a picture repairer for Charles II, petitioned the Treasury in October 1681 for permission to bring his goods, including his paintings, into England. He evidently got the goods but not the pictures, as over four years later he was still writing letters asking that they be released from the customs warehouse.[11] Some paintings impounded in this fashion did eventually find their way into English hands via sales held at periodic intervals to clear away unwanted goods,[12] but such a method of augmenting the national stock of works of art was not, perhaps, one that was likely to stimulate entrepreneurial activity.

By the 1680s a degree of dissatisfaction appears to have been felt about the general working of the law and in the early 1670s the Treasury evidently wished to establish with the customs 'some rule about bringing in good pictures'. There also exists for 5 February 1673/4 a draft bill to ban completely the importation of all pictures, a proposal which was not implemented.[13] Nevertheless in 1686 Thomas Manby held an auction at the Banqueting House in London which was extensively publicised and consisted almost entirely of paintings he had accumulated during his long periods living abroad. As the sale took place quite openly on Crown property it can be assumed that the government knew about it but remained unconcerned.[14] Similarly in the early 1690s dozens of auctions were advertised as containing 'pictures newly come from abroad' without apparently incurring any penalties.[15] From the late 1680s onwards the law was clearly being totally ignored — when dealing with the pictures of Sir John Williams in 1679 the customs men still felt the need to write to the Treasury for guidance, 'refusing to pass any pictures without treasury warrant'.[16] From then on there are many such references in the Treasury books but from about 1689 they stop, rather as though the government had lost interest, despite the fact that paintings were by now arriving in much greater quantities than ever before.

This alteration in official attitudes ultimately gained formal embodiment in 1695 with a law which for the first time permitted the importation of all paintings and which on its own signified a major shift in attitude towards the subject of art.[17] The laws which had previously prevented the practice had been designed, it may safely be assumed, to protect the interests of the guild of the Painter-Stainers' Company. As such they reflect an attitude towards painting which was basically artisanal. Painting was a craft and the importation of paintings would have damaged the livelihood of English craftsmen in the same way that the importation of pottery would damage potters. Previously there was little notion that any distinction should be made

between paintings and other luxury products and certainly no sugges-
tion that they possessed superior intellectual qualities. Officially at least
this attitude changed in the Restoration period and the memorandum
quoted above gives an early indication of this process taking place. Its
clear reference to the question of bringing in 'good' paintings signals that
this was being recognised as an inherently different matter to bringing in
paintings in general. As will be shown later, this was a change in attitude
that was reflected by alterations in the structure of the painting profes-
sion itself along lines that were approximately similar.

Over the period 1695 to 1722 the reordering of official attitudes was
completed, with the government moving by stages from banning impor-
tation to tolerating it and finally to making it as easy and as painless as
possible. In sum, it seems to have come around to the idea that such
imports were to be desired and encouraged rather than regretted. The act
of 1695 laid an import duty of 20 per cent on the value of all pictures
coming into the country and this method was continued under Anne.[18]
Eventually, however, it was considered unsatisfactory and the law was
changed again in 1721, according to Vertue on the instigation of Thomas
Broderick, MP for Hertfordshire and an enthusiastic virtuoso.[19] The
problem with the original method of taxation was that the better the pic-
ture, the more it cost to bring into the country. The law of 14 February
1721 solved this by making the amount of duty dependent on the size of
the painting, rather than on its original price.[20]

Although this could have involved the government accepting a drop
in tax revenue from this source in fact this did not happen. With the old
system, as the House of Lords made clear when reviewing the act in
1724, duty was paid '*ad valorem* on the oath of the importer'. When the
amount of duty to be paid was no longer tied to the cost of the paintings,
importers became less modest about the value of their possessions. They
were also prepared to bring in far more works, and the limited duty
levied on the larger numbers produced an income for the government far
in excess of its previous revenues.

The surviving records of the customs give a good guide to the levels
of pictures coming into the country and the fluctuations in the market.
However, such figures as exist before the passing of the 1695 law are of
a very basic nature and are of little use in an attempt to determine the
number of pictures that were being imported. From then until 1722 the
quality of the information improves somewhat although the customs
officials tended on occasion to lump together both paintings and prints
under the title 'pictures', and the records are remarkably complete from
1722 until further legal alterations stop the series in the 1770s.[21]

As the figures chart the gradual rise of imports into England (see
Tables 1-2) they also give firm evidence of the way the art market was
subject to constant interruption from outside influences. Chief amongst

these was war, with the perils of conflict wreaking havoc on the international movement of delicate objects. An upsurge of imports after the end of the War of the Spanish Succession in 1713 led to a period of high activity which slowly tapered off, falling to a low point in the mid-1730s. Signs of recovery were interrupted by another war, that of the Austrian Succession, and another rise after the Treaty of Aix-la-Chapelle in 1748 was broken by the Seven Years' War in 1756. As the figures demonstrate, such conflicts affected particular countries even more dramatically, with the number of imports from France, England's frequent adversary, being especially badly affected. With the restoration of peace in 1763, the importation of works of art was free to resume its normal course and, after a considerable post-war boom to clear backlogs of shipments, settled down at much higher levels than the century had seen before, with the numbers of pictures arriving at English ports consistently over the thousand a year mark.

The exception to this pattern was the case of prints, the prime supplier of which was France (see Table 3). Their importation seems to have been much less affected by the War of the Austrian Succession and the French dealers seem to have found it a simple matter to reroute their wares via Holland, Flanders or Germany during the Seven Years' War. Certainly the sudden expansion of prints coming from Flanders and Germany, both countries which normally provided England with an insignificant number, strikingly coincided with the prohibition of imports from France. On the other hand the post-war expansion was not nearly as extreme as it was with pictures and statues, reaching a peak in 1768 and then beginning a steady fall. This was doubtless partly due to the fact that as the war caused no blockage in supplies, so there was no great backlog to be cleared. Also, in the longer term, it may well be that the late 1760s marked the turning point when England finally escaped the dominance of foreign production of prints and began to establish that superiority (partly based on highly advantageous customs tariffs) which led by the 1780s to France being a net importer of English works.

Domestic as well as international conditions were also of immense importance in determining the pattern of imports. Of the leading European countries two, the Spanish/Austrian Netherlands and Spain, were surprisingly unimportant as suppliers of paintings. The former was probably a small-scale source because of its economic decline had begun in the early seventeenth century and a huge number of paintings had already left by 1700. Indeed it was not until the dissolution of the monasteries in the second part of the eighteenth century that the amount of domestic stock available for export became temporarily significant once more.[22] The lack of pictures from Spain is more difficult to understand, but was partly due to tariff barriers which made it easier and

cheaper for works of art leaving Spain to go firstly to other parts of the Hapsburg Empire or later to France. Also, although Spain was declining economically, its social structure protected the church and upper classes to a much greater extent than it did those elsewhere, so that is possible that most of the national painting stock never came onto the market.[23]

Both France and Holland had large and voracious domestic markets for works of art. Their continued economic buoyancy meant there was no serious long-term trend for large numbers of paintings to leave the country and the threat of the national stock being depleted was insufficient in both cases for there to be any serious attempt to regulate exports. Domestic demand, however, meant that in normal circumstances prices were relatively high and this put a limit on the operations of English dealers and collectors in both countries, although this factor was partially counteracted by strong indigenous production.

In a very different category was Italy, where long-term economic decline was putting many paintings on the market despite the restraints imposed by the legal inheritance system of entailing. Nearly all the Italian states, but above all those which had a rich stock of paintings, — ie. Venice, Florence and Rome — had laws designed to stop the export of works of art.[24] Clearly, however, these did not always work, partly because they were in general applied sporadically and arbitrarily. Not only did the idea of what an important painting was change frequently, but also giving or withholding permission to export depended on who the buyer was. Thus, Robert Walpole had few problems getting the works he purchased out of Rome,[25] whereas the painter Charles Jervas (*c*.1675-1739) had a drawing held up by Papal order for over two decades.[26] Would-be exporters seeking a way round the regulations would go to considerable lengths to achieve their ends, with some apparently going so far as to cut pictures up in order to get them out of the country.[27] However, although the laws governing the export of works of art from the Italian states may have occasionally prevented exports, they probably had little overall effect as the vast majority of works leaving were of relatively low value and too insignificant to draw official attention.

As far as exports from England go, the information available is insufficiently detailed to give any precise figures. Only very infrequently are they broken down and then it is very difficult to decide what it is that they have been broken down into. The most important artistic export was painters' colours, of which there were shipments valued at £3,364 in 1750, the main destinations being Eastern Europe, Flanders, Portugal and Ireland. This category, however, presumably included trade paint as well as artists' colours. The very approximate figures suggest that England had completely failed Jonathan Richardson's hopes that the arts should become an important contributing factor to the national wealth.[28]

The only significant exports were to countries within the British Empire, in which, of course, England had a complete trade monopoly. Pictures and prints were sent to nearly all of the colonies, with Jamaica, New York and Pennsylvania receiving the largest quantities.

Indeed, England seems to have been very much more adept at exporting its painters than its paintings. John Smibert (1688-1751), who made a career for himself in New England at the end of the 1720s, was only one of the first of a large number of English artists to go and paint abroad. Smibert was not only a painter but, rather like his contemporary and friend Arthur Pond, set himself up as a general supplier of things artistic to the community he painted. He seems to have supplied not only painting materials but also prints and pictures, all of which came from England.[29] In a similar fashion, there is the example of Michael Hay, the reprobate nephew of the Scottish art dealer Andrew Hay, who was sent off to Jamaica with a load of prints when he proved to be something of a failure as an apprentice engraver.[30] This excursion seems to have been successful enough for him to continue as a dealer in the West Indies, where he spent the rest of his life until his death in Kingston in 1762.[31]

Auctions and Auctioneering

Opening England's ports legally to foreign works of art was not, however, the only material task that had to be accomplished before the English art market could become of significance. Of equal importance was the development of a system whereby the paintings, once in the country, could reach their ultimate owners with the minimum of fuss and the maximum of speed. Once more, however, there were obstacles which impeded the growth of such methods as auctions.

The auction was a type of sale that originated in Holland and Flanders at the beginning of the seventeenth century and only reached England in 1676, when it was used to sell the library of Lazarus Seeman.[32] Nonetheless, variants had been in use for some considerable time, although they had never proved popular for the sale of luxury goods. Outroping, for example, defined as to 'sell by the voyce, for who gives most', had been in use since at least 1585 and references to a similar method, known as sale by candle, can be found from the 1640s onwards.[33]

Neither of these procedures appear to have been used to sell paintings and the first picture auction did not take place in London until 1682. It is, however, possible that such methods of sale reached Britain before this. A sale of pictures recorded in Edinburgh in 1668 may well have been conducted by means of bids.[34] Even so, it was not until the massive boom of the late 1680s when, as the Ogdens have shown, there

were more than 400 auctions in the space of five years,[35] that the method
can be said to have established itself properly. Probably the major reason
why the auction did not appear as an important method of trading until
this relatively late date was the fact that, once again, it was strictly
speaking illegal. One of the offices of the City of London was that of the
Outroper, who, since the reign of James I, had had at least a technical
monopoly of 'all public sales of goods', a right originally covering the
city alone but which in 1688 was extended to include Southwark as well.
Theoretically the profits from this office were meant to help finance the
orphan's fund, although in the Restoration period both office and
orphans appear to have been somewhat neglected. However, apparently
stimulated by the growing interest in auctions in the 1680s, the city
authorities undertook a determined attempt to regain control of what had
suddenly developed into a potentially highly lucrative line of business.
As a result, on 18 October 1688 — before, that is, the massive increase
in the number of auction sales in London — the following announce-
ment was placed in the *London Gazette*:

>The Lord Mayor and Court of Aldermen of this city hath lately
> made an agreement with Thomas Puckle, citizen and ironmonger, for
> the exercise [of the office of outroper] ... and the west pawn (*sic*) of
> the Royal Exchange being the place now prepared for the purpose
> aforesaid; it is ordered by the said court ... that no person or persons
> do hereafter take upon them the like selling of goods by any manner
> of public sales, as aforesaid, within the said city and liberties at their
> peril.[36]

In attempting to impose this the City miscalculated badly, and few of
their orders can have been such dismal failures. They evidently had
failed to appreciate how interest in the arts had altered in the past few
decades; no longer classifiable with other types of goods, painting was
instead on its way to becoming an upper-class fashion. As an auction of
quality, such as the Lely sale, could draw together in the same room
Lords Montagu, Rutland, Newport, Shrewsbury, Leicester, Cavendish,
Berkeley and Kent, as well as members of the gentry and government, [37]
it clearly could not be as easily shut down as a sale of wool or surplus
linen. Moreover, the sale of pictures also rapidly came to require such
skill that it could no longer be left in the hands of someone who, like the
worthy Puckle, had little training or expertise either in the painting or
the auctioneering business.

The City, in other words, appears to have been caught unprepared for
the consequences of the massive expansion of London and its commer-
cial activity that were mentioned in the first chapter. The vast increase in
all types of commercial exchange, and the fitness of the auction for

many of them, meant that the economic pressures behind such types of sale were too great to be contained in a small and essentially amateurish office like that of the Outroper. By the start of the eighteenth century, auctions were used to sell virtually everything the capital had on offer, from household goods and houses to ships, crops and raw materials, as well as shares in financial institutions, land and estates. Not having the administrative power that characterised France under Louis XIV, the City was, consequently, ill-equipped to follow the example of Paris and maintain a tight bureaucratic grasp of the auctioneer's business.[38] Its intervention, in fact, probably only hastened what was an inevitable shift caused by the drift westwards of the rich and fashionable. The need to escape regulation provided an extra reason for the auctioneers to move out of their original sites around the Royal Exchange to more fashionable and convenient sites around Covent Garden.

A more practical reason why the privately-run auction triumphed so completely was that it was more competitive. The Outroper's office charged a farthing in every shilling plus one shilling in the pound for 'writing and keeping the books', plus one shilling in the pound for crying the goods. The standard fee for an ordinary auctioneer, in contrast, was sixpence in the pound and even the more expensive specialists, such as Christopher Cock or Abraham Langford in the early eighteenth century, charged only 1/6*d*. For someone selling £500 worth of paintings, therefore, the Outroper would have charged £60.8*s*, a private auctioneer £12.10*s* and Cock £37.5*s*. [39]

The Outroper's office conducted only seven of the ninety-nine picture sales recorded in 1691.[40] Ferdinando Verryck, one of the more frequent holders of auctions, held eleven immediately over the Outroper's office at the Exchange, and continued to do so with impunity until he disappeared from the scene in 1694.[41] Nor is there any other evidence that the City knew how to exert its authority in an effective fashion. In response to a question from the House of Lords the Lord Mayor told them on 19 January 1691/2:

> Public sales of goods becoming more frequent, in hope of improvement the office was let to Mr John (*sic*) Puckle for the term of 12 years (*viz*) for the first three years for one third of the said profits, and for the next four years one half of the said profits, and for the residue of the said term for two thirds of the clear yearly profits ... but as yet no profit is either made or received.[42]

The City appears to have taken no action to try and rectify this situation and in 1692 they gave up and annulled Puckle's lease.[43] Apart from a short-lived attempt to revive it in 1710, when the lease was granted to one Bartholomew Smyth, the office disappeared completely. An anonymous memo of the same date asked the following question:

Q — Whether the city of London, by virtue of the grant of Charles I
can suppress ... public sale warehouses by an action at law ...
Q — If such Public Sale Warehouses cannot by common law be sup-
pressed will they relieve the Outroper against the grant of the said
office ...

The answers to these two questions seems to have been no and yes, and
as a result the final institutional hindrance to the art market was
removed, creating largely free conditions which were only partly inter-
fered with in the second part of the eighteenth century. [44]

If the removal of these restrictions can be taken as an indication that
the attitude of the English had altered, then the nature of the auctions
and of the auctioneers who conducted them gives a more precise indica-
tion of the nature of this change. It seems to have been generally
accepted, and acceptable, that very few of the auctions contained gen-
uine, original paintings. Nonetheless, they sold their works very well
and it appears to have been sufficient to have labelled a painting 'an
original' or 'of a genuine Italian hand' for it to find a buyer. Nor does the
low reputation of the auctions seem to have caused much dismay.
Several satires on the subject appeared in the period whose tone was
remarkable good humoured, the parody focusing on the auctioneer's
manner rather than on the fact that he was fraudulent.[45] The great
Millington himself freely admitted that many of his paintings were
'slight or defaced',[46] even though the surviving catalogues of his sales
suggest that this did not stop him labelling them as being by Rubens or
Titian. The English, it seems, in this period wanted pictures, but not nec-
essarily good ones. The first stage of the establishment of painting as a
widely supported fashion had been accomplished; its development to a
secondary stage, which placed greater emphasis on quality, was only
beginning.

From this early period, the art market evolved in a pattern which sur-
vived long after the rationale for it had disappeared. The works of art
being offered for sale were luxury goods and depended substantially on
the upper ends of the social scale for support. The system of distribution
which the auction embodied could necessarily only operate at maximum
profitability when the largest possible section of the market was avail-
able and this in effect meant during the London social season, the period
from about September to March when the gentry and aristocracy fled
from their country seats and flooded into the metropolis. The vast major-
ity of auctions consequently took place in this period and there was very
little activity throughout the summer, except, perhaps for the early
attempt by Edward Millington to move his auction room and pictures
from London to the then fashionable watering place of Tunbridge Wells
in order to catch the aristocracy off-guard.[47] On the whole, however,

such activities were rare and the potential penalties for trying to break the pattern was considerable. In 1751, for example, the Earl of Orford tried to hold an out-of-season sale of some of his father's pictures and got only very low prices for them.[48]

The auctioneers themselves were also indicative of this early stage of development. Very few sales were conducted by specialists and most were by people ready to turn their hands to disposing of any product. Millington, for example, was by trade a bookseller, who moved into pictures when they became popular and evidently moved out again after 1693/4.[49] His success depended not so much on the quality of his paintings as on his excellent entertainment value and his ability to attract people through the dexterous use of gimmicks such as artificial lighting. Ferdinando Verryck would sell anything at all and John Bullord, like Millington, was a bookseller. These three on their own accounted for the majority of sales whose auctioneers are known in this period. Signs of change, however, begin to appear early on and, not surprisingly, were recognised and acted upon by the more astute.

A section of the buying public had always been interested in the quality of the paintings but it was only gradually that this group became big enough to make fairly regular auctions of more expensive works feasible. Millington conducted a few sales to cater for this newly emerging section. In some he attempted to generate business by hawking copies of books (probably that by Marshall Smith) on the appreciation of art,[50] and in one he added the following disarmingly honest preface:

> We thought fit for the benefit of Virtuoso's and more understanding Gentry to select out of vast Numbers such as for the sureness and rarity of their Blackness will doubtless be admired by all that see them, such Persons only are desired to come. Those which are slight or defaced being reserved for another Time and Place.[51]

A small number of auctions consequently began to offer a more exclusive type of painting. One auctioneer who provided such works was Edward Davis, presumably the dealer Le Davis referred to by Vertue, who was by training an engraver.[52] Another was John Smith, who, amongst other auctions, conducted the sale of Lankrink's collection and who may have been a relation of Marshall Smith, since both lived at the same address.[53] By far the most important of this group, however, was Parry Walton (d.*c*.1700), mender of the King's pictures and an old pupil of Peter Lely's. Beginning with Lely's sale, at which he advised Roger North and prepared the pictures, Walton eventually conducted some half dozen auctions in the 1680s and 1690s, all of which featured the possessions of some distinguished collectors such as the Duke of Norfolk, John Riley, and two sales containing the remains of Peter Lely's paintings and drawings.[54]

8. William Hogarth: *An Art Auction* (ND).

A quite detailed description survives of Walton's methods of preparing for a sale, and it is clear from this that a considerable degree of skill was necessary to get both good prices and a reputation for honesty in selling pictures of quality. In 1692 Sir Charles Littleton decided to sell some of his pictures, and wrote to Christopher Hatton to ask his advice:

> In a letter I lately had from your Lordsp you said something by way of caution to my dealing with Mr Walton; which pray, my Lord, be a little more plaine with me. Have you had any experience of his not dealing fairly with you? For I have bin advised and know not who to trust better in ye matter of ye disposal of my Pictures. Ye Method I use with him; I sen yem to a Houss clos by him, for he has not Room in his own, it is already so full, and there he cleans them and mends what is worn or torn, and, after, I am to get a couple of Painters, who, together with himself, appraise them. Wch Appraisements the two Painters set their hands to the Lists of, and then they will be exposed in an Auction, but such as will be privately bought. [55]

In sum, to be successful and reputable, an auctioneer needed the dual skills of knowing about painting and being an effective salesman, two qualities which did not necessarily go together. As the art market developed, therefore, a degree of specialisation began to appear with the two functions increasingly being performed by different people. Thus, for example, on 23 November 1691 when the collections of Barberini and

Palmer came up for auction, the sale was under the dual control of Edward Davis and Edward Millington, a distinction which became the norm by the middle of the eighteenth century.

By the first half of the eighteenth century then, auctioneering had become noticeably split into two parts. Firstly, there were the auctioneers proper, men like Cock, Langford, Prestage and Lambe, who succeeded in establishing for themselves a degree of social reputation and who also managed to become fairly rich. The remainder (Mortimer's *Universal Director* lists twenty-two in London in 1763)[56] seem to have been very much less distinguished. Many of them had their origins in the Upholders' Company, that is the liveried company of upholsterers, which in the sixteenth century had secured the right to sell second-hand household goods. Until the eighteenth century they held fixed price sales, with their main task being to establish the price of the goods beforehand and then wait until people came along to buy them. The example of the auction establishing itself in the book and picture trades meant that they too increasingly began to use this method. As pictures gained acceptance as articles of furniture, upholders' sales inevitably included these as well. Often two distinct methods would be used to dispose of household goods. At the sale of General William Stuart in 1730, for example, the furniture was for sale at a fixed price, while the paintings were auctioned.[57]

Upholders in fact probably conducted far more sales than the auctioneers proper. In 1730 there were advertisements in the papers for fifteen upholders' sales, compared with only three of paintings by auctioneer. [58] Nevertheless the total number of pictures they sold was probably not that great; many of the sales clearly had no pictures in them at all, and the advertisements for nearly all of those that did refer to 'a packet' 'a parcel' or 'a roll' of pictures, suggest that the numbers were small. In general, if the pictures were numerous or above average quality then an auctioneer, capable of attracting a more distinguished audience and providing a more specialised service, would be employed.

By the end of the eighteenth century, however, the practical distinction between upholders and auctioneers had all but disappeared. Following the same route as the Painter-Stainers' company, the guilds of the Masons, Barber-Surgeons and many another, the Upholders all but collapsed and lost their grip both on their second-hand business and on their main task of supervising furniture manufacturing. The cause of the initial connection is clear — makers of furniture were liable to be best able to judge the value and worth of second-hand furniture. Yet again, however, greater volumes of goods separated the two functions and permitted the emergence of a more specialised category of salesmen, ranging from auctioneers down to second-hand furniture shops. The early eighteenth century division between auctioneer and upholder was similarly reflected in the difficulties of appraising articles for sale.

Working with the upholder was the appraiser, a trade described in the *London Tradesman* as:

> generally joined to that of the Upholder, and as such he makes estimates of Goods on all Occasions, when that is necessary: But, for the most part, the Business is carried on by Brokers of Household Goods; They are called Sworn-Appraisers because they take an Oath to do Justice between Parties who employ them; but they generally value things very low, not only of respect to any of the parties, but because they are obliged to take the Goods if it is insisted on at their own Appraisement...[59]

The special difficulties of the art market made such a method utterly inappropriate for selling or valuing pictures. Sworn appraisers undoubtedly dealt with the lower end of the market, the category dubbed furniture pictures, but it was clearly to nobody's advantage that they be used for anything more ambitious.

Commercial pressure on the structure of the resale sector therefore had the effect of increasingly splitting art from other areas of trade and, by creating a clearly distinct art market, helped foster the aura of exclusivity that began to surround paintings and distinguish them from other products. The specialist art auctioneers of the eighteenth century, like Cock and his successor Langford, provided a blanket service for their clients that no other dealer in second-hand goods even approached. They would indeed take care of all aspects of disposal. Richard Ford, for example, put in a comprehensive tender for conducting the sale of the Earl of Oxford's collection. It is clear from this, and from the contract of sale ultimately given to Cock, that by mid-century the auctioneers were well on their way to being large-scale companies, rather than being individuals acting solely as master of ceremonies in the auction room itself. For the right to perform the Oxford sale, for example, Ford proposed:

> That the expense of putting the Collection into proper Order for Sale, taking and printing the Catalogue, advertising in the foreign and domestic Papers, removing the Collection, providing the Place for Sale, Servants to attend and all other incidental Charges, shall be included in the rate of 5 p.cent. And all such single Articles as shall sell at upwards of 40 or 50 pounds at a lower Commission. The Money received daily at the Sale to be immediately taken by such Persons as you shall please to appoint, and the whole Sale to be settled, and the Balance paid within 10 days after the Sale. The Disposition of the Collection for Sale and all the Proceedings necessary thereto, to be wholly submitted to your Advice and Approbation.[60]

The only thing such auctioneers did not do in fact was to take the money, which went directly to an agent of the seller. It seems, therefore,

that they did not have the comfort and security of being able to deduct their fee at source, but had to wait until they were paid.

Like Ford, and like Walton in the 1690s, Cock also seems to have given an estimate for the pictures he was going to sell. In addition, apart from operating in their professional capacity as auctioneers, the specialist picture-sellers were frequently called in, as were dealers and connoisseurs, to give estimates of picture collections even if these were not going to be sold. However, when this was done as part of the pre-sale service, there is no indication that it was in any way binding. The estimate was simply a general guide-line and did not place the auctioneer in the same position as the sworn-appraiser. Nor does the estimate seem to have been used in order to facilitate the system of 'buying in', or having preset minimum prices, which seems to have scarcely existed.[61]

From the collapse of the Outroper's office until 1777 there was no direct supervision of auctions as a method of sale. Complaints abounded, however, from elementary satire on the frauds and abuses supposed to be inherent to them, to more substantial criticism dealing with deeper economic consequences. In 1731, for example, The *Taste of the Town* commented:

I am sensible that many People ... will immediately object to the Progress these Auctions have made, and call loudly for a stop to be put to so growing an Evil. They'll assert, that in Time, their irregular Motions will cause a stagnation in Trade, hinder Money to circulate justly, and ruin even those of large Fortunes, by buying so many good Bargains.[62]

However the first indication that legal moves were being considered comes in a government memorandum dating from about 1741:

Auctions in general being a loss to the fair Trader or otherwise often calculated to take in the Ignorant or Unwary by made up Sales or other iniquitous Contrivances or such as are honest might each afford to pay a Duty of the sum of — for a Stamp or Licence and the Sum of — for each day the Sales continued [*sic*]. [63]

This proposal did not come to anything at the time, but the note was in fact remarkably similar to the law *17 Geo.III cap 50*, of 29 September 1777, which levied 20s. for a licence. This was subsequently modified in *19 Geo. III cap 56*, in 1779, which provided the basis of legal regulation of auctions up until the twentieth century.

Although it showed some willingness to regulate the mechanics of sales, however, the law proved quite incapable of dealing with the difficulties of attribution and, as satirists constantly pointed out, this was an area that remained notably open to abuse. The statutes introduced from 1777 onwards were unable to give the buyer any more effective protection

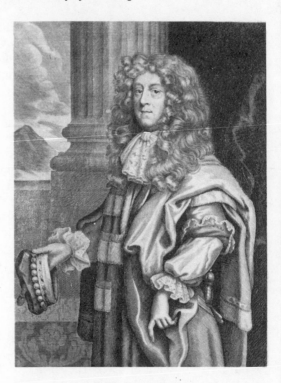

9. Anon: *Thomas Belasye,*
Viscount Fauconberg.

than did Section 17 of the Statute of Frauds, which had been in opera-
tion since the seventeenth century and never seems to have been
applied for artistic deceit. The law could deal with such abuses as
puffing, or the bidding-up of pictures by having accomplices placed in
the audience, but decided that authenticity was not susceptible to legal
reasoning.

As far as legal history goes, the most decisive case was not the cele-
brated one in which Gainsborough and other artists and connoisseurs
were called into court to give testimony, [64] but the less well known case
of Jenwardine vs. Slade, which became the established precedent for
such matters. The dispute, which took place in 1796, was the familiar
one in which two pictures sold as originals were later said to be copies.
In coming to his decision the judge, Lord Kenyon, refused to involve the
law in questions of connoisseurship:

> It is impossible to make this the case of a warranty. Some pictures are
> the work of artists for centuries back, and there being no way of trac-
> ing the picture itself, it can only be a matter of opinion whether the
> picture in question was the work of the artist whose name it bears or
> not ... what does this catalogue report? That, in the opinion of the sell-
> er, the picture is the work of the artist whose name he has affixed

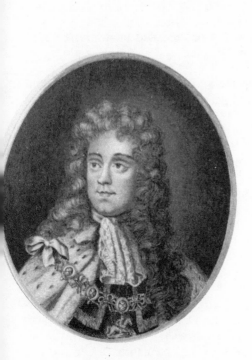

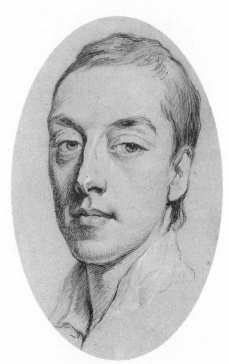

).(left) B. Reading after F. White: *Charles Talbot, Duke of Shrewsbury, c.*1694.

. (right) Jonathan Richardson (1665-1745): *Portrait of Matthew Prior,* pen and ink sketch.

upon it. The action, in its present shape, must go on the ground of some fraud in the sale. But if the seller represents what he himself believes, he can be guilty of no fraud. The catalogue of the pictures leaves the determination to the judgement of the buyer, who is to exercise that judgement in the purchase. [65]

Unless fraud could be established, in other words, art was not a question in which the law would interest itself. Indeed, it was seen to be in the very nature of art that such proofs would only rarely be forthcoming. Concrete proof, beyond reasonable doubt, was not compatible with the possibilities, intention and personal beliefs that formed the basis of artistic perception.

Dealers

Clearing legal blockages and developing a sophisticated and flexible system of internal distribution for works of art were not in themselves

sufficient for the full development of the English market in resold paintings. The final problem that had to be overcome was the initially small number of pictures in England, which necessitated heavy reliance on foreign stock, and consequently required an equal development of more sophisticated methods of importation.

The most obvious and simple method of collecting pictures from abroad was for the buyer to go and get them himself. There were three main reasons why the English went aboard in this period: firstly, for educational reasons on the Grand Tour, secondly, if they were diplomats, and thirdly, if they were engaged in trade. Many people used these opportunities for collecting pictures. In the first case Giles Isham[66] and the Earl of Exeter[67] are notable examples. Lord Fauconberg in Venice[68] in the 1670s and Matthew Prior in Paris[69] at the beginning of the eighteenth century, Thomas Wentwort[70] in Germany and above all Sir Luke Schaub in Spain[71] all used their positions as diplomats to exploit opportunities offered to buy works of art. Finally, Consul Smith is the towering example of an artistically-inclined merchant, who put together one of the most remarkable collections of the eighteenth century from his base in Venice.[72]

On the Grand Tour, however, collecting works of art was not necessarily a simple matter. Firstly, so Daniel Defoe claimed, in many cases until the eighteenth century was well under way, it was the second rather than the eldest son who was sent off to be educated abroad. According to Defoe, the reason for this was that the eldest son inherited the estates and consequently had no need for education whereas the younger, having to live off his wits, necessarily needed to have those wits sharpened and refined.[73] Although he was no doubt exaggerating in order to bolster his argument about the inadequate education of the English aristocracy, it nevertheless does seem that many of those who went abroad did so without the means to buy paintings even if they had the inclination to do so. Fathers who dispatched their children on a continental tour, such as the Earl of Macclesfield,[74] were somewhat wary about entrusting large sums to their sons' discretion and, although few of the tourists were starved of funds, most had either to account for their expenditure or have it funnelled through a tutor whose continued employment depended on a certain amount of caution.

Moreover, many of the English sent off thus to broaden their minds tended to be very young, often no more than fifteen years old, and their interest in the arts was frequently distracted by more immediate and less abstruse pleasures. Of the most important people who bought their own works abroad in this period, Exeter was in his twenties, Fermor in his thirties and Shrewsbury over forty.[75] Those like William Beckford, who were both young and with the good luck to have already inherited a vast fortune by the time they set out, were not numerous. Most people of the

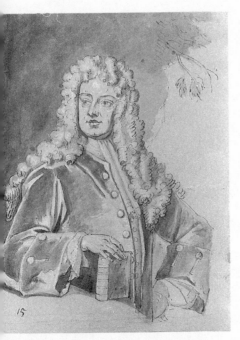

12. Edward or Robert Byng: *Portrait of John, Lord Somers,* pen and ink sketch after Kneller.

3. Edward or Robert Byng: *Portrait of Charles Montagu, Earl of Halifax,* pen and ink sketch after Kneller.

age when they were likely to have full control over their incomes and were more likely to spend it on pictures, were not in a position to go aboard and were instead often occupied at home in making or holding onto their fortune. The Duke of Shrewsbury's behaviour in abandoning England to retire to Rome was regarded as eccentric in the extreme, whereas Shaftesbury's decision to quit English politics and preserve his ebbing health with the airs of the Mediterranean was seen, by himself as much as anyone, as a grave misfortune.

If the majority of rich and potentially artistically-minded Englishmen were not able to go to the paintings, then some method had to be devised to bring the paintings to them. The standard method for this was to rely on friends and acquaintances who were abroad. There are innumerable instances of this throughout both the seventeenth and eighteenth centuries. John Talman (d.1726), for example, offered his services while in Rome and acted as the go-between in the purchase for Lord Somers (Plate 12) of the collection of drawings of Padre Resta.[76] Shrewsbury likewise bought works for Somers and Halifax (Plate 13)[77] Kent for Somers,[78] and while in Naples Shaftesbury bought works for Sir John Croply.[79] The diplomatic network was also useful — Doddington,

Fauconberg's successor as emissary in Venice in the 1670s, kept a look out for paintings for his employers[80] and in 1672 Joseph Williamson was approached while in Antwerp by Lord Clifford via William Southwell about the possibility of his buying paintings there.[81]

Such a system was not entirely satisfactory. In the first place it was necessary to know people who were living aboard and many people did not have such contacts. Equally, it was important to know someone whose judgement was reliable. In the case of Talman and Shaftesbury this was evidently the case, since both had a rare reputation as virtuosi in the arts before they left England. With Shrewsbury, however, the matter was more dubious. Both Somers and Halifax expressed surprise at the sudden development of Shrewsbury's cultural interests — as Halifax put it, 'I am glad you are grown so great a virtuoso. I shall have much more pleasure in that sort of conversation than in the field sports you admired when you went from hence ...' and Somers pointed out to him that virtuosity' was a quality you did once despise'. Despite the novelty, however, both men were willing and even eager to entrust considerable quantities of money to his taste and expertise. Somers was especially keen:

> I give your grace a thousand thanks for the account of the fine pictures. I am not capable of judging what I do not see, ... But if your grace thinks there be any one ... among them, or elsewhere, very good, and at a reasonable price, I could be extravagant enough to lay out about two or three hundred pounds, and should be very pleased of having something, chosen by you ...[82]

However, even being assured of the services of someone like John Talman did not remove all difficulties. Paintings were still bought sight unseen, and the Italian postal service and unsophisticated banking system made matters more problematic. While in Italy Talman was far from being wealthy. Indeed, he was perpetually complaining about his lack of money and was at one stage reduced to walking from Florence to Rome as he could not afford the coach fare. He relied totally on his father sending him an allowance — an event which he considered happened less frequently than was ideal — and even when money was sent it often took a very long time to arrive. He was not, therefore, in a position to advance cash on behalf of the people for whom he was buying but instead had to wait for transfers of money from England in order to clinch a deal. Even if the banking system operated efficiently, the business of writing to England and having the money sent out could take several months, with the constant danger that a rival whose finances were better organised would buy the objects before it arrived. As Talman put it: 'I t'other day saw a great Curiousity of Alber Durer's wch is now sold, for before I can have an Answer from England two Months pass at

least, and sometimes four, and ye Italians always make ye best of ye first Opportunity.'[83] However, a combination of war and the financial difficulties of many Italian families at least meant that paintings were on sale at prices which for much of Europe were bargain rates. Shaftesbury, in particular, commented on this:

> Meanwhile never was there such a deadness to all arts in Italy; and many families sinking here under poverty make pictures a sad drug ... if a sudden peace comes not I shall be able to buy out of your £200 to so much advantage in some pieces of the best hands that you may wish perhaps your commission had been for as much again ... I could even have a Raphael or a Guido for a single pistole...[84]

As a partial answer to this problem of bringing painting and buyer together there developed the professional agent working to commission, the supreme example of this type being William Petty, who worked for the Earl of Arundel in the 1630s.[85] Others followed his example in the Restoration period, with Prosper Henry Lankrink (*c*.1628-92) operating for the Postmaster General Charles Fox in 1684, [86] while one Jocson acted for the Earl of Sunderland in Rome in the 1660s.[87] The potential of the agent was, however, inevitably limited. On the one hand, if he worked for only one person then that buyer had to be prepared to spend on a lavish scale to make such an expensive employee worthwhile, and the number of people in the eighteenth century who were ready to lay out cash on the scale of an Arundel was decidedly limited.[88] On the other hand, if the agent worked for two people simultaneously in order to cut costs then different but equally severe problems arose. When Thomas Roe acted for both Arundel and Buckingham in the Eastern Mediterranean in the 1620s, for example, the co-operative scheme fell apart because both employers began to suspect that the other was taking an unfair advantage in capturing the better works thus acquired. [89]

If agents were to work for several clients at a time they had consequently to become more or less independent, taking responsibility for their purchases themselves and letting the distribution of the paintings be decided by that universal arbiter, the greatest willingness to pay. Such a scheme also offered the tempting prospect of greater rewards for those who chose works which sold well in the English market. Before this could happen, however, such traders had to be assured that there was a sufficient demand for paintings to provide a healthy profit. To buy a large number of paintings, even at bargain Italian prices, to ship them back to England and prepare them for sale, was far from being a cheap process and constituted a considerable entrepreneurial risk, especially as those people both prepared, and able, to perform these tasks were almost by definition unlikely to be independently wealthy.

The auctions of the 1680s and 1690s, however, demonstrated quite conclusively that the market for art was sufficiently buoyant for the agent to cut his links with his employer. The first Englishman who can definitely be identified as having set up as an independent dealer was Thomas Manby, a landscape painter who studied for several years in Italy. During that period he acquired a large number of paintings (there were 168 in his sale) which he disposed of at an auction after his return to England in 1686. [90] This sale moreover seems to have been a considerable success — Vertue noted that Manby was able to live comfortably on the profits for the remaining ten years of his life. [91]

Manby was, however, an amateur who rested content with his initial success and did not try to repeat the experiment. Despite the boom of 1688-93 and perhaps because of the combination of its collapse and the onset of the wars against Louis XIV, no Englishman seems to have emulated him for some time. The painter Closterman brought paintings back with him from Italy in 1702[92] but the next step towards professional dealing was not taken until James Graham held his three sales, on 17 May 1711, 6 March 1711/12, with the third in 1713. [93] The first was advertised in *The Spectator*, where he claimed to have 'travelled Europe to furnish out a show for you, and have brought with me what has been admired in every country through which I have passed'. [94] The catalogues for two of his sales have survived, and the second, although relatively small, appears to have been remarkably successful. With a total of seventy lots, the prices fetched by sixty are known and produced the very high total of £1,669. Moreover, the quality of the pictures was evidently high enough to attract some of the most distinguished English collectors of the period as buyers.[95] After this, however, Graham seems to have retired from the more active part of art dealing and does not appear to have travelled abroad for more pictures. He nonetheless remained in the art world, and set up a gallery of some sort in London in 1715, which is, unfortunately, the last trace of him that has survived.[96]

The central role of dealers in facilitating the expansion of interest in the arts cannot be disputed. For the rest of the century, a stream of them, initially relying on the exploitation of price differentials between England and the continent to produce their profit, followed the examples of Manby and Graham and went abroad, bought pictures and brought them back to England to sell, generally by auction.

One of the few pieces of evidence on the costs of such an operation comes from the accounts of the Duke of Beaufort. In the 1720s he set off on a Grand Tour of Italy where he bought a large number of pictures.[97] The pictures were bought in three stages; firstly, up to April 1727, when the painter and dealer John Gore sent off an uncertain number of works to England; secondly, between May and September when Phillips supervised the purchase of 142 pictures; thirdly, in September 1728 when a

further eleven were bought. The pictures in the second batch cost Beaufort a total of slightly over 12,144 crowns. However, the additional costs — travel, valuation expenses, wharfage, customs duties, freight, packing and so on, pushed the final bill up to almost 20,000 crowns, an increase of about 40 per cent. Much of this was by its nature a fixed cost that depended on the size and the number of the pictures rather than their quality.

Faced with similar costs, dealers consequently had to be sure of very substantial mark-ups in order to make their profits. As an indicator of how difficult this could be, when Phillips purloined some of the paintings and sold them at an auction, in most cases he managed to get far less for them than his master had originally paid in Italy. Even though lower prices may have been a result of the circumstances of the sale and the fact that he was not established as a reputable operator, it is nonetheless clear that making money on such an enterprise was not certain. Because of the costs, dealing which involved foreign travel tended to develop in three ways. Firstly, trips aboard became less frequent and when they occurred were on a substantial scale. Secondly, the tendency for dealers to concern themselves with the bottom end of the market shrank. Thirdly, there was an expansion of contact with foreign dealers, the evolution of a partial system of correspondence which further extended the line of supply by inserting another layer of middlemen into the process of bringing buyer and painting together.

The main importance of international dealers was that their existence took most of the pain and difficulty out of collecting. With such problematic areas as transport, insurance and laws governing exportation safely in the hands of the specialist, not only were the amounts of time and energy necessary for collecting reduced substantially but the element of risk involved was reduced to that inherent in the process of selection. In addition, although the appearance of the dealer was a result of the buoyancy of English demand for works of art, by ensuring that a steady flow of paintings arrived in England and were distributed efficiently, the dealers played a substantial role in maintaining and extending the development of that interest. The importance of paintings in the English social system increasingly came to rest on the significance engendered by their relative ubiquity, not in their exclusivity. For this to be possible it was essential that availability was subject only to taste and financial ability to purchase, not on arbitrary access due to having the appropriate contacts, or being in the right place at the right time. The concept of taste could not have gained its artistic and social significance if the evolution of an interest in the arts had been hindered by such practical and erratic barriers. The intervention of the dealers therefore played a major role in conditioning the English response to painting. In simple financial terms their emergence placed an additional level between buyer and

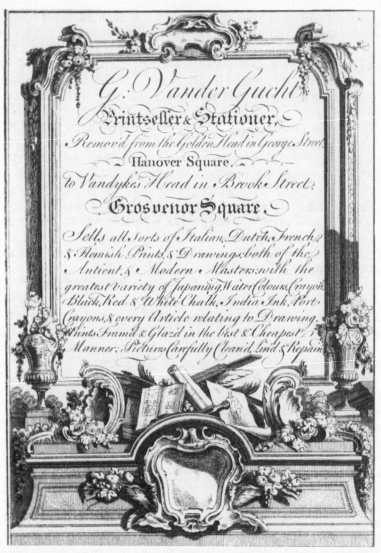

14. Gerard Van der Gucht (1696-1776): Tradecard 1740s. The Card shows the virtuosity of The London domestic dealer – Van der Gucht not only sold paper and prints, paint, colours and drawings, he also framed pictures, cleaned and restored them.

work, while in social terms the enormous simplifications they permitted placed the buyer in close contact with the paintings and allowed much greater emphasis on the problem of choice.

Several types of dealer can be detected, although there was a gradual tendency for all to coalesce into one as the eighteenth century progressed. The two main categories were the shop dealer and the international

dealer. Crossing over these two were the painter-dealer and the con-noisseur-dealer who performed either of these main functions. In addition to this there was, as in the seventeenth century, the private agent acting on behalf of a particular client, either going aboard for works — as John Ellis did for Walpole, or Matthew Brettingham for Leicester — or doing the bidding at an auction.[98] This last category how-ever had precious little independence and should be regarded as an extension of the purchaser.

There does not appear to have been any strict line of supply in this period; it was not the case, for example, that the international dealer sup-plied the shopowner, who supplied the customer, although this was one fairly common route. International dealers supplied the customer direct-ly via the auction and these sales were an increasingly important source for the domestic operator. The latter were growing rapidly in number and they were often also involved in other activities in the artistic field (Plate 14). Thomas Mortimer, for example, observed that picture cleaners were generally dealers on the side and to the four names he gives (Collivoe, Matthyson, Smart and Van der Gucht) two further can be added from a slightly earlier period: Parry Walton, mentioned before, and John Howard, in operation from about 1710 to about 1745.[99]

Domestic dealers, who often ran picture shops as a way of selling their wares, did, it seems, occasionally employ artists to work directly for them, a topic to be returned to in chapter four. However, the central element of their business was the entrepreneurial operation of taking advantage of fluctuations and imbalances in what was still a very imper-fect market. Although demand for pictures clearly fell off outside the period of the London social season, it is highly unlikely that it disap-peared altogether and as virtually no auctions took place during the summer months, supplies of pictures must have come mainly from their stock. Increasingly in the eighteenth century such operators seem to have gone to auctions for their works and, with the exception of Walton, all of the six mentioned above were regular attenders of sales. In the period 1738-50, for example, the younger Collivoe appears at eleven of the surviving sales, and Smart at seventeen between 1711-50.[100]

Although domestic dealers occasionally held sales of their own, as Collivoe did in 1726/7,[101] this seems to have been rare and, until the 1740s, the boundaries between the domestic and international were fair-ly well-defined. The domestic dealers, by recirculating stock within the national boundaries, helped to flatten the fluctuations of supply caused by the timing of auctions and provided a method for those who lived out-side London to acquire works of art. The international dealer, on the other hand, gained his profit by augmenting the national stock. Many of this latter type can be identified. Three however will be examined in greater detail to give a clearer idea of how they operated.

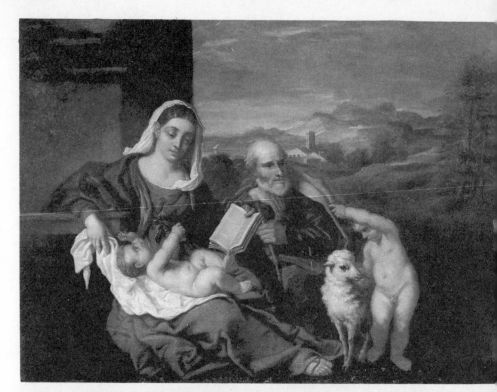

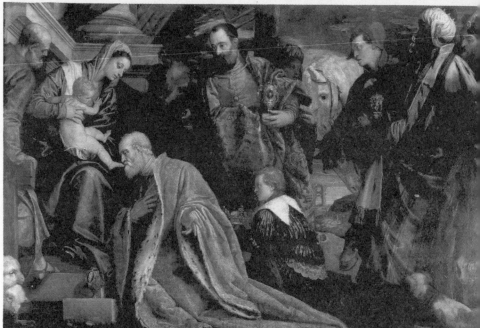

Early collecting through auction:
15. (top) After Titian: *Holy Family*, oil on canvas. Bought for the Duke of Devonshire at the 17?
Portland sale, as an original Titian, for £126.
16. (bottom) Attrib. P. Veronese: *Adoration of the Magi*, oil on canvas. Bought for the Duke
Devonshire at the 1722 Portland sale, as an original Veronese, for £367.

17. Andrew Hay (d. 1754): *Portrait of George Baillie of Jerviswood*. oil on canvas.

Andrew Hay

If Manby was the first English art dealer and Graham the first to hold
more than one sale, Andrew Hay represents the emergence of a new fig-
ure in the English art world, that is the full-time professional. Unlike the
others, Hay made dealing his career and it was one which lasted for over
a quarter of a century. He was not alone in this — the period which sees
his emergence similarly saw the arrival of Peter Motteux (1660-1718) and
Samuel Paris (d. 1745) amongst many others — but he does appear to
have been by far the most distinguished and financially successful.

Hay was a Scotsman, originally apprenticed to John Medina (*c.*1659-
1710) in Edinburgh as a portrait painter. Around the time of Medina's
death the first, and only, results of his training as a painter can be traced,
in portraits of James, Lord Torpichen, and of George Baillie of
Jerviswood (Plate 17). It also appears that the portrait of Baillie was
copied by Hay, possibly several times, for distribution amongst Baillie's
friends.[102] Shortly after this, Hay set off like many another painter to
study in Italy. Unlike many others, however, he was realistic about his

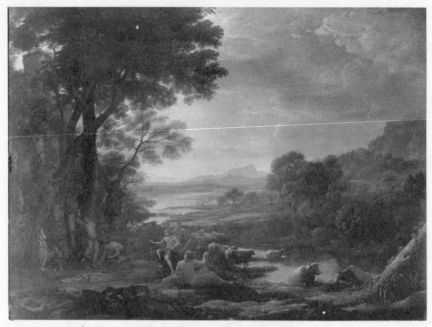

18. Claude Lorraine: *Landscape with Apollo and Marsyas*. oil on canvas. Supplied by Andrew Hay to Thomas Coke in 1719/20 for £200.

abilities and 'possessing only a middling degree of talent, he soon abandoned it [ie. portrait painting] and, as he had passed several years in Italy, he had acquired a knowledge in the works of the great masters and of course became a dealer'.[103] It is not clear when Hay made his first trip to Italy, but it would seem likely that his first concrete appearance in the records, in 1715/16, was near the end of his original voyage.

If this is the case, then it seems that his beginnings as a dealer were fairly orthodox, that is as a guide for English tourists and as an agent for them in the purchase of pictures. In 1715 he acquired two very valuable clients, Thomas Coke (1697-1759) and Edward Harley, later 2nd Earl of Oxford (1689-1741). On 2 January 1715/16 eighteen pictures and a head worth £111.5s. arrived at Harley's country house at Wimpole sent by Hay in Rome and brought from London by the architect James Gibbs.[104] A further shipment worth £551.7s.6d. arrived in 1716. Hay had clearly not bought these speculatively but instead had been commissioned to acquire them. In the same year he sold drawings to Coke, then in Rome on his Grand Tour, which were worth 33 crowns and more for 29 crowns the year after.

From this period until 1722 Hay was working partly as an independent dealer and partly for particular clients as their agent. His disengagement was a gradual affair and is difficult to chronicle precisely. He appears to

have come back to England towards the end of 1717, arranging a ship-
ment of pictures and statues for Coke *en route*, for which he was paid 15
guineas plus a further £39.18s. for costs. He continued this connection
throughout 1719, being paid on 21 May £352.10s. for a picture by
'Bulovius' and £200 on 16 January 1719/20 for a large Claude
Lorraine.[105] This latter work was probably bought during his second trip
to France in the second half of 1719.

A further result of this journey was the sale to Harley of a collection of
pictures, medals and manuscripts worth £433.10s. It was also then
that Hay appears to have first run into the inherent difficulties that
accompanied art dealing. The inadequacies of the international banking
system, as mentioned, had bedevilled the collection of art for as long as
the English had been interested in the subject. For men such as Talman or
the Duke of Shrewsbury, the problems were at least straightforward in
that, acting as they were on the behalf of someone else, they knew the
money existed. For the independent dealer the problems were much
greater. Essentially Hay was gambling, buying works with his own
resources on the assumption that he would be able to dispose of them
speedily and profitably back in England. In order to make this possible he
worked with his brother George, to whom he sent his foreign purchases
for sale.

On the 1719 trip to France, however, he overreached himself and bills
arrived in London which George could not pay. His brother consequently
had to exploit the goodwill built up amongst clients during the past few
years. A letter from George Hay to Lord Harley, dated 15 August 1719,
sets the problem out with few scruples:

> Your Lordship may justly be surprised at the Freedom I am going to
> take, which nothing but the knowledge of your Goodness, could make
> me bold enough to do. I have some Bills drawn on me from France for
> more Money than I now have, and if it was Convenient for your
> Lordship to order that small Sum, which I hereto add, it would do me
> a greater Favour than thrice the Money at a later Time.[106]

Attached was a bill for £77.18s, which Harley, noted for his unusual gen-
erosity, appears to have paid. Indeed it is possible that he paid more than
was asked, as the bill which accompanied the delivery of 1719/20 has a
note to the effect that £355 had already been settled.[107]

Hay returned once more to England in January 1720 and immediately
prepared to set off for another trip, this time to both France and Italy.[108] In
the meantime, as was his habit, he first went back for a brief visit to
Scotland,[109] and it was possible at this time that he married Margaret
Nicholson, daughter of Sir William Nicholson, 2nd bart., an Edinburgh
merchant and comptroller of the customs at Aberdeen. Nicholson owned,

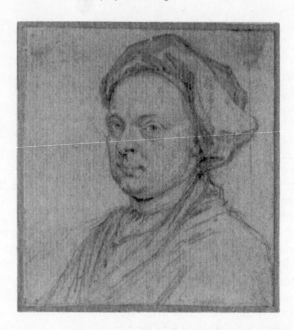

19. George Vertue:
*Portrait of Edward
Harley, 2nd Earl of
Oxford.* 'Drawn from
the life...1725' pen
and ink.

from 1721, a substantial estate at Glenbervie which he enlarged through
a subsequent marriage, and his sister married into the Scottish aristocracy
in the figure of William Kerr, 3rd Marquis of Lothian. Not too much,
however, should be read into Hay's well-connected match: daughters
were notoriously more difficult to marry off than sons, and Nicholson,
who eventually produced a total of twenty-two children, was probably
not in a position to be overly fastidious about his offspring's choice of
husband.

Hay left England again in May 1720 and took with him on his depar-
ture a commission from Harley to buy manuscripts. He went firstly to
Paris, where he saw and bought those of the Abbé Seguier, and arrived in
Italy on 25 July. Material he bought in France on his own account arrived
in England in August and was auctioned from the 31 to 2 September.
Because the expedition was a long one, he adopted the expedient of send-
ing lists of his purchases back to his brother who then went round the
regular customers trying to sell them before they even arrived in England.
In Italy he made two major purchases — a collection of printed portraits
from Padre Orlandi and half of the Valetta manuscript collection, the first
part of which he had brought back to England in 1717. He returned after
nearly two years abroad towards the end of 1722.[110]

At this point Hay got into potentially very serious trouble and was pre-
vented from taking any more trips abroad for over a year and a half. The
nature of his difficulties illustrates the degree to which it was still highly
unusual for the English to travel and even more odd to do so regularly.

It has already been mentioned how the Duke of Shrewsbury had to be cautious merely for living in Rome at the beginning of the century, and how William Kent was suspected of being a Papist for having studied there.[111] Hay, who travelled around Catholic countries frequently in a period when the Hanoverians were still far from secure, came under suspicion of being a Jacobite agent. Being an art dealer was, of course, a fairly standard disguise for eighteenth-century espionage. John Macky (d.1726) doubled as spy and collector for Robert Walpole in the 1720s and similarly Crozat used the cover of hunting for pictures while doing some cautious diplomacy for the Duc d'Orléans at approximately the same period.[112] Hay had the misfortune to be travelling to and from Rome at the same time that the Jacobites were hatching a plot which, however harebrained, was nonetheless taken very seriously by the English government. The scheme was masterminded by Christopher Layer and involved an armed uprising, the overthrow of the government and the re-establishment of the Stuarts. As plots go it was a total disaster, but this did not stop the government from arresting and executing Layer together with as many of the chief conspirators that they could lay hands on.[113]

Ultimately the authorities seem to have been unable to make up their mind whether Hay was involved or not. The evidence certainly was circumstantial and it is completely impossible to decide now. He was in Rome at the same time as Layer, he was a Scotsman and he mixed in Jacobite circles, certainly being acquainted with Thomas Rawlinson.[114] Even more unfortunately, he had the same surname as one of the chief conspirators and trying to decide whose wife was whose caused the authorities no little trouble when the case was being investigated later on. At the height of the affair, Hay was examined and summoned to appear at Westminster Hall, a difficulty which he evaded by once more playing on his contacts. He wrote directly to Robert Walpole, asking to be excused on the grounds that he was 'being forced by such confinement to neglect the way of business which I have for several years dealt in and is now my only support'. To make doubly sure the letter ends:

> your Petitioner humbly prays that you will be so good to give the proper Directions herein, and hopes for your Favour and Indulgence since his Grace the Duke of Devonshire assured your Petitioner that you had been so good as to promise the discharge of ...yr. most obedient humble Sert., Andrew Hay.

This letter thus forms the only concrete personal connection of Hay with Walpole and Devonshire, two of the principal collectors of the day, who are specifically mentioned by Strange as his main clients.[115]

The letter appears to have had the appropriate effect, as despite the fact that his wife was still under investigation (a man called Crew went to

interview the neighbours in September 1724),[116] Hay went off for another trip round France from May to January 1724/5. This voyage resulted in further sales to Harley and the first auction for which a catalogue has survived. There then follows another sale in 1725/6, presumably also the fruits of a French expedition, whereupon he fades from the scene almost completely for over a decade.[117]

Although Hay's career began in an orthodox fashion it rapidly began to develop along more novel lines. At no time after about 1721 does he seem to have worked for any one person nor did he work under any form of retainer. His income, rather, came from the sales to people rather than from any allowance given him. Similarly, his purchases all seem to have been paid for out of his pocket, rather than his simply spending money drawn on others.

From the beginning, therefore, his position was one of much greater independence than that of, say, William Petty. There was always an element of risk in his purchases in that, from 1719 onwards, there was no guarantee at all that even his private clients would be prepared to buy the goods he had on offer. The 2,420 portraits from the Orlandi collection bought in 1720/1, for example, were presented to Harley when they arrived in England — 'and being disliked, they were all returned'.[118] Also the orders given to Hay by Harley shortly before he left on this trip seems neither generous nor favourable — there is no mention of a fee and the strong impression is that Hay was to buy the manuscripts out of his own funds and be refunded on his return. Apart from useful encouragement from Harley about relying on 'your fidelity, your prudence, your usual dexterity in business matters and your personal affection', Hay was on his own, setting off with a list of requirements that would have bankrupted a man of considerable fortune.[119] Not perhaps surprisingly, the connection with Harley began to lapse, although a degree of affection clearly remained — Hay's portrait at least was in the Oxford collection until the sale of 1742.[120] The 1720 commission seems to have been too onerous, and was largely ignored — a letter was written in April 1721 reminding Hay of its existence, and eventually, in April 1722, it was withdrawn, 'he having done nothing therein ...' From this point onwards Hay appears to have worked directly for the market, selling his goods principally by auction.[121]

This increased degree of commercialisation was a testament to the rapid growth that had occurred in the English interest in the arts. The changes, moreover, were recognised as being financially reliable enough to allow the possible alienation of an important and useful client. Apart from this feature of Hay's career two other things stand out: the gradual specialisation of the goods he dealt in, and the increased reliance on France as his principal source of supply. In the early stages of his career Hay appears to have bought and sold almost anything: the sales to Harley, for example,

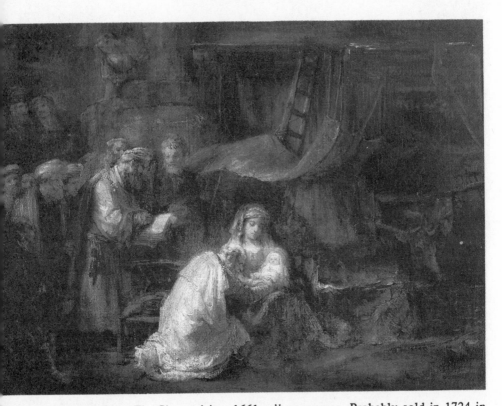

0. Rembrandt van Rijn: *The Circumcision*, 1661, oil on canvas. Probably sold in 1724 in ondon, and resold by Andrew Hay in 1744/5 to Spencer.

include manuscripts, medals, books and jewellery. Similarly Harley's librarian Humfrey Wanley specifically mentions that the sale of August 1720 was of antiquities, not paintings. From the 1724/5 sale onwards, however, all these miscellaneous articles disappear and thereafter the emphasis is very heavily on paintings, with only prints and drawings, and very occasionally statues, receiving some minor attention.

The greater reliance on France gives an indication of the difficulties posed for dealers by the very extended trips required to buy works from Italy. Also it would appear that Hay was one of the first dealers to take full advantage of legal changes of 1722 which equalised the tariffs on goods coming from France with those for other countries. Until then the rate had been substantially higher, which probably played a considerable part in ensuring that until then the proportion of pictures coming from France was very much smaller than for either Holland or Italy.[122] Vertue says that Hay made over fifteen trips to France during his career and only six to Italy. There is, however, no mention in any source of his having bought in Holland,which provided only an insignificant number of

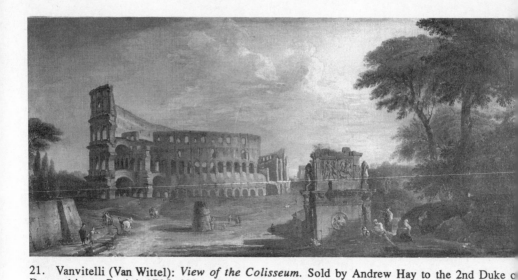

21. Vanvitelli (Van Wittel): *View of the Colisseum*. Sold by Andrew Hay to the 2nd Duke of Devonshire as Panini, 1725, £30.

paintings to England in the 1720s and 1730s, although he does appear to have had some sort of arrangement with a man called Wilkins who appears frequently in Dutch auction catalogues and with whom he held a joint sale of prints in the late 1730s.[123]

A further development was that Hay increasingly abandoned the upper end of the market. The 1725/6 sale, for example, included several pictures of quite substantial value — twenty out of the seventy-three fetched more than £30 and the whole sale, which brought in a total of £1730.14s with an average value per painting of £23.14s., was exceptionally valuable.[124] However, in the last period of his career from 1738-45 no sale came close to these figures; all his remaining auctions had an average lot value of between £7.15s. and £11.5s and only on one occasion did a picture fetch more than £60.[125] Like nearly all other dealers, he seems to have found greater security and profit by balancing pictures from the expensive and more unpredictable end of the market with supplies for the larger number of more modest collectors whose greater quantities cancelled the dangers of personal idiosyncrasy.

Finally, it is necessary to examine the quality and reliability of Hay as a supplier of pictures. Information about this is necessarily highly variable because of the difficulties of tracing many of the pictures he sold. However, the auctions he held were capable of attracting the more eminent collectors so in that respect he was clearly highly thought of, even though few of his paintings were particularly expensive. At various times pictures in his sales were bought by Lord Burlington, Sir Robert Sutton, the Duke of Devonshire, Robert Walpole, Robert Furnese, and Lords Cavendish and Cholmondeley.[126] However, as far as giving value for money is concerned, the only guide is the pictures sold to Lord Harley between 1716 and 1719, subsequently sold at the auction after his death,

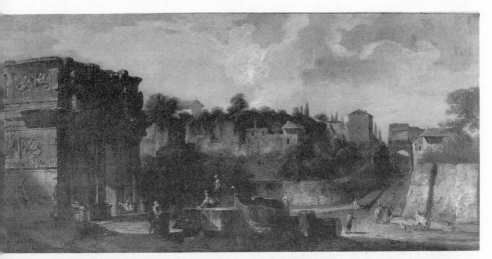

Vanvitelli (Van Wittel): *Arches of Titus and Constantine*. Sold by Andrew Hay to the Earl of ⸜rlington as Panini, 1725, £40.

and this gives a less favourable picture. Of these works thirty-seven can be identified at the sale, and, although they were bought for a total of £688.14*s*., they sold for a mere £318.2*s*.6*d*. Still, buying by private treaty was generally recognised as a more expensive way of acquisition and these pictures were supplied when the market was still not very highly developed. Equally, Harley was renowned for his prodigal generosity and carelessness in such matters. Nevertheless, the loss of value was very marked and it is unfortunate that this cannot be checked with pictures brought at an open sale.[127]

Hay's career as a dealer ended in 1745 when, after a final sale, he retired to Scotland with his wife. The reasons for his retirement are unclear, although age — he must have been in his fifties and possibly older — provides the simplest explanation. However, it must also be remembered that 1745 was the year of the Young Pretender and, apart from the crash in prices this civil disruption seems to have engendered, the coming of Bonnie Prince Charlie may have made life for Hay — Scottish and once under suspicion of Jacobite sympathies — much less comfortable. He spent the remaining years of his life in Carubbers, a court off Princes Street in Edinburgh. He died in October 1754 and an obituary published in the *Scots' Magazine* described him as 'a noted antiquary', not an art dealer.[128]

His retirement does not, however, appear to have been total: his testament refers to 'the shop moveables', suggesting that he continued in a small way to supply works of art to the growing number of Edinburgh connoisseurs. He had certainly kept up his contacts during his career in London, returning home frequently and keeping on good terms with one of the most notable Scottish virtuosi, Sir John Clerk of Penicuik.[129] In addition he had, during the 1730s, given an estimate of the collection of

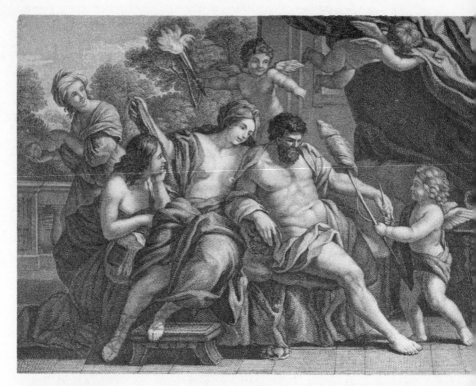

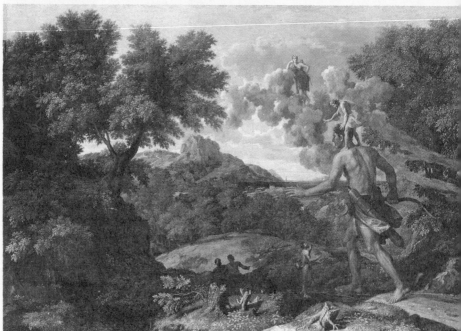

23. (top) Romanelli: *Hercules and Omphale*, print after, by Jean Baptiste Michel, publishe
Boydell, 1770. Sold to Robert Walpole, 1725/6, £44.2.0*s*.
24. (bottom) Nicholas Poussin: *Blind Orion Searching for the Rising Sun*, sold to the Duk
Rutland, 1744/5, £31.10*s*,0, oil on canvas.

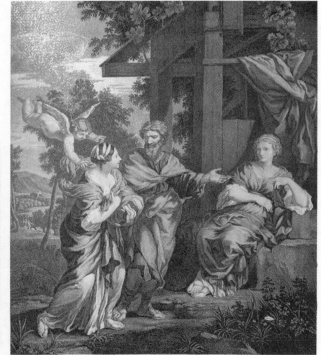

Velásquez: *Innocent X*, Print after by Valentine Green, (1739-1813) published by Boydell, 74. Sold to Robert Walpole, 1725/6, 11 gns.

Pietro da Cortona: *Abraham, Sarah and Hagar*, print after, by J.B. Michel, published by ydell, 1770. Sold to Robert Walpole 1725/6, no price.

the Earl of Annandale and had possibly also bought some pictures for him.[130] On his death he was quite well off — Vertue states that he had made 'some thousands' by the time he retired. Certainly, in addition to the 'furniture, jewels, Plate, drawings, lying money and banknotes... and pictures' he also left his wife a total of £2715.14s (English pounds), a quite substantial sum, especially considering that he had been retired for nearly nine years on his death.[131]

Samuel Paris

Samuel Paris paralleled Hay in many ways, having a career of approximately the same length which covered virtually the same period. Similarly he seems to have been a painter who abandoned his profession for a more lucrative line of business. However, he was decidedly less successful in both social and financial terms. Hay moved easily in some of the more exclusive circles of the virtuosi, as indicated by his membership from the early 1720s onwards of the artistic and antiquarian Rose and Crown club, with the highly valuable connections that provided. Paris never appears in these areas and although paintings of high quality

passed through his hands he was relatively poor when he died in 1745. His will makes constant allusions to his poverty, directing that his small estate was to be divided between his wife and his brother Thomas, a joiner at Chatham Dockyard, and his legacy of one guinea to his servant was accompanied by the apology that 'my narrow fortune and poor relations hinder my doing more for him'.[132]

Paris' career seems to have started in the early 1720s, since Vertue mentions one of his sales in 1722,[133] but whatever prospects he had in the early stages were soon stopped very sharply, with the difficulties of trading already noticed in Hay's case reappearing on a much larger scale. Briefly, he appears to have overplayed his hand to such an extent that he went bankrupt and had to disappear in some haste to the continent. Unlike Hay, whose dealing went in one direction only, Paris wanted to be a little more ambitious and set up as a trader who also sold goods abroad. This sort of thing occurs frequently in the history of art dealing, pictures being a fairly common article of trade for normal English merchants in the seventeenth century. In general, however, they only dealt on a very small scale, one example being that of George Lucy in Rome who exchanged copies of paintings for 'Birmingham nick-nacks'.[134]

What exactly Paris was trading in is far from clear, although it is certain that he was not very good at it. A petition setting out the case of his creditors was sent to the government by one Firmin van Fleet in 1724, stating that Paris had bought up some £12,000 worth of goods, shipped them over to the continent and had then been unable to pay for them. Van Fleet and others pressed their claim, whereupon Paris promptly fled to Boulogne and refused to return. Protests to the authorities in France persuaded the government there to lock him up and the creditors at this point launched their petition asking that he be repatriated so they might recover at least some of their money.[135] Unfortunately there the evidence ends so it is not possible to find out how Paris managed to extricate himself from the predicament. Get out of it he certainly did, however, as in 1727 he appears in Italy helping Phillips with the ill-fated shipment of pictures for the Duke of Beaufort.[136]

A few years later he appears once more, this time in the French capital, and again there is a suggestion of dishonesty in his methods of operation. The otherwise unidentifiable Parisian dealer de Roussel tried, unsuccessfully it seems, to sell some pictures to Robert Walpole in 1733. In his long and rambling letter of 15 April, de Roussel discourses at some length about his many problems, chief amongst which were the numerous enemies who were trying to sabotage his career and moreover deny Walpole the inestimable opportunity of acquiring some of his paintings. The main foe was none other than Samuel Paris:

il y a ici un appellé Paris peintre anglois quy achète des tableaux pour

les vendre il vint chez moy il vut mes tableaux admirables il me tendit un piège ... il me dit que comme je ne recevois pas beaucoup de monde que le les envoyer mes tableauz chez lui qu'il les avoit fait vendre je sais que l'etoit pour les faire copier et puis il avoit vendu les copies pour des originaux ...*137

By the late 1730s he was back in England and from 1738 onwards there is a sale by him every year until his death, with two in 1740 and 1742.138 As with Hay, the rapid sequence of sales suggests very strongly that he did not go very far for his wares: a trip to Italy and back, with enough time to buy the pictures and also prepare them for sale was not possible in the nine months or so that separate his auctions. His most probable source of supply was France, which developed noticeably as a supplier of pictures to England throughout the 1730s.

Paris' sales will be examined in greater detail (see Table 4) later on and only a few points will be mentioned here. Firstly, like Hay, he concentrated most of his attention on the middle section of the market — some 63 per cent of the paintings he sold came from the £2-£10 area, with the result that the more expensive pictures depended heavily on this bulk part of the market. The £40+ section amounted to 3.49 per cent of the pictures and 23.3 per cent of the value, considerable certainly but hardly dominating. However, every now and then Paris could rise to great financial heights in his sales, the supreme example being the Poussins in the 1741/2 auction sold to Peter Delmé for £482 (Plates 27-8).139 Again like Hay, he could on occasion attract the great collectors, such as Bedford and Cholmondeley, but these appear much less frequently than in the sales of the latter. 140

From the 1740s onwards the prevailing distinction between the international and domestic dealers becomes increasingly blurred, the cause of which was partly the much greater integration of the market. It would seem that price differentials became of much smaller importance with the comment by the 3rd Earl of Shaftesbury, for example, to Sir John Croply in 1712 about the cheapness of Italian pictures becoming less true.141 Certainly by the late 1730s Andrew Hay believed that the boom was over. Writing to Sir John Clerk in 1738 he said: 'As to the virtu, the profitts are far short of what they used to be, and I am not yet determined whether to log another journey. I see several pictures sold here att sales cheaper than I would pay for them abroad ...'142 The costs of expeditions abroad meant that dealers increasingly acted through other dealers and were less

* ' There is someone called Paris here, an English painter, who buys paintings to sell them. He came to me, saw my admirable paintings (and) set a trap for me... He told me that as I had few visitors, to send my pictures to his house, so that he could have them sold. I know that this was to have them copied and then he sold them as originals...'

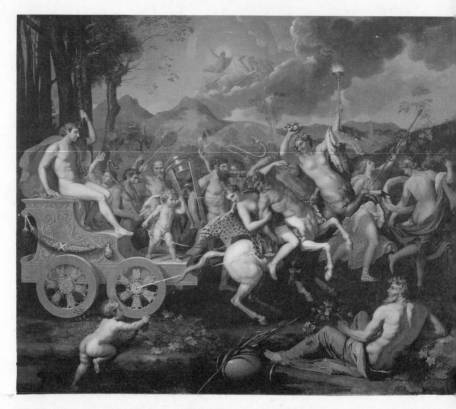

27. Nicholas Poussin, *Triumph of Bacchus*. Sold to Peter Delmé, 1741 sale, £230.

inclined to travel in search of paintings themselves. Robert Bragge, for example, appears to have worked with the French dealer Rémy[143] and Sam Glover had pictures bought for him in Holland in 1743 by Harsebroek, one of the largest Dutch dealers of the century.[144] This is not to suggest that dealers no longer went abroad at all but rather that they went less often, as evidenced by the introductions to auction catalogues in which the description 'brought from abroad by ...' is noticeably supplanted by the alternative 'sent from abroad...'.

The greater integration of the market meant that profit increasingly had to come from speculation rather than the more simple method of commercial supply. As a foreign expedition was necessarily expensive and as the expansion of the market meant that the supply of pictures in England was that much greater, international dealers increasingly began to act on the domestic market as well, joining shop-dealers in buying at auctions. This tendency developed rapidly from the mid-1740s onwards, producing a market of sufficient complexity for it to include an element of self-sustaining activity. In the 1758 van Haecken sale, for example,

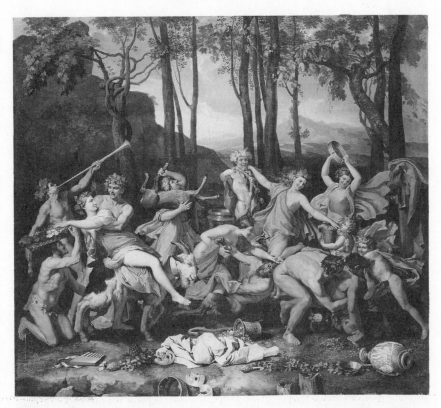

28. Nicholas Poussin, *Triumph of Pan*. Sold to Peter Delmé, 1741 sale, £252.

dealers bought 43 out of the 150 lots, i.e. nearly a third. This sale was a complicated one from the outset; it was a group effort put together by several dealers, that is van Haecken, Kent, Winde, Lloyd, Major, Rongent and Blackwood. Most of the dealers involved in this sale on both sides conducted their main business through the auction, so we have the unusual spectacle of dealers getting together to hold an auction to sell pictures to other dealers to sell by auction. Indeed the picture becomes even stranger, as both Rongent and Blackwood attended the sale in the capacities of both seller and buyer and in several cases put in successful bids for their own pictures.[145]

This sort of savagely criticised practice was far from rare: Robert Bragge, for example, did exactly the same thing although in a slightly more subtle fashion. On several occasions he bought his own pictures disguising the fact by bidding through an intermediary. This increasing complexity meant that the route from old to new owner became greatly lengthened. Instead of passing through one middleman, several pictures clearly went through many of them, going from one dealer to another, and

occasionally even back to the first. A proportion of trade in the art market was thus artificially generated, with the result that, in part at least, art dealing became not only a market in the normal sense of the word, but even began to show distinct signs of the characteristics of a commodity market, where the article traded had its external value as a painting complemented by an abstracted value as a speculative asset. This should not of course be overestimated. It can be assumed that the overwhelming majority of paintings ended with 'genuine' owners, but there was nevertheless a growing stock of floating paintings in the limbo of the market and part of this was used for speculative purposes.[146]

The dealers who operated in the period from 1745 to 1760 were very different from their predecessors. Two things are striking about Hay and Paris: neither seems to have been a collector in his own right nor did they operate significantly as buyers in the domestic market. Also, although Hay was described as a 'noted antiquary' on his death, neither seems to have placed much store in establishing a reputation as a connoisseur. Such an approach changed in the next generation, and the nature of the alterations can best be classified by an examination of Robert Bragge, one of the most prominent dealers of the mid-century.

Robert Bragge

Bragge is one of the first examples in England of the gentleman-connoisseur-dealer, a concept hitherto unknown. His claims to have been learned, however, might be doubted; the 'Doctor' frequently attached to his name does not appear to have been genuine and may well have been whimsical attachment of his own, drawing its inspiration from his distant relation, also Dr Robert Bragge, a troublesome non-juror who died in the 1730s. He came from a family of minor landed gentry in Huntingdonshire where he had an estate, and his niece Phoebe married into the gentry, becoming the wife of John Booth of Chendon Hall, Northamptonshire. Bragge appears to have moved in much higher social circles than was the norm for art-dealers. Instead of living in the Covent Garden or Soho areas of London he had a house in the more select quarter of St James, Westminster, and one of his closest friends was Sir John Chapman, bart., a beneficiary of Bragge's will and a frequent buyer at his auctions. [147]

Apart from dealing in paintings, Bragge also built up a considerable collection for himself, which was sold by Langford after his death in February 1778. This consisted of slightly over 200 works and was clearly of some value. Unfortunately no annotated copy of the sale survives so there is no completely reliable guide to the opinion held of it. Nevertheless Bragge claimed that many of the pictures came from some

of the most notable European collections, such as those of Tallard, Valentini and Ottoboni, and several of the works were sufficiently highly regarded by John Boydell for him to produce engravings of them.[148]

The earliest record of Bragge as a dealer is in 1742 when he held the first auction for which a catalogue has survived. From then on until the records break down again in 1759 he is ubiquitous, holding at least thirteen sales, half of which took place in the 1750s despite his announced intention in 1750 of retiring from business.[149] Also he appears often as a buyer, successfully bidding for over thirty pictures from 1742 to 1750 and a great many more thereafter. None of the pictures that he bought in England can be traced to his own collection, so the assumption must be that they were subsequently disposed of at auction.[150]

Bragge also went abroad for his supplies of pictures, and was one of the many dealers responsible for the sudden surge of imports from Holland at the end of the 1740s and early 1750s. He was, for example, in Amsterdam in April 1749 for the sale of his fellow-dealer David Tetswaert, at which he bought six paintings. In 1756 he was in France and although the pictures bought at the Tallard sale were purchased for him by Rémy he also bought another two from someone else. In addition he was in Italy in 1741 to buy pictures from the Ottoboni collection for Dr Newton. More pictures from this collection bought in Rome appeared in his 1754 sale while others remained in his own collection.[151]

Bragge was not a painter or a direct member of the artistic community, but an amateur, staking his business on a reputation for being educated and, in so doing, drawing together several strands of the art world. His sales, however, were not of noticeably higher quality than those of his predecessors and like them he concentrated above all on the middle range of the market, with 64 per cent of his paintings falling in the £2-£15 bracket. However, 5.5 per cent fetched above £40, and several of these appear to have been considered as being of some distinction.

His attempt to claim the status of the connoisseur may have been the reason for some of the minor innovations that he introduced in his auction catalogues. His stance makes him resemble more closely some of his French counterparts, such as Edmé-François Gersaint. Suffice it to say that Bragge made much more of a production of his sales than previous dealers. His 1754 sale, for example, seems to have been the first in England since the Cadogan auction of 1726 in which the catalogue gave the dimensions of the pictures. This list was also more voluble than most in giving lengthier commentaries, both of description and provenance, than had hitherto been usual. However, it must be noted that at no stage did he, or any other English dealer, come close to reproducing for an English audience the highly scholarly and detailed catalogues that were produced in Paris in the same period. The lengthy lists often running into dozens of pages, with detailed commentaries and the paintings

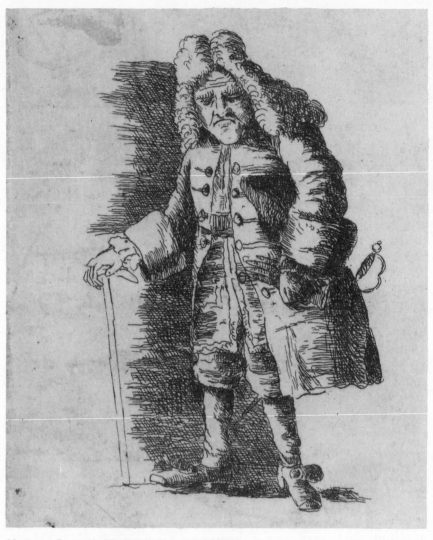

29. Anon: *Portrait of Dr Robert Bragge, c.* 1757.

organised according to school rather than by the order in which they
were to be sold, was a type of presentation — with the accent clearly on
the knowledge of the seller rather than the practicality of the catalogue
as a guide — which had little appeal in London.[152]

Bragge is also noticeable for the remarkable degree of animosity that
he managed to arouse in his contemporaries. Indeed every comment
about him that has survived is in some way unfavourable. Engravers in
particular disliked him and produced several unflattering portraits of
him, with one by Sandby being thoroughly offensive (see Plates 29 and
30).[153] Horace Walpole also seems to have found him suspicious. On 15
December 1744 he wrote to Horace Mann:

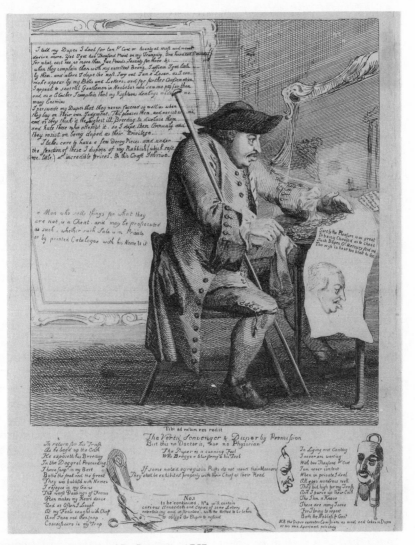

30. Paul Sandby: *Portrait of Dr Bragge*, c.1757.

I write in great fright ... my Lord has been told by a Dr Bragge, a vir-
tuoso, that, some years ago, the monks asked £10,000 for our Coregio
[*sic*] and that there were then made two copies of it: that afterwards
he is persuaded, the King of Portugal bought the original ... now, I
think it very possible that this doctor, hearing the picture is to be
come at, may have invented this Portuguese story ...[154]

Such suspicions about Bragge's honesty did not, however, prevent the
Walpoles from using him as a frontman to disguise the origins of the
first sale of the Orford collection in 1748.[155]

Another violent attack on Bragge was published immediately after his

death. The 'Voyage of Dr Bongout' gives an exceptionally unfavourable picture of the man, portraying him as not only dishonest but also greedy, fat and vulgar.156 The personal nature of this assault is unusual; it was commonplace to attack dealers and suchlike but this sort of abuse was generally directed against a type rather than an individual. The venom that Bragge attracted was, as far as can be seen, unique. Probably he was singled out because, acting as he did in the domestic market, his methods were more noticeable than dealers of equally dubious integrity such as Samual Paris. Also, as the Bongout poem makes clear, a major stimulus to the criticism of Bragge was not dishonesty, which was taken for granted, but the attempt to disguise his doings with the affectation of being a connoisseur. Not only was he a crook, he was a fraud as well, and thus doubly open to abuse. Finally, it indicates the degree to which the art market was becoming established and its members figures of note — the prints produced were all commercial efforts, and there would have been little point in the exercise if not enough people had heard of the man to understand the satire.

The growth both in the number and the prominence of dealers and auctioneers not only revolutionised the art market but also had a considerable impact on the way in which the painters were viewed by on-lookers. Dealers, as mentioned, frequently acted as middle-men between artist and public and this often unhappy relationship formed an important element in the evolution of artistic perceptions in the first part of the eighteenth century. In simple terms, the dealer frequently drew the lightning of social criticism from the painter, partially separating him from the taint of lucre and thus allowing the more idealised, intellectual aspects of the painting profession to attain greater emphasis.

Moreover, the supposed nature of the relationship between the two parts of the art world was frequently used indirectly to boost the reputation of the painter by presenting the dealer as a parasite. Any understanding of the service the latter gave in filling the gaps in the market was slowly submerged in a torrent of abuse, a process from which the artist benefited enormously. Both the dealer and the auctioneer, the two figures who earned public disapproval by earning money through the arts, lacked the positive points which aided the painter. Apart from isolated and largely unsuccessful cases like Bragge, they could make no appeal to educational values to strengthen their position. The nature of the art market largely prevented them from following the French model and laying claim to being disinterested.157 Instead, the popular image of the dealer was almost universally that of a crook, a polluter of the arts who contaminated the pure activity of painting by the vulgar search for gain.

The separation of the commercial and the artistic took place slowly. In satirical literature at the beginning of the eighteenth century there was frequently no distinction made between the baseness of the painter and

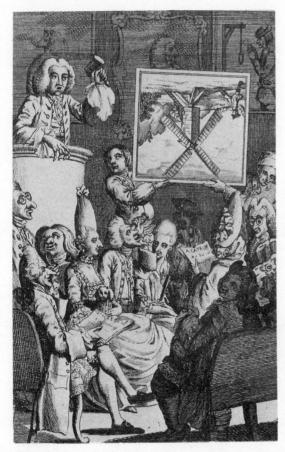

31. Anon: *The Auction, or Modern Connoisseurs*, 1758, From *Oxford Magazine* VIII p.188. The print illustrates a common theme of satire by poking fun more at the customers than at the auctioneer. The dandified bidders fail to notice that the picture on sale is upside down, a frequent way of demonstrating ill-judgement. The auctioneer, in contrast, is presented in a fairly benign form, relying on his customers' stupidity rather than, like Dr Bragge, being actively dishonest himself.

that of the dealer; the mechanical nature of the former merely exacerbated the dishonesty of the latter and vice versa. The tongue-in-cheek *Satire against Painting in Burlesque Verse...*, for example, makes it seem entirely appropriate that such products as paintings should be sold in such a dishonourable fashion:

Now some ... Will cry,
'this censure is too smart,
Painting's a brave and liberal Art'
Liberal! Pray let themselves be judges
Are not its chief disciples drudges,
Their bodies much impaired by Toils
And stinking scent of Poisonous oyls?

Having asserted that the very nature of painting is unrespectable, the author goes on to confirm this by pointing to the connection between production and the method of selling:

As mean, as cheap as it does appear,
Vending its works by Auctioneer...
A modern piece is sometimes sold
When smoked, and mellowed, for an old
Beside 't has setters to entice
And if need be, to raise the price
Thus whilst it does each piece expose
It leads its buyer by the nose.
This practice sure is not the part
Of liberall, but of vulgar art ...

The author concludes that the combination makes painting 'Th'arrant Prostitute i' the Nation', and, therefore, something to be avoided.[158]

Auctioneers, particularly, never recovered from the strong impression made in the 1690s by the forceful personality and methods of Edward Millington. The image he projected — slick, dishonest, but equally entertaining — became established as part of folklore. Millingtonesque figures appear frequently throughout eighteenth-century literature and it was not until the huge auctioneering houses like Christies managed to stamp their own more sober and professional character on the trade that the stereotype of the 1690s partially evaporated. The most prominent auctioneers did certainly manage to gain a certain amount of prestige. Langford, for example, died rich, a JP, a respectable property owner and with a reputation for being a devoted husband and father.[159] But in general Peter Puff the auctioneer, played by Garrick in Samuel Foote's play of 1748, is the quintessence of the public image. With his two sidekicks, Brush and Varnish, whose job it is to bid up prices, in a garrulous and immensely amiable fashion Puff exploits the ignorant aristocracy and tricks them out of their money.[160]

There was, however, a degree of public tolerance for the auctioneers because their misbehaviour was made possible by the stupidity of the public. True venom, on the other hand, was reserved for the dealers. Bagatelli, in Conolly's *The Connoisseur*, published in 1736, is in many ways the satirical archetype. Not only is he a foreigner but as an Italian is almost by definition a crook and so highly suited to his occupation.[161] However, although in this respect his dishonesty is little different from that of Peter Puff, there the similarities end. Whereas Puff succeeds by his wits and his charm, Bagatelli insinuates his way into the home and pulls the wool over his clients' eyes through oleaginous sycophancy. The dealer Varnish in Hayley's *Two Connoisseurs* is similarly portrayed as being unfairly crooked because, instead of attempting to defraud the man of the house, the middle-class Mr Bijou, he instead picks the altogether too easy target of his wife, who naturally could not have been expected either to know anything about paintings nor to resist the

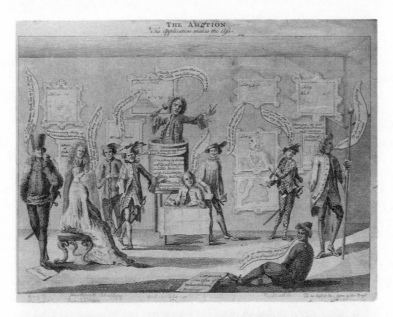

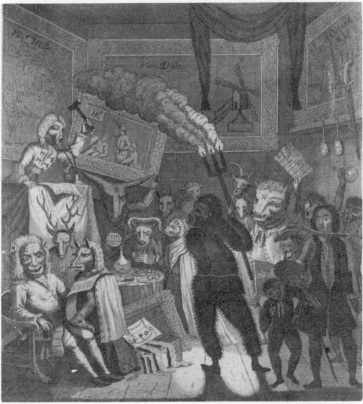

32. (top) Anon: *The Auction: T'is Application makes the Ass,* (1756). The idea of the auction as being dishonest is used here for political purposes. Dated to the start of the Seven Years' War, the satirist targets the way the Kings of Prussia, Hardwick, Byng and Newcastle are dividing up Europe.

33. (bottom) Anon: *Satire on Picture Auctions, c.1766.*

temptation to spend money. It is not until Varnish is faced with a genuine, male aristocrat in Lord Seewell that his activities are exposed.[162]

The source of this hatred seems to have been not merely the trickery involved in their dealings with their clients but also the supposed exploitation of the inadequacies of the market structure which delivered painters into their unscrupulous hands. It was the wider problems that ensued, rather than simply their greed, which caused John Gwyn to regret that dealers acted as a retarding factor on the development of English painting in general: 'The Arts in England have hitherto been depressed by picture dealers, who in the most unfair manner never fail to oppose to rising merit the works of some dead master... .'[163] Dealers, it was believed, made their money by destroying the careers of painters, keeping them in obscurity while making large profits through selling their works. Not only were they tradesmen, they were the worst form of tradesmen, similar to pimps, exploiting innocence for their own ends without even having the merit of any particular ability themselves. Indeed, it was often pointed out (for example by Mortimer) that dealers were frequently failed painters, so that they were also seen as bitter inadequates taking revenge on their superiors. By far the most extreme attack in this period came from the anonymous writer T. B.:

> Yet however mortifying to Professors or pernicious to Science it may be, to see an unskilled Gentry, or ignorant Tradesman, set up for Judge in Painting, there is another class of mortal still more so, and those are the Picture Dealers: The former at worst are weak, these are wicked, one is contemptible, the other detestable... The picture dealer is generally some painter or engraver whose utmost abilities amount to the daubing of Window Blinds, or graving of Tankards; and not being able to live on his own wretched productions, his dependence and support are the labours of others, and 'tis remarkable that those wretches bear the same antipathy to a real Artist as a Eunuch does to a Man.[164]

The author's condemnation of people living off the labour of others did not extend to a blanket denunciation of the way English society functioned. It is the conception of the artist as genteel — and consequently an inappropriate target for such treatment — which makes the activities of dealers disreputable. In this respect, dealers were vulnerable because they disturbed the natural order of society by taking advantage of his superiors, rather than being exploited by them.

In general, therefore, the public image of the art market was far from favourable. The only time this all-embracing condemnation was partially lifted was on the few occasions when there was grudging recognition of the fact that the various merchants of art might have a useful function,

no matter how unappealing they might be individually. Edmund Burke, possibly trying to temper James Barry's hatred of dealers, attempted to put such people in the best possible light:

> You may be assured, that the traffic in Antiquity and all the enthusiasm, folly and fraud which may be in it never did nor never can hurt the merit of living artists. Quite the contrary in my opinion ... and though now and then ... the dealer in such things runs away with a great deal of profit, yet in the end ingenious men will find themselves gainers, by the dispositions which are nourished and diffused in the world by such pursuits.[165]

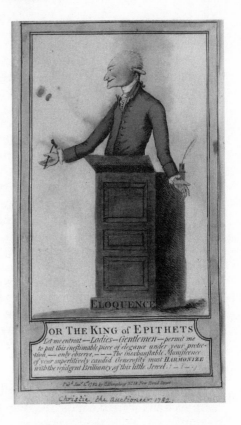

Buying and Selling

Having sketched out the main characters who made the art market work, it is now necessary to examine their achievements. To accompany the raw information on imports it is important to form some sort of estimate of the number of works in circulation within the market as a result of the normal breaking up of collections. For this reason the number of imports alone would underestimate the growth of interest in painting. Instead, the constant flow of new arrivals should be seen as acting as an accelerator, pushing domestic transactions up by far more than their quantity would indicate.

From the figures available, the importance of the auction as the centre of the art market becomes clear. The precise number in the period 1710-60 is difficult to estimate but approximate figures can be given which will indicate the overall scale. Examination of newspaper advertisements for the years 1730, 1740 and 1750 would suggest that the number of sales per year averaged from about five to ten, with possibly

34. Anon: *Eloquence, or the King of Epithets* (1782). A satire on James Christie, which focusses on the salesmanship established as a characteristic of auctioneers by Edward Millington in the 1690's.

another dozen sales per year by upholders, which were primarily of household goods but which sometimes contained a few pictures. This would suggest a total of between 250 and 500 auctions in all, with a maximum, perhaps, of 750. Although a relatively high proportion of catalogues have survived, no lists of sales by upholders are now extant, the most likely reason for this being that the majority of such sales were conducted with no catalogue being printed.

As there is no reason to suppose that sales by dealers were any better equipped to have their catalogues survive than any other type of auction, it seems reasonable to suppose that those which do now exist form a fairly representative cross-section indicating the level of their activity in this period. Examining the catalogues as a whole, therefore, the importance of the dealers for the market becomes readily apparent; their sales account for some 35-40 per cent of all surviving records of auctions between 1711-60 which means about 10,000 of a total of about 25,000 pictures. Equally their activities were largely responsible for fluctuations in the market. In both the slow period of the late 1720s and the early 1730s the level of non-dealer pictures coming up for sale remained fairly steady, at about 1,500 for each five year period. This sudden rise of activity by dealers also coincides very nearly with the rise of the figures for paintings imported, that is a low level in the 1730s, followed by a boom in the early 1740s.

The sales by dealers can be used for a more general analysis of the nature of the demand for pictures, as it seems reasonable to assume that their auctions were the most likely to reflect and to take into account its requirements. With the exception of the early sales by James Graham, all the dealers consistently aimed themselves at similar types of customers and achieved the same sort of spread of works through the price range. Samuel Paris' two most typical sales, for example, conducted in 1738/9 and 1741 (see Table 4) demonstrate the obvious weighting towards the lower end of the price scale and, although in terms of overall value the more expensive works were of greater significance (pictures over £40 bringing in 26.9 per cent and 17.3 per cent of the total value respectively) even so they still accounted for a relatively small proportion of the overall worth of the sale.

Turning to prices generally, both the evidence of the sales and other material indicate that the eighty or so years after 1680 saw a general — if often interrupted — inflation of prices. Again, the scattered and often incomplete nature of this material makes it perilous to draw any more than tentative conclusions. In the earlier period, for example, virtually no hard evidence at all exists, although according to Sir Charles Hatton at least, the boom in prices which accompanied the burst of auctions in the late 1680s and early 1690s burnt itself out quickly as the market became glutted. As he rather gloomily put it:

As to my pictures, I have a good many of Sir Peter Lillyes, which I am told will not yield neer wt they cost; and I doubt those of more esteeme will not be very ready money, unless mitily undersold, at this time, because there are so many auctions, as the Duke of Norfolk and others, of ye best collections... .[166]

The suggestion of a slump in the 1730s is supported both by the comments of Andrew Hay to Sir John Clerk mentioned above, and also the import statistics which indicate a low level of imports through the period 1731-40. Again, the inactivity of dealers in the 1730s would also tend to add further weight to this: both Hay and Paris, for example, are noticeably absent until 1738 and Hay at least was discouraged by the state of prices. Their absence might, of course, be due to the vagaries of evidence but even a search of advertisements reveals nothing to suggest that they are working.

From the 1740s onwards, however, there seems to have been little interruption in the steady inflation of prices for works of art, with Horace Walpole, for example, commenting on the high prices fetched at the Oxford and Schaub sales in 1741/2 and 1758.[167] This seems to have continued until the 1770s, when, possibly due to the onset of war again, a brief slump appeared. In 1770, for example, Walpole was complaining to Mann, 'I have touched before to you on the incredible profusion of our young men of fashion ... it is not extraordinary that pictures should be so dear...'[168] By 1779, however, the recession appears to have set in: Walpole, referring to his father's collection, says to Mann: 'Imaginary value depends on circumstances and times. I once should have thought 40,000 pounds a high price ... five years ago, with the opulence and rage for virtu, they would have produced more. At present, not so much.'[169]

Although paintings seem to have generally inflated in value in the period under discussion, it remains to be seen whether they did so at a rate sufficiently high as to justify their collection as an investment. That desire for profit fuelled dealers is undoubted; whether it also fuelled the customers is another matter. On occasion, of course, the potential gains from painting were enormous — for example the two Poussins bought by Peter Delmé in 1741/2 for 430 guineas and resold to Lord Ashburnham in 1790 for 1,630.[170] Similarly there are occasional examples of pictures being bought for a song, discovered either truly or falsely to be by a well-known artist, and resold for a huge amount. Equally, the reverse process can occasionally be detected, such as Luke Schaub's *Holy Family*, supposedly by Corregio, bought by Lord Ashburnham for £220 and later resold for £28 when its attribution was called into question.[171] Such examples, however, are exceptional. For the most part, paintings tended to keep their original attribution and

were brought and sold on the open market in which the principal decid-
ing factors were neither luck nor accident but the inexorable laws of
supply and demand.

The difference between price at purchase and price at sale is not in
itself an adequate indication of whether a picture was a worthy invest-
ment. In addition, length of possession and other investment possibilities
must be taken into account. Eighteenth-century England was not short of
places for the rich to put their money to earn interest and many of the
opportunities available could offer very high rates of return. The stan-
dard average, however, was the percentage offered by government
bonds, which fluctuated around 3.5 per cent and at no time in this period
went over 4.5 per cent. Given these figures the collection of Richard
Mead (1673-1754), for example, does not appear to have been an espe-
cially wise investment in strictly financial terms. Nearly everybody who
mentions his collection claims that it was sold for about twice the price
he spent on it. But, as the collection seems to have been built up largely
in the mid-1720s, this figure, spread over its twenty-five year lifespan,
would give an annual rate of return of under 3 per cent, that is probably
below and certainly not significantly higher than the rate offered by the
government, who also had the merit of offering security to the investor.[172]

The figures for the Mead collection are of course very vague, so a
more detailed look will be taken at the collection of Roger Harenc.
Harenc appears to have been a man of moderate fortune who spent most
of his time at his house at Henrietta Street, Covent Garden. He was an
enthusiastic attender at auctions, buying pictures at thirty-two sales
between 1734 and 1760. He died in 1762 and his collection of 239 paint-
ings was sold by his son in 1764 for £3,799.14s.6d. As a collection it
was not in the first rank, either in terms of average worth or of total
value. It was, however, many times bigger than was usual for someone
of his middling social position and it is clear that the man was a great
enthusiast. Of the seventy-seven pictures known to have been bought at
auction sales some thirty-five can be definitely identified at the 1764
sale, and of these all but two increased in price. Worked out as a com-
pound percentage interest per annum the paintings provided a rate of
return of 4.18 per cent.

Broken down into schools of painting, Italian paintings gave a yield
of 3.4 per cent, French paintings 2.6 per cent and paintings of Dutch or
Flemish origin 5.04 per cent. Although Harenc would clearly not have
made his fortune out of this, it must be remembered that this was a peri-
od when inflation was virtually non-existent, and the percentage was
adequate if not remarkable. The pictures, however, seem to have sold
well, as Sir Thomas Phillips commented: 'The collection was in general
in very fine preservation, but might, in my opinion, be rather called
pretty than fine. They sold in general at enormous prices, nearly as high

as Sir L. Schaub's'.[173] Such evidence is not conclusive, of course, but it would appear that although there was only a very small financial incentive to collect pictures, at least the collector was not making an enormous sacrifice by buying. Broken down again, this time into price ranges, the Harenc sale would indicate that financially the best paintings were the cheapest ones: paintings in the £0-£5 group yielded an average of 6.54 per cent, whereas those over £20 produced a net loss of -0.69 per cent.[174]

A second example that can be quoted is that of John Barnard. Barnard is now principally known as a collector of prints, of which he amassed a large number of highly esteemed works. Nevertheless, he also put together a fairly large collection of paintings which passed on his death to Thomas Hankey and was sold by auction in 1799. Of his forty-two purchases at auctions between 1738 and 1759 only a small number, that is eleven, can be positively identified with lots in the Hankey sale. However, an analysis of the general picture these eleven permits supports the figures of the Harenc collection. The total investment works out at £295.10s., with a sale value of £463.5s., that is, an increase of 55.4 per cent, or at compound rates of a mere 0.9 per cent per annum. The greater period separating the two sales means that they are not, of course, perfectly comparable, but the overall suggestion that there was gradual long term inflation of value, although one which was less than a return that could have been gained by a more orthodox and secure investment, seems to be confirmed.[175]

Conclusion

The large amount and frequently disparate information that can be gleaned about the English art market in the late seventeenth and early eighteenth century scarcely presents a neat and orderly pattern. Several things, however, are fairly obvious and most clear of all is the fact that the market for paintings was booming through much of the period and that large numbers of the English were probably well prepared and eager to buy by the time the early generations of dealers had the idea of holding auctions. Half a century after this first venture into large-scale selling, the market, with all its complexities, specialists and formal practices, was well established and had taken on a form which has changed surprisingly little ever since.

A second idea that can be put forward with some confidence is that this development did not take the form of single cultural imitation, with, in the manner laid down by Fawconer, the middling ranks seeing the upper echelons of society buying art and therefore deciding to do likewise. Instead, even from the early days of the auctions the standard

lay-out of the sales was quite rigid, with the overwhelming majority of the pictures, much of the turnover — and most of the reliable profits that such an operation would depend on — coming from supplying relatively inexpensive works of art to the more modest customers. Because of this it is important to re-evaluate the nature of the grand collections. They did not lead the development of interest in art. In the majority of cases they could only be formed because the much wider degree of interest in pictures permitted the establishment of the necessary mechanisms of trade to bring large quantities of works into the country. To put it another way, if Samuel Paris could not have sold the 85 per cent or so of his paintings to the usual modest customers, he would not have had the resources to bring in Poussins for the likes of Peter Delmé either.

Thus the practice of auctions substantiates the idea that buying paintings can be fitted into, and confirms, the general picture sketched out in the first chapter. The aristocracy were exhorted to buy pictures, not because this was a habit seen to be peculiarly aristocratic, but rather because it was an occupation in which those doing the exhorting were taking an increasing interest as well. At the same time, the very institutions of the market serve as further useful examples of the mixing process that was variously seen as a perilous development threatening the safety of society or as a vital and important aspect of general education. The auctions were not only popular because of the great demand for pictures, they also established themselves as part of the social round, a way in which aristocrats, commoners, traders and even occasionally artisans were brought together in the same room and, as all came at least on the pretext of seeing works of art, they were implicitly there on equal terms with interest temporarily but significantly erasing social boundaries.

Finally, the pattern of the art market that was established in this period indicates how the history of interest in the arts in England was fractured so that it cannot be seen as a progressive development beginning with the court of Charles I. The early collectors such as Arundel and Buckingham should instead be seen as having acted in a vacuum, their procurement of works of art being a personal business conducted not only independently of the rest of society but even partly at odds with it. The pattern of collecting in the eighteenth century was very distinct from the form established in the 1620s and 1630s and had its origins in largely different roots. What had been an eccentricity became an accepted and widely-spread activity and the great collections, far from existing in isolation, depended both economically and socially for their very existence on the fact that they were now merely the pinnacle of a general interest. The grand assembly of works of art, in other words, changed from being an assertion of independence into being one of conformity to the standards of the period.

4

PAINTERS

THE SOCIAL OBSTACLES facing English painters were substantial and shifted only gradually in the course of the eighteenth century. The battle for professional re-definition was not one that was easily won, especially in a country where the division between physical and non-physical labour was one of the greatest of social divides. Indeed, the frequency with which both artists and their supporters returned to this topic gives some indication of their struggle against it. The draughtsman Alexander Browne (Plate 35) brought ancient authority to bear in support of their argument in 1669:

> Because of Arts some be *Liberal,* and some *Mechanikal,* it shall not be amiss, to shew amongst which of these *Painting* ought to be numbered. Now *Pliny* calleth it plainly a liberal *Art* ... there is so little labour bestowed in [painting] that there is no Ingenious Man in the World unto whose Nature it is not most agreeable.[1]

The argument, that painting did indeed involve some labour, but so little that this disadvantage was more than compensated for by the intellectual benefits, became a standard formula in the next half century.[2] The feeling that painters were far from being recognised for their true worth was still strong enough to fire Jonathan Richardson into an intemperate outburst in the second decade of the eighteenth century. Once more the argument criticises the injustice of disapproving of artists because they worked with their hands: 'T'is strange if [a gentleman] should forfeit his Character, and commence Mechanick, if he added a Bodily Excellence, and was capable of *making,* as well as of *judgeing* of a picture ...'[3] However, as he goes on to make clear, this formerly crucial issue was displaced by other, more fundamental, concerns. Professional painters did not merely work with their hands but also gained money by

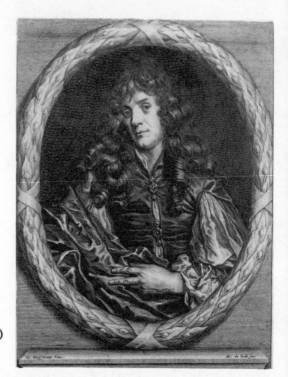

35. Aernout de Iode (d. *c*.1670)
after Huysmans: *Portrait of
Alexander Browne* (*c*.1665)

the process and this appears to have remained a social difficulty which
hindered their full acceptance: '... for a Gentleman to paint for his
Pleasure without any Reward is not unworthy of him, to make a
Profession of, and take Money for this labour of the Head and Hand is
the dishonourable Circumstance'.[4] Again, this reaction suggests that
there was something to react against. The number of gentlemen in the
ranks of professional painters was extremely small and even these tend-
ed to be impoverished ones, like James Thornhill.[5] Hugh Howard
(1676-1738), for example, abandoned his career with some speed once
he had obtained a moderately lucrative government post, preferring the
more dignified activity of amateur-connoisseur. Viscount Perceval, writ-
ing of Howard in his diary, describes him as being 'of good family, but
obliged to paint to support himself', and the 'but' hardly indicates that
Perceval thought gentility and earning a living by painting particularly
compatible states. He later states that painting is something which is
'Mechanical though Genteel', a contradictory notion which suggests con-
siderable confusion.[6] While painting itself was winning the battle for
acceptance, the financial aspect of the business was still able to cause
problems.

However, enormous strides were made and prior to 1770 five of the
most distinguished painters were given knighthoods, a partial but

significant indication of increased recognition.[7] The end of the period also sees the rise of Joshua Reynolds (1723-92), the archetype of the model painter. He was a gentleman-artist, competent, recognised, able to mix easily and successfully with both the élite by birth and the élite by education. However, like the recipients of the knighthoods before him, Reynolds was an exception to the rule. If his distinction demonstrates that the artist could be accepted, then it equally shows that the vast majority were not, with most of the hundreds of fairly poor artists who congregated in Covent Garden failing to qualify for social esteem.[8] Even some of the more successful encountered persistent problems. Allan Ramsay's wife, for example, was constantly snubbed because of her husband's occupation[9] and, as mentioned, someone like Arthur Pond had to go to considerable expense to put on the necessary show of elegance that would overcome the taint of his profession.[10] In the 1760s Benjamin West (1738-1820) was also less than sanguine about the position of his profession:

> Artists stood, if possible, lower in the scale of society than actors; for Garrick had redeemed the profession of the latter from the degradation to which it had been consigned from the time of the Commonwealth; But Reynolds, although in high repute as a portrait painter, and affecting a gentlemanly liberality in the style of his living, was not so eminently before the public eye as to induce any change of the same consequence toward his profession ...[11]

Much later in the century, some artists were still trying to avoid the taint of professionalism, and writers on art at least showed themselves easily stung. In 1798 Nathanial Dance (1735-1811), who had retired on marrying a fortune, entered pictures at the Royal Academy and ostentatiously demonstrated his amateur status by affixing the term 'gentleman' to his entry in the catalogue. The *St James' Chronicle* carried the hurt response: 'Mr Dance sets his name down as "a gentleman" as if he had not been one when an artist. When fortune made him a gentleman by means of a rich widow he bought up his paintings and destroyed them ...'[12]

Although the process was incomplete and unsatisfactory, the reputation of the painter did nonetheless improve in this period and this was at least partly due to the profession's efforts to change their public self-presentation and organisation. The period was one of transition when painting emerged in a new guise and abandoned its previously artisanal image. While some painters came to be seen as gentlemen, existing uncomfortably on the fringes of polite society, this position was virtually institutionalised in the structural reorganisation that accompanied it. Such a change, which essentially coalesced around the move to establish some sort of painters' academy, was far from unique. In a way similar to

dozens of other middle-class occupations, painters appear to have felt the need to assert a sense of identity, to serve the dual purpose of having an institutional prop to aid their social progress and define themselves professionally by making it clear that they possessed special and valuable skills.

Painters were in the vanguard of the middling orders, laying claim to the possession of intellectual attainments that justified their acceptance by the upper ranks of society. As shown in the previous sections, this process was made all the easier by the fact that painters, as well as the other professions who trod the same route, accepted the superior position of those above them, seeking not to drag them down but wanting only the same esteem for themselves. The closest parallel to their trajectory was the related progress made by architects.[13] Similarly shrugging off the taint of manual labour by distancing themselves from their erstwhile comrades, the masons, they left these latter to sink further into the ranks of artisanal labour while appropriating all the creative elements that their occupation possessed. As architecture progressed from Wren, who allowed considerable freedom to the masons to improvise designs as they built, to Adam, who absorbed all aspects of design from furniture and door handles to carpets and the hanging of paintings, architects successfully disguised their origins and coated themselves with a patina of respectability which only an emphasis on intellectuality could confer.

However, such parallels did not exist solely in the sphere of the visual arts but can be seen with all the new professions slowly emerging from the anonymity of the middling ranks. Lawyers, civil servants, army officers and teachers were all increasing both in number and importance, a fact to which Richardson could allude when staking the claim of artists to respectability:

> ... as to setting our selves to hire, we Painters are content to own this is really the Case; and if this has something Low and Servile in it, we must take our place amongst Men accordingly. But here we have this to comfort us, we have good Company ... [14]

The most striking parallel is perhaps with medicine, whose early links with the arts strengthened as the century progressed. Two early writers on art were doctors — Salmon and Sanderson — and a disproportionately large number of medical men appear in the lists of enthusiastic collectors, for example, Drs Mead, Chauncey, Baker, Chamberlain, Kennedy, Peters, Scott and Hunter amongst others.[15] In addition there was the symbiotic relationship established between the two at the Foundling Hospital, which used the first public exhibition of arts to generate joint publicity.[16] Such a closeness and mutual sympathy was perhaps based on the similarities between the two professions: like painters, doctors were slowly struggling towards social respectability,

shrugging off the more demeaning aspects of their trade in its medieval guise, divesting themselves of the connections with barber-surgeons, midwives and so on. The leading figure in this rise was the physician, who stressed the philosophic nature of his work and his understanding of the human body, curing by drugs and regulation rather than by the knife.[17]

Like painting also, medical knowledge was far from being clear-cut. In the same way that painting laid claims to be a science, so medicine claimed to be an art, as both attempted to gain more acceptance within the hallowed halls of 'liberal knowledge'. Medicine proceeded along 'scientific' lines, in that it had a corpus of data on which it could work in order to come to conclusions. In addition, however, it was an art in the liberal sense of the term. This tradition, stretching back to the Greeks and beyond, was by far the more powerful aspect. A doctor did far more than apply facts to sicknesses and wait for the result. Rather he had to observe and judge in order to reach his conclusions about the best possible treatment, in other words, to use his intuition which was trained and sharpened by practice and education.

This was virtually identical to the claim made for the appropriate way of appreciating the arts and was the basis of Richardson's assertion that connoisseurship was a science.[18] Not, in other words, that connoisseurship was susceptible to unbreakable rules, but rather that it was intuition sharpened by knowledge. The parallel is brought out perhaps most strikingly in the work of the French painter Charles Lebrun (1614-90), who sought to provide brief sketches and descriptions of the various human emotions. The idea that emotions were discernible by observation of the face and body again parallels the medical idea that sickness was discernible by symptoms. In both cases the skill, art or science lay in the intuitive interpretation of the nature and causes of these manifestations.[19]

A close sympathy between painters and doctors hence becomes the more understandable; by supporting and recognising the others' importance, they were implicitly asserting their own claims to intellectual and hence social respectability. Indeed, a demonstrable prowess in one field implicitly suggested an equivalent ability in the other because of the close parallels which existed between methods of assessment.

The progress of the painter was not, therefore, a simple case of his gaining recognition and rising from one pre-existent social category to another. This was, perhaps, his aim but in attempting to fulfill it he, along with his fellows in other occupations, broke the old boundaries completely, redrew the map of social status and took part in a process which ultimately had a considerable impact on the structure of class and social relations. An alteration in social position and in organisational structure was necessarily accompanied by shifts in the vision of what art was. On the one hand, the painters and their supporters lodged a claim to

be considered as a part of the ancient system of 'liberal' arts but, on the other, the intense and prolonged consideration given to the nature of the artistic process made this old division partly obsolete. The liberal arts were defined above all by two considerations: they should be non-mechanical, involving the absolute minimum of physical labour, and capable of being taught and hence passed on by intellectual processes. However, new aesthetic theories, above all in the first part of the eighteenth century, came to stress the role of intuition in the process of artistic work. Artists therefore were consequently trying to do two things at once; to establish their claim to liberal status and at the same time make new claims for their occupation which were totally incompatible with traditional concepts.[20]

The primary practical change affecting painters was a growth of specialisation, an alteration due largely to the opportunities offered and pressures created by a larger and more demanding market. This economic stimulus, as in the case of the art market as a whole, provided the basic motor which set off the shifts that took place throughout the eighteenth century. The relatively small number of painters operating in the earlier part of the seventeenth century, and the limited amount of work available, had necessarily restricted the degree to which they could specialise. The lack of any clear theoretical distinctions between the various branches of painting also meant that rapid transitions between one type and another were easily possible. Perhaps the classic example of this type of painter was Robert Streeter (1624-80), Charles II's serjeant painter and Wren's collaborator at the Sheldonian Theatre. 'Streeter of all paintings', as he was called, was highly distinguished in his profession and his reputation was clearly not damaged by the wide range of work he undertook. Although capable of history pieces and highly complex allegories, he was also perfectly ready to turn his hand to gilding coaches and decorating bandstands when required to do so.[21]

Such catholicism was, however, becoming less common as the seventeenth century progressed and the wide range of Streeter's activities can be seen as partially due to the traditionalism of a royal post. A clear contrast to the nature of the sergeant-painter's office, as well as a presage for the future, lay in the attitudes of the foreign painters who flooded into England in the reign of Charles I and hastened changes amongst native English artists. Indeed, by the 1750s the old-fashioned style appears to have survived only in the provinces, where the market for pictures was still sufficiently small for it to permit, and even demand, that painters retain a degree of virtuosity in the work they were prepared to undertake.

In cases such as Streeter, as well as in minor examples such as Hondius and Cradock, the connection between what was increasingly coming to be seen as the 'mechanical' and the 'artistic' ends of painting was preserved for some considerable time.[22] Nonetheless, such artistic

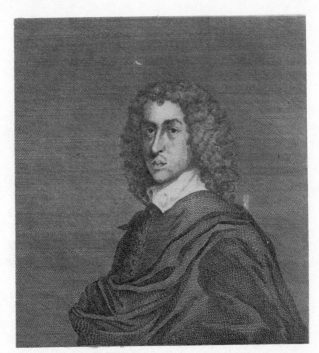

36. Alexander Bannerman, after Robert Streeter (1624-80): *Portrait of Robert Streeter*

virtuosos were slowly dying out. The greater number of commissions available made it possible, then desirable and ultimately necessary, that the artist concentrate his endeavours on one particular genre. The expanded market made it feasible for a previously minor genre, such as flower or animal painting, to generate an adequate income.[23] Secondly, a reputation for expertise became an important part of the painter's advertisement and renown for particular skills developed into a significant means of building up an adequate clientele in the face of greater competition.[24] This, indeed, could sometimes work to the painters' disadvantage, particularly if they attained a reputation in an area in which they were not entirely content; Stubbes, for example, appears to have become typecast partly against his will.[25]

The Fall of the Artisan

Straightforward economic pressures were not sufficient on their own to fragment the painting trade and split it into distinctive parts. As long as the actual skills involved were broadly similar throughout the range then it was likely that some crossing of lines would take place. However, technical, administrative and theoretical developments paralleled economic expansion and completed the process of division. From being

made up of similar people doing different jobs, the various branches of painting eventually came to have little in common other than their use of brushes.

The changes of this period were not, therefore, due simply to the painters 'rising'. Instead it would be more accurate to say that such increase in status as artists acquired was bought at the cost of a dramatic fall from grace of erstwhile colleagues. This new painterly hierarchy is perhaps best epitomised by the progress of the Scottish painter John Smibert. Apprenticed to a housepainter, Smibert worked for some time as a coach-painter, before coming to London after his training with Medina and being employed as a copyist for a dealer. Then he managed to go abroad to study in Italy for several years, coming back as a painter of portraits. The different degrees of status in this progression was accurately described by Vertue when outlining the very similar career of James Crank (1707-80) who had, as he put it, 'from the lowest degree ... advanced himself to reputation'.[26]

Alterations in the nature of the work that painters were called upon to produce played a major role in bringing about this change. In the seventeenth century there were four areas of trade painting which were highly intricate and which were consequently both skilled and well paid. The decorative painter, painters of signs, coaches and scenery all needed considerable ability because their work was often no less 'artistic' than that performed by artists themselves.[27] The career of the coach-painter reached its apogee around the beginning of the eighteenth century, but thereafter a combination of fashion and practicality brought about its decline.[28] Coaches built for travelling greater distances and for enduring much harder conditions were less well suited to ornate decoration than the more stately and purely urban varieties current at the end of the seventeenth century. Indeed the sports car of the mid-eighteenth century, the phaeton, tended not to have any decoration at all.

The use of heavily decorated coaches thus became increasingly limited to special occasions and their numbers — and hence the number of highly-trained coach-painters — steadily fell. Even when used, as Edward Edwards describes, the decorative schemes that they carried became a good deal simpler:

> At the commencement of the last century, the pannels of coaches were painted with Historical subjects, which were often but little suited to the character or profession of the owner ... after this fashion ceased the pannels were painted simply with arms and supporters displayed on a large mantel ... [29]

The overall effect of this was that the trade of coach painting became deskilled, with the result that in both social and professional terms, its

practitioners were increasingly separated from the artistic profession, their lowly status and abilities making a negative contribution to the grander claims of the new art form. Indeed, on the few occasions in the eighteenth century when such highly-decorated coaches were required, the coach-painter, by now no longer deemed capable of performing the work desired, was liable to find himself supplanted by one of his old kinsmen. The state coach of George III, for example, was finished with decorative panels by John Baptist Cipriani (1727-85).[30]

Another branch of painting that declined in the eighteenth century was sign-painting, again very much a trade but one which demanded considerable skill in its practitioners and acted as a bridge uniting the extreme ends of the profession. Samuel Wale (1721-86), Cipriani, Kneller and Hogarth turned their hands to the form, albeit briefly, [31] and several artists such as Catton and Harding used their training in it to graduate to the painting of more highly esteemed works. However, while coach-painting went into decline, sign-painting was wiped out altogether. Edwards again, talking of Wale, provides the story:

> Mr Wale painted some signs; the principal one was a whole-length of Shakespeare, about five foot high, which was executed for, and displayed before, the door of a public house, the north-east corner of little Russel St, in Drury Lane. It was enclosed in a most sumptuous carved gilt frame, and suspended by rich iron work; but this splendid object of attraction did not hang long before it was taken down, in consequence of the act of Parliament which was passed for paving, and also for removing the signs and other obstructions in the streets of London. Such was the total change of fashion, and the consequent disuse of signs, that the above representation of our great poet was sold for a trifle before this change took place, the universal use of signs furnished no little employment for the inferior rank of painters, and sometimes for the superior professors.[32]

This bill, passed in 1768, completely eliminated one important part of the painting profession and completed a public attack that had been running for several years.[33] Probably no other act of government has ever had such a dramatic effect on English art as a whole, even though the wording of the statute clearly indicates that this drastic outcome was utterly unforeseen. The act was, as Edwards notes, merely designed to improve traffic flow in a city that was becoming increasingly congested.

A third type of practitioner whose status declined in the eighteenth century was the decorative painter, who fell from being an essential part of a highly-skilled team to being the social equal of a plumber. This is one of the most complicated examples of professional change that the period affords. Decorative painting had always been highly stratified.

The work was necessarily carried out by a team of very different abilities and status. At the top were the Verrios, the Thornhills and the Laguerres, whose principal role was the purely intellectual aspects of the job, that is composition and supervision. The actual amount of painting that these people did was probably proportionately quite small, limited to the more important areas and making improvements on the work of assistants. Under them came a host of secondary figures, varying from painters who were highly competent in their own right down to those who had the task of preparing the paint and washing the brushes. Most importantly, many of the more routine tasks — preparing the walls for colour, marbling, gilding and so on — were performed by people of considerable skill, since the lines of distinction between art and trade were not very rigorously defined. At its height between 1680 and 1730, the term decorative painting covered a multitude of meanings and often represented a package of work. The painters would decorate an entire room, or set of rooms, and provide not only the central representative portion, but do the woodwork and paint the columns as well.

When grandiose decorative schemes became less fashionable and such teams of painters less frequent, the effect again was to increase the separation between the varieties of painter. Decorative schemes continued, of course, but the tendency was for them to become more modest in size and to be confined to specific areas surrounded by frames. As cherubim and the like no longer sprawled all over the walls, the work was more often executed on canvas, wherever the painter saw fit, and then simply fitted into the frame. Much artistic decorative work therefore became more like the products of any other painter and the social separation from the tradesmen was mirrored by a physical separation of the jobs they performed. The remainder of the work was carried on by the housepainters, working of necessity on the site, with much less need or opportunity for performing tasks which required artistic accomplishment.

The housepainter had, of course, existed long before the decline of the Baroque decorative scheme but what is important here is the accelerated drop in status brought about by increasing specialisation. As with coach-painters, many artists began life as apprentices or sons of housepainters and rose above this status, but few if any continued work as both. By mid-century the distinctions between the two were perfectly apparent. In the *London Tradesman*, for example, representative painting is 'a Noble Art', whose practitioners must be 'born, not made'. House-painting, on the other hand, was not something that the author recommended:

Anybody that can but handle a Brush may set up for Housepainter ... They must indeed have a sound Head; I do not mean with respect to their Understanding; that may be as lame as you please, but a steady

Brain to go aloft ... the Journeymen of this Branch are the dirtiest, laziest and most debauched set of Fellows that are of any Trade in London: Therefore I think that no Parent ought to be so mad as to bind his Child Apprentice for seven years, to a Branch that may be learned in as many Hours ... in which he ... in the end turns out a mere Blackguard. [34]

It was the impact of technical advance and the size of the trade which helped to destroy its artisanal skill. The expansion of painting and specialisation within the profession was paralleled by the growth of a substantial supporting industry which reduced the range of the painters' activities. The appearance of brushmakers, framemakers and colourmen meant that the skill of painting was for the first time concentrated solely in the act itself. Most important in this respect were the colourmen who appeared in the 1690s, [35] whose increasing number thereafter took the task of preparing paints out of the hands of the painters themselves.

Manufacturers did not of course confine themselves to the production of artists' paints, but expanded throughout the range so that by mid-century paint manufacture had become a small but important article of England's trade. [36] It was above all this development which destroyed the prestige of the housepainter and finally marked the barriers between the artisan and the artist. The mystery of housepainting had always lain as much in the preparation of the colours as it did in their application. The growth of a paint industry removed this skill, so that housepainters no longer had a monopoly to retail but had only their labour power left. Ready-mixed and easy-to-use paint even threatened their status as specialist labourers: 'By the help of a few printed directions, a House may be painted by any common labourer at one third the expense it would have cost before the mistery was made public'. [37]

Such changes meant that by the mid-eighteenth century only one member of the old painting trade continued to occupy the ambiguous position between art and trade, that is the painter of theatrical scenery, [38] and the growth of the theatre from the Restoration period onwards naturally increased their numbers. However the scale of the operation produced a split similar to that which was apparent in decorative painting, as the inventive, 'liberal' and artistic part of design tended to become increasingly distinct from the operation itself. As with Verrio's and Thornhill's teams, much of the work was done by a small army of journeymen of little status, with the most respectable elements of design concentrated in one figure — the prime example of this being George Lambert. [39] Even so, the scene painter scarcely achieved respectability. The term itself settled down as a frequently used epithet of abuse hurled at artists whose work was considered inadequate. [40]

Specialisation of function was matched by the emergence of more diverse types of organisation, with the artistic section of painting evolving carefully regulated methods of control and evaluation while the organisational structure and the artisanal parts were virtually dismantled. In the seventeenth century the central focus for the trade was the Painter-Stainers' Company, a body incorporated in the reign of Elizabeth. Its original function was to oversee and regulate all aspects of the business, although one small area — heraldry painting — was lost to it during a protracted and bitter fight with the Heralds' Company in the 1590s.[41] This, however, was a comparatively minor affair, and of more importance for the hurt feelings and wounded pride than the squabble aroused. Indeed, it was perhaps more an indication of the continued vigour of the Company in its willingness to fight for its rights in such an insignificant area rather than a first symptom of incipient collapse.

Much more serious was the influx of foreign artists under Charles I as, protected by the monarchy, there was little that the Company could do to control them. Nevertheless the effects of such painters were probably highly limited. Although a few took on apprentices, this does not seem to have been a frequent occurrence and the small number of adopted trainees were often acquired through the Painter-Stainers', for example when the painter Peter Lely asked to be given one in the 1650s.[42] As long as the proper term of apprenticeship was recognised, with fees paid and the entire transaction officially registered in the Company's books, at least the form of the old organisation was maintained. The main weakness introduced by the foreign arrivals was that the Company felt unable to regulate the quality of their production and indeed was increasingly seen as ill-equipped to do so. Once artistic painting began to take on more overtly intellectual tones, its analysis and judgement by the criteria of artisanal workmanship became less appropriate and was increasingly criticised and resisted.

Although the Company was being challenged from the early seventeenth century onwards, its final collapse did not come until the last part of the century. After the Restoration its demise was swift and the organisation was effectively dead by 1710. Foreign travel as an increasingly important part in training; the greater willingness to move from master to master with individually negotiated fees and no need to stay for the old apprentice term of seven years; the ability of market demand to overwhelm and render superfluous any attempt to stop a painter from practising: all of these factors meant that the Painter-Stainers' followed a route to oblivion which paralleled that of the masons' and many another medieval guild.

While the most famous of the new generation of painters were regarded as beyond the Company's reach it nevertheless did not resign itself to extinction without a fight. Official searches were carried out

until 1708 and until a late stage these were clearly more than a meaning-less tradition. In 1673, for example, the searchers impounded several paintings, including one of *Joseph and Potiphar's wife*, on the grounds that they were unfit for sale and, in 1706, it prosecuted a plasterer for painting.[43] In November 1693 the Company embarked on one of its final attempts to reassert its waning authority with searchers confiscating all the works of two painters — a Mr Knife and a Mr Butler. This action apparently triggered a law-suit from the outraged artists, who clearly disputed the Company's right to act in this way any more, and the Company's minutes record that any legal costs of the searchers would be covered if the threatened action went against them. There, unfortunately, the records fall silent, and there is no final note of the outcome of what was one of the last attempts to operate as its charter said it must.[44]

By the start of the eighteenth century, this charter, giving it full rights to legislate over painting in the London area, was clearly a charade. Henceforth few of the artistic painters even troubled to join the organi-sation unless, like Thornhill or Reynolds, they were fired by notions of tradition. As the Heralds' Company put it — rather smugly and clearly not having forgotten their fight of a century before — the Painter-Stainers' now only dealt with 'an inferior class of painters ... a race of mechanical artificers so low that, like daily labourers, their hire and daily wages were settled by Act of Parliament ...' [45] Even this, however, came to be too big a claim, and the Company was unable to adapt well enough to the expansion of London even to maintain control of this much more limited sector. [46]

The Rise of a Profession

By simple expansion of numbers and amount of business, therefore, economic pressures were brought to bear which separated the various parts of painting from each other. One of the simplest and clearest dis-tinctions was that which divided the unregulated artists from those still at least technically under the aegis of the Company. Such a boundary was however necessarily an unsatisfactory and porous one, which defined the painters of art only by negatives.

One of the underlying pressures leading to the formation of an Academy was an attempt to overcome this situation and provide a stronger sense of identity and definition. Whereas the old Company took in everyone who used paint, the qualifications for the Academy excluded many types of painter but eagerly embraced sculptors and engravers — as well as the occasional connoisseur and doctor-lecturer — whose connection with painting was more tenuous.[47] Although the new body originated with painters, the changes that resulted from its formation amounted to a concentration on the arts replacing an

emphasis purely on painting. The Academy was thus a crystallisation
of a movement which changed the way painting was understood from
the simple use of paint to being instead the visual expression of ideas, a
definition lodged almost entirely in the conception rather than the medi-
um. More than this, the period from the foundation of the St Luke's
Academy in 1711 to that of the Royal Academy in 1768 saw the discus-
sion of several basic issues about the role of the painter and his place in
English society.[48]

The English in this period had two models readily to hand for the
training of painters. Firstly, the Italian artisanal workshop, presented
through such books as Vasari and demonstrably capable of producing
outstanding painters, and secondly, as a complete contrast, the French
Académie Royale, founded in 1648. The overwhelming majority of
English writers preferred this second variety and called for the establish-
ment of an English equivalent, a desire prompted not least by the
concern that painters in England were, so to speak, unfavourably entan-
gled in their own theoretical justification. English artists steadfastly
subscribed to the continental notion that, as the prime purpose of paint-
ing was its educational role and ability to give visual expression to
intellectual ideas, then history painting was the loftiest and most useful
manifestation of the art. However, as Aglionby and many others pointed
out: 'for a painter, we never had, as yet, that was an Englishman, that
pretended to History Painting'.[49]

Occasionally, indeed, painters attempted to slip around this awkward
fact either by lauding excessively those few English history painters that
did exist or, like Richardson, indulging in a piece of convoluted special
pleading that implied that portrait painters were just as good.[50] In a very
slow fashion, the pressures of market demand did cause a gradual bend-
ing of the orthodoxy. In a much-quoted passage, Johnson expressed the
hope that Reynolds would not be tempted out of portraiture,[51] while men
like Gilpin and Burke advocated a compromise — the portrait as history
— which would effectively merge the two genres.[52]

Such suggestions should not be seen as an example of self-serving
hypocrisy designed to get painters out of a difficult position, however.
The portrait in its eighteenth century form did encompass something of a
transmuted 'heroic' approach normally associated with history painting.
The psychological approach to mental operations chronicled in chapter
two found legitimate expression in an increased concentration on the
individual, best shown through a study of physiognomy. Such a revised
approach in turn suggested that mankind might, to paraphrase Pope, best
be engaged in studying man, rather than his acts. In literature generally,
the age of heroic endeavour had passed. *The Spectator*[53] asserted the
worth of heroic virtue in common life, Grey's *Elegy in a Country
Churchyard* identified ploughmen with heroes of the past while Samuel

Richardson chronicled the adventures of a very ordinary and 'unheroic' heroine in *Pamela*.

It would perhaps have been strange if painters, unlike poets, play-wrights, and other artists, had succeeded in finding a market for a type of representation which could find no audience elsewhere. Thus, in painting, one of the most successful of those who strayed from a strict regimen of portraits was Francis Hayman (*c*.1708-76), with his illustrations of ordinary scenes at Vauxhall and his Pamela series, while Hogarth also attempted to represent morality through scenes of daily life. In contrast, West sold many of his history paintings to the monarch and high aristocracy, James Barry sold few at all while the confections of Cipriani and Angelica Kauffman (1741-1807) were essentially prettified objects with little attempt at heroic presentation. The psychological analyses in the most successful portraits of Reynolds and Gainsborough, or the symbolic representations of individual worth and idealised gentility produced by Ramsay were, perhaps, better fitted for an age 'without heroes' that was concerned above all with appearance and the internal workings of the mind. [54]

It is evident, however, that for some time painters were insufficiently confident to advance these notions of painting and to risk upsetting the entire structure of evaluation on which they were staking their claims to respectability. In general, they were faced with the obvious and clear obstacle that, even on their own terms, they scarcely deserved much respect. Nor did the situation change significantly as the English slowly formed a taste for pictures. Artists and their supporters lamented that most Englishmen seemed to be under the impression that the only good history piece was a foreign one. The idea of the Academy, therefore, was to develop the art of history painting in England, restoring the painters' respect for themselves as well as gaining that of others. As it taught good art to its students it was also to instruct the public and cultivate an 'encouragement for good Painters in the Historical way of our own Country',[55] as the artists realised well the dangers of developing a type of work for which there was no market.[56]

Finally, the advocates of an Academy saw such a body as a way of taking a short-cut to social esteem, in the manner of the French Academy's highly explicit and well-publicised eighteenth century link to royalty, and thus of boosting the reputation of painting as a whole, irrespective of the perceived merits of individual works. The association of painting with an institutional structure was thus to heighten the merit of the art form by lending royal support to a vision of what English painting could be, rather than having it tied down to the less favourable impression of what it actually was.

The history of the academies is comparatively well-known but a brief summary here may perhaps avoid confusion later. Although first mooted

by John Evelyn in 1662,[57] the initial attempt to formulate an English painting school appears to have come with Peter d'Agar's 'Royal Academy for Painting, Designing, Mathematics etc in the Savoy'. This made a brief appearance in 1681 but then vanished, although another reference to a 'Royal Academy', headed by Henry Foubert, appears in 1697.[58] The next, and better documented, was set up by Godfrey Kneller in 1711 under the name of St Luke's Academy. Control of this passed to Thornhill in 1716, and after a dispute it was run by Louis Cheron and John Vanderbank from 1720 onwards. Thornhill then founded a rival academy in 1724 in Covent Garden, which later passed to Hogarth, who re-established it in St Martin's Lane in 1734. After an initial approach in 1749, the St Martin's Lane school entered abortive negotiations with the Society of Dilettanti from 1753-5 in an attempt to put the school on a firmer and more respectable footing and to organise exhibitions. The next spurt of organising activity came later in the 1750s when a group of artists led by Hayman successfully negotiated with the Society for the Encouragement of Arts, Manufacturers and Commerce (SEAMC) for the use of their rooms to hold an exhibition.

Immediate problems arose between the artists and the SEAMC and, as a result, the painters split into the Free Society of Artists, which lasted until 1783, and the Society of Artists of Great Britain, which held an independent exhibition at Spring Gardens in 1761. A further outbreak of dissent broke this latter group up in 1768, with one group walking out to form the Royal Academy, while the remainder turned themselves into the Incorporated Society of Artists. In the provinces there were also some, albeit minor, attempts in this direction. A St Luke's Academy was set up in Edinburgh in 1729, the Foulis Academy in Glasgow in the 1750s. Equally some engravers, drawing masters and painters gave classroom instruction, while Cooper set up his Edinburgh Winter Academy in 1734/35. Liverpool attempted to set up an academy in 1769 and held an exhibition there in 1774.[59]

Such constant reorganisation suggests that there was much more at stake than the simple foundation of an academy of painting. In fact the arguments focused on the central issue of what sort of academy would best represent the interests of the painters. The problem seems to divide around the nature of the training and of the organisational structure which was to assume control both of training and of the profession as a whole. Over the issue of training, the weight of opinion seems to have inclined towards an imitation of the French model, for reasons which were deeply rooted in the emerging notions of the theoretical position of the painter. The essence of a liberal art was that it could be taught: like medicine, history or philosophy, it was capable of being transmitted from teacher to pupil through example and lesson. At the same time, however, the ideal of painting was seen as an imitation of nature, even

though the precise definition of nature could vary dramatically from writer to writer.

The problem was, therefore, to combine the two so that the painter's metaphysical function could merge coherently with his social aspirations. The socially-supported artistic academy formed an ideal solution to this potentially paradoxical double aim. At the same time it created a coherence surrounding the painting profession which led ultimately both to its greater isolation and to a greater degree of respect from the rest of society. The central notion of the academy, whether in its French or English varieties, rested on the value of learning from the leaders of the profession. All of the country's best painters were to become members and their collective wisdom was to be passed onto the next generation. The greatly hoped for result would be that the national school would, in a fairly short period, be refined, developed and improved. To imitate nature consequently involved the painters in simultaneously imitating other painters. The senior painters in the academy were to mediate on the one hand between nature and pupil and on the other between artistic tradition and pupil, instructing in both cases what to imitate and how to do it. [60] As Reynolds put it,

> The principal advantage of an academy is, that, besides furnishing able men to direct the student, it will be a repository for the great examples of the art ... by studying these authentic models that idea of excellence which is the result of the accumulated experience of past ages, may be at once acquired.[61]

Such suppositions on the nature of artistic work and how it could best be developed thus inevitably posited an artistic hierarchy based on merit, while for the first time seeing painters as a uniform bloc which could be taken and moulded. What such propositions did not provide was a satisfactory conception of how this merit was to be measured and regulated.[62] The great breakthrough that the movement leading to the foundation of the Royal Academy represented was the final triumph of the intellectual component of the painter's art over the technical aspect. From then on the guild mentality that concentrated on mechanical technique was abandoned, with such matters becoming more a simple vehicle allowing intellectual ideas to find expression. The importance of this for the respectability of the artist is attested to by Reynolds, who returns to the theme time and again. Even in his last discourse, he stresses the dignity and poetry of Michelangelo despite his mechanical skills while also emphasising that mere proficiency was insufficient — it was the 'divine part' which contained the worth.[63]

The nature of the splits in the artistic profession became manifest in the debates surrounding the academy's establishment, with the model of Hogarth's St Martin's Lane school clearly contradicting the newer

theoretical emphasis. Hogarth's academy combined a frank anti-gallicism with a determined democracy of organisation:

> I proposed that every member should contribute an equal sum to the establishment, and have an equal right to vote in every question relative to the society. As to electing Presidents, Directors, Professors, etc., I considered it was a ridiculous imitation of the foolish parade of the French Academy ... [64]

Such a structure refused the professionally eminent a concomitant institutional elevation and also denied a central claim of the artistic community to distinction. Far from seeing eminent practitioners as the embodiment of a cultural thread perpetuating the achievements of the past, his vision of the academy did little to distinguish between the type of teacher required. The selection between what was good and what was bad was not to be presented to the pupils in a ready-made, monolithic bloc, bolstered by the assertion of being unchallengeably correct. Instead they had to choose for themselves, thus undermining the notion of painters as elements of a larger historical continuum.

Both Hogarth's view of the academy and his own artistic output opposed the imposition of a predetermined order and the formalism it offered. The symbolic culmination of this can be seen in the production of — and animosity aroused by — his *Sigismunda*. [65] At the centre of the furore that surrounded this work was not any artistic argument about the painting's merits or demerits, but rather its ability to bring together in stark opposition two very different conceptions of what painting was about. Throughout his career Hogarth had ostentatiously set his face against the idea of the historical evolution of painting, ridiculing old-master worship and poking fun at those who believed it was not possible to be a good painter without having first studied the works of the great Italians: 'The Italian students avail themselves of the works of antiquity as a coward do of putting on the armour of an heroe'.[66] At the same time, many of his works do bear a clear imprint of foreign models and owe a considerable debt to them. Such a fact does not, however, necessarily indicate that he was simply confused or hypocritical. There was nothing inherently wrong with learning from foreign works that each individual painter found useful and stimulating, as long as this was a personal choice, not unthinkingly absorbed *en bloc*. His refusal to boost his reputation by claiming to have studied the Italians, his distaste for the French, as well as his attempts to invent new forms of painting for a specifically English context all fostered the notion of a dislocated, individual source of merit that was to be acquired by each painter on his own.

Sigismunda, a word inspired by the high price fetched by a painting supposedly by Corregio at the Schaub sale of 1758 (Plate 37),[67]

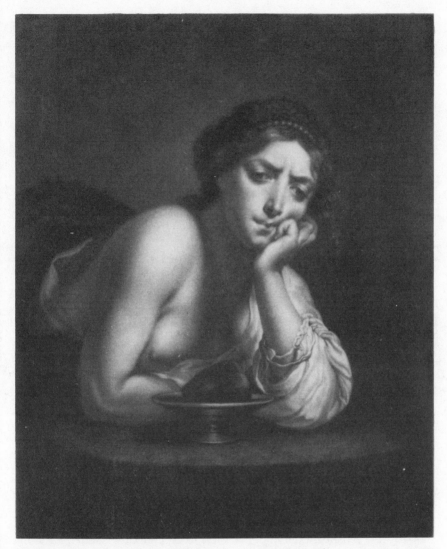

37. James McArdell (1726-65) after Corregio (Furini) *Ghismonda*, 1753. The original, now attributed to Furini, was sold at the Schaub sale in 1758 to Sir Thomas Seabright for £404.5*s*.

embodied this assault on the rapidly-forming orthodoxy of the artistic tradition. An English historical painting, it challenged the public to live up to their patriotic words and pay as much for domestically produced works as for foreign ones. It equally asserted that such works could also be as good. At a time when the first moves for setting up an English academy based on the belief in history were taking place, such a painting could scarcely fail to arouse the interest of the audience. Although at one level the epitome of what the academy was meant to foster — that is a native school of history painting — at another level it undercut

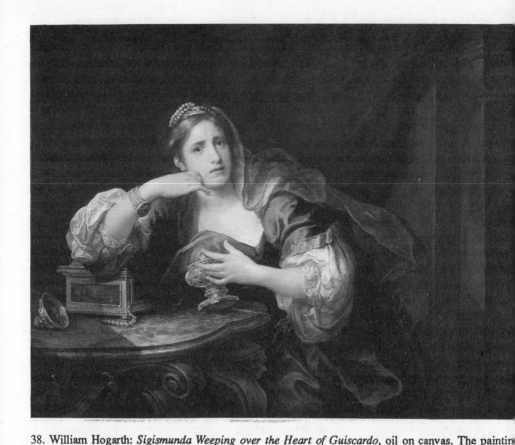

38. William Hogarth: *Sigismunda Weeping over the Heart of Guiscardo*, oil on canvas. The painting was Hogarth's reply to plate 37.

everything the body represented. Because it was painted by Hogarth, whose views were well known, the painting asserted that works of history could be produced without the need of the sort of academy its advocates wanted, that such a body was in fact little more than an unpatriotic and fashionable concession to foreign dominance, aimed at boosting the status of a few eminent painters at the expense of a genuine, domestic style (see Plate 38).

Although the Hogarthian model for the organisation of the English academy was unsuccessful, this did not mean that the way was clear for the quiet establishment of a body along orthodox French lines. All the arguments of the 1760s directly or indirectly focused on the task of presenting the best possible image of painters to the outside world. Broadly speaking, the new profession divided itself into two parts, one seeing the new organisation as the concern only of the painters themselves and the other, which ultimately formed the basis of the Royal Academy, placing greater stress on the values and norms of society at large, tailoring the professional structure to elicit the most favourable response.

The handling of exhibitions demonstrates most clearly the importance of this point. The public show was thought of in three different but inter-wined ways. Firstly, it was seen as a method of education, cultivating the general public into a love of the arts. Secondly it was an exercise in public relations, demonstrating what English painters were capable of and giving them tangible form as a profession rather than as a group of individuals. Thirdly and most straightforwardly, it was a market-place, designed to overcome the inadequacies and inequities of the English art-market. What it was not, however, was an attempt to develop any form of two-way process through which the opinions of the public could be absorbed. The audience was there to be manipulated and moulded, not to have any influence on the development of painting through their reactions.

Despite all these clearly perceived advantages, it took a long time for the artists to organise themselves well enough to put on a show.[68] The first one at the Foundling Hospital in 1739 was without any of the acri-mony which characterised the later exhibitions, partly because the artists involved formed a relatively small and coherent group.[69] However, the first exhibition held under the auspices of the SEAMC as well as those that came after were increasingly riddled with dissent and bad humour.

The disputes in the early exhibitions centred on which pictures were to be shown, who was to choose them, how they were to be shown and who was to see them. The final question, that of admittance, became important because the exhibitions proved to be so unexpectedly popular. Edwards states that the 1761 show resulted in the sale of over 6,000 cat-alogues and was probably seen by more than 20,000 people.[70] Such a horde was more than could be easily accommodated. In addition, great and indiscriminate public interest did not serve the painters' interests. Despite the frequently stated belief that painting was a means of educat-ing and raising the vulgar, this moral duty was clearly not uppermost in the minds of the artists. As mentioned, one purpose of the exhibitions was to give artists social respectability and the more interest shown by the lower orders, the more difficult it would be to accomplish this task: 'When the terms of admission were low, our room was thronged with such multitudes, as made access dangerous, and frightened away those whose approbation was most desired'.[71]

Consequently, at the next show organised under the auspices of the Society for the Encouragement of Arts, the committee attempted to put a sufficiently high admission price on the tickets to filter out the lower orders. To make double sure that nothing could go wrong, it also took the additional right, 'to exclude all persons whom they shall think improper to be admitted, such as livery servants, foot-soldiers, porters, women with children etc, and to prevent all disorder in the room, such as smoking, drinking, etc., by turning the disorderly out ...'[72]

The prime cause of anxiety was not therefore that there might be too many people, but too many of the wrong sort of people. The artists complained bitterly that the powers given to the committee responsible for the first SEAMC show were inadequate and ineffectual, and disapproved strongly of 'the intrusion of persons whose stations and education disqualified them from judging of statuary and painting...'. [73] Such a mistake was not repeated, and the shilling price tag for the second show did indeed restore the sort of social balance the organisers thought most desirable: 'The visitors, who were highly respectable, were also perfectly gratified with the display of art, which, for the first time, they beheld with ease and pleasure to themselves ...'. [74]

Such a desire on the part of the painters was partly caused by the view of the exhibition as a market place. If they wished to sell pictures directly, and indirectly stimulate interest in those who could afford to buy, then it was necessarily the respectable who required all the care and attention while the rest, having little spending power, could be safely ignored. In the view of the organisers such considerations also merged into more abstracted ones. English painting was trying to establish itself as the proper concern of the elevated by the nature of its intrinsic intellectual merits. As Dr Johnson's preface to the 1761 catalogue states quite baldly: 'Though we are far from wishing to diminish the pleasures, or depreciate the sentiments of any class of the community, we know, however, what everyone knows, that all cannot be judges or purchasers of works of art'. [75] The claim of painting to respectability was rooted in its supposedly difficult, intellectual nature. If the uneducated appreciated it, one of its major selling points was implicitly devalued.

Despite the important part played by the SEAMC in developing and stimulating the exhibitions, their connection with the painters was severed and an independent body of painters took over control of the shows. The precise cause of the break is not clear, although the painters accused the society of organisational interference. [76] As an undercurrent to this, however, there was once more a clear element of professional delineation. Alongside the increasingly visible profession of artist, a new trade using pens, pencils and brushes was developing under the pressures and demands of economic expansion. These two aspects of visual design, art and draughtsmanship, were necessarily becoming increasingly differentiated, above all in the minds of painters. To a certain extent the patronage of the society threatened to blur these distinctions and thus endanger the painters' claims to the 'gentlemanly' status of the new conception of art, as it reinforced and emphasised the mechanical and utilitarian origins and functions of visual design.

The SEAMC, especially in relation to painting, was in many ways something of a challenge to the pretensions of the painters from the

moment of its foundation. It was stimulated by an attitude to the production of goods that was to become increasingly irrelevant as both the nature of manufacture and of technological innovation and improvement changed. Its attitude was strongly conditioned by the views of its founder, William Shipley, [77] whose idea of the importance of the arts was deeply influenced by the perception of their possible economic advantages. This was a growing preoccupation of the English in this period, as many were convinced that the road to commercial success and dominance lay in better design, above all in the market for luxury goods, where French superiority was especially strongly felt. The arts therefore were to be encouraged for exactly the same reasons that investigations into cobalt manufacture or turnip growing were to be stimulated. Their value lay in their functional impact on commercial performance, rather than in more rarified intellectual or educational properties.

The other major issues which caused uproar in the 1760s revolved around other questions of control and exclusion. Of the disagreements which resulted in the split between the Society of Artists and the factional elements who eventually left to form the Royal Academy, the most crucial concerned the very nature of the academy as an organisation representing the image of the profession, rather than in the details of the organisation of the body for teaching.

Just as the Painter-Stainers' Company included all those who used paint, so the essence of the Society of Artists was that it included, potentially at least, all artists who were prepared to pay the subscription fee. In other words it was a body whose definition of the profession was the sum of all its parts. The Royal Academy, on the other hand, excluded the vast majority of artists and sought to present painters to the public by concentrating attention on pinnacles of success in both social and artistic terms. Whereas membership of the Society of Artists was an indication of no more than occupation, membership of the Royal Academy was held to be a sign of success in it. By rigidly maintaining the number of full academicians at forty, and by attaching to the body the status conferred by Royal sanction, the Academy embodied a strong element of qualitative assessment and became an organ for the dissemination of taste to which the Society of Artists could not pretend.

A squabble along these lines formed the leitmotif of the internal rifts in the Society of Artists after it broke away from the SEAMC. Faced with outside interference, either from the SEAMC or from an early attempt by the Society of Dilettanti to set up a form of training system, the artists managed to put up something of a united front, with Hogarth criticising the attempts of others to become 'Lords and Masters'.[78] All, with the exception of Robert Strange, were agreed at least that the artists should govern themselves. It was over the nature of this self-government

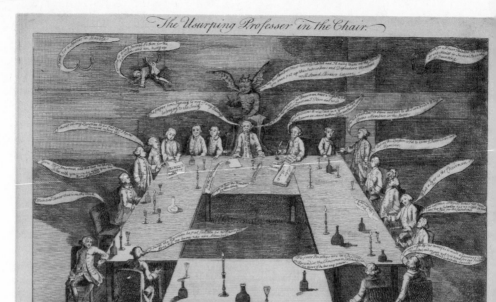

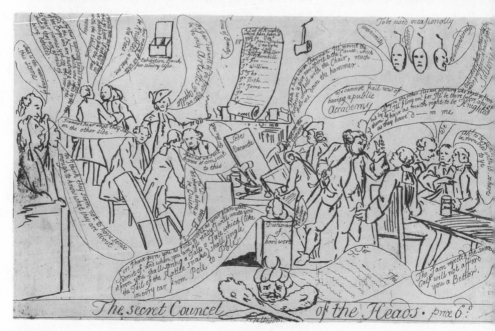

39 and 40. (George Towneshend?) (top) *The Usurping Professor in the Chair* and (below) *The Secret Councel of the Heads* (1768). A satire on the Royal Academy, from the point of view of those excluded

that later dissensions arose.[79] As suggested, the first sign of trouble centred on the role of the committee in determining which pictures should be hung and where:

> [The painters] saw their own works placed in the most obscure and distant places, ... and on the other hand the most conspicuous situations were carefully selected for performances of the committee and some favoured adherents, whose abilities did not seem to merit much distinction: so that the exhibition which ought to be an advantage to all, was really a detriment to many.[80]

Efforts to alter this perceived injustice later developed into a full assault on the constitution of the Society and finally precipitated the great breach in 1767. It is difficult, and rather pointless, to assess the validity of either side of the argument. Each attacked the other with some vitriol and no compromise ever emerged. Ultimately the debate was over authority to decide taste. The complaint of those who toppled the original governing committee was that it ignored merit in the pursuit of factional interests; those who broke away to form the Royal Academy equally accused their attackers of being second-rate mediocrities.[81]

In the case of the exhibitions both sides agreed that the best pictures should have the best sites, but disagreed over which were the best pictures. The size of the society as a whole, the ambiguities of its charter and the absence of any form of external pressure to decide matters made the committee unable to exert its authority and obtain a consensus.[82] It was an arena of confusion from which the future Royal Academicians learnt well, and they took pains not to repeat the mistake. The administrative structure of the Royal Academy ensured its dominance of aesthetic perceptions and ruled out any possibility of doubt manifesting itself in tangible forms.[83] As the committee was made up of twenty-four out of the total of forty people eligible to vote, decisions could not be overturned by a factional cabal, as happened in the Society of Artists. The charter carefully excluded from membership the most troublesome of the original Society,[84] and it explicitly gave the Council complete jurisdiction over the selection of pictures and their layout at the exhibition.[85] Equally, the distribution of the prizes and premiums was left to the discretion of the committee which also had the right to select new members and remove those it found unsuitable.

With such an iron grip combined with the external sanction of the king, it is scarcely surprising that the Academy triumphed over the alternatives, especially as the Society of Artists weakened itself at a crucial moment by wasting a large portion of its money on building an ostentatious exhibition room.[86] No matter how much it was disapproved of by those on the outside, the Academy could claim to represent the cream of

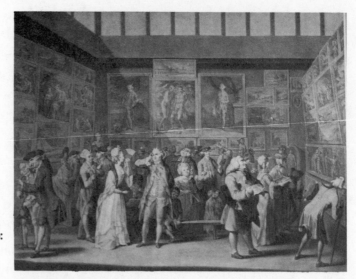

41. Charles Bardon, engr.
James Sayer (1748-1823):
*The Exhibition at the
Royal Academy*, 1771.

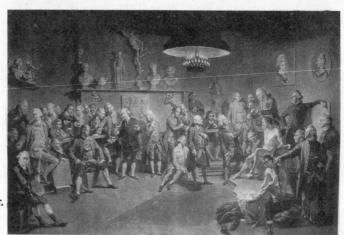

42. Johann Zoffany: *The
Royal Academy*, 1768. engr.
by Richard Earlom (1743-
1822).

the profession and cite royal approbation to support this assertion.
Moreover, for the reputation of the painters with English society as a
whole, it can be deemed to have been more effective than the more
amorphous mass of the original Society of Artists, as the painters were
presented to the public in the institutional shape of the most acclaimed,
not through the entire spectrum of varying abilities and reputations.
However, this necessarily involved a considerable element of self-repro-
duction: if the Royal Academy contained the most eminent and
successful, this was at least partly because it rapidly achieved a substan-
tial role in deciding who the most eminent and successful were.

5

PATRONAGE

IF THE SOCIAL status of painters was somewhat ill-defined in this period and the reorganisation of their profession far from complete, then this position was closely mirrored by ambiguities and changes in their commercial and economic position. Despite a good deal of idealisation that surrounded the topic of their relationship to their customers, reality had little in common with any lofty conceptions. Painters were seen to operate in an area marked at one extreme by the idealised figure of the benevolent patron and at the other by the equally stereotypical notion of the malevolent art dealer. One represented the altruism of a traditional personal relationship, the other the full evil of a sophisticated market economy. In fact, the commercial and social position of the painter was similar to that of many other emerging occupations in the period. A supplier of specialised products at a high price with marginal utility, the painter necessarily had to rely on a considerable catchment area and supply small quantities of his products to a large number of people in order to make a living. In his eighteenth century English form, the painter was a by-product of urban development, highly dependent on the existence of substantial surplus resources available for expenditure on objects of luxury or status by a growing number of people.[1]

Largely because of the way in which painters in England emerged with a developing mass market for all types of painting, orthodox, continental models for their relationship with clients on the whole failed to apply. Equally, the virtual absence of a main patronage centre such as the crown, the church or individual city-states, also helped ensure that the English pattern would be radically different to the one polemicists, engaged in the discourse of resistance to commercial change, held up as the ideal. [2]

Once the peculiar combination of political and financial conditions which enabled Charles I to emerge as the foremost patron of the arts in

England were dispersed during the Civil War, the monarch never again felt the need to undertake large-scale and dominant support, a fact which has done little to advance the reputation of the later Stuarts or early Hanoverians. The interpretation of them was laid down first of all by Horace Walpole and has changed little since. Walpole contrasted all the monarchs he mentioned back to the supreme example of Charles I and found them to be, almost without exception, lacking in taste, generosity and enthusiasm: 'The Restoration [of Charles II] brought back the Arts, not Taste'; George I 'was void of Taste', and George II 'had little propensity to refined pleasure'. 3

The extent of the English monarchy's patronage of the arts seems to have had relatively little to do with the presence or absence of taste in the incumbents and the scope of patronage was probably more determined by down-to-earth matters such as need and finance. The monarchy after 1660 had inadequate resources to become the central focus for artistic patronage and after 1714 (and probably after 1688) felt no particular need to try. Although such a state of affairs was loudly lamented by those who wished to gain access to the royal pocket and distribute its contents around the artistic world, others took a broader view which saw implicit connections between the politics of Charles I and his artistic predilections. As the reviewer of Walpole's catalogue of his pictures put it: 'Great pity it was we lost the Pictures; but however, we may console ourselves with the reflection, that we preserved our Liberties'.4

The attitude of Charles II to painting was certainly radically different to that of his father. He was no connoisseur and only a grudging patron. But his reasons for this were quite understandable: the monarchy under Charles I had been chronically short of funds and its spending of such large sums in an ostentatious — and little understood or appreciated — manner was little short of lunatic. In the quarrels which both of the first two Stuarts had with Parliament, one of the most frequent reasons given for the refusal of the Commons to grant funds was that the crown was already wasting too much on unnecessary luxuries. Painting was one of the more prominent expenses which supported this natural, if in fact largely erroneous, viewpoint.

Charles I's support of painting was politically unwise — he gained no credit for patronising when the meaning behind the patronage was not understood by those with enough power to cut off his funds and his head. Instead of being a sign of cultivation and humanity, it was an indication of his extravagance and tendency towards absolutism. Ultimately it did more harm than good to the cause of painting in England. It set up a model against which all those who followed him onto the throne had necessarily to be seen as pale and inadequate imitations. Moreover, the disruption caused by the destruction of the patronage network and the consequent flight of many foreign painters

probably set back the development of a solid, home-grown school of English painters by at least a generation.

While Charles II had not the integrity or taste of his father he had at least a good deal more political sense. Although far from stable, his finances were a little more secure and, until the attempt to secure a pension from France, the monarchy was heavily dependent on keeping the House of Commons in good humour.[5] At least for the early part of his reign, expenditure on aesthetic matters was not lavish. When he did begin to spend, he poured the vast majority of the funds available into building, which was something more readily acceptable and more likely to evoke a favourable response. He gathered together as much of his father's collection as was possible without having to pay out much money and rested content. For the rest of his reign there are no surviving records of his having bought an extant painting and few of his commissioning anything but portraits and decorative schemes for his building projects.[6]

As a setter of fashion also the crown hardly stood out as an ideal model. It did employ Verrio and spent some £10,000 on Windsor Castle alone, but only after other people, and in particular the then Chief Minister Arlington, had brought him over to England and made large-scale decorative painting fashionable. Equally, like later patrons such as George III, the last Stuarts tended to concentrate the bulk of their patronage into a small number of hands, Verrio and Laguerre in the late seventeenth century, and Benjamin West a century later. Moreover, even Verrio could not have survived in England on royal largesse alone. The crown paid well, and also gave him a house and a pension, but there were no commissions between 1687-93 and 1694-1700. With the need for constant work to keep the large team of specialist painters, brush cleaners, paint mixers and so on from dispersing, Verrio's continued success necessarily depended on his entire range of clients, with the crown being no more than one customer amongst many, and sometimes not even the most important or generous.[7]

Similarly, the last Stuarts were neither adventurous nor prodigal with regard to portrait painters either. Like Verrio, Peter Lely (1618-80) was already established as the country's leading face painter before the crown appointed him to its official sinecure and even then the payments of £200 a year were often enormously in arrears.[8] When Lely died, John Riley (1646-91) and Kneller (1646-1723) were jointly given the post with only half salary each and after the former's death the crown decided it could manage without any portraitist at all. Referring to Kneller, the state records remark laconically that 'on regulating the establishment in 1690 [he] was left out'. Kneller was given the post back in 1695 but received no back-pay.[9] As with Verrio, none of the country's portraitists would have been either rich or busy had they not been able to fall back

on a large and established clientele during the frequent periods when the crown was in one of its moments of financial strain.

Perhaps the most complete example of the monarchy's unreliability as the theoretical summit of the patronage system came after the death of William III. Having overspent ferociously on the French wars, he left the monarchy heavily underfunded and on his demise the opportunity was taken to rectify the situation by calmly repudiating debts totalling some £800,000. Out of this half a dozen painters were left with useless bills for more than £2,500.[10] That the collapse did not in turn trigger of a crisis in the art world is in itself an indication of how relatively unimportant its custom was.

The state support of portraitists that existed was more for utilitarian than aesthetic motives. Portraits of the monarch, which all the royal face painters turned out like a conveyor-belt, were part of the standard equipment of the diplomat and were also seen as suitable gifts indicating royal favour. A substantial number of Kneller's portraits of Queen Anne were sent to the American colonies to hang in the offices and homes of royal administrators and still more were dispatched to monarchs, princes and noblemen throughout Europe as part of the stately round of diplomatic courtesies. The miniature set in jewellery was seen to be particularly appropriate in this respect, combining as it did both image and expense, which is probably why there continued to be a 'King's Painter in miniature' after the fashion for such articles had largely died away elsewhere. Even so, the crown was scarcely over-generous either to its painters or to those who received the products. When the Viscount of Fauconberg, for example, was sent as ambassador to Venice, he duly took a portrait of Charles II with him but found that £60 had been deducted from his allowable expenses to pay for it. The crown even indulged in a bit of petty profiteering in the transaction: Lely at the time was paid only £50 for each portrait he turned out.[11] The administration continued to be quite prepared to use its position to obtain a bargain. As late as 1710 Kneller, for example, was paid only £50 for a full-length picture of the monarch, despite the fact that by then he was charging £66 as a standard fee for other, less exalted customers.[12]

Relations with James Thornhill (1675/6-1734) again suggest that the crown generally saw itself merely as an ordinary customer and, far from giving special support, tried instead to exploit its position to get a discount. In 1717 Thornhill was negotiating with the directors of Greenwich Hospital to establish his rate of pay. Although he made the point that under Charles I Rubens had been paid £10 a yard for the Banqueting House and more recently Lord Montagu had paid Rousseau £7, the directors rejected his request for a mere £5. They clearly realised that painting such a public building had advantages for the painter which would make him willing to do the job more cheaply. As they put it,

'concluding that this was the first great work he ever undertook in England, and served as an introduction to bring him into reputation, [we] are of the opinion that £3 a yard is sufficient ...'[13] Even under George III, whose relations with West, Gainsborough, Zoffany and the like have secured him a better reputation as a patron, liberality was far from common. Reynolds, for example, complained to the Duke of Rutland that,

> The place which I have the honour of holding, of the King's principle painter, is a place of not so much profit, and of near equal dignity with his majesty's rat-catcher. The salary is 38 pounds per annum and for every whole length I am to be paid 50 pounds instead of 200 pounds which I have from everybody else. Your Grace sees that this honour is not likely to elate me very much ...'[14]

This reluctance of the Stuarts to take up what many saw as their artistic responsibilities was a characteristic which became even stronger under their Hanoverian successors. Portraitists continued to paint royal faces but, on the whole, patronage dwindled from its already low level of the late seventeenth century until it became virtually insignificant. The reasons for such a decrease in support are, however, quite understandable, even if they were rarely commented upon favourably by artistically-minded contemporaries. Indeed, it is difficult to think of many good reasons why the eighteenth century monarchy should have felt inclined to lavish large sums of money on the arts. The ideological impetus that fired Charles I and dimly lit up his two sons vanished into anachronistic absurdity under the pressure of the political and constitutional changes which accompanied the upheavals of the transition to the new ruling house. The political settlement of the period 1688-1714 made grandiloquent artistic posturing of the varieties favoured by Charles I and more noticeably by Louis XIV faintly ridiculous if not downright foolhardy. A warrior king such as William III might, perhaps, have retained enough self-importance to commission the flattering and complicated allegories that adorned the staircase of Hampton Court.[15] He was, however, the last English monarch who might reasonably have contemplated such celebrations. [16]

The first Hanover was neither military nor English and his presence on the throne was easily spotted as having less to do with personal qualities and divine will as with the machinations of the Commons and a small group of noblemen. Being in a position of outright dependence on these who in theory were his subjects, the histrionic displays of artistic glorification that seemed appropriate for an absolute ruler like the Sun-King were as likely to cause ribaldry and worry over political intentions as admiration. Impressing the court or even the nobility and gentry as a whole was scarcely relevant to the new realities of political power. Instead, the duty of the monarch in social and abstract terms

was to present a face which corresponded to the circumscribed — if still powerful — role that political expedient had created. The crown was set off on the path to becoming the overseer of the political process, watching, advising and choosing ministers who carried out its will in day-to-day administration and in the Commons. It was perhaps natural that its relationship to the arts should have followed a similar route.

The growth of the governmental machine, largely as a result of the pressures of the wars at the beginning of the century, further diluted and removed the personal element from royal patronage. The offices and sinecures which occasionally fell into the hands of artists might, perhaps, have been paid for by the monarchy in its widest sense, but the credit for such patronage rarely went to the monarch himself. It was clearly recognised that such gifts were as much the result of political necessity as a recognition of artistic prowess. Thus, such credit as Charles II received for appointing Lely as chief painter was not repeated: when William Kent was given a position, for example, it was clearly acknowledged that the force behind the appointment, and the person who should properly be thanked or criticised for it, was the Earl of Burlington.[17] Royal — as opposed to governmental — patronage came from the funds allotted for the monarch's personal expenditure and this more limited sum rarely achieved large-scale support of the arts for any long period. Only on rare occasions did the monarchs of the first half of the eighteenth century interpose, one case being in the succession to Kneller, when George I reputedly blocked the appointment of John Michael Dahl for the sake of Charles Jervas because of a slight the former had offered to the two-year-old Duke of Cumberland. [18]

The only substantial way in which the monarchy could patronise was, therefore, in the careful deployment of its influence. The social status this could confer, due to the semi-official recognition of merit it carried, could do more for a painter's reputation and income by increasing his clientele than any amount of direct buying. Innumerable examples of this can be given: once established as royal face painter, Jervas built on his good fortune and established a healthy practice by appearing to have the court's favour;[19] James Housman (1656-96) received an enormous boost to his career by painting the Queen,[20] and, in the case of Thornhill, as mentioned, the government showed itself perfectly aware of the advantages that royal favour might confer. Artists themselves were equally aware: Thornhill, after all, undertook the Greenwich project despite the fee and others went to extraordinary lengths to gain at least the appearance of royal connections. Vertue refers to 'the desire and affection of being great in public reputation', making Highmore cobble together pictures of the king and queen from quick sketches drawn by stealth and painted from memory.[21]

The best example of this type of patronage by influence comes with

the relationship that developed between the monarchy and the Royal Academy, where once more the crown's financial contribution was virtually insignificant. George III occasionally made token presentations of small sums of money to both the Society of Artists and to the Academy but his more substantial offering was in the gift of official status. Nor did this apparent stinginess occasion any adverse comment: there was no expectation that the Academy should have been anything other than self-financing. The real patron of the academy was the viewing public, as it was supported largely by the income derived from the exhibitions. The official contribution was the prestige which encouraged the public to treat the Academy more seriously and hence be prepared to pay more generously. [22]

If the absence of royal patronage was a result both of the requirements of the monarchy and the nature of the spread of interest in the arts, then much the same argument can be made for the equally noticeable absence of patronage from the other main body of the state, the church. Ecclesiastical attitudes to painting on the more theoretical level have already been looked at,[23] so here it is only necessary to point out that a combination of theological uncertainties and acute financial difficulties effectively precluded any major intervention by the Church of England in artistic affairs. The period 1680-1760 saw the amount of construction of new buildings by the church fall to an extremely low level. With the exception of the fifty churches rebuilt after the Great Fire and the project for the fifty new churches at the beginning of the eighteenth century, relatively little was erected.[24] Financial strains also meant that the amount of money available for unnecessary, and possibly irreligious, decorations was cut to the bare minimum. The churches of Wren, in particular, were built to very tight budgets and although there are occasional mentions in the accounts of altar pieces — such as those painted by Robert Brown [25] — these were relatively rare. Certainly in no church, apart from St Paul's and the Catholic propaganda pieces of James II at Whitehall and Windsor, did any large-scale decorative work take place.[26] There were also occasional projects for altar pieces, including Kent's ill-starred work for St Clement Danes. [27] Later in the eighteenth century Amiconi, Casali, Hogarth and Hayman all also produced works that were hung in English churches. The number of artists who benefited from such commissions, however, was an exceptionally small proportion of the total, and few even of these painted more than one ecclesiastical work. [28]

Patronage

Who then did patronise the developing profession of painting in England? First, however, some definition of terms is necessary.

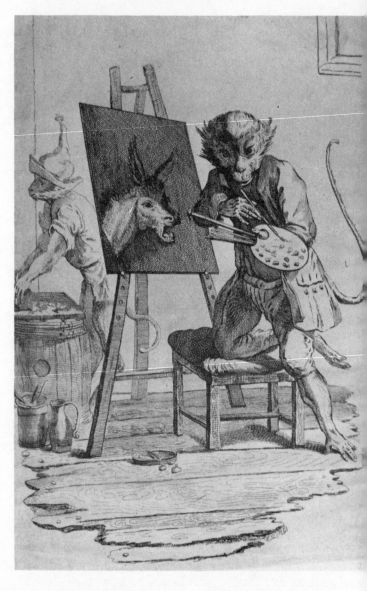

43. (left) G. Bickham
(1684-1769): *Ape
painting the Portrait of
an Ass,* 1753? Possibly a
satire on Hogarth, but
more particularly a com-
ment on the relationship
between painters and
patrons — the former
seen as an imitative
drudge, the other as a
fool.

Patronage implies a good deal more than the simple exchange of goods
for money and the patron should ideally do more than buy at the most
advantageous price. Instead, he should provide some means of non-
financial support for the artist or in some way involve himself in the
production of the work of art. Whether this support comes in the shape
of providing accommodation or food, or by supplying long-term security
is of no great importance. The distinction between patron and customer

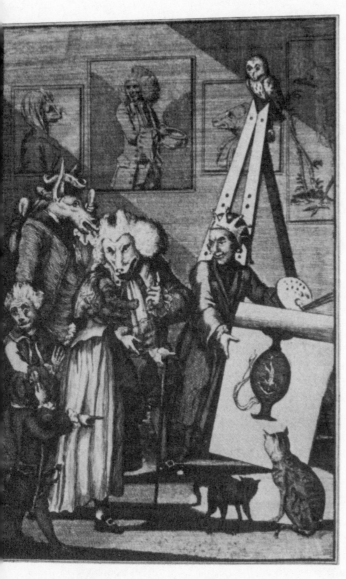

44. Anon: *The Painter
submitting his Picture
to the Examination of
Connoisseurs and
Antiquarians, c.1733.*
Another critique of the
painter/patron relation-
ship, with the painter
this time actively mak-
ing fun of his customers.
One dogmatises about
the work, the other is
simply boaring.

is thus a fairly clear one and in the eighteenth century particularly it is
necessary to separate the two.

It is very doubtful whether patronage, in this sense of the word, was
of any great importance in the development of English art by the middle
of the eighteenth century. Indeed, comments on its absence form almost
a standard element in the introductions to books on painting. What was
needed, so the argument went, was more effort from those ultimately

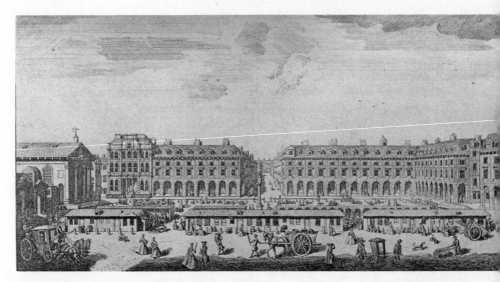

45. J. Maurer (fl.1740s-1750s): (detail) *Perspective view of the North side of Covent Garden*, 175
Covent Garden was the focal point of the art world in this period, housing many artists, auctioneers a▸
collectors. Cock's auction house was at the back of his house at no. 9-10, behind the 6th and 7th arch
of the North-East range. It was flattened in the early 20th century to open up Mart Street.

responsible for English art, that is the upper classes.[29] Moreover, the
manifest inadequacy of the national effort at patronage, and the fact that
the English seemed prepared to patronise only portrait painters, was
readily seen as a comment on the low moral quality of the patrons rather
than as proof of the painters' inadequacies. As Johnson put it in 1759:

> That the Painters find no encouragement among the English for any
> other works but portraits, has been imputed to national selfishness.
> T'is vain, says the satirist, to set before any Englishman the scenes of
> a landscape, or the Heroes of History; Nature and Antiquity are noth-
> ing in his eyes; he has no value but for himself nor desires any copy
> but of his own form.[30]

Although examples may be found of artists living in the houses of
members of the nobility or gentry, or having trips to Italy subsidised,
such instances are relatively rare.[31] That this was the case, however, is
not especially surprising given the nature of English society and the art
market it produced. The decline of the vogue for large-scale decorative
works meant that there was little practical purpose for long-term patron-
age. Equally, the collector of 'modern art' was a phenomenon of the
future — few customers or families could have enough work to keep
any single non-decorative artist busy for very long.[32] Being a patron of
painters might, perhaps, have conferred a degree of status. However,
having an unbalanced collection of works by English artists, which were

likely to be seen as second rate in comparison with foreign pictures, would merely have produced condemnation.

A further factor which prevented 'traditional' patronage from meeting the demands of critics was the prolonged process of change which redesigned the aristocratic household and indeed the entire domestic existence of the upper ranks of society. The period after about 1650 saw the final stages of the establishment of the 'house' in its modern sense with an increased concentration on the family as the central unit of importance. [33] Servants of all sorts were gradually moved out and hidden from view and the house became an increasingly private arena only occasionally open to outsiders. [34] It consequently became less normal for patronage to be given in the form of living accommodation or in the old-style notion of a retainership, although some examples of this can be found well into the eighteenth century.[35] The relationship between painter and patron became more distant and impersonal. Defined solely by the exchange of goods and payment and only occasionally by a degree of personal interest and support, it was less likely to contain elements of non-monetary aid or intervention in the nature of the work produced.

The ideal of the patron collaborating with the artist in order to achieve exactly the sort of work he wanted — a process demonstrated in its more extreme form by the Earl of Shaftesbury's creation of his *Judgement of Hercules* — becomes exceptionally rare as this period progresses.[36] On occasion, traces of the more involved and enthusiastic patron can be found, such as Archbishop Drummond reading extracts of Tacitus to West in order to give him an idea of what he wanted in the *Agrippina*; [37] or George III repeating the operation by reading the poor man Livy for the *Final Departure of Regulus*.[38] However, more usually, the patron was little more than a simple client who gave rudimentary instructions and exercised control only after the event by retaining the ability to withhold payment.

Thus, for example, Lady Wentworth in 1711 commissioned a series of portraits from Charles Jervas and appeared to pay no attention to them until they were nearly finished, whereupon her wrath was instantly aroused: 'he has made a dwarf of you and a giant of me, and he has not touched the dressing of the scenes you want, for they are neither of them like. He is so engaged with the Marlborough daughters that he minds nobody else...' [39] Faced with such a disappointment, she refused either to take delivery or to pay unless the pictures were reworked and improved, a process which took another four months: 'I have been at Mr Jerviss to see our pictures; I think he has mended them both extremely and has made you a good deal taller and the robes are well of them both'.[40] Other customers were just as tiresome for the artist. Kneller and Thornhill, for example, were hired by the Marlboroughs to produce historical works to decorate Blenheim Palace. Although both were

required to submit long explanations of the allegories they intended to paint,[41] no instructions were given to them apart from Kneller being told of the general wish of the Duke that 'no person should be represented by the life except the Queen's majesty, but that the whole picture should be allegorical'.[42] Once again, however, the patrons took little interest until the question of payment came up. In Thornhill's work (Kneller's being abandoned) [43] even the fees failed to concern the Duchess until she found out that she had paid, through Vanbrugh, £978 for a work which she decided, considerably after the event, 'was not worth half a crown'. [44]

Some fortunate artists did succeed in the winning full-scale aristocratic patronage in the first quarter of the eighteenth century, a fact that Vertue remarked on in the mid-1730s: 'Several noblemen have their particular painter or favourite who is wholly at their promotion — and recommendation as particularly ye Earl of Burlington who has promoted and supported Mr Kent'. He then goes on to list Lord Oxford and Dahl, Wootton, Gibbs, Rysbrack and Zink, Lord Pembroke and Ellis; Walpole and Jervas; and Lord Pawlett and Gibson. But, as he points out at the same time, such connections were not only rare, they were becoming even less frequent as the nature of patronage changed in the decades after the deaths of such luminaries: 'Lately the Duke of Devonshire and the Earl of Pembroke were the greatest Maecenas, especially spent most money on those accounts in England. Since their deaths has not appeared amongst the nobility any so generous above the common...'.[45]

If the interests of the nobility had changed sufficiently to make patronage less attractive, then painters also began to find the constraints such a relationship imposed less to their advantage. In an increasingly diverse and pluralistic society an attachment to one individual could mean they were cut off from other lucrative areas and hampered in the development of an independent career. Thus Hannan in his early career 'was taken under the protection of Lord DeSpencer, who employed him in ... decorating his house ... but Hannan was inclined to think this patronage of not very solid advantage to him, as he was thereby obliged to relinquish an offer, which Lord Bath and others had made, to send him to Italy upon their pension'.[46] Another example of this is Cipriani, who in the mid-1750s apparently found the patronage of Lord Tilney not especially helpful.[47] Summing up how the market had changed, West turned down the offer of a huge £700 a year from Lord Rockingham to paint histories at Wentworth Woodhouse: 'On consulting his friends [he] found them unanimously of the opinion that ... he should not confine himself to the service of one patron but trust to the public ...'[48]

What did exist in large measure was a sort of bastard-patronage which was much better fitted to eighteenth century conditions. One common form of this was for the 'patron' to act purely and simply as an

advertisement for the painter, either by the elementary means of being well-known and buying a painting, or by putting the word around and recommending him to friends and relations — extending the artist's reputation with little personal cost or effort. Mrs Delaney (1700-88) gives a clear example of this when in 1748 she felt particularly well disposed to an artist called Barber. Instead of giving him much work on her own account, she limited her patronage to doing whatever she could in the way of publicity: 'I will recommend him as much as lies in my power; at present the town is so empty that I can do him but little service. Lady Geo. Spencer has promised me her picture, and I will have it by Mr Barber'. [49]

Like the monarch, members of the upper ranks were valuable to the artist not merely because of the worth of their purchases but because connection to them made them better known. On occasion painters also benefited from patronage of a more orthodox political variety through an appointment to a government post. As mentioned, Hugh Howard exploited his connection with the Duke of Devonshire and received a life appointment to the Paper Office, whereupon he gave up painting for good. Similarly, John Ellis, in Walpole's circle, achieved a unique position in the history of art by becoming Master Keeper of the Lions in the Tower of London. As Vertue points out, however, this was as much due to his services to Walpole as an agent in picture collecting as to his merits as a painter.[50]

An alternative form of support which grew out of evolving market conditions was group patronage, when several people would band together to give some type of sponsorship. Examples of this are William Kent on his first trip to Italy,[51] Edward Penny in Rome,[52] Allan Ramsay and the support he received from the Scottish in London,[53] and the activities of the Society of Dilettanti.[54] Having turned down Rockingham, West handed himself over to the fund-raising activities of Archbishop Drummond, who introduced him to the king only after an attempt to raise 3,000 guineas through subscription had failed.[55] Such a method had also been used before; the Earl of Leven raised such a subscription more successfully in order to entice John Medina away from London and up to Edinburgh.[56] A similar form of patronage, the only type which could guarantee portrait painters in particular large-scale support, was that which came from clubs or institutions who wanted a record of their membership. The most famous of these was perhaps Kneller's *Kit-Kat* series, but Lely's *Admirals* and *Court Beauties* in the 1660s as well as Wright's and Riley's *Judges* date from around the same period. Such a phenomenon, however, appears to have become less common, with few examples existing for the mid-eighteenth century period with the exception of Bardwell's *Norwich Mayors*.[57]

Instead, a form of institutional support came to dominate the upper

parts of the Art World, *via* the medium of the Society for the Arts, Manufactures and Commerce and the Royal Academy, bodies which encouraged the development of a more distant and flexible form of patronage through prizes and awards given to the winners of various competitions. The spread of interest had created a wide willingness to contribute something to painting but, reasonably enough in view of the limited possible gains for the patron, few were prepared or even capable of providing individually the considerable and increasing sums required to give substantial long-term aid. It was only through the mediation of artistic clubs and professional bodies that this problem found a solution, creating a system of bringing patrons together in a group and placing them in contact with artists. This was a much more impersonal form of patronage, in which a project or cup would be underwritten, with support frequently going to artists with whom the patrons had little or no personal contact. Nonetheless, both widened the catchment area for artistic support and, in the form of the Royal Academy and the later more important British Institution, represented an integration of public support and the professional artistic structure.

As the century progressed, painters increasingly threw themselves on the public in general, but such a course was fraught with difficulties and only occasionally embarked upon. The principal difficulty was practical and commercial — because the painter produced only a small amount of high cost goods, he necessarily had to rely on a compact and wealthy segment of the population. One way round this was the method adopted by Hogarth, who partially by-passed the traditional network through winning both publicity and an effective subsidy for his painting by his engravings; a further method was the lotteries through which he attempted to dispose of his works. The most perfect example of the meeting of commerce and the public perhaps came with the Shakespeare Gallery project of Alderman Boydell later in the century, in which Boydell mediated between the mass and the artists, creating an audience on a large scale without relinquishing to it any say in matters of taste. Both these examples, however, illustrate the dangers of such methods; Hogarth's income was at best erratic while the Shakespeare Gallery was eventually wound up because of financial difficulties.

If the painter ultimately had little option but to rely on a narrow band of the population, and probably wanted little alternative, there remained the basic problem of how to bring painter and client together in the first place. The picture shops, of course, provided one simple method for bringing the two sides into contact. This was not, however, something that appears to have been particularly advantageous to the painter. 'Working for the shops' was seen to be one of the lowest points to which a painter could fall as, above and beyond the possibilities of gross exploitation, one of the main things the artists desired - publicity - was

frequently denied. Even when original works rather than copies of old masters were sold, dealers were naturally keen to continue acting as a middle-man and consequently anxious to prevent his suppliers developing an independent reputation. According to Edwards, the dealer in Castle Street, Leicester Square who employed Brooking had the signatures on the paintings erased before they were put on display in order to keep his identity secret.[58] Some artists had shops of their own which served to publicise their work. Thus William James maintained a shop in Maiden Lane, Covent Garden, for this purpose.[59] Many more from the late seventeenth century onwards took the more respectable route of having a discreet studio where they hung examples of their work to be seen by visitors and potential customers.[60] Hayman, Pond and Wills kept such small exhibition rooms, which were seen by Egmont in 1740, [61] while the Barrister John Baker saw Nathanial Hone's pictures at his studio in 1771.[62]

The difficulty was that these could only be seen by those who already knew where the artist was, and consequently could only serve as a marginal aid in enhancing his client base and reputation. The need to be relatively near likely customers also probably underlay the shifts in the artistic quarter in the seventeenth and eighteenth centuries. Following the rich and fashionable at the cautious distance required by ability to pay rent, the artists slowly crabbed westwards across London. In the seventeenth and early eighteenth centuries the main centre for artists was the Covent Garden area. Before that, when this was still much more well to do, Vertue states that the central area had been Blackfriars. From about the 1730s onwards the centre of gravity shifted again, this time towards Soho,[63] although by the 1770s a small and more independently-minded colony of painters appears to have established itself in Hampstead, possibly because of the combination of cheap rents and rural atmosphere.[64]

Proximity, however, was again only a partial, and on its own inadequate, solution to the problems of finding clients. One attempt at a more lasting answer came in 1763 with the publication of Mortimer's *Universal Director:*

> Surely it is necessary to establish a free Intercourse between the Artist and his Patron, especially as it is a Fact too notorious, that several Picture Dealers and Shopkeepers of various kinds, have long engrossed the Work of our Artists and thereby had it in their Power to keep many deserving Men in obscurity for Years ... The following Work, by means of which Patrons of Merit will have an Opportunity of visiting the Artists of this Metropolis, and of employing them in their several Departments, instead of applying to those general Undertakers, who engage to furnish a Picture ... at an exorbitant Price...[65]

There then follows a list of some 120 painters with their addresses, plus a list of various auctioneers, brushmakers, colourmen and so on. Not surprisingly in view of the above comments, few dealers are included and then only if they worked in some other capacity as well.

This remedy, however, was clearly only a partial and temporary one and no further edition of it appeared, although such a fate was certainly not the intention of the author, who makes a request in his introduction for readers to send in further information for the next printing. That the book was not a great success is not altogether surprising. It is a basic axiom of salesmanship that the potential customer should have to make as little effort as possible in order to buy and the prospect of trailing round some 120 artists in search of one who pleased would have been a daunting prospect for even the most enthusiastic. The most satisfactory solution was the exhibition, whose consequent importance gave it the ability to become the focus of the struggles within the profession, enabling the battles for control to express all the acrimony and political manoeuvring that were more muted elsewhere.

Inclusion in an exhibition or even in Mortimer's directory touched only the uppermost peaks of the profession. Those relatively few artists who had their pictures shown were generally either quite well established or rapidly heading towards that status. Between this élite and the rest there were substantial and ever-widening gulfs. For the majority of painters, earning a living and finding clients was more problematical. The distance between the extreme ends of the profession is naturally indicated most clearly by prices. The upper ranks were in a position to charge gigantic amounts for their work; for a full-length portrait, for example, Lely in the 1670s charged £60, Kneller in the early 1700s £66, Ramsay in the 1760s 84 guineas while Reynolds at his peak could command the huge sum of more than 200 guineas. [66] The more humble had to be content with very much less. Vertue reports that Simon Dubois early in the century was amazed at Lord Somers' generosity in paying him £50 for a portrait, a figure presumably far above his usual price.[67] In the pages of Walpole and Vertue there are many instances of painters who were poverty-stricken and Vanderwaart, it seems 'got more money by mending pictures than he did by painting them'. [68] The accounts of the Earl of Bristol suggest the same. In these the fashionable painters were paid very much at the rates given above — in 1699 Kneller was paid £35 and in 1711 Dahl £21.10s, both for half-lengths. Others managed less well; in December 1716, Brook, a local painter from Bury, was paid £8.12s for three portraits and, in December 1717, Mrs Brown £12.10s for two half-length portraits and one three-quarter-length. Mrs Brown, a rare example of a professional woman painter, appears like Vanderwaart to have been able to earn more by copying. [69]

The point that books like Mortimer's underline is that the market for

painting in eighteenth century England was composed largely of relatively small-scale buyers with the conglomeration of a large number being required to keep the profession going. It is for this reason that London managed to retain its pre-eminence in the artistic world and pioneered all the developments in professional organisation.

Of course, there were painters in the provinces but in general they led a far more difficult life and lagged behind in achieving even the limited degree of prestige won by their metropolitan comrades. There was nothing like a substantial indigenous population of provincial painters until the second half of the eighteenth century and even then many who operated outside London were, so to speak, colonists from the capital, like Mercier in York between 1739 and 1751.[70] Even a town like Norwich, which was second only to London in size and importance until overtaken by Bristol in the 1730s, could boast only one or two painters in the first half of the century, men such a Henry Munford from 1707, Reid from 1718 and the two Germans, Heins between 1720 and the 1750s and Lewis Hubner from the 1740s onwards.[71] Apart from these and the occasional foray from an artist painting at nearby country houses — such as Pellegrini at Sir Andrew Fountaine's Narford Hall — there was no local artist on the scene until Thomas Bardwell in the 1730s, and even he spent much of his time in London and Scotland.[72] Much the same story can also be told of Liverpool. The city produced some painters attached to its pottery trade in the seventeenth century and Dibdin found some trace of a couple of limners in the early eighteenth but again there is little sign of major artistic activity until the second half of the century. Even then, the beginnings were slow and the initial and short-lived attempt at an academy produced only three professional artists and a possible four others.[73] Nonetheless, there were signs of a growing public interest in the provinces. Lewis Ourry offered drawing lessons in Norwich in 1744 and Lens did likewise in 1761.[74] Equally it was becoming possible to risk holding an auction sale of pictures outside London, such as the 1752 Dyrham House sale held in Gloucester, or the post-mortem sale of Heims' works held in Norwich in 1757.[75]

Nonetheless, much of the 'reputable' painting performed in the country was done by artists on tour from their base in London. Until quite late in the seventeenth century it was fairly common for painters to leave London and travel around the countryside looking for business in the small towns or at the country houses, and even Peter Lely went on circuit in this way in the early days of his career.[76] As London became more obviously the main artistic centre with a sufficient number of clients, the practice died out for those who could succeed in the capital. For the less exalted, however, travelling in search of work seems to have gone on throughout the eighteenth century. Engravers particularly kept these habits, emulating their seventeenth-century forebearers Kip and

Knyff.[77] Even in the mid-eighteenth century Arthur Pond, one of the more successful of his trade, went to the country to find work,[78] as did the painter Thomas Beach almost every year until near the end of the century.[79] Some painters left London to find new business on a more permanent basis, as we have seen for example with Medina in Scotland, and John Michael Wright's cousin in Ireland,[80] while others went even further afield to prospect the new markets of the Empire, such as Ozias Humphrey and Tilly Kettle in India,[81] or Smibert, William Williams or Woolaston in America.[82]

In addition to these more prominent figures, however, there was also a substantial number of painters, such as Adnel and Gandy,[83] whose life-style and financial resources were more akin to that of the travelling pedlar than the London-based artist with servants and aristocratic patrons. Oliver Goldsmith briefly describes a travelling limner who went around the country doing entire families for 15 shillings a head.[84] In addition to these figures — introduced into the plot of the *Vicar of Wakefield* as no unusual occurrence — there were the specialists in animals and small landscapes who are now given the description of 'folk-artists'. In London as well there was a host of anonymous painters whose education, fortune and training gave them little claim to social respectability by the standards of the age. These were the literally hundreds of face painters, drapery painters and so on, who either did sub-contracting work for the better established, or picked up commissions copying, painting and drawing for the less wealthy of the middle classes.[85]

Hence, in this period the traditional notion of 'patronage' was not the dominant form for the relationship between artist and public and indeed was probably decreasing in importance as the exhibition and cash transaction showed themselves to be better adapted to the age. Nonetheless, the eighteenth century was the era when patronage was talked about more than in any previous age, with countless writers discoursing on the subject and almost unanimously lamenting the inadequacies of the current situation. To understand this phenomenon better, it is necessary once again to move away from the artists themselves and look at their more general social position. As mentioned, the image of the painter in this period did not undergo a neat and orderly evolution nor were the changes achieved consistently to the advantage of the practitioners. If, on the one hand, they successfully established themselves as a distinct entity, on the other, they failed to define clearly their place in society, and the manifest contradictions embedded in the notion of patronage underlined the partial nature of their transformation.

Like many of their literary brothers, painters often had an ambivalent attitude towards patronage. Beginning to see the advantages and even the necessity of working independently on the open market, many were

still clearly nostalgic for what they considered old-style methods and the security these provided, even if such a system of support had only ever existed in the mind's eye of idealisers. However, if the artists entered into a new area of confusion, cut off from the supposed comforts and support of traditional patronage, then contemporaneous developments helped to lay the foundations for more far-reaching claims to importance. As mentioned in the second chapter, one of the great claims of painting was that it had enormous potential for educating the illiterate masses who were too badly prepared to benefit from any other form of instruction. Painters consequently began to find themselves described as educators who would render ideas of virtue and correct behaviour into visual forms. On one level these would necessarily be too intellectual to be comprehended by the masses but on another they could be grasped through the sheer emotive power of the images presented.

Such a notion necessarily imposed a considerable degree of responsibility on the painter or engraver who was seen as bound to act in the public interest, opening up an entirely new range not only of duties to society but also to significance within it. The artist was offered prestige not as someone who could provide attractive objects for buyers but rather as one who could put truth in a clearly comprehensible form. This role, moreover, was to derive not from the inherent qualities of his technical or creative abilities but rather from the effects such abilities had on those who saw his works. The emerging claims for genius and special vision were consequently hemmed in by the imposition of new duties and the offer of increased rewards. Creative activity was most acceptable when it conformed to wider needs, with the fulfilment of this obligation providing a new justification for inclusion within the ranks of the morally and socially acceptable.

Such a line of argument, one that is directly linked to the question of taste, was put forward by the polemicist John Gwyn in 1749. According to him, Beauty is truthfulness to Nature, which implies an acceptance of the appropriate moral standards, and thus any work of art which is designed to arouse immoral sentiments can only be a false representation of reality and hence is not beautiful. A painter who employs his talents in such a way is thus not only potentially subversive, but also, by definition, a bad painter. Infringement of the accepted social code is, consequently, liable to be instantly metamorphosed into an aesthetic error.

That those Studies [ie. design] have really such a Tendency, [ie. towards the inculcation of virtue], when not perverted to lascivious or immoral Purposes, is undeniable: And whether, when thus perverted, they ought to be ranked among the Ornaments of Life, I very much doubt. We are certain that the Poets, Artists and Philosophers, who

have acquired the highest Seats in the Temple of the Fame, are not those who prostituted their Genius or Skill to the gratification of the Sensual and Culpable Passions.[86]

In this sentiment, Gwyn was echoing the view put forward by Charles Lamotte in 1730, who considered the topic to be of such importance that he devoted to it an entire section of his work on painting. Indeed, he was so concerned about the potentially bad effects of paintings that he was exceptionally severe on those artists who transgressed, ending his polemic by redefining the nature of artistic responsibility in a highly significant fashion. Dealing with the baseness of some painters, he denounced them in perfectly unequivocal terms:

Those Artists ... that go about ... to corrupt and debauch Mankind and ... endeavour to heighten and enflame [the passions] ... cannot be looked upon otherwise than as the Agents of Darkness, and Pests and Nusances [*sic*] of Mankind: and as such ought to fall under the Lash ... as corruptors of Public Honesty, and open and declared Enemies of Virtue and Religion. [87]

Following this onslaught, he turns to the question of responsibility, an issue previously addressed by Jonathan Richardson who had concluded that, although the effects of some painters might be bad, it was not necessarily all their fault. Painters, he maintained, were the employees of their patron and therefore had to paint what was required of them. The true blame, consequently, lay with those people who had caused the work to be created, and the painter strictly speaking was irresponsible as he was merely the means of transferring the patron's desires into reality. Lamotte was, quite justifiably, contemptuous of such an argument:

I deny this to be a lawful excuse. A great Artist and Noble Genius should set himself above such mean Considerations and such low Compliances, as will destroy the Truth of all History. He should not debase his Pencil, nor sacrifice his Glory or Reputation to the Wrong Taste and Vanity of Others.[88]

The point is a good one, not least because it catches Richardson out in a thoroughly unworthy excuse. If, as he claimed, painters were gentlemen and the equal of their patrons, then to make the excuse that they had to obey as a servant does a master was an implicit denial of their quality.

Lamotte's resolution was to alter the status of painters while at the same time maintaining their subservient position. Ideally, painters were the servants, not of individual patrons, but of society itself. Thus, they were to obey their patron only if he was a 'true admirer' of the arts — ie.

was a good man with good taste — but were to override his require-
ments if these went against the general good. The painter's respectability
and social importance, in other words, depended on his accepting the
moral responsibility that his increased status demanded.

If the new notion of artistic responsibility involved a shift in emphasis
from the patron to society as a whole, then this was matched by changes
in attitudes about the obligations of patrons and the purpose of their
actions. The patron-patronised relationship was one of the dominant and
ideal models of social interaction, its artistic face being only a small
aspect of a much broader phenomenon that characterised trade, religion
and politics. Governments and politicians rose and fell by their ability to
hand out patronage in an effective manner, giving out enough favours to
maintain support but not too many in case deprivation forced others to
turn hostile. In the doling out of parliamentary seats and bishoprics, the
awarding of contracts, farm tenancies, pensions and jobs, there was a bal-
ance of benefit in which both sides calmly counted the gains. In the arts as
well, Aglionby was more than willing to point out to those whom he was
attempting to goad into support that the benefit conferred was mutual:

> The Liberal Arts ... do so naturally depend upon the Countenance of
> Great Men, that without their Protection, they seldom take Root
> enough to defend themselves against Envy and Ignorance: Nor, on the
> other side does Greatness it self, though never so Luxuriant, sit Easie
> in its present Enjoyments, or live Kindly in the Memory of Posterity,
> without those Ornaments of its Power, the Arts and Sciences ... [89]

If patronage was a duty, it was also for advantage. Above all it was the
sign of true dignity to patronise correctly and not pervert a system readi-
ly acknowledged as being open to abuse. For many, the methods used by
Robert Walpole to stay at the head of the government for twenty years
were the ultimate in abuse and commentators were well aware of the
potential dangers patrons could create when unaffected by moral consid-
erations:

> From the nature of things it ever will be, it ever must be, that Religion
> and Learning will flourish in proportion to the Encouragement which
> is given to Learned and Good Men; not only because proper Rewards
> are necessary Motives to excite Mankind to acquire Merit, but
> because proper Stations are requisite for the exercise of their several
> Capacities ... Patronage is a Trust ... Patrons are obliged to dispose of
> their Preferments, with a regard to the great Ends for which they were
> intended and not at Liberty to serve private Views, to promote the
> Interest of a party, to gratify the Inclination or Humour of the
> Patron... [90]

If the issue of patronage and the arts generated such concern amongst the English at this period, therefore, it was because it was virtually impossible to separate the two. Patronage was one of the strongest links which joined art to the outside world and gave it relevance greater than it might otherwise have enjoyed. Its ability to act as an indicator of the health of the nation helped to advance the transformation which made painting far more important than, for example, furniture making or any other artisanal trade.

The question acquired even greater significance because of the increasingly strong links between painting and a sense of patriotism. Indeed, the convergence of the two became an important aspect of social legitimation. The actions of patrons formed part of a greater strategy which, it was thought, would enhance England's standing *vis-a-vis* its European neighbours and rivals.[91] On the simplest level this argument took the form of straight economics – the encouragement that patrons could give to artists would lead to an improvement of their products and would in turn result in a drop in imports. Such an assertion may seem to have been more than wishful thinking than serious economic analysis, but nevertheless the frequency with which the argument was put forward indicates that the suggestion was seen as both relevant and important. Richardson summed up the belief when he waxed lyrical over the potential contribution that an English school of painting could make to a healthy balance of payments:

> If our People were Improved in the Arts of Designing, not only our Paintings, Carvings and Prints, but the Works of all our other Artificers would also be proportionally Improved; and consequently coveted by Other Nations and their Price advanced, which therefore would be no small Improvement of our Trade, with that of our Wealth ... Instead of Importing vast Quantities of Pictures, and the like Curiosities for Ordinary use, we might fetch from Abroad only the Best and supply other Nations with better than now we commonly take off their Hands.[92]

The socially eminent were the natural focus for the calls for the hard cash and encouragement necessary to realise this goal. As Wills put it in the dedication of his book to the Duke of Cumberland: 'Sir, if the elegant, and not unuseful arts, do not find Favour with the Great, to whose particular Service and Pleasure they are devoted, where can they hope it? Or even seek a Shelter from the envious Insults of Brutality and Ignorance?'[93]

However, as with more general economic developments and with the actual means by which the painters obtained commissions and an income, vague glimmerings of change were beginning to appear in the

formalised fabric that made up the traditional notions of patronage. Many of the calls for an Academy implicitly suggested that this be in the form of a national institution, the implication being that patronage was, perhaps, becoming too important a matter to be left in the hands of the private individual. Matthew Decker, for example, dealt with the question in an expanded form which included all the arts of design and urged that public funds be made available to help the English compete with the French. Thus, the tenth proposal of his essay on trade insisted on the 'need to establish a drawing school at public expense and not suffer the French to be the only people of taste and invention ...'[94]

By the middle of the century, responsibility for the arts showed signs of going beyond the notion of purely individual support. Developing a point originally brought to English attention by Richardson (who was again borrowing from notions that stretched back to the ancient Greeks) the idea grew that the arts were very much a reflection of the worth of the nation's constitution. The maintenance of a good and just government — generally taken to mean that which already existed — was consequently the best, if only an indirect, way of supporting the arts. As Hurd put it, 'There is something, I have ever observed, congenial to the liberal arts in the reigning spirit of liberty'.

Such sentiments did, of course, cause some difficulties to those who espoused them in that they were then forced to explain why it was England had painting that was generally agreed to be so sadly lacking while Italian painters did so well on their diet of tyranny and priestcraft. The discrepancy was used to give an added twist to the call for extra efforts from patrons, whose lack of zeal was considered responsible for the arts failing to achieve an excellence matching that of the constitution. As Hurd continued: 'It must be our own fault if progress in every elegant pursuit does not keep pace with our excellent constitution ...' [95]

Despite the decidedly commercial pattern of buying that solidified in the first half of the eighteenth century, the perceived role and importance of patronage was not only maintained but even increased. Like the 'Man of Taste', the ideal patron was almost unknown. However, the term was never abandoned but rather transformed to assume different meanings. Its continued use enabled simple commercial transactions to take on greater significance. A buyer of a Chippendale sideboard was a customer but a buyer of a portrait by Reynolds was a patron. The usage gave to the purchaser some of the status hinted at above. It suggested he was a supporter of the arts, an encourager of the creative and an appreciator of the beautiful. Moreover, it gave to the transaction a national significance, placing it as part of the grand strategy of developing the arts to a more appropriate plane of perfection.

The techniques of large-scale and often anonymous support that developed inside the term 'patronage' mobilised a small portion of the

resources of thousands of people and channelled the combined sums to artists through academies, prizes and exhibitions. A large portion of patronage changed from being an individual affair — in which the occasional Maecenas shone out as a dazzling example of duty performed — to become a self-conscious class operation through which art became the possession of these groups and helped determine their identity as a unified social entity.

Through these means, they became the defenders of the national heritage and the carriers of the burden of improving the country's art production. Such a duty was taken on most clearly by the Society of Dilettanti, which set out to direct taste through antiquarian research and the nurturing of those artists it considered to be promising. As with individual patronage, such actions were seen as duties, and those who performed them with diligence were considered to be deserving of thanks. Although from the point of view of the painters the purpose of patronage should have been to encourage the arts and to support the painters for the social good, the perspective of others was somewhat different. Painters were concerned with the end result, but many of the authors on the subject who where not artists attached as much importance to the means. For them, one of the main and most important roles of the painter was to be patronised, to fulfil a role that would enable the great, the rich and the educated to demonstrate their concern for, and worth to, their country.

6

COLLECTORS AND COLLECTIONS

BY THE 1760s collecting was far from being only for the excessively rich
or the unusually educated. Instead a large number of people were pre-
pared to lay out significant proportions of their income in order to have
a few visual images on their walls. Before examining the collection,
therefore, it must be borne in mind that the definition of the term was a
wide one. It includes everything from that of Robert Walpole (1676-
1745, Plate 48), whose single picture by Guido Reni (Plate 49) was the
equivalent of the yearly wages of more than 500 labourers to more hum-
ble souls who would pay out a few pence for a print or maybe up to a
guinea for an old, battered copy of an oil painting.[1]

In between these two extremes there was an almost infinite range.
There were people of immense wealth and influence, like the 1st Duke
of Newcastle (1662-1711) or the Earl of Bristol (1665-1751),[2] who
bought a few paintings every now and then but with a casualness which
suggests all the enthusiasm of someone buying a shirt or a pair of shoes.
Then there were people like Roger Harenc, who busied themselves
forming their collection over a period of years or even decades, and oth-
ers, like Edmund Burke, who acquired it all in a lump, as an accidental
addition to the purchase of his house.[3] There were people whose paint-
ings were valued in the tens of thousands of pounds and those who had
only a small number worth perhaps a few shillings. Finally there were
those who, like the Duke of Rutland,[4] spent a fortune buying pictures but
then never bothered to take them out of their packing cases and others
who, like James West,[5] or more dramatically the 2nd Earl of Sunderland,[6]
spent a small fortune in putting them in uniform frames, had them
cleaned, repaired and then hung to best advantage.

The possession of paintings was far from being a novelty to the
English even before the great expansion of the art market at the end of
the seventeenth century. Throughout the course of the sixteenth century

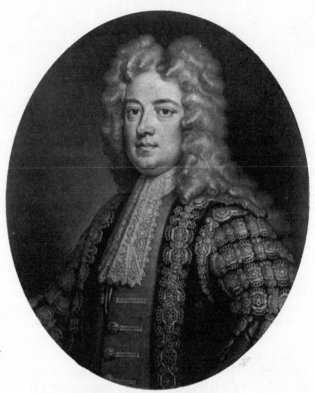

46. John Simon (1675-1751) after
Kneller: *Portrait of Robert
Walpole*, 1720's?

and certainly by the mid-1600s, the upper ranks of English society
bought an increasing number of paintings to hang in their houses.[7] In
general, however, the majority of these were portraits whose aim was to
act as a convoluted form of name-dropping, impressing the visitor with
the number and range of powerful friends and relations that the owner
knew.[8] Nonetheless, it is equally clear that other types of painting were
also present, with landscapes and hunting pieces, as well as more ambi-
tious historical works, beginning to make their appearance.

However, it is doubtful whether such assemblages can be termed 'col-
lections' in the eighteenth century sense. In its most literal meaning, of
course, a collection of pictures is simply that, ie., two pictures or more
owned by the same person or held in the same place. However, if such a
definition is adopted, the term becomes so broad as to be meaningless
and this is not how the word was understood by about 1750. The essence
of the collection as it emerged in this period was its transformation
from an agglomeration of individual objects, or individual pieces of fur-
niture hung on the walls, into a state where the parts made up a greater
whole, the collection itself taking on a character that was more than sim-
ply the number of pictures that made it up. By the eighteenth century the
collector was engaged in a form of self-expression which, even if it was

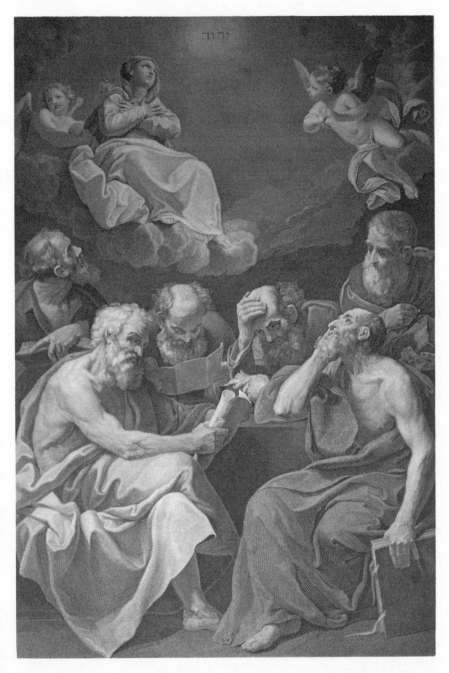

Guido Reni: *The Doctors of the Church*, engr. William Sharp (1749-1824) and published by Boydell.

constrained by the rules of taste, was nonetheless a form of creation through the process of selective acquisition. Such an aspect distinguished him from the seventeenth-century virtuoso who, in satire at least, was positively magpie-like in his desire to acquire virtually anything. Both shared the idea, however, that they were creating a 'repository' which had national overtones, and that their activities were at some level a contribution to the common good. The link in form is therefore between the eighteenth century collection of pictures and the virtuoso cabinet of curiosities, rather than with the court collections of Charles I, which do not appear to have been primarily motivated by such ideals.[9]

With the brief exception of court collecting under Charles I, the picture collection that conformed to external, continentally-influenced, standards of taste made little headway until the end of the seventeenth century. Difficulties of supply in the earlier period created artificial but nonetheless very apparent divisions based on access rather than money. Although some collections corresponded to theoretical orthodoxy, such as those of the 5th Earl of Exeter (1648-1700) who bought abroad, or Peter Lely who profited from the break-ups caused by the Civil War, these were exceedingly rare.[10] Far more in the Restoration period corresponded to the type epitomised by those of the 1st Duke of Beaufort and Thomas Povey (d. after 1665), where the simple unavailability of good foreign pieces is indicated by a much heavier concentration on copies, works by English artists, pieces by foreigners working in England, as well as by the very low number of history pieces.[11]

In the later seventeenth century the difficulties of acquiring foreign works were such that to have any at all was something of an achievement and besides this the question of choice was but a secondary matter. In the courtesy book *Country Conversations*, for example, the two visitors to the country house of the much-admired Eugenius duly praise his paintings but in order to give an idea of their merit, do not deem it necessary to go beyond the bald statements that the works were both expensive and foreign.[12] It was only when possession of foreign works required nothing more than a certain amount of ready cash, and a willingness to go along to the nearest auction room, that this situation could develop much further. Hence, as the eighteenth century progressed, there was an increased emphasis on the process of selection from a large range, rather than simply on possession. In practical terms, therefore, as far as painting is concerned satirical onslaughts on the Vulgar and Tasteless only became viable with the opening of the market and the refinement of perceptions that resulted. In other words, it was not until people had the option of choosing well that there was the possibility of castigating them for not having done so.

On the simplest level, collections of paintings were little more than another form of conspicuous consumption, a display of opulence which

gave visible indications of wealth and thus converted money into a social or political asset. In this fashion, the collection takes its place alongside a myriad of other displays which ranged from the building of large country houses through the keeping of horses to a willingness to lose a fortune playing cards. Such a simple explanation is, however, clearly insufficient. Conspicuous consumption had long been an essential element of the life of the wealthy so it is necessary to isolate the particular reasons why it took the forms it did when it did. Horses, for example, were not only an ostentatious consumption of excess wealth, but their possession also resonated with a love of sport and rural existence. Gambling also was a type of expenditure which gave expression to a particular attitude to life: the willingness to take unnecessary risks and to accept the consequences in a fashion which gave tangible evidence of the extreme self-control deemed an important possession of one claiming the right to dominate others. It seems reasonable to suppose, therefore, that the collection of paintings demonstrated more than simple wealth, that spending money on art was a cautious choice with a specific purpose behind it.

Using a collection of paintings to advance one's social status can be seen most obviously in the case of Thomas Wentworth, Earl of Strafford (1672-1734), for whom the relative unimportance of a love for art is apparent. The Wentworth family had more than its fair share of domestic upheaval in the eighteenth century as, although Wentworth inherited the baronetcy of his great-grandfather, Sir William Wentworth, his cousin, Thomas Watson, fell heir to the family fortune. From this there developed an acrimonious feud which, according to Girouard, involved both sides of the family in a battle for supremacy in their county of Yorkshire, as each indulged in an orgy of building to try to outdo the other in size and splendour.[13] Paintings had a small role in this contest. Watson, it appears, had a collection which Wentworth, then Lord Raby, was anxious to eclipse. The paintings he bought while abroad as a diplomat seem to have had a reception which he found pleasing: 'I have great credit by my pictures, and find I have not thrown my money away. They are all designed for Yorkshire, and I hope to have a better collection there than Mr Watson.'[14]

Expenditure of a financial surplus on pictures was not in itself a habit guaranteed to ensure the appropriate response from the audience. Collecting rapidly developed a set of rules which, although very vague, enabled many purchasers to be attacked with vitriol. Pope was able to make the assaults contained in 'The Use of Riches',[15] with others launching similar attacks in later pastiches, because they could hang their criticism on suggested breaches in the protocol of taste.[16]

However, neither in theory nor practice was there any assumption that the collector should also be a 'Man of Taste'. Merely because a wealthy

individual had no taste did not mean he should refrain from buying. Attitudes in this respect seem to have been more than a little contradictory. On the one hand, the collector-without-taste was the target of merciless satire:

> 'Tis strange the Miser should his Cares employ
> To gain those Riches he ne'er can enjoy
> It is less strange, the Prodigal should waste
> His Wealth to purchase what he ne'er can Taste
> Not for himself he sees or hears or eats,
> Artists must choose his Pictures, Music, Meats... [17]

In contrast, however, there was also a strain of thought which insisted that the responsible collector should employ artistic advisors and that to have doubts about one's ability to choose correctly was perfectly healthy. Beginning with the claim that it was necessary to know about pictures to avoid being swindled, Richardson extended the argument to advocate the use of such advisers, even though he admitted that such a situation was not ideal:

> There are two ways whereby a Gentleman may come to be perswaded of the Goodness of a Picture, or Drawing; He may neither have Leisure, or Inclination to become a *Connoisseur* Himself, and yet may delight in these things, and desire to have them; He has no way then but to take up his Opinions upon Trust, and Implicitly depend upon Another's Judgement ... And this may be the Wisest and Best Course he can take all things considered ... [18]

Writing some forty years later, the anonymous author TB continues the same theme and manages to give an additional edge to it by working it around his general thesis about the need to support artists. Reliance on experts would ensure that collections were appropriately tasteful and would also divert a bit of much needed money into the hands of painters whom, he asserts, are anyway the only people really capable of telling a good picture from a bad one:

> If different, or more important Studies have prevented our N-b-l-ty and Gentry from arriving at a sufficient degree of Skill to enable them to judge for themselves, it is not very obvious how the giving so high a Price for a bad Picture, and sometimes for a good one, can well be avoided. Yet I must think it extremely easy, for if our N-b-l-ty would ...retain an Artist in his Service, by Pension or otherwise, whose Judgement and Instructions they could always have recourse to, and which as it would do equal honour to the Patron and the Painter, I don't suppose any would be proud enough to refuse, all the Enormities here complained of would cease ...[19]

These two attitudes towards collecting were equally strong and clearly contradictory. On the one hand, there is the strain of thought which appears to suggest that the collection had to be individual; the accumulation of works should be a reification of the owner's taste, with the buyer personally responsible for any lapses and consequently gaining approbation should his preferences mesh with the continentally-derived orthodoxy laid down in works on art. On the other, there was the assumption that the collection was too important a matter to be subject to such whimsical notions as individual choice, that in a potential clash between good taste and personal preference the would-be collector should consult those in the know and, as a result, suppress his own desires for the sake of the greater good. The result was to create conditions for collecting which were very constraining: the truly respectable collector was the one who had internalised taste so that it became his own. People were encouraged to express their preferences by choosing, but only in so far as their choice reinforced an orthodoxy that already existed.

Conformity in choice was clearly a matter which was only important if the collection was seen by people other than the purchaser himself. The collection existed in an area that was highly ambiguous. It was both domestic and private, hidden from the public but also partially in the public domain by being bought at auctions and frequently hung in the semi-public reception rooms of the house so that all who entered could see it. As collecting became popular, so the perceptions of it evolved to take account of this public exposure.

From the middle seventeenth century onwards, the signs of this concern start to manifest themselves. At first, the more complex questions of choice and taste were passed over and attention was instead devoted to the more practical aspects of display. Blome, Sanderson and Elsum, for example, gave straightforward instructions as to the most appropriate rooms to hang different types of paintings.[20] This concern rapidly developed into a more complex form, as the potential of the collection for humiliating the purchaser increased. As Buckeridge, for example, pointed out while in the midst of praising the good taste and excellent example of Robert Child (d.1721), 'Numerous collections injudiciously made are the sport and contempt of the painter and a reflection on the owner'.[21]

However, there was no rigid structure to be followed and it was acceptable that a relatively wide variety of schools and of types of work should be present to indicate that the owner's preferences were not too narrow. There was, however, a growing strain of opinion in which the first subjugation of personality to the external pressure of art scholarship can be detected. In practical terms, the most coherent emulator of the carefully structured, art-historical approach to collecting was the Earl of Pembroke. With his collection of sculpture, he 'resolved not to run

48. R. Houston, after Allan
Ramsay: *Richard Mead.*

into all sorts of curiosities but to buy such as were illustrative of antient
history and antient literature' and decided to confine 'his choice to the
best ages'.[22] The author of *'A Letter on ...Curiosity'*, speaking of the ten-
dency to overvalue names, also mentions the aspirations of some
collectors to demonstrate their knowledge more than their aesthetic pref-
erences, making the collection into a coherent whole by turning it into
an illustration of the highlights of art history. This attitude was one
which ultimately justified the inclusion of works not because the owner
liked them or even because he or others considered them to be good, but
for the qualitatively very different reason that they were either interest-
ing or historically important:

> But now as to the particularity of Names, which some seem extreme-
> ly fond of, or are greatly affected with, so as often to mind the Name
> even more than the true Merit of the Performance. 'Tis true indeed,
> that such who pretend to make Collections, or Galleries of all the
> Particular Genius's or Masters, may indeed have more especial
> Regard to this; or otherwise, where they incline to observe the gradu-
> al Advancement or Progress of Painting in each Time ...[23]

49. William Hoare: *Portrait of Charles Wyndham, 2nd Earl of Egremont,* oil on canvas.

In the case of Richard Mead (Plate 48), whose assembly of pictures, busts and sculpture has been described as a text-book example of eighteenth-century taste,[24] there was a fairly typical balance between the major schools — with the Italian in the majority — as well as between portraits, views and history pieces. Only a few whimsicalities can be detected: the number of expensive landscapes was unusual, as was the relatively large number of costly portraits.[25] Much more

noticeable, perhaps, was his almost total lack of frivolity, as befitted a serious medical man concerned to impress his learning upon the world in general and his clients in particular. Mead's grand gallery in Great Ormond Street contained few genre paintings and showed an equal disdain for the favourite English wall covering of seascapes and animal pieces. In his choice of painters also, Mead was orthodox in the extreme, revealing the usual prediliction for the Roman and Bolognese Baroque schools and early seventeenth-century Dutch and Flemish painters. Only in his possession of paintings by Watteau, which came to him in unusual circumstances, did he show much in the way of innovation.[26]

The collection of the Earl of Egremont (1710-63, Plate 49) also followed the same pattern devotedly, despite the fact that their sources of supply were as different as their backgrounds, characters, education and professions. Whereas Mead rarely appears to have attended an auction, buying his works either while on tour abroad or through friends, Egremont made use of all the resources of the London art market to put together his collection of nearly 200 works. As with Mead, the emphasis was on the possession of original works, however doubtful their attribution. Again typically, seventeenth-century Italianate Dutch and Flemish paintings, seventeenth-century Bolognese and contemporaries of Maratti from Rome were what he sought especially.[27] Thus, his most expensive acquisition was a Maratti, the *Martyrdom of St Andrew*, for which he paid £273 at Robert Furnese's sale in 1758.[28] His next most expensive works were a *Landscape* by Paul Brill (Plate 50);[29] a Guercino *Supper at Emmaus*;[30] a Bassano of *Christ and the Money Changers*,[31] a Bourdon of *Joseph sold by his Brethren* (Plate 51);[32] a Teniers *Gallery* [33] (Plate 52) and, less typically, a painting of the *Parting of Laban and Jacob* by La Hyre.[34]

The evidence of the auction catalogues in general supports the picture presented by these two examples. The upper end of the market, that is the 545 pictures known to have fetched more than £40 at auction between 1711 and 1759, provides some basic indicators (see Appendix, Tables 1-5). The theoretical dominance of the Italians, advanced by every serious English writer on the subject from Sanderson onwards, was only gradually whittled away and that country remained the single most important source of high quality works. Equally, the preference for painters working in the first half of the seventeenth century remained extremely strong. The most popular painters changed little, although the number of artists generally who could attract a high price was rising steadily, with Flemish painters such as David Teniers and Paul Brill and the Spanish Murillo, increasing noticeably in esteem. The central core of reputation was nonetheless still the Italian Baroque — particularly artists like Guido Reni and Carlo Maratti — with the classicism of the Franco-Italians Claude, Gaspard and Nicholas Poussin matching this.[35] Other

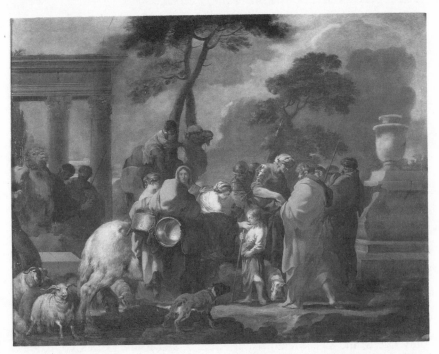

50. Paul Brill: Landscape: bought by the 2nd Earl of Egremont from Dr Bragge in 1754 for £126, oil on canvas.
51. Sébastian Bourdon: *Joseph sold by his Brethren*, bought by the 2nd Earl of Egremont from Dr Bragge, 1755, for £99.15s, oil on canvas.

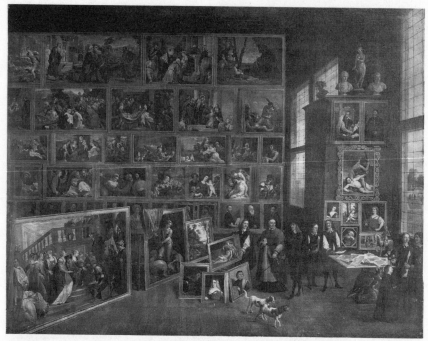

52. David Teniers: *The Archduke Leopold's Gallery*. Almost certainly the picture bought at the de Pester's sale in 1756 for £41.10s, oil on canvas.

than these three, French painters were in a decided minority with only Bourdon and LeBrun apparently being particularly popular. Paintings from the 'High Renaissance' period were still in a small minority and those from the fifteenth century rarer still. The maximum price paid at auction in this period was, however, for a work attributed to Raphael, a *Holy Family*, for which the Duchess of Portland offered £703.10s. at Sir Luke Schaub's sale in 1758.[36]

The popularity, high prices and even esteem earned by Dutch and Flemish painters such as Rembrandt, Poelenburg, Vanderwerff, Teniers and Wouverman caused one of the very few ripples to disturb the surface of placid conformity in early and mid-eighteenth century views of aesthetic propriety.[37] That Dutch paintings of genre scenes could command the same degree of interest that was normally reserved only for the history paintings of Italy was viewed by some to be an outrageous infringement of the canons of good taste which not only indicated the fundamental triviality of English preferences but also undermined the delicate theoretical structure that conferred value on the visual arts as a whole. Horace Walpole, for example, remarked acidly in the 1740s: 'As for the Dutch painters, those drudging mimics of nature's most uncomely coarseness, don't their earthen pots and brass kettles carry away prices only due to the sweet neatness of Albano, and to the attractive delicacy of Carlo Maratti ... '.[38]

Even such criticism, however, was not enough for others, and the possession by both Walpoles, father and son, of a considerable number of Dutch works drew sneering comments from James Barry: 'As to the Dutch taste, I shall leave it to the deep researches of the Hon. Horace Walpole, or to any other learned Gentleman (if such another can be found) who may happen to have a gusto for this kind of art'.[39]

If increased availability cancelled one of the main rifts dividing types of collectors in England, new financial distinctions increasingly pulled the parts of the market apart. The upper end had all the factors required for rapid inflation which were lacking elsewhere: the knowledge of events provided by an *ad hoc* system of correspondence between the dealers, connoisseurs, sellers and collectors meant that the appearance of a major work for sale would be known to all interested parties in a very short period. In addition, there was much greater knowledge of what to look for; the orthodoxy of what constituted the 'great' works of art was laid down in the ever growing number of guide books, so that many of the paintings likely to attract the interest of the great collectors were known about well in advance.

Equally, there were more than adequate financial resources available to generate competition. The increasing significance of the art collection as a source of national prestige meant that competition for certain works of art was likely to be a battle between many of the richest and most powerful in Europe, that is not simply the Crozats, Walpoles and Chandos' but also the House of Hapsburg, the Empress of Russia and the kings of Prussia, Sweden and Denmark, all with virtually infinite resources and a distinct willingness to buy.[40] As a result, prices at the upper range accelerated and reached dizzying heights by the end of the century. This battle for prestige increasingly made the great works less available for the ordinary citizen. It was insufficient to be rich, it was necessary to be gigantically so, with, if possible, a considerable amount of political influence as well. Eventually such pinnacles passed beyond the competitive and financial ability of even the vastly wealthy and the battle for possession passed to institutions with all the backing of the state.

There had always been a recognition that the process of selection differentiated the great from the more modest but, until the beginning of the eighteenth century, the emphasis had been much more on the question of appropriateness. Elsum in 1703, for example, stated that 'Other sorts of subjects are required in a Palace or Publick Edifice, than in a Private Home', and the idea that the collector should regulate his choice according to his station was a fairly common one.[41] The establishment of a much greater unity of taste in the eighteenth century, however, slowly replaced this implicitly hierarchical argument with a more mundane one based on money. In the 1720s the Frenchman Dezallier D'Argenville

identified two brackets of painting, one for Princes and one for the rest, but made it clear that the cause of the division was cost, not content: 'c'est aux facultez du curieux et à des hasards très-rares que l'on doit la decouverte des bons tableaux, dont le nombre monte à de si grandes sommes, qu'il n'y a que les Princes ou des gens d'une très grosse fortune ne qui y puissent aspirer ... '42*

This observation was repeated by many others throughout Europe, most forcibly by Joullain in the 1780s.43 As financial resources became the main determinant of the contents of a collection, the aspiring collector of taste was left in an unfortunate position. There being no logical connection between taste and money, he found himself nevertheless cut off from the possession of the greatest works of art by inadequate wealth.

The most notable development stimulated by this situation was perhaps the growth of print collecting as a substitute, accompanied by an equal increase of interest in drawings. This trend drew strength from shifting conceptions of where the value of a picture lay. The supremacy of composition as the focus of the merit of a work of art meant that, although not everybody could demonstrate their wealth through a collection, then at least it was still possible for a large number of people to give concrete evidence of their taste. The history of such types of collection is somewhat obscure; certainly it was quite common for artists to possess considerable numbers of drawings in order to provide them with inspiration and practice, and the English interest in prints appears first to have taken off in the period immediately after the Restoration. The majority of prints in this period, however, seem to have been very down to earth and unsophisticated. Either they were political and often very crude, or they were straightforward representations of notable figures, the overwhelming majority probably being images of the more memorable English kings, archbishops and soldiers.44

The collection of prints and drawings for their own sake seems to have begun in England much later. Early enthusiasts included Peter Lely and John Talman, while another was John, Lord Somers, who through Talman paid £600 for the collection amassed in Italy by Padre Resta. Another early eighteenth century collector was the 2nd Duke of Devonshire (1673-1729), who put together one of the largest and most substantial selections of drawings of the period. In general, however, such interests received little attention until the second part of the century. William Graves, for example, made very clear the connection between the increased interest in prints and the ever-rising price of

* 'It is through the abilities of the curious and very rare chance to which one owes the discovery of good paintings, whose prices amount to such great sums that it is only princes or people of a very large fortune who can aspire to them...'

paintings, and in doing so underlines the clear distinction in his mind between possession of money and possession of aesthetic judgement:

> When I reflect on the Usefulness of this Art [ie. engraving] I am surprised to find so few Gentlemen professed Admirers of it. It requires a large Fortune to make a fine Collection of Paintings, and Great Judgement to avoid Imposition, and understand their Beauties; but Prints are adapted to all Ages, all Ranks of Men & all Fortunes; They cost much less than Paintings, the Knowledge of them is more easily attained, and as they comprehend all sorts of Subjects, they are equally as useful and entertaining ... they give us an Idea and, as it were, the possession of an infinite number of Pictures, which it would require an immense Sum to purchase ... [45]

Horace Walpole also ironically chronicles the steady growth of interest in such things, ultimately complaining that the large number of people now collecting had so put up prices that he was no longer able to afford them himself. In 1770, for example, he grumbled to Horace Mann:

> Another rage is for prints of English portraits: I have been collecting them above 30 years, and originally never gave for a mezzotinto above one or two shillings. The lowest are now a crown, most from half a guinea to a guinea. Lately I assisted a clergyman in compiling a catalogue of them; since the publication scarce heads in books, not worth threepence, will sell for five guineas ... [46]

The collection attained such importance primarily because it rested on conceptions which elevated its nature into a matter of national importance. Overshadowing the simple and individualist argument that collecting was a subtle and complicated version of conspicuous consumption, there was the theory which gave the accumulation of paintings a role in maintaining the political, economic and moral health of the entire country, and it was this latter accretion of meaning which triggered criticism of bad taste. The earlier and less complex view was summed up by Sanderson in the mid-seventeenth century. For him the purpose behind collecting works of art is scarcely a profound one, but simply a combination of fame and ostentation: 'The Great *Oeconomistes* of all ages ... have indevoured to magnifie their own Memories, with Princely *Pallaces of structure*, and after to adorn them distinct and gracefully, with *Pictures* within and *Sculpture* without'.[47]

It has already been shown how there was pressure to view Art as an important moral and financial stimulant to the country. It was, of necessity, the private collection which housed these objects of emulation, as there was no other conceivable area where they might be amassed. For

those who took the view that England's trade, moral health and honour
were at stake, the collection was far too important to be left merely to
the individual whimsicality of any collector who might have enough
money to buy, as he was not purchasing merely for himself but for the
good of the nation as a whole. Equally, outright mercantilism was
invoked to prove that the collector had no right to buy merely what took
his fancy, as by not living up to his responsibilities he could incur a
grievous loss of national treasure:

> If we consider the great Number of foreign Statues, Paintings and
> Prints, that are brought into this Kingdom, the prodigious Price that is
> given for some, and the more than equitable Price that is given for
> all; Must not the Consideration suggest to us, that there is a very great
> Balance against us in Trade? ... Sometimes ... the Ignorance of the
> Purchaser, or the confident Knavery of the Seller, imposes on us a
> Copy of little Value ... I say *on us;* for so, in this Light of viewing the
> Matter, we ought to esteem it; because, whatever is paid for one of
> these extravagant Articles of Luxury, more than it will again sell for at
> a foreign Market, is so much Loss to the common national Stock ... [48]

This argument was not, however, purely abstract and economic but
tied in very closely with English pride and, conversely, distaste for the
French. The fact that England's habitual enemy was generally recog-
nised as being superior in the arts was ruthlessly exploited as a means of
increasing interest in the arts and patronage. This close linkage was
made by Richardson, who immediately proceeded from his statement
about the balance of payments to sly references to 'the National Vanity
of Some of our Neighbours'.[49] He was, however, far from the first to use
this national weakness to advantage. Aglionby also deployed it while
Buckeridge, at the height of the wars against Louis XIV, drew constant
parallels between English and French attitudes to the arts. In the dedica-
tion of the *Art of Painting* he also compares the good taste of the banker,
Robert Child, with that of most of his often better-born compatriots:

> By the nicety of your choice [of pictures] the World admires that of
> your gout and are surprised to see so many rare things together in a
> country where painting, and the polite arts are not so much encour-
> aged as in those places, where, perhaps, the nobility and gentry are
> not so well qualified to judge of merit nor so well able to reward it as
> in England.[50]

In the same way that the economic arguments for painting in this peri-
od became established as an important part of its overall image, so too
the patriotic element lodged as a standard eighteenth century English
response to the subject of collecting. Such a development was not,

however, confined to painting alone but was part of a much more general development of national self-consciousness in everything from the arts to a vision of English character and government. The same strategy was used, for example, by Colen Campbell when attempting to popularise Palladianism through his emphasis on Inigo Jones and his 'British Pencil' in *Vitruvius Britannicus*.[51]

This view elevated the status of the collector as a guardian of the nation's health, someone who not only did no harm by spending money and demonstrating his wealth and personal attainments, but in fact had a beneficial effect on all around him. This conception of the collection, therefore, was an aspect of the eighteenth century obsession with the question of luxury. On the one hand people like Bernard Mandeville[52] maintained that grossly extravagant consumption was morally destructive but economically desirable, in that it stimulated demand and hence was good for trade; while on the other, those like Samuel Fawconer dismissed the utilitarian argument out of hand and concentrated solely on the potentially disastrous effects of England's increasing wealth and hence expanding spending power.[53]

All writers on luxury, however, agreed that the surplus money in the hands of the wealthy was going to be spent on something. The problem, for those who worried about such things, was to find methods of absorbing the excess in ways which would satisfy the desire for opulence without wreaking havoc on the social structure. Of the innumerable solutions, painting was one which was invariably looked on with some approval. The relation of collecting to luxury, in fact, provides a parallel to the problem mentioned before which related the interest in painting to an excess of spare time. The virtue of collecting was that it not only prevented the rich from sinking into depravity by giving them examples of nobility to emulate and by using up their money harmlessly, but it also increased the national stock of works of art and hence brought about an absolute positive good as well:

> What are then the Uses we can reasonably make of riches (if not in Charities or publick Benefits..) unless it be, I say, to attain thereby, acquire or purchase such curious things, as not only may give us Pleasure in the Admiration, but at the same time also to improve our Knowledge; since our Superfluous wealth must either be thus laid out in such reasonable way *[sic]* or otherwise in the foresaid vicious, extravagant or unwarrantable ways ... [54]

However, if collections were to have the desired effect of not merely keeping the individual owner out of trouble but also of improving trade, stimulating painters and reforming the lower orders, then they had to be seen. The difficulties of gaining access to collections once they had

53. Robert Adam (1728-1792): *Designs for the Parlour at Headfort House, c.* 1771-5,
Compare the precise method of hanging with illustration 41,

been formed led to a concerted campaign throughout the first half of
the eighteenth century to persuade owners to make their possessions
more public and hence more useful. The question of visibility is howev-
er a complicated one. To a certain extent, English collections of painting
had always been visible and indeed would have had no purpose beyond
the much derided obsessions of the virtuoso if they had not been so.
Even in their simplest manifestation as demonstrations of wealth, they
could function only if their existence was known and frequently proven.
In general, however, gaining access to collections of works of art, or
even knowing where precisely they were, was clearly a very difficult
business. Buckeridge, for example, gives early testimony to this prob-
lem, and in the course of his fulsome praise for Robert Child he states:

> I have heard a famous Painter assert that our English Nobility and
> Gentry may boast of as many good Pictures, of the best Italian
> Masters, as Rome itself, and yet 'tis so difficult to have access to any
> of these Collections, unless it be yours Sir ... they are in great
> Measure, useless, like Gold in Misers' Coffers ... 55

Even towards the middle of the century this theme reoccurs with con-
siderable frequency and there is still an underlying assumption of
perverseness on the part of people who kept their collections to themselves.

54. Robert Adam (1728-1792): *Designs for the Parlour at Headfort House*, c.1771-5
Compare the precise method of hanging with illustration 41.

George Turnbull, for example, writing on the subject in 1740, states that: 'Nothing can be more Absurd than to keep such Incentives to noble Emulation out of Sight. It is disappointing the very End and Scope of them.'[56] Such an opinion stems directly from the author's belief that 'ingenious, useful and ornamental arts, aggrandise a state'. His argument is thus a strictly functional one based on the assumption that the prime purpose of paintings, and hence of possessing them, lies in the power they have when made visible: possession consequently carries an implied obligation to let the paintings exert the beneficial effects inherent in their nature. The glory of the collector, therefore, lay not simply in the display of the taste which went into putting the collection together, it was also in the public service contained in making it visible. Buckeridge, by drawing his parallel with a miser's hoards also implies a distinction between correct and incorrect possession.[57] As Speck points out, much of the acid of Pope's criticisms of Timon stem from the fact that he indulges in extravagances that are not tempered by public service; his 'private vices' are not redeemed by a corresponding 'public virtue'.[58]

For others, however, simply opening up the collection was insufficient and the collector had an obligation also to act as a repository of knowledge, guiding the public to an appropriate appreciation. This attitude seems first to appear in the 1730s in the *Letter...on Curiosity:*

... why, I say, should [owners] not be persuaded to publish Prints of their fine Pictures, or other things? this being both amusing and reputable, as well as instructive (often also profitable) to the Proprieter, and beneficial to the Publick; so why should not such also be induc'd ... to give, or have given the World, at least Catalogues of their valuable Collections ... [59]

If the audience failed to react to the works as they should then the whole public function of the collection was lost. Behind this lay the increasingly strong view that the visual image on its own was inadequate, that it needed to be interpreted by experts in order to function. This surrounding of the image by language implicitly negated its supposed value as a type of communication capable of contacts that words could not manage. The idea that painting without words was incomplete was summed up best by Thomas Martyn in 1766:

It is well known at how few Houses into which, by the indulgence of their illustrious Owners, the Curious are admitted, any Catalogues of the Paintings ... can be obtained, and it must be confessed little use can be made, by the yet uninformed Observer of these valuable Collections, besides that general one of pleasing the Eye and the Imagination ...

Bit by bit, the owners responded, with Martyn's work — culled from a variety of sources and complete with descriptions — being only the most comprehensive of the guidebooks.[60]

Before any more general conclusions are drawn, it is necessary to examine the degree to which the collection was hidden from public view. In many cases it is clear that entry was a haphazard business strongly dependent on good fortune and personal contacts. The collection of Charles I was partially open to the public but Charles was the last monarch who existed in an almost medieval blaze of availability, eating, sleeping and ultimately even dying in public. His son was cast in a very different mould. There were the official levées and public receptions but these were formally marked off occasions of exposure, set in strong contrast to long periods of privacy.

The royal collection of pictures after 1660 can be contrasted with Charles I's in the same way. Certain elements, such as the Raphael cartoons, were open and visible to some people, though most of the collection clearly was not. Vertue indirectly testifies to this when he recounts the anecdote of Jervas' great good fortune in happening to know Norton, the royal picture cleaner, who allowed him the immense and clearly unusual privilege of copying certain works.[61] Similarly, the stir made when the Duke of Richmond opened his gallery in London to

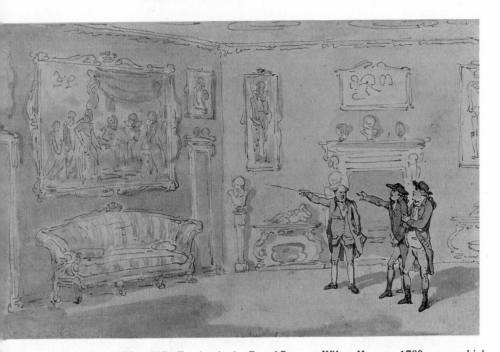

. Thomas Rowlandson (1756-1827): *Tourists in the Grand Room at Wilton House*, c.1780s, pen and ink.

painters who could then come and use his collection for copying was such that it was evidently a highly unusual — and consequently much admired— event. [62]

Seeing paintings, let alone copying them, was clearly not always easy. Undoubtedly men like the Earl of Oxford or Horace Walpole had few problems getting into people's houses, but their exalted social positions gave them a very valuable passport.[63] Others had more trouble. In order to get into Montagu House in the late seventeenth-century, for example, Thomas Povey had to pursuade one Scawen to intercede with a lengthy exchange of letters before permission was granted.[64] Even later, when it was more generally accepted that the collection should be readily accessible and when a sizeable country house tourist trade had begun,[65] there were still substantial difficulties. For a start, it was the custom to charge an admission fee. Secondly, when the collection was in the countryside the expense and difficulties of transportation frequently dissuaded visitors. Thirdly, there was the great bane of the English, the domestic servant, who could prove thoroughly obstructive if not tipped generously and even then often took any pleasure out of the visit, as the unfortunate Vanloo discovered when visiting England.[66] In 1781, Viscount Torrington recorded: 'We dined at the Bear Inn at Woodstock, and were wise enough not to dissipate the small remains of our purse in

the purchase of steel and leathern wares ... because the expense of see-
ing Blenheim is very great. The servants of the poor D- of M- being very
attentive in gleaning money from rich travellers ... '[67] Finally there was
no guarantee that admission would be granted at all:

> In a few miles came to Wroxton, where Ld Guildford has an old seat
> and I prevailed upon my party to drive down to it: when unluckily for
> us Lord G was just arrived from London, and denied us admittance.
> Very rude this, and very unlike an old courtly Lord. Let him either
> forbid his place entirely; open it allways; or else fix a day of admis-
> sion; but, for shame, don't refuse travellers who may have come 20
> miles out of their way ... [68]

Even if the sheer expense and inconvenience of seeing collections
was insufficient there were other ways of making sure that, despite
painting's reputation for being able to convert and reform the vulgar,
such people were never given the opportunity of testing the assertion. In
a similar manner to the attempt of the exhibitions in London to exclude
the lower orders, those considered disreputable were kept out or at best
promptly dispatched to the servants' quarters. As late as 1806, the Earl
of Stafford firmly stated that his works would be open only to 'persons
of the first rank, to first rate connoisseurs and first rate artists'.[69]

Although many owners scarcely went out of their way to encourage
visitors, many still wanted their works to be known. Certainly until the
second half of the century, most of the best collections tended to be
where the audience was, in London itself. Robert Walpole's collection,
for example, is a good instance of the dominance of the capital in this
respect, as it was only after his fall from power in 1742 that Houghton
took on its final overwhelming character which is apparent from Horace
Walpole's catalogue. Until then much of the cream of his paintings, that
is the works ultimately hung in the Gallery, were in the London resi-
dence.[70] In the same way, the Methuen collection was kept in London
and only moved to Corsham Court in the 1770s.[71] Even when a
substantial number of pictures were sited in the country residence, in
many cases the emphasis clearly rested with the London house. Thus
Thomas Martyn could say of Chatsworth in 1766 that it had 'very little
in it which can attract the eye of the connoisseur ... the pictures in it are
few and indifferent' whereas he could enthuse about Devonshire House
in Piccadilly: 'The collection of pictures with which this house is
adorned, is surpassed by very few either at home or abroad'.[72] Similarly
the bulk and the best of the pictures in James West's collection were kept
in his house in Covent Garden rather than at Alscot Park in
Warwickshire.[73]

In Walpole's note of 1757 he gives a location for thirty-one of the

forty-six English collections he lists. Of these eighteen were in London, others — such as those of Orford, West and Guise — had only relatively recently moved out of the capital and still more — such as Sampson Gideon's in Kent[74] and Sir Gregory Page's in Blackheath[75] — were close by. Only Sir Andrew Fountaine's at Narford, the Earl of Exeter's at Burleigh, and the Earl of Pembroke's at Wilton could claim to be long-established country house-based collections.[76] Walpole's note is also a good illustration of the point made earlier about the the role of art as a cultural unifier and identifier in this period. The catalogue is drawn up in no particular order and runs from the pinnacles of society right down to what by any stretch of the imagination fell into the category of 'servile trades'. The category of collecting, therefore, brought together as almost equal parts of the same group the King and Prince of Wales, the high aristocracy such as Marlborough, Pembroke and Devonshire, soldiers such as Guise,[77] antiquarians like Ducarel,[78] doctors like Chauncey [79] and Mead, gentry such as Fountaine and West, state employees like Schaub right through to people like 'Mr Ward, the Chymist, at Whitehall'.[80]

The collection is now such a cultural commonplace that it is easy to underestimate the speed of its development and the novelty of its nature in the period. Its emergence in its new form heralded a much greater change in the way art was perceived. The medieval site for works of art was above all the church, that is in a public place, freely accessible to all who came and worshipped. Moreover, the work of art was incidental, an accessory illustration designed to increase enthusiasm for something generated elsewhere. The desecration of churches, and particularly the distaste for images, largely removed all forms of paintings from their original public exposure and placed them behind locked doors. This practical privatisation of art was accompanied by the re-evaluation of painting along the lines laid down during the Italian Renaissance, so that the purpose of a picture became less its value as a religious aid and more an intellectual end in itself. The picture increasingly took on many of the aspects of being an intellectual fetish: from having a function as an illustration of, or commentary on, religious devotion and worship (although this might also demonstrate the generosity of the person who provided it), the picture itself became the object of commentary and discussion.

Such a mixture gave a unique flavour to the collection in its eighteenth century form. The retreat into the realm of the private owner emphasised the fact that seeing it was a privilege to be given or withheld at the owner's discretion. The exhibition was another form of this same tendency. As has been said, the exhibition was in many ways a market place but,

although the aim was to publicise and sell, the public nevertheless had to pay for the right to enter and view, with the ability to deny entry being held very firmly by the organisers. The mere act of looking — and by implication gathering the benefits that art offered to the viewer — was a privilege controlled by others.

This approach was not, of course, confined to the arts. As has been mentioned with regard to the commercial position of painters, much of the shape and nature of the art world was conditioned by the emergence of the house as a domestic arena cut off from the outside world. The exclusion of all but servants, and indeed the partial exclusion even of them, the decline of the old medieval standards of the extended 'family' stretching from the head of the house down to the peasants, as well as the impact of rapid commercial change in the towns and cities, inserted horizontal divisions into the social structure far more evident and striking than any that had previously been discernible. As the classes became increasingly separate — and indeed began to form — so the upper ranks took art with them, redefining it as private and intellectual as they did so. As a result, not only was commissioning and possessing works of art a symbol of the élite but the very knowledge of their existence became so as well.

The conversion of painting from public decoration to private possession created for the owner a new role as guardian of art, both in the sense of a custodian who regulated access, denying it when he saw fit, and equally in the sense of a trustee who kept works in good order. Possession, in other words, was elevated into a cultural event in a way previously impossible. No longer a static fact, it became a continual activity which preserved art from day to day for the sake of the future and for the glory of the nation. The eighteenth century collection was a triumphant act of enclosure, with the owner mediating, in the same way as did the patron, between the work and the viewer and determining the way art was seen. By surrounding art in secrecy, the symbolism of the painting and hence of the collection was able to grow. The collection was not only a visible symbol of wealth and social hierarchy, it was also one of its justifications, metamorphosing wealth into the discharge of a duty and an altruistic act.

7

THE CONNOISSEUR AND CONNOISSEURSHIP

THE POSSESSION OF expensive objects, no matter what they are, has always been used as a way of achieving distinction. Paintings, however, were distinguished from the usual brand of such symbols because the status they conferred eventually became dissociated from possession. The idea of where the true value of painting lay underwent a long period of change, with the initial identification of interest with an ability or wish to paint slowly breaking down. This chapter will therefore examine the separation of the two aspects of concern and look at how knowledge about painting came to dominate the literature on art in the eighteenth century. It will also examine the growth of an idealised notion of 'connoisseurship' and indicate the particular character it adopted under English conditions.

To understand the changes that had taken place by the mid-eighteenth century, it is only necessary briefly to examine descriptions of painting in earlier periods. In the literature of the sixteenth century that is typified by Elyot, knowledge of art was above all defined by an ability to paint and draw, so that the possessor could better serve as a military leader, the designer of forts or whatever was required of him. Painting and designing, he says:

> serued them [ie. Roman emperors] afterwarde for deuysinge of eng-
> ynes for warre; or for making them better that be all redy deuysed
> ... Also by the feate of portraiture or payntynge, a captaine may descriue
> the countary of his aduersary, wherby he shall eschue the daungerous
> passages wyth his hoste or nauie ...[1]

Such an ability was required only by a small fragment of society and, as the upper ranks of English society became progressively demilitarised

and as there was more scope for having professional draughtsmen and designers to attend to the nuts and bolts of military design, even these arguments lost their relevance. The increasing specialisation which accompanied the growth of a more complex society and economy effectively killed off the rationale for the aristocratic 'universal man'. The nobleman increasingly dissociated himself from military practicalities in the same way that architects came to concentrate on design and leave the business of building to others.

The emergence of the seventeenth-century virtuoso contributed greatly to the idea of connoisseurship in the next century. The virtuoso was also supposed to know something about the practicalities of the arts of design. As Evelyn put it, the ability meant that 'such as are addicted to the more noble mathematical sciences, may draw and engrave their schemes with delight and assurance'.[2] At the same time, however, the purpose of the virtuoso was not simply to edify himself but rather to collect information that could further the general knowledge of mankind. Emerging out of the scientific movement, the virtuoso was an empiricist whose collections of sea-shells, freakish monstrosities and so on were to be studied so that the information gleaned from them could be passed on. If the virtuosos came to attract ridicule and abuse, it was largely because they failed in this aspect of their calling, and came, at least by repute, to place undue stress on knowledge for its own sake.[3]

From the Renaissance and seventeenth-century view of painting as a useful skill for the gentleman, the emphasis slowly switched to the view that its prime importance was to mould the mind by giving pleasure. The practice of painting itself, therefore, came very much to take second place as only an agreeable diversion that could keep the aristocracy out of mischief. As a result, it lodged as a small weapon in the arsenal of social campaigners wishing to convert the upper reaches of society to a more suitable way of life.

In fact, there is little sign that even this relatively limited role was played with much success. Although some recreational manuals, such as Blome's *Gentleman's Recreation*, give space to the practice of painting, these were exceptional. Virtually all such books give far more time to traditional pursuits than they ever do to painting and often even fail to mention the topic at all. Indeed, the evidence suggests that the aristocracy remained loyal throughout the eighteenth century to the old faithful time-fillers like hunting, riding or gaming.

Nor did painting ever succeed in establishing itself as a part of the orthodox curriculum of education for the young gentleman. Smith, writing in the 1690s, remarks that painting was disapproved of because of its sedentary nature, an objection which seems to have hardened into orthodoxy.[4] The educational manuals produced to aid the parents of young gentlemen (or would-be gentlemen) all come up

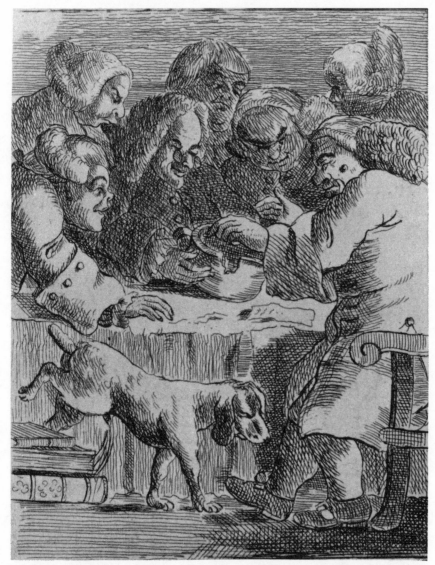

56. Anon: *Antiquarians* c.1770. The dangers of unbalanced knowledge and excessive devotion to one interest. The virtuosi gather round an old, cracked chamber pot and are so fascinated they fail to notice the dog urinating on the books, or true learning.

with a bewildering variety of possible subjects but the inclusion of painting is rare even as an optional extra. In 1732, the educational writer Costeker, for example, followed the traditional pattern of dividing his educational schema into two parts, the 'sound basis' and the 'polite accomplishments'. The former category consisted of such matters as

writing, the languages, arithmetic, philosophy, theology, and in neither his work nor in all the educational literature of the period is there even a suggestion that painting might be included under this heading. His second section is more whimsical, ranging as it does from geometry, geography and history on the one hand to optics, architecture and fencing on the other. Painting, however, totally failed to make the grade in this section either.[5]

One of the most influential works on polite education in the eighteenth century was John Locke's treatise. Although more sympathetic to painting, he also ignores all claims made by the more ardent apologists. In his layout of the ideal education painting is regarded very much as an instructive pastime, which amuses and at the same time teaches a mildly useful skill. As such, it ranks no higher that 'turning, gardening, tempering and working in iron' — that is amongst skills clearly identifiable as artisanal. While Locke was perhaps unusual in that he recommended that gentleman acquire some form of mechanical skills, he refrained from going so far as to challenge seriously the traditional division between the mechanical and liberal arts. Even so, he then proceeds to reduce the importance of painting still further. Having second thoughts about his recommendation, he dismisses it as a potentially useful recreation for children for two reasons:

> First ill Painting is one of the worst things in the world, and to attain a tollerable degree of Skill in it, requires too much of a Man's time. If he has a natural Inclination in it, 'twill endanger the Neglect of other more useful Studies to give way to that, and if he have no Inclination to it, all the Time, Pains and Money which shall be employed in it will be thrown away to no Purpose. Another Reason why I am not for Painting in a Gentleman is, because it is a sedentary Recreation, which more employs the Mind than the Body. A Gentleman's more serious Employment I look on to be Study, and when that demands Relaxation and Refreshment, it should be in some Exercise of the Body ...

He concludes by deciding that, by and large, gardening or carpentry are much to be preferred.[6]

Locke's attitude thus undermines one of the major arguments of painting's supporters by denying it the significance accorded to such pursuits as writing. Its value lies in the fact that it is a manual craft and consequently he adheres to the older view of its nature: the essence of his disapproval is that it is not manual enough to serve his purposes. There is a tension in this attitude which is highly illustrative of a much more general approach to the topic. It is clear from his discussion that Locke values the end-product highly but is dubious of the process

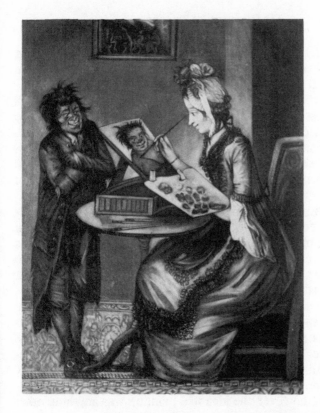

57. William Humphrey (1740-1840): *The Paintress: 'The Proper Study of Mankind is Man'*, 1772.

required to make it. It is not painting but pictures which are to be admired and as a result he implicitly suggests that the task be left to the professionals, who can do it best. The role of the gentleman is instead to have the necessary intellectual equipment and training to appreciate the product. It is also in this business of viewing that the more valuable intellectual achievement lies.

This somewhat unenthusiastic approach seems to have been reflected in reality. Several decades after Locke put forth his opinions George Turnbull could still lament that 'the Fine Arts have never had any place in Liberal Education amongst us'.[7] There are, of course, numerous instances of individual members of society's upper ranks becoming adept and even enthusiastic about painting and drawing, but there is no evidence whatever that this was ever anything more than a minority habit. Moreover, there is the occasional suggestion that even those people who did paint were mindful of the possibility that what they were doing might not be good for them: 'Did I tell you I have taken again to my pencil? ... Lady Dysart performs miracles for the time she has learned; I have but one objection to that form of employment, which is, the sedentary life it may lead me into; and that it is not healthful to be sure.'[8]

Consequently, few examples can be found of painters being employed as personal tutors to the sons of the wealthy. When visual records were required, for example on the grand tour, it appears a painter was frequently taken along as much as a sort of human camera than as a tutor for the tourist to learn the necessary skills himself.[9] The basic attitude to the practice of painting in fact seems to have been represented in extreme form by Locke's pupil, the 3rd Earl of Shaftesbury, who, knowledgeable as he was about all forms of art, hired an artist to work under his instruction when he wanted to try out his ideas on composition.[10]

If the art of painting failed to live up to the aspirations of its supporters by becoming a central part of male aristocratic education, then at least it did manage to establish a bridgehead in the upper ranks. This achievement, however, serves more to emphasise painting's failure to become accepted as a matter of consequence, as on the whole amateur painting developed as a female preserve.

Following the Renaissance courtly model, not only did people like Salmon and Sanderson advocate painting as an occupation, but educational works such as that by William Higford suggested the legitimacy, if not the importance, of the practice of painting.[11] In the eighteenth century this echo of earlier conventions dies out for men and is replaced by an emphasis on appreciation. For women, however, it becomes much more evident. Again, however, the idea that painting was anything other than a harmless and practically useless pastime does not appear.

The end of the seventeenth century saw a small but vehement outburst of genteel feminist sentiment which concentrated its attention on education and the need for women to be more adequately instructed. Not only did the leading figure in this movement of the 1690s, Mary Astell, not see painting as educational, she categorised it as one of the mindless occupations which kept women from real learning:

> [Men] have endeavoured to train us up altogether to Ease and Ignorance ... about the Age of six or seven (the sexes) begin to be separated, and the boys are sent to the Grammar School and the Girls to Boarding Schools, and other Places, to learn Needlework, Dancing Singing, Music, Drawing, Painting and other Accomplishments ... Reading and Writing are the main Interests of Conversation, though Musick and Painting may be allow'd to contribute something toward it, as they give us an Insight into the Arts that make up a great Part of the Pleasures and Diversions of Mankind ...[12]

Astell clearly does not regard painting as being the most inane way in which women are kept occupied, but her recognition of its uses is distinctly double-edged. It is not education but a social skill, necessary

not because of the enjoyment it gives but because it makes an interesting topic of conversation and permits women to understand male entertainments.

The pattern laid down by 1700 scarcely altered throughout the next century. Whereas for men a balance existed between 'solid education' on the one hand and 'accomplishments' on the other, the upbringing of women concentrated heavily on the latter. As a result, education, and with it the place and importance of painting, became the target for the next outburst of feminist sentiment towards the end of the eighteenth century. Certainly the number of women in the upper ranks of society skilled in the use of the paintbrush and the pencil seems greatly to have exceeded the number of men. There were also fewer arguments against their learning such skills, as not only did they also have large tracts of time to fill up, there was also no suggestion in their case that it might be better spent on more worthwhile pursuits. Women were instructed in painting from an early date — in 1667 Browne dedicated his book to his pupil the Duchess of Monmouth — but the habit appears to have become much more pronounced in the next century. For example, the circle around Mrs Delaney in the 1740s nearly all seem to have had lessons of one form or another and it is equally noticeable that of Arthur Pond's pupils, the vast majority were the young daughters of wealthy men.[13]

In contrast, there were very few women who were known as connoisseurs or as collectors; and while someone like Mrs Delaney knew a great deal about the styles of many painters through copying them, she rarely felt the desire to discuss either the quality or nature of the works she had seen. One of the very few women who did take an intellectual approach was Lady Lempster, who composed a biography of Van Dyck while on tour in Rome with her husband early in the century.[14] In the area of connoisseurship women tended to arouse little better than scorn, the general image being that they were easily duped or carried away with foolish female excitement at auctions.[15] Those educational manuals which touched on the subject for women also tended to take a somewhat patronising view. Rather than discussing the merits of what makes a picture good or bad, for example, the pseudonymous Cosmetti devotes time in his ladies' courtesy book to instructing on the proper way to *appear* in front of a painting, so as not to look foolish.[16] Equally, out of perhaps six or seven hundred names of people buying pictures at auctions in the period that have survived, less than a dozen are women. The greatest exceptions were the Duchess of Portland (1714-85, Plate 64) and Lady Betty Germaine (1680-1769), both of whom who had the good fortune to combine their interests with widowhood and a large personal income.[17]

The distinctions drawn between an ability to paint and a knowledge

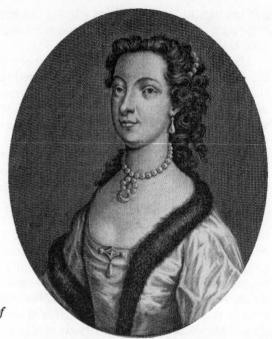

58. John Barlow: *The Duchess of Portland*, 1760s.

of painting can be discerned most clearly in the discussion of the role of painters. The belief that painting itself was not an ideal practice either for health or judgement was an important element of the discussion of the appreciative ability of painters, and hence of their social worth. Part of painters' greater self-assertion was to lay claim to a special ability to discern taste. One of the main purposes of the Academy was to provide a counter-weight to the vagaries of fashion which, as mentioned, was seen not only to damage art but also to harm the proper functioning of society as a whole. The Academy was a small attack on this perceptual anarchy, aiming to reintroduce rational judgement and thereby ensure the triumph of good taste and the success of those painters who deserved it.

However, this desire cut across many precious beliefs. As has been suggested, the question of taste was no dry debate on philosophical niceties, but rather focused some of the most immediate concerns on the state of English society. 'The Elegant Choice of Pleasures' was, as Stubbes insisted, far more than an abstraction or an idle amusement but instead was 'A Science [which] contains all the secrets of Political as well as Moral Knowledge, and comprehends the entire theory of Government ...'[18] The most fundamental quality of the judgement necessary for good taste was objectivity, which enabled the individual to stand

back from himself, so to speak, and assess matters on merit alone. Only if this was present and prejudices prevented from clouding the vision could accurate perception be assured.

Such objectivity was not, however, a quality that was easily attained, but rather needed to be inculcated in the individual by a carefully regulated education. Above all else, the ideal education had to have balance, a correct relationship between its various parts, so that the mind had enough material to function correctly. It was for this reason that John Locke and his successors disapproved of teaching the young to paint, not simply because it left insufficient time for other pursuits but because it created an imbalance, distorting the mind and endangering the ability to perceive accurately. Moreover, it created the possibility that the infection of enthusiasm — a distorted concern for one topic over others — might develop, again something which both indicated and was a cause of a fault in assessment. Accurate perception and hence the ability to act in a moral fashion and be fitted to rule was thus dependent on the lack of specialisation that an all-round education generated.

Judgement, therefore, was the product of a balance of different types of knowledge, not merely the result of knowledge itself. In the case of painting, certain types of knowledge, ranging from perspective to history, were necessary before an individual was capable of assessing a picture accurately.[19] Such possession was, however, insufficient to judge particular objects unless the individual was himself balanced and unprejudiced, in other words, unless the particular knowledge required for a certain operation fitted into an overall harmonious structure. Knowledge of painting was only a small part of the requirement for judging art and was in itself useless unless it existed as a coherent part of a wider educational and psychological whole.

The increasingly confident and assertive painters made a very precise, if indirect, challenge to these beliefs. It was in the nature of their claims that it was knowledge alone, and knowledge of a very specific type, which conferred the ability to judge correctly. As John Gwyn put it in 1749, while discussing the virtues of the French Academy and the need for a similar institution in England:

> As to the Works of the Members themselves ... the Academy was to form a Judgement, without any Inter-mediation. Who can be so good Judges of Arts, as the Artists themselves? Who are such severe Censurers of every Fault, as those who emulate each other in the Pursuit of Excellence?[20]

The point was pursued with more ferocity by TB in the anonymous pamphlet which begins with an extreme and provocative statement: 'None ... have a right to judge who have not Abilities to perform ... a

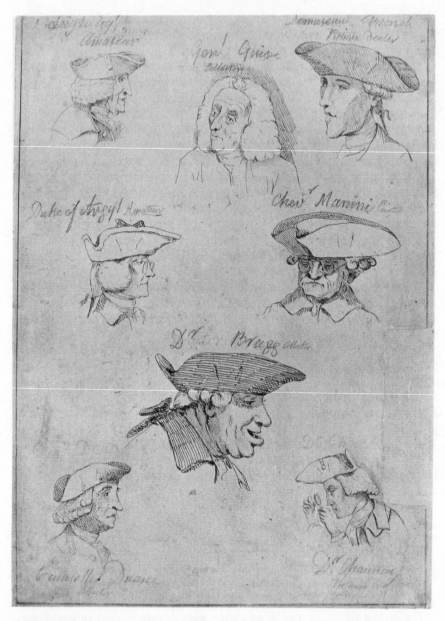

59. Anon: *Collectors and virtuosi c..*1760s — engraved protraits of Dr Bragge, Dr Charles
Chauncey, Matthew Duane, Duke of Argyll, George? Leigh, Demaseau, General Guise.

Man ought to be judged by none other than his Peers, and that none but his Equals have a right either to acquit or condemn him ...'[21] The later exposition of the argument indicates that he accepted only part of the educational orthodoxy prevalent at the time. Completely by-passing the question of balance, he elevates specific knowledge until it is the key which releases and enhances the reasoning faculties and, as a result, diminishes the place of a general clarity of perception:

> As all Painters therefore improve this first Faculty [ie judgement], at least in relation to their Art; so they alone of all Mankind are thereby enabled to judge from those Principles which that and their Studies have taught them to revere; and all Others who would intermeddle, or pretend to determine in their Works, must judge from no Principles at all.[22]

Whatever his other qualities, therefore, the simple fact of a painter's training raises his clarity of perception far above that which could be attained by the gentleman-connoisseur. The painter was, in other words, by definition a better judge of painting simply because he was a painter. As a claim to authority in matters of painting it was remarkably sweeping. As an attack on an important and strongly held belief, it was even more so, despite its oblique approach. The quality of objectivity dependent on perception became less important than the concentration of knowledge that specialisation brings with it. If the detached gentleman was not ideally equipped to judge paintings and this could be done better by painters, then he was no more competent to evaluate the need for laws, better done by lawyers; to see the requirements of trade, better done by merchants; or to take decisions concerning foreign policy or war, better done by diplomats and by soldiers. The rivalry between the two schools of thought on competence, the one advocating the detachment of the amateur, the other insisting on the specialised knowledge of the expert, is a battle which has been fought ever since. Although English painters did not dream up this assertion themselves, borrowing it probably from Coypel if not earlier polemicists, then they and their colleagues in other professions made the point with greater clarity and persistence.

Such claims, however, led to the question of how painting could be so important if it could only properly be appreciated by a tiny number of experts. If the value of painting lay in its ability to communicate grand ideas to the outside world, then the belief that only artists could truly see these ideas severely undermined its utilitarian claims. The painter Joseph Highmore pointed this contradiction out with some acuity:

> If it were true, that none but Artists are good Judges of these

Performances, it must follow, that the Arts themselves are not worth cultivating ... because the greatest Effects that could be produced by their best Works would be only their mutual Admiration, Emulation or Envy, no lasting Pleasure to the outside World ...[23]

TB's solution is to suggest that there are two levels of painting to be appreciated, 'one is from the picture, the other is from its effects'[24] with the amateur spectator able to appreciate only the latter and the painter both. What exactly he means by this is far from clear, the only possible explanation being that he was distinguishing between composition and painterly technique. Behind this assertion therefore lies the implication that technique is being raised from the level of being simply the means of expressing the composition, to being an end in itself.

Neither this argument nor the assumption which lay behind it met with much approval. Any suggestion that painters were inherently better judges than the gentleman amateur was, for example, repudiated in 1732 by an article in the *Weekly Register*. Fixing his opinion on the standard interpretation of education, its author concludes that painters, by definition of their training, are likely to be less well versed in educational matters. Equally, therefore, they will be less able to comprehend fully everything that painting embodies:

> very few Men among the greatest have cultivated their own Minds enough to have a compleat Knowledge of that Divine Art. Indeed I will venture to assert that Painters themselves are not always the best Judges and many ... have been amazingly defective in the grand Principles ...[25]

The point was made more explicitly by Daniel Webb, himself an artist, in 1760. He makes the specific distinction between a painter and a gentleman and clearly prefers the claims of the latter. Webb implies that if the painter is also a gentleman then he can legitimately claim to be as good a judge but that practical knowledge of painting itself, rather than being an advantage to appreciation, is in fact a mental distraction which has to be overcome before impartial assessment can be obtained:

> [Artists] seldom, like Gentlemen and Scholars, rise to an unprejudiced and liberal Contemplation of true Beauty. The Difficulties they find in the Practice of their Art, tie them down to the Mechanic; at the same time, that self-Love and Vanity lead them into an Admiration of those strokes of the Pencil, which come nearest to their own ...[26]

This sentiment in many ways marks a synthesis of the two differing strands of thought which had previously been in competition. As mentioned, the issue of painters' respectability centred on whether or not the

act of painting was gentlemanly. The debate moved from the crude social discussion current from the 1660s onwards to the effects of the act of painting on the mind. Granted the painter could create objects of immense value and educational purpose, but did not the act of producing such works destroy the possibility of his attaining a truly objective insight into the nature of things, and thus equally remove the possibility of his attaining both the central feature and justification of genteel status?

The answer which both Webb and the author of the *Weekly Register* seem to be hinting at is that the nature of the painter's work necessarily carried with it the danger of mental imbalance, but that this natural tendency towards the distortions of prejudice was not an absolute bar. If, by other accomplishments and attainments, the painter could transcend the obstacles created by his training, then he too could join the truly genteel. Philosophy and natural prejudice, therefore, met in mutual sympathy, with the nature of painting attaining a half-way state, no longer by definition an obstacle to respectability, but equally an insufficient cause on its own to allow admittance to the ranks of the genteel. Some painters, in other words — and Joshua Reynolds is an ideal example — were deemed worthy despite their occupation, a view which coincided perfectly with the less reasoned and more instinctive reactions chronicled earlier.

If painters, be they amateur or professional, were not the best trained to appreciate pictures fully, then the field was left to the gentleman, who benefitted from the breadth and balance of a general education. Rather than painting himself, the gentleman had the possibility of expressing his interest in the topic through knowledge and appreciation, with the collection forming only the most tangible aspect of his enthusiasm. The idea that painting was in some ways an agreeable business had a long history but in early writers such as Elyot it was a pleasure that was attached above all to the process. Only from the late seventeenth century onwards did the idea that appreciation alone was pleasurable and worthwhile begin to gain at first a grip and later domination over the subject.

As shown in previous chapters, pleasure was an aspect of morality. To gain pleasure and to taste well was an indication of goodness and moral worth. In an age where true worth and its external signs were becoming increasingly separate, paintings emerged as articles which had the rare ability to indicate both. By the time Richardson addressed the topic in the second decade of the eighteenth century the point was a virtual orthodoxy. People were exhorted to encourage painting and take an interest in it not only because their knowledge would protect them from financial loss but also because it would give a sure sign of their superiority:

I said that *Connoissance* Had a Natural Tendency to promote our

Interest, Power, Reputation, Politeness and even Virtue ... In Conversation (when as it frequently does) it turns upon Painting, a Gentleman that is a *Connoisseur* is distinguished, as one that has Wit, and Learning ... Not to be a *Connoisseur* on such an Occasion either silences a Gentleman, and Hurts his Character; Or he makes a Worse Figure in pretending to be what he is not to Those who see his Ignorance.[27]

The pursuit of pleasure gave an immaterial window into the souls of those who took part in the hunt, allowing the reality of what they really were to come through with a clarity that confusion in dress and manners did not allow. Pleasure consequently became a new and important social indicator and, through it, a further level of significance was attached to painting. However, the way in which pleasure was achieved was also important: balance was always to be maintained in order to demonstrate and preserve a correct apprehension of priorities:

> form a taste for painting, sculpture, architecture, if you please, by a careful examination of the works of the best and modern artists; those are liberal arts, and a real taste and knowledge of them becomes a man of fashion very well. But beyond certain bounds, the man of taste ends, and the frivolous virtuoso begins ...[28]

The ideal of appreciation found its most perfect exposition in the connoisseur or man of taste, a concept which was theoretically defined not by specific external signs but rather by the possession of a quality.[29] Such people were in principle divorced from any specific group or any overt relationship to wealth. The type was thus more abstracted than its seventeenth-century ancestor. While the virtuoso was defined by his interests, the connoisseur was defined by the quality of his interests. Richardson, for example, regards the ideal connoisseur as an early form of *philosophe*, whose dominant feature was that he could apply detached absolute standards to the object he was perceiving, and hence assess its nature: To infer a Thing Is, because it Ought to be, is unreasonable ... [the connoisseur's] Business is to judge from the Intrinsic Qualities of the thing itself ...[30]

On the basis of this ideal, writers on the arts were forever alerting the foolish about the difficulties of connoisseurship. Readers were constantly warned about the necessity of judging from inherent qualities, rather than from assumed ones such as the painter's name or the price paid. Even though using such information could produce an enjoyable response, such a reaction was false, unreliable and deceitful. The essence of true connoisseurship, therefore, lay not so much in the degree of appreciation but rather in the means through which that appreciation was facilitated.

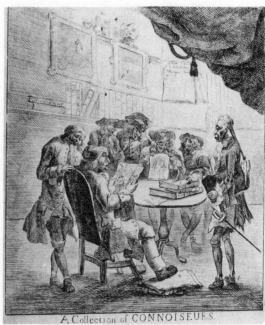

A Collection of CONNOISEURS.

0. Anon: *A Connoiseur admiring a Dark Night Piece*, 1771.
1. Anon: *A Collection of Connoiseurs*, 1724, subtitled — 'How long, ye Simple ones, will ye love implicity?

However, although the connoisseur was an ideal and a-social type, in practice the concept implied very distinct social categories because of its origins in the notion of taste. Firstly, of course, there was the emphasis on education as one of the prime requirements for superior discernment. Moreover, the way in which false connoisseurship was described gives a clear picture of the social connotations that were implicit in the term, it being a fairly ordinary device to locate falsity in people of vulgarity and ill-breeding. Thus, for example, the Duke of Buckingham:

> The criticism which is vented in Eating Houses, Coffee-Houses and Playhouses is nothing in the World but a mixture of ill-Nature and Ignorance ... any Man who drinks his Pot can judge a paltry Picture to be worth nothing, but how few can discuss the best Touches, and judge of a good Collection.[31]

The false connoisseur was generally associated with loudness and boorish behaviour: 'And yet at auctions and private collections, who so loud and so knowing, who takes more pains to draw the attention of everybody around them that there may be sufficient witnesses of their want of skill ...'[32] Whereas the false connoisseur was motivated by his

own vanity, the true one was more concerned with the general good and was thus a gentleman. The most overt description of the contrast comes in the *Female Spectator* in 1745:

> [True Taste] is polite, modest, affable and gentle:[False Taste] is Haughty, tenacious, overbearing and disdainful...A fine Taste is quick in discerning Merit, wherever it is concealed; industrious in making it conspicuous and its Professor Happy:— The Gross Taste seeks nothing but its own Adulation — the Flatterer, the Sycophant, the Time Server, without Birth, Parts, Integrity or any one worthy Quality is, by a Patron of this worthy turn of Mind, protected and frequently promoted even to ridiculous Heights...[33]

Despite the supposedly detached nature of true knowledge, the connoisseur was designated in practice by the external appearance of gentility. He was therefore a very distinct social type, an idealised artistic version of the 'new gentleman' whose production was such a predominant concern of eighteenth-century educationalists. Standards in art, through the medium of this figure, thus became even more strongly identified in practice with absolute rules of behaviour.

The role of the connoisseur as the arbiter of opinion had very distinct practical implications. In France, the institutional position of the expert developed early on, with places in the Academy reserved for the honorary amateurs, whose task it was to encourage painters and act as artistic propagandists. There were few parallels in England. Even when the Royal Academy was founded, the only place in it for amateurs was to offer specialised lessons, such as in anatomy, for the benefit of the students. Connoisseurs did, however, vie with painters for the role of expert advisor, with both Frederick, Prince of Wales and George III preferring the opinions of these amateur experts to those of artists. When referring to Schaub, Vertue significantly says he was 'The King's prime minister connaisseur in pictures whose judgement as a gentleman and his great collection very noble and complete ...'[34] The social recognition that giving such advice bestowed not only elevated the positions of men like Schaub and John Guise, but at the same time further reinforced the standing of the connoisseur in general, as it was solely this quality that singled them out. A further example comes with Hugh Howard, who convinced a substantial number of his worth as a connoisseur. Much of the distaste felt by the Richardsons towards him seems to stem from this fact:

> Hugh Howard, by means of his name, and affecting to be of the Norfolk family, a small Estate of a Gentleman, a solemn Air and slow Discourse, with a very moderate swathing of polite Knowledge, covered so well his

extreme Ignorance and Illiteracy, that he easily passed for a leading Virtuoso with the Nobility...[35]

Moreover, Howard is a perfect practical example of the process of reward briefly laid out in the first chapter. Laying claim, justly or unjustly, to the external trappings of quality, he in due course reaped the benefits in the form of a lucrative sinecure for life to match his gentlemanly appearance.[36] If few were as successful as he, the attempt was probably less rare. Similar aspirants provided an easy target for those, such as Oliver Goldsmith, who disapproved of the use of art as a ladder for social climbing:

> Music having thus lost its splendour, Painting is now become the sole object of fashionable care; the title of connoisseur in that art is at present the safest passport into every fashionable Society; a well timed shrug, an admiring attitude and one or two exotic tones of exclamation are sufficient qualifications for men of low circumstances to curry favour.[37]

The social and manipulative aspects of connoisseurship perhaps comes out most clearly in the chapter of the *Investigator* which deals with the subject. Written by the painter Allan Ramsay in 1762, his essay was published in the form of a dialogue that rings with the didacticism of the middling ranks. The first protagonist is Lord Modish, an aristocratic follower of fashion and a dogmatic advocate of absolute taste as defined by the preferences of the very exclusive group of people to which he belongs. Modish consequently represents crudity and false taste, breaking the rules by substituting partisan preference for absolute values. Opposed to this aristocratic clumsiness, on the other hand, is Colonel Freeman, whose very name underlines his advocacy of liberty and sturdy origins in the middle ranks. Presented as far more intelligent and reasonable, Freeman puts forward the views which are clearly the author's own: 'These Virtuoso's ... have nothing but their own Taste, that is their own private Likeing, to set up for a Standard ... or ... the likeing which those of their Club, City or Nation have acquired by Habit ...'[38] Freeman does not go on to assert that taste as an absolute quality does not exist, but merely that those people who found the absolute on the considerations used by Lord Modish are false connoisseurs. Behind such crudities lay real taste which, although built on social foundations through the lack of any alternative, was nonetheless a genuine and sincere attempt to approach truth rather than merely to exploit advantage.

The sophistication of approach to the appreciation of the arts which is implicit in Ramsay's writing, and the very emergence of the idea of connoisseurship, rested on complex foundations. The essence of the

connoisseur is that he is, by definition, someone who *knows* about the arts. As mentioned, taste was formed from judgement assessing information. As long as these facts were lacking, connoisseurship, the practical application of taste, could not develop properly. How to tell whether a picture is good and genuine, or bad and a fake, can be performed only through the application of a vast range of knowledge that must be readily available. The discussion of genuineness, for example, depends sometimes on an experience of a painter's works and the output of others who operated at the same time. It can also depend on knowing the history of where the work came from and how it got to its present position. Cross-referencing of both fact and style, therefore, is essential not only for the smooth operation of an art market itself, but also for the evolution of 'canons of taste', as it is only by comparison with other works that the quality of any individual picture can be assessed. As J. T. James put it at the beginning of the nineteenth century, introducing his own contribution to this process, 'It is upon the historical criticism of art alone that a classification necessary to form a good connoisseur can be securely founded'.[39]

Such critical ability depended above all on the existence of an effective art market to provide the works for the aspirant connoisseur to examine and judge. Inevitably, therefore, England at the beginning of the eighteenth century possessed few people with this knowledge and only limited means to rectify the situation. Before 1700 a few painters, such as Lely, [40] had accumulated considerable expertise. Later those who studied abroad, like William Kent, Charles Jervas or Andrew Hay, also acquired substantial and rare knowledge.[41] The occasional aristocrat who had gone on a tour could also become acquainted with the subject — the spectacle of the Duke of Shrewsbury building up his knowledge from nothing is laid out in fascinating detail in his diaries.[42] Equally, many of the voyaging diplomats, traders and antiquarians who bought paintings also came to have some familiarity with the history and criticism of art at the same time.

But around 1700 there were, perhaps, only a few dozen who really knew about the history of painting or could 'judge a picture with confidence'. Aspiring collectors could certainly learn from these people, especially if their interests drew them to an early gathering of virtuosi like the Rose and Crown club.[43] For the rest familiarisation was hard: collections were few, difficult to see and badly catalogued if at all. There were no exhibitions before 1739 and auctions provided one of the few opportunities for all but a small élite to look at paintings.[44] Literature on the subject was also in short supply. With most of the seventeenth century books on art in English being practical manuals on painting and drawing, only a few made much of an attempt to communicate an idea of the history and stylistic evolution of painting as it was then conceived.

Nearly all of these were translations or heavily dependant on foreign models, such as Evelyn's translation of Fréart de Chambray in 1668,[45] Aglionby's *Dialogues* or the 1699 translation of Monier's *History of Painting*.[46] There were equally few guide books that gave some sense of the scale of foreign collections, the notable exception being William Lodge's translation of Giacomo Barri's *Viaggio Pittoresco* that appeared in 1679.[47] Otherwise, the aspiring English connoisseur had to rely on foreign works in the original language. The difficulty of getting hold of these and the need to speak French or Italian to read them inevitably restricted the speed at which knowledge of painting could develop.[48]

The achievement of the first half of the eighteenth century was to establish a corpus of readily accessible knowledge that could be drawn on, easing some of the perils and uncertainties that made the appreciation of art such an imprecise business. Much of this knowledge was private and was never published. Vertue's notes, of course, were largely unknown until Walpole published parts of them as his *Anecdotes,* and even then the vast mass of his material on collections remained hidden. Even more was in the form of private communications of art dealers and travellers, such as those of Andrew Hay with the Earl of Oxford and Vertue himself.

However, far more was available than before. First, there were published diaries and accounts, if only abbreviated, of the greatest foreign art objects, such as the translation of Bernard de Montfaucon in 1712[49] and Richardson in 1722,[50] as well as incidental comments that appeared in books such as those by Macky, Breval or James Russel.[51] Equally, there were translations of books on the nature of appreciation, such as Buckeridge's version of de Piles in 1706,[52] as well as the first such works in English with Richardson's essays. Next came a start on the task of cataloguing and assessing works already in England, the great figures being Vertue and Walpole,[53] but also men like Kennedy in 1758,[54] *London and its Environs* in 1761[55] and Martyn's synthesis in 1766.[56] There was the activity of the copyists, reproducing famous works, learning from the process and spreading knowledge of style among a wider range of people.[57] Finally and perhaps most importantly, engravings made a huge amount of information on style easily available. This mass of information was initially mainly imported and then, with people like Robert Strange and Boydell, produced in England itself.[58]

The discussion of art sprang from the roots of virtuosoship and antiquarianism rather than from the tradition of literary commentary, and all its finest exponents from Evelyn on were classic representatives of this style. The virtuoso strain was even evident in the collections of the Earl of Oxford and Richard Mead whose paintings were only one aspect of a broad accumulation of human knowledge that ranged from shells and curiosities to books and manuscripts. Vertue was first and foremost an

62. Jonathan Richardson: *Portrait of George Vertue*, 1733, oil on canvas.

antiquarian who applied the methodology of virtuosoship to a new area of investigation.

Writing on art was dominated by two elements, the virtuoso and the 'philosophic', one concerned totally with the facts of art, the other treating the subject only tangentially and seeking instead a moral and 'civic' structure in which it could be enclosed. Almost entirely lacking, however, was a strain which might have derived from the interests of the connoisseur or critic. Indeed, aesthetic commentary on painting was never an English speciality, as a comparison of French Salon criticism of the 1760s and 1770s and the infrequent, crude and virtually incoherent English equivalent readily demonstrates. While French critics such as Diderot or La Font de Saint Yenne wrote in a style adapted from the mainstream of philosophic and literary criticism, much of the English commentary on exhibitions originated in the satire, the burlesque and the newspaper article.[59] Equally, as mentioned, while French auction catalogues would frequently include both a full description and an analysis of the merits of paintings on sale, English sales only rarely followed suit.

Even the antiquarian accounts, however, fought shy of venturing into analyses of the pictures they discussed. A very full account of a collection, such as Walpole's *Aedes Walpolianae*, largely avoids assessments of the pictures described. Take, for example, the listing of the *Doctors of the Church* by Reni. His three-page account begins with history, appropriate enough perhaps considering the stress placed by aesthetic theory on knowledge of events depicted for appropriate appreciation. Walpole describes the controversies, the role played by the various theologians shown and then digresses from the subject — the immaculate conception of the Virgin — to discuss Raphael's depiction of a similar subject and a painting of Duns Scotus at Windsor before swinging back to talk about the Jesuits and Dominicans in the later seventeenth century. It is only after this that he returns to the picture itself, gives the name of the painter and then confines himself to the brief assertion that

> In this picture, which is by Guido in his brightest manner, and perfectly preserved, there are six old Men as large as Life. The Expression, Drawing, Design and Colouring, wonderfully fine. In the Clouds is a beautiful Virgin all in White, and before her a little sweet Angel flying. Eight Feet eleven inches high, by six feet wide.

The remainder of the discussion concerns the difficulties that Robert Walpole had in getting the work out of the papal states and giving the name of the previous owner, Marquis Angeli.[60]

The particularity of English concerns when writing about art can be

seen most clearly if Walpole's treatment of Reni is compared with that of
the French critic, François-Bernard Lepicié, writing at about the same
time.[61] In dealing with Reni,[62] the individual descriptions of the pictures
are entirely different. With his account of the *Enlevement de Dejanire
par le Centaure Nessus*, for example, the recounting of the myth on
which the work is based is brief to the point of being terse, taking up
only three sentences. This taken care of, the rest is a critical description
of the quality and nature of what Guido had performed:

> Le Guide a mis dans son sujet toute la poësie dont il étoit susceptible;
> aucune chose ne lui est echappée pour rendre avec force les passions
> differents dont le Centaure et Dejanire sont agités. Le Centaure abor-
> de au rivage, sur lequel il pose dela un pied; l'amour, la joie et le
> plaisir sont peints dans les yeux; il regarde et tient Dejanire avec un
> transport qui decouvre l'état de son âme ... L'ordonnance précise, la
> composition simple, l'elegance du trait et le sublime des expressions,
> ravissent tous ceux qui regardent ce tableau avec attention. La figure
> du Centaure a toute la profoundeur et la grandeur du dessein de
> Michel-Ange, sans en avoir l'austerité: Celle de Dejanire reunit la
> noblesse et les Graces de l'Antique à toutes la verité de la Nature; et
> l'on est en droit d'avancer que le tout ensemble merite egalement pour
> l'execution et pour la couleur.[63] *

The relative treatments of Reni have been discussed here because
Walpole exemplifies the English approach and, indeed, if anything is
considerably fuller than most. Walpole was not a man who was ever
without a very definite opinion; his letters are strewn with commenda-
tions and condemnations of paintings he had seen. But while he was
prepared to say in print that he thought his father's Reni was good, he
did not think it appropriate to lay out details of the reasoning and feel-
ings that led him to this assessment. Rather, in common with all English
writers, he avoids any form of analysis and confines himself largely to
assertions and historical account. Also, when he passes judgement in the

* 'Guido put into his subject all the poetry of which he was capable. He missed
nothing to render with power the varying passions affecting the Centaur and
Dejanire. The Centaur approaches the river bank, on which he rests a foot.
Love, joy and pleasure are painted in his eye. He looks at Dejanire with a trans-
port that reveals the state of his soul ... The precise ordering, the simple
composition, the elegance of line and the sublimity of the expressions, ravish
all who look at his picture with attention. The figure of the Centaur has all the
profundity and grandeur of a drawing by Michelangelo, without its austerity.
That of Dejanire reunites the nobility and grace of antiquity with all the truth of
nature; and one has the right to sugest that the whole ensemble is equally wor-
thy for its execution as for its colouring.'

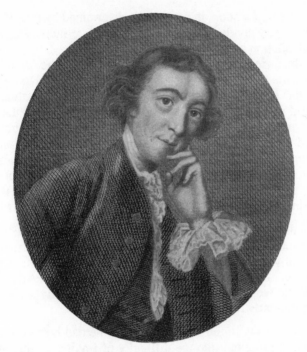

63. B. Reading after Sir Joshua Reynolds: *Portrait of Horace Walpole.*

Anecdotes, he generally comments on the abilities of the painter, and rarely refers to individual pictures. The attempt of a Lepicié to get inside the mind of the painter to explain what he was trying to do, and give a stylistic account of a painting, was almost unknown.

As Lipking points out,[64] the object of much of English writing specifically on works of art was the patron and collector, not the public at large, and he detects in the writings of Walpole particularly a patronising attitude towards artists themselves. Thus, the *Anecdotes* are organised around the monarchs, instead of, say, around painters and their disciples, to give an overall impression of the history of taste rather than of painting. Similarly, the catalogue of Houghton is overtly intended as a glorification of the collector and the house rather than of the paintings.[65] While the *Anecdotes* largely castigate the monarchs and use the artists as evidence for their failings, the *Aedes* is primarily a tribute to Robert Walpole. The pictures are described room by room for the convenience of the visitor rather than the elucidation of the scholar. Other English catalogues also tended to be dominated by a presentation which centred on the collection as a conglomeration of the owner's taste rather than as contributions towards the understanding of the arts. Thus, the history of painting always took second place to a room-by-room account. The

structure of Lèpicié's book, in contrast, is determined by that of the histor-
ical model and is divided into schools, a practice increasingly common
with French auction catalogues.[66]

The 'art-historical' view of the arts, taking them rather than the collec-
tor as the focus of the account, is almost as rare in England as aesthetic
criticism; the insights of the Richardsons on classical statuary [67] were
not followed up and the English made little contribution to the 'systema-
tisation' of art history. One of the few books that was constructed around
the artist, indeed, was that produced by Matthew Pilkington in 1770,
which brought together a vast mass of information necessary for the con-
noisseur to situate a work in the historical continuum of painting.
Pilkington particularly made a point of including tables for the sake of
correct identification; as the title-page itself says, the book has

> Two catalogues; the one, a CATALOGUE of the DISCIPLES of the
> most famous MASTERS; for the use of those, who desire to obtain a
> critical knowledge of the different hands, and manners, of the differ-
> ent schools.— The other, a CATALOGUE of those PAINTERS, who
> imitated the works of the eminent masters so exactly, as to have their
> copies frequently mistaken for originals.[68]

He goes on to say in the introduction that he had been motivated by a
love of painting that ran into the difficulty of finding writers on the sub-
ject 'too onerous, and very few of them in our native language'.[69] His
contribution was fired by the desire to expand the taste of painting wider,
so that interest would not be constrained by artificial matters:

> Although it may be justly supposed, that to persons of high rank and
> education, all the languages of Europe may be familiar; yet there are
> numbers of all ranks and stations, who may feel the utmost fondness
> for the imitative arts, and yet be totally unacquainted with several of
> those languages, from which the knowledge of the most memorable
> artists can be acquired.[70]

Nonetheless, the approach is still aimed at a particular audience, and
is not an account of painters for their own sake. The interests of the
collector that Lipking detects in Walpole also shine through the pages
of the *Gentleman's and Connoisseur's Dictionary*. Talking of Reni,
Pilkington is far more forthcoming in analysing style, even if he is just as
reluctant to discuss emotional and intellectual content. At the same time,
however, he is offering advice for the potential buyer: 'his works have
ever been deservedly admired through all Europe, and to this day
increase in their value...'[71]

This approach was strengthened by the doctrine of taste and the domi-
nant conception of the appreciation of beauty. Beauty was an idea
'raised in us' and it existed not on the canvas but in the mind. Describing

the painting and its beauties was therefore irrelevant; if the mind was sufficiently balanced it would comprehend the goodness of the picture anyway, if it was corrupted no amount of explanation would assist the viewer to appreciate what they literally could not see. Lèpicié maintains that the elements of his Reni 'ravissent tous ceux qui regardent ce tableaux avec attention' but few Englishman would have been so sanguine about its universal ability to communicate. Appreciation was instead an individual business. Painters would paint, experts would provide digests and catalogues for assistance, and moralists would stress the social and individual virtues of appreciation, but at that point the role of the expert ended. It was the duty of the individual himself to come to the point of comprehending the goodness and badness of the picture — and the reasoning behind this.

The interest in painting that developed in this period was therefore composed of a variety of fragments. Above all it was the result of an increased availability of knowledge that stemmed from the establishment of an art market, the emergence of collections, and the growth of a minor industry of commentators, journalists and antiquarians who provided the raw information on which ever more sophisticated assessments and distinctions could rest. On the one hand the body of knowledge that resulted was an aspect of the process of unification of the upper ranks of society described in earlier chapters, an element of the 'republic of taste' that derived from the 'virtuoso republick' of the start of the century. On the other, however, it was also hierarchical, providing new means of perpetuating the divisions of the different parts of society.

This process can be discerned most clearly through the attitudes of painters. The central feature of artists' claims in this period was that they be accepted as equal members of the 'republic of taste' and that traditional demarcation lines between the liberal and mechanic be dismantled or modified. As part of this they lodged their claim to be useful, asserting a 'public role' in moulding and civilising while also contributing to the country's wealth. However, painters were uncertain about who their public was. Although the term was frequently meant in the Aristotelian sense of citizens, that is qualified and educated members of the body politic, from early on a wider application was recognised. If painting was to be in churches, to soften and civilise, then a much broader notion of the public was clearly implied.

However, while such a definition expanded the public usefulness of artists, it also diminished the intellectual worth of painting. The indecision about their aspirations equally affected artists in the realm of patronage. As mentioned, painters began to recognise aristocratic patronage as confining and to see the importance of winning a wide

reputation. However, there was distinct nostalgia for the security provided by an idealised notion of aristocratic patronage, and considerable doubt about exposing themselves to the chill winds of economic demand and public taste represented by exploitative dealers and a fickle, wayward print-buying mass.

While painters were in two minds about their role, the assumptions implicit in the approach of the SEAMC and the Society of Dilettanti tended to reassert the subservience of painters not to the public but to gentlemen of taste, who mediated between art and the common good. It was they alone, so the alternative went, who could see the needs of society and, without this relationship, the artist would be lost and ineffective. If the painter's assertions achieved institutional embodiment in the Academy and the attempt to form taste 'without intermediation', then those of the gentleman came later in the British Institution.[72]

The claims of the gentleman-connoisseur were rarely challenged in the same fashion. On him, as patron and collector and 'taster' of the arts, all glory and responsibility descended. It was he who was ultimately responsible for the production of good paintings by guiding the painter and protecting him from the vagaries of market demand. The connoisseur as collector built up accumulations of works that formed the national taste, wisely deploying wealth for the best advantage of society as a whole. It was even they who derived most benefit from painting as the arts not only distinguished them from the rest of society, but proper appreciation refined their judgement and made them into more legitimate rulers.

Dubbing this period the 'Age of Taste' is, therefore, in some ways felicitous; not in the sense, sometimes intended, that it was a period of particularly good aesthetic sensibilities, but rather because the appreciation of the viewer was the central element around which the entire art world revolved. From the ideology of patronage and collecting to the philosophy of taste, it was the observer who was crucial for the development and importance of the arts, not the producer. No matter what social advances they made, painters consequently remained in the inevitably subservient position of creating works for others to taste.

Appendix to Chapter Three

Table 1

IMPORTS OF PAINTINGS INTO ENGLAND, 1722-1774

(Source: Public Records Office series *Cust 3*)

Date	Italy	France	Holland	Flanders	Germany	Spain	Portugal	Others	Total
1722	147	94	151	42	12	-	-	9	455
1723	194	86	223	64	5	12	-	2	586
1724	320	78	171	60	116	-	56	6	807
1725	334	198	123	33	47	1	-	21	762
1726	302	62	35	51	8	37	18	1	648
1727	394	46	141	51	14	-	2	-	648
1728	324	135	35	54	7	-	14	2	571
1729	136	66	71	13	-	1	23	5	315
1730	356	102	56	44	2	3	5	16	584
1731	122	144	45	9	7	5	6	4	342
1732	179	57	12	19	10	7	-	7	291
1733	203	96	14	1	61	49	2	5	431
1734	189	61	40	9	-	15	21	1	336
1735	175	99	94	33	8	-	1	1	411
1736	174	93	32	32	-	1	3	1	336
1737	137	66	14	13	-	1	-	-	231
1738	141	188	47	35	3	9	-	-	423
1739	190	114	30	12	4	1	7	1	359
1740	168	85	21	58	3	-	-	4	339
1741	285	226	18	42	-	-	2	-	573
1742	131	345	12	30	7	-	-	-	525

Date	Italy	France	Holland	Flanders	Germany	Spain	Portugal	Others	Total
1743	149	443	29	52	1	-	-	-	674
1744	142	54	20	39	-	-	-	-	255
1745	83	57	121	37	-	-	2	-	300
1746	54	-	107	-	4	-	-	-	165
1747	66	-	205	-	-	-	25	-	296
1748	46	39	217	-	30	2	10	-	344
1749	90	83	491	25	21	-	-	-	710
1750	113	97	183	62	9	-	-	38	502
1751	114	164	144	63	13	8	-	12	518
1752	101	58	71	41	2	-	2	16	291
1753	154	103	66	31	-	-	1	8	363
1754	392	276	113	12	2	2	37	18	852
1755	118	140	62	39	19	-	-	3	381
1756	87	75	146	8	3	1	1	3	324
1757	59	-	300	5	5	-	-	3	372
1758	245	-	280	6	1	4	-	-	536
1759	530	-	230	60	4	-	4	2	830
1760	82	-	149	33	4	2	1	17	288
1761	130	4	132	28	-	9	-	14	317
1762	154	-	81	35	17	66	-	-	353
1763	500	85	189	82	35	9	10	7	917

Date	Italy	France	Holland	Flanders	Germany	Spain	Portugal	Others	Total
1764	435	103	202	133	16	4	-	5	898
1765	450	121	156	485	53	10	25	5	1305
1766	454	181	100	115	13	-	4	1	868
1767	329	118	109	47	14	16	-	10	643
1768	363	109	71	70	7	56	-	8	684
1769	541	220	86	128	77	10	13	53	1128
1770	399	252	98	107	2	-	7	1	865
1771	474	231	380	215	21	12	2	13	1384
1772	510	260	310	137	9	4	-	9	1239
1773	658	139	69	175	6	2	3	-	1052
1774	448	302	86	82	6	4	-	5	933

Table 2

PROPORTION OF PICTURES COMING FROM THREE MAIN SOURCES, 1722-4

Date	Average % from Italy	Average % from France	Average % from Holland	Average Imports per year
1722-26	41.5	16.6	22.5	625
1727-31	54.2	20.0	14.2	492
1732-36	51.0	22.5	10.6	361
1737-41	47.8	35.2	6.8	385
1742-46	29.1	46.8	15.1	384
1747-51	18.1	16.2	52.3	474
1752-56	38.5	29.5	20.7	442
1757-61	44.6	0.2	46.6	469
1762-66	45.9	11.3	16.8	868
1767-71	45.1	19.9	12.2	934
1771-74	50.1	21.7	14.4	1075

Table 3

IMPORTS OF PRINTS, 1725-74

Date	France	Holland	Italy	Other	Total
1725	3151	1991	5893	-	11035
1726	1731	1747	5972	90	9540
1727	2589	3121	6783	660	13153
1728	4600	1779	1209	754	8343
1729	2929	1339	7854	6958	19098
1730	3841	3671	4078	6219	17809
1731	3943	4583	2990	831	12347
1732	2355	966	2782	1559	7662
1733	3226	2214	1335	1051	7826
1734	3668	612	1866	166	6313
1735	4225	410	3027	45	7707
1736	4258	289	271	1371	6289
1737	4174	818	621	570	6183
1738	3155	2166	908	375	6604
1739	2863	916	994	323	5096
1740	3377	493	2004	708	6582
1741	1522	-	1768	149	3439
1742	3614	323	2001	271	6155
1743	3573	426	2310	750	7059

Date	France	Holland	Italy	Other	Total
1744	2268	3804	600	-	6672
1745	42	3098	660	-	3800
1746	-	1960	1866	-	3826
1747	956	4301	411	-	5668
1748	1121	4079	638	-	5838
1749	3862	4692	852	1744	9410
1750	4293	1980	998	10	7281
1751	3312	2339	1003	319	6973
1952	3782	702	1117	946	6547
1753	4306	1883	3263	85	9537
1754	2180	3118	3129	19	8446
1755	4233	4454	1871	397	10955
1756	2285	2760	882	1116	7043
1757	-	7294	117	2337	9748
1758	-	5464	573	3143	9180
1759	-	7120	8124	2664	17908
1760	-	3694	962	6494	11150
1761	80	2410	2124	2735	7349
1762	-	2030	3113	8576	13719
1763	4820	1352	2028	1995	10915

Date	France	Holland	Italy	Other	Total
1764	6354	1359	6459	2000	14139
1765	9733	1307	5542	884	17466
1766	6692	1488	4113	902	13195
1767	6616	2789	5338	458	15201
1768	8263	1876	6793	344	17276
1769	11614	1813	5432	1032	19891
1770	6036	1573	5047	374	13130
1771	4096	1059	4425	781	10361
1772	5584	1466	2424	733	10207
1773	2899	1351	4156	1814	10220
1774	2576	525	7018	1982	12101

The Discovery of Painting

Table 4

ANALYSIS OF SALES BY SAMUEL PARIS, 1738/9, 1741

1738/9

Price Range £	Number	% of Total Number	Total Cost £	% of Total Cost
1. 0-2	11	8.2	18.3.0	1.2
2. 2-5	45	33.3	142.17.6	9.2
3. 5-10	37	27.4	268.2.6	17.3
4. 10-15	18	13.3	222.3.6	14.3
5. 15-20	5	3.7	111.6.0	7.2
6. 20-30	5	3.7	147.10.6	9.5
7. 30-40	7	5.2	228.3.6	14.7
8. 40-80	7	5.2	414.18.0	26.7
9. 80-100	-	-	-	-
10. 100+	-	-	-	-
Total	135	100.0	1533.14.6	100.0

Table 4

ANALYSIS OF SALES BY SAMUEL PARIS, 1741

1741

Price Range £	Number	% of Total Number	Total Cost £	% of Total Cost
1. 0-2	11	13.3	15.13.6	2.5
2. 2-5	41	49.4	141.9.6	22.2
3. 5-10	14	16.9	113.4.0	17.7
4. 10-15	4	4.8	46.11.0	7.3
5. 15-20	9	10.8	135.19.6	21.3
6. 20-30	2	2.4	43.11.6	6.8
7. 30-40	1	1.2	32.0.6	5.0
8. 40-80	-	-	-	-
9. 80-100	-	-	-	-
10. 100+	1	1.2	110.5.0	17.2
Total	83	100.0	638.12.6	100.0

Appendix to Chapter Six

Table 1 lays out the elevated preferences of the English at auction, listing the artists who are known to have fetched more than £40 for their works in the years between 1711 and 1759. The painters are divided according to their country of origin and are given a category corresponding to the quarter century in which they were born, so that an approximate picture can be built up of the periods which found the greatest favour. The categories are allotted as follows.

1	-	1401-25
2	-	1426-50
3	-	1451-75
4	-	1476-1500
5	-	1501-25
6	-	1526-50
7	-	1551-75
8	-	1576-1600
9	-	1601-25
10	-	1626-50
11	-	1651-75
12	-	1676-1700

In this period 545 works are known to have fetched more than £40 and 108 more than £100, the former figure being well under 5 per cent of the total number of pictures sold by auction for which records survive. The list provides considerable information about changes in taste and the relative slowness of its evolution.

Firstly, it is clear that the increased numbers of pictures available led to buyers becoming more, rather than less, conservative in their choice. Table 2 gives the ten most highly sought-after artists in terms of price; if this is compared with that ultimate catalogue of orthodoxy created by de Piles (and presented to the English in its most accessible form through Richardson and Buckeridge's *Art of Painting*), in the earlier period only three of the ten were equally highly rated by de Piles (Rubens, da Cortona and Van Dyck). In the later period, this rises to six (Raphael, Rubens, Corregio, Poussin, Teniers, Van Dyck). In both periods the English had a strong affection for Maratti (who probably did not appear in de Piles' list as he was still alive) while Claude was possibly not included as he was counted as a landscapist.

Turning to types of painting, it is clear that the dominance of Italy, while far from being erased, was at least being eroded. A noticeably larger proportion of the paintings originated in France (18.4 per cent in

1731-59 compared with 13.3 per cent before) and Holland (19.7 per cent after 14.2 per cent). Taken together, the two Northern Schools of Holland and Flanders accounted for 39.9 per cent of pictures fetching more than £40 in the latter period after 35.5 per cent earlier. However, it is clear that a much smaller proportion of Dutch pictures were able to fetch high prices, while in this area the advance of the Flemish school was striking. If the number of painters admitted into the upper price range is examined (Table 5) then a different picture emerges. If more pictures from France and Holland fetched higher prices in the later period, then these works came from a relatively more restricted number of painters than in the case of Italy, and in this respect the Italian dominance remained more secure.

Finally, there is the question of which epochs of painting the English wanted (Tables 5 and 6). As can be seen, the robust conservatism that preferred work by artists born between 1575 and 1650 was scarcely dented. Once more, only in Italy can a degree of experimentation be discerned, with some willingness to accept works from a wider range of periods. Equally absent were modern works, although this can largely be accounted for by the fact that it took some time for modern paintings to filter through to the auction room. When they did, however, they generally fetched low prices, the two main exceptions being Watteau and Panini.

The Discovery of Painting

Table 1

PAINTINGS FETCHING MORE THAN £40 AT AUCTION, 1711-59

Italy

Name	Total No. of Pictures	Category	No. of Pictures 1711-30	No. of Pictures 1731-59	Maximum Price 1711-30	Maximum Price 1731-59
Albani	5	8	1	4	80.0.0	120.0.0
Barocci	2	6	-	2	-	58.16.0
J. Bassano	8	5	-	8	-	100.0.0
Battaglia	3	9	-	3	-	79.16.0
Bellini	1	2	-	1	-	110.5.0
Bolgnese	9	4	-	9	-	105.0.0
Borgognone	6	9	4	2	70.0.0	170.2.0
Cagnacci	2	9	2	-	121.1.6	-
L. Carracci	5	7	1	4	43.0.0	90.0.0
V. Castelli	2	9	-	2	-	86.2.0
Castiglione	4	9	2	2	250.0.0	53.11.0
Chiari	3	11	-	3	-	44.2.0
Cignani	4	10	-	4	-	69.6.0
Corregio	2	4	-	2	-	404.0.0
P. de Cortona	4	8	2	2	215.0.0	53.11.0
Carlo Dolci	3	9	1	2	53.11.0	64.1.0
Domenichino	2	8	-	2	-	58.16.0

Name	Total No. of Pictures	Category	No. of Pictures 1711-30	No. of Pictures 1731-59	Maximum Price 1711-30	Maximum Price 1731-59
S. Ferrata	2	9	-	2	-	100.16.0
C. Ferrari	1	10	-	1	-	54.12.0
D. Feti	1	8	1	-	70.0.0	-
Gentileschi	1	7	-	1	-	44.0.0
Chisolfi	1	10	-	1	-	44.2.0
Giordano	11	10	3	8	225.0.0	147.0.0
Guercino	3	8	-	3	-	103.19.0
Imperiali	1	12	-	18	-	42.0.0
Lauri	11	9	6	5	73.10.0	55.13.0
Luti	3	11	-	3	-	157.10.0
Maratti	14	9	3	11	159.7.0	273.0.0
M. Angelo	2	3	2	-	100.0.0	-
Mola	1	9	1	-	60.0.0	-
Occhiali	11	6	-	11	-	84.0.0
Panini	5	12	1	4	40.0.0	110.8.0
Passionelli	1	10	1	-	44.2.0	-
S. de Pesaro	1	9	-	1	-	42.0.0
S. del Piombo	1	4	-	1	-	86.0.0
Pordonone	1	4	-	1	-	47.5.0
Raphael	4	4	1	3	58.0.0	703.0.0

Name	Total No. of Pictures	Category	No. of Pictures 1711-30	No. of Pictures 1731-59	Maximum Price 1711-30	Maximum Price 1731-59
Reni	12	7	2	10	133.7.0	328.0.0
Ricci	1	11	-	1	-	44.2.0
Romanelli	2	9	1	1	44.2.0	78.0.0
G Romano	3	3/4	-	3	-	78.0.0
S. Rosa	3	9	-	3	-	53.11.0
A. Sacchi	2	8	-	2	-	52.10.0
Sassoferrato	1	9	-	1	-	42.0.0
Schiavone	1	5	-	1	-	42.0.0
Schidoni	2	8	1	1	89.5.0	45.14.6
Solimena	4	11	-	4	-	73.10.0
Solo	1	11	1	-	68.5.0	-
Tintoretto	3	5	2	1	244.0.0	66.0.0
Titian	9	4	3	6	120.0.0	173.5.0
Trevisiani	2	11	-	2	-	44.2.0
Turcho	1	8	1	-	40.0.0	-
P. del Vago	1	4	1	-	80.0.0	-
Veronese	12	6	5	7	367.0.0	106.1.0
Viviano	6	8	3	3	45.0.0	65.2.0
Zuccaro	1	6	-	1	-	88.4.0
Total 58	203	-	49	154	-	-

France

Name	Total No. of Pictures	Category	No. of Pictures 1711-30	No. of Pictures 1731-59	Maximum Price 1711-30	Maximum Price 1731-59
Blanchard	1	8	-	1	-	72.0.0
Boudon	4	9	1	4	-	99.15.0
Claude	31	8	4	27	280.0.0	170.0.0
Colombel	2	10	-	2	-	68.5.0
Le Brun	4	9	-	4	-	127.0.0
Le Moyne	1	12	-	1	-	61.19.0
Le Nain	1	8/9	-	-	-	180.0.0
Le Sueur	2	9	-	2	-	65.2.0
Mannier	1	10	1	-	49.7.0	-
Parocell	1	10	-	1	-	41.0.0
G. Poussin	26	9	8	18	100.0.0	110.0.0
N. Poussin	17	8	2	15	80.0.0	252.0.0
Valentin	2	8	-	2	-	65.0.0
Watteau	5	12	-	5	-	50.0.0
Total 14	101	-	19	82	-	-

Holland

Name	Total No. of Pictures	Category	No. of Pictures 1711-30	No. of Pictures 1731-59	Maximum Price 1711-30	Maximum Price 1731-59
Asselyn	1	9	-	1	-	84.0.0
Bamboccio	1	8	1	-	48.6.0	-
Berchem	4	9	1	3	53.0.0	89.5.0
F. Bol	1	9	1	-	58.0.0	-
J. Both	7	9	-	7	-	66.0.0
A. Cuyp	4	9	-	4	-	99.15.0
Dekker	1	9/10	-	-	-	46.4.0
G. Dou	5	9	-	5	-	92.18.0
F. Hals	1	8	-	1	-	43.0.0
Hobbema	2	10	-	2	-	42.0.0
G. Metsu	1	10	1	-	52.10.0	-
Van Mieris	5	10	-	5	-	105.0.0
Van Ostade	3	9	1	2	44.2.0	78.15.0
Poelenburg	3	8	3	-	210.0.0	-
Pynacker	1	9	-	1	-	53.11.0
Rembrandt	20	9	2	18	80.0.0	166.0.0
Romyn	1	9	-	1	-	77.0.0
Ruysdael	2	8	-	2	-	46.14.0
Savery	2	8	1	1	50.0.0	42.0.0

Holland

Name	Total No. of Pictures	Category	No. of Pictures 1711-30	No. of Pictures 1731-59	Maximum Price 1711-30	Maximum Price 1731-59
Schalken	2	10	2	0	64.0.0	-
Steenwick	1	8	1	0	52.10.0	-
Vanderheyden	4	10	-	4	-	55.2.6
Vanderneer	2	9	-	2	-	48.6.0
Vanderwelde	8	9/10	-	8	-	85.1.0
Vanderwerff	2	11	-	2	-	156.0.0
Van Huysum	2	12	-	2	-	53.11.0
Weenix	4	9	1	3	140.0.0	85.1.0
Welbots	1	-	1	-	63.0.0	-
Wouverman	10	9	-	10	-	126.0.0
Wynatts	3	10	-	3	-	63.0.0
Total 30	104	-	16	88	-	-

Flanders

Name	Total No. of Pictures	Category	No. of Pictures 1711-30	No. of Pictures 1731-59	Maximum Price 1711-30	Maximum Price 1731-59 .
Breughel	3	7	2	1	68.5.0	42.0.0
P. Brill	10	7	2	8	68.5.0	174.6.0
Brouwer	1	9	-	1	-	45.3.0
Fyt	2	9	-	2	-	152.5.0
Jordaens	5	8	2	3	60.0.0	117.0.0
Mille	2	10	-	2	-	49.7.0
Rubens	34	8	11	23	500.0.0	425.0.0
Snyders	6	8	-	6	-	74.11.0
Teniers	28	8/9	2	26	44.2.0	241.10.0
Vandermeulen	1	10	-	1	-	56.14.0
Van Dyck	18	8	4	14	150.00	211.0.0
de Voss	2	8	-	2	-	55.13.0
Vosterman	2	8	1	1	46.0.0	52.10.0
Total 13	114	-	24	90	-	-

Germany

Name	Total No. of Pictures	Category	No. of Pictures 1711-30	No. of Pictures 1731-59	Maximum Price 1711-30	Maximum Price 1731-59
Bemmell	1	11	-	1	-	42.0.0
Durer	2	3	1	1	90.0.0	52.10.0
Frank	1	9	-	1	-	57.0.0
Holbein	4	4	1	3	50.8.0	110.5.0
Total 4	8	-	2	6	-	-

England

Name	Total No. of Pictures	Category	No. of Pictures 1711-30	No. of Pictures 1731-59	Maximum Price 1711-30	Maximum Price 1731-59
Cooper	1	9	1	-	66.3.0	-
Total 1	1	-	1	-	-	-

Spain

Name	Total No. of Pictures	Category	No. of Pictures 1711-30	No. of Pictures 1731-59	Maximum Price 1711-30	Maximum Price 1731-59
Murillo	8	9	1	7	42.0.0	174.6.0
Spagnoletto	6	8	-	6	-	175.0.0
Total 2	14	-	1	13	-	-

Table 2

PAINTERS ATTRACTING THE HIGHEST PRICES AT AUCTION, 1711-59

	1711-30	1731-59
1.	Rubens	Raphael
2.	Veronese	Rubens
3.	Claude	Corregio
4.	Tintoretto	Guido Reni
5.	Giordano	Maratti
6.	da Cortona	N. Poussin
7.	Poelenburg	Teniers
8.	Maratti	Van Dyck
9.	Van Dyck	Le Nain
10.	Weenix	Brill

Table 3

PICTURES FETCHING MORE THAN £40 AT AUCTION, 1711-59

1711-30

Country	No. above £40	% of Total	No. above £100	% of Total
Italy	54	47.7	15	53.6
France	15	13.3	5	17.8
Holland	16	14.2	2	7.1
Germany	2	1.8	-	-
Flanders	24	21.3	6	21.4
Spain	1	0.9	-	-
England	1	0.9	-	-
Total	113	-	28	-

1731-59

Country	No. above £40	% of Total	No. above £100	% of Total
Italy	154	34.5	30	37.5
France	82	18.4	16	20.0
Holland	88	19.7	5	6.3
Germany	6	1.3	1	1.3
Flanders	90	20.2	23	28.8
Spain	13	2.9	5	6.3
England	-	-	-	-
Total	433	-	80	-

Table 4

PAINTERS ATTRACTING PRICES OF MORE THAN £ 40 AT AUCTION, 1711-59

1711-30

Country	No. above £40	% of Total	No. above £100	% of Total
Italy	27	50.0	10	62.5
France	4	7.4	2	12.5
Holland	12	22.2	2	12.5
Germany	2	3.6	-	-
Flanders	7	13.0	2	12.5
Spain	1	1.9	-	-
England	1	1.9	-	-
Total	54	-	16	-

1731-59

Country	No. above £40	% of Total	No. above £100	% of Total
Italy	49	47.1	17	48.6
France	13	12.5	5	14.3
Holland	23	22.1	4	11.4
Germany	4	3.9	1	2.9
Flanders	13	12.5	6	17.1
Spain	2	1.9	2	5.7
England	-	-	-	-
Total	104	-	35	-

Table 5

PICTURES FETCHING MORE THAN £40 AT AUCTION BY CATEGORY, 1711-59

1711-30

Country	2	3	4	5	6	7	8	9	10	11	12
Italy	-	1	3	1	1	3	6	8	2	1	1
France	-	-	-	-	-	-	2	1	1	-	-
Holland	-	-	-	-	-	-	4	6	2	-	-
Germany	-	-	2	-	-	-	-	-	-	-	-
Flanders	-	-	-	-	-	2	5	-	-	-	-

1731-59

Country	2	3	4	5	6	7	8	9	10	11	12
Italy	1	-	8	3	4	3	7	13	4	4	2
France	-	-	-	-	-	-	5	4	2	-	-
Holland	-	-	-	-	-	-	3	14	4	1	1
Germany	-	-	2	-	-	-	-	1	-	1	-
Flanders	-	-	-	-	-	2	1	1	2	-	-

Notes

Chapter 1: Introduction

1. James Millar (1706-44), *The Man of Taste* (London 1735) preface.
2. *Connoisseur*, no. 25, (18 July 1754).
3. E.A.Wrigley, 'A Simple model of London's Importance in changing English Society, 1650-1750', *Past and Present*, 37 (1967) pp. 44-50. F. J. Fisher, 'London as a centre for conspicuous consumption', *Transactions of the Royal History Society* 4th ser., no. 30 (1948) pp. 37-50. P. J. Corfield, *The Impact of English Towns 1700-1800* (Oxford 1982) especially pp. 66-81 and 168-85.
4. John Millar, *Observations concerning the Distinction of Ranks* (London 1771) pp. 186-7.
5. Samuel Fawconer, *A Discourse on Modern Luxury* (London 1765) pp. 7-8.
6. *Ibid.*, p. 15.
7. *Universal Spectator*, 28 October 1732. For a report on the courts of Honour see *Gentleman's Magazine* for 30 March 1732.
8. *Ibid.*
9. *Hist. Mss. Comm. Egmont Diary* (London 1920) vol. 1, p. 11.
10. Samuel Johnson, *The Rambler*, no. 187 (7 January 1752).
11. Written 20 March 1773; quoted in Iain Gordon Brown, 'Allan Ramsay's Rise and Reputation,' *Walpole Society* (1984) vol. 50, p. 211.
12. Philip Dormer Stanhope, Earl of Chesterfield, *Letters of the Earl of Chesterfield to his Son* (London 1929) letter from Dublin Castle, 19 November 1745.
13. G.C. Brauer, *The Education of a Gentleman: Theories of Gentlemanly Education in England 1660-1775* (New York 1959) esp. pp. 15, 36, 155. For a general look at education in this period see J. Lawson and H. Silver, *A Social History of Education in England* (London 1973) and Sheldon Rothblatt, *Tradition and Change in English Liberal Education* (London 1976) chapters 3 and 4.
14. For Johnson's view of Addison's role in attempting this, see his *Lives of the English Poets and a Criticism of their Works* (Dublin 1781) vol. 2, pp. 17ff.
15. J. L. Costeker, *The Fine Gentleman: or, the Complete Education a Young Nobleman* (London 1732) p. 5.
16. Stephen Philpot, *Essay on the Advantage of a Polite Education joined with a Learned One* (London 1747) pp. 52-3.
17. W. L. Ustick, 'Changing Ideals of Aristocratic Character and Conduct in Seventeenth-Century England',

Modern Philology, 30 (November 1932) pp. 147-66.

18. Chesterfield, *Letters* (undated - 1740?) p. 7 written from London.

19. *Universal Spectator* (28 October 1732).

20. Daniel Defoe, *An Essay upon Projects* (London 1697) p. 93ff and p. 232.

21. William Ramsay, *The Gentleman's Companion, or, a Character of True Nobility and Gentility* (1673) p. 2.

22. For an examination of the 'civilising' purposes of magazine literature in the eighteenth century, see R.W. Harris, *Reason and Nature in Eighteenth Century Thought* (London 1968) chapter 3; D. Daiches, *A Critical History of English Literature* (London 1960) vol. 3 pp.766-808, and G. S. Marr, *The Periodical Essayists of the Eighteenth Century* (London 1924) pp. 21-83.

23. *The Plain Dealer*, no. 38 (31 July 1724)

24. *Common Sense*, no. 272 (1 May, 1744); *Gentleman's Magazine* (1744) vol. 12, p. 247.

25. Oliver Goldsmith, *The Vicar of Wakefield* (1st edn., London 1766), printed in *Collected Works*, vol. IV, ed. Arthur Friedman (Oxford 1966) pp.101-2. A more comprehensive version of this theme can be found in the pages of the late eighteenth-century social campaigner Hannah More, particularly in her *Thoughts on the Manners of the Great* ...(London 1788). She is most concise in her *Strictures on the Modern System of Female Education* (London 1797) pp. 62-3: 'Most worth and virtue are to be found in the middle stations'.

26. Mark Girouard, *Life in the English Country House* (London 1978) p. 182.

27. *Ibid.*, p.183. On leisure see J.H. Plumb, *The Commercialisation of Leisure in Eighteenth Century England, The Stenton Lecture 1972* (Reading 1973) and *Georgian Delights* (London 1980). See also the series of articles in N. McKendrick, J. Brewer and J. H. Plumb, *The Birth of a Consumer Society; The Commercialisation of Eighteenth Century England* (London 1982).

28. *Egmont Diaries*, vol. III, p. 311.

29. Vertue, III p. 120 (1744) 'As I have for so many years. made observations on the works of the most eminent and remarkable Artists in their several kind of works in England, so I have spent no little Time to be acquainted with them in all Parts of the Town, especially, and at many several times & places, to see their works. & hear the sentiments of all persons...as this has been some loss of Time, also. The costs and expenses to get into companyes conversations Clubbs, has been a continual expence...'

30. Chesterfield, *Letters* (London, 7 August OS 1747) p. 33. For clubs see E. J. Bristow, *Vice and Vigilance: Purity Movements in Britain since 1700* (Dublin 1977); B. Rogers, *Cloak of Charity: Studies in Eighteenth-Century Philanthropy* (London 1949) pp. 1-25; Joan Evans, *The History of the Royal Society of Antiquaries* (Oxford 1956); John Timbs, *Club Life of London, with Anecdotes of the Clubs, Coffee houses and Taverns* (London 1866).

31. *Encyclopaedia Britannica* (London 1771), essay on Taste.

32. James Nelson (apothecary), *An Essay on the Government of Children, under three General Heads, viz; Health, Manners and Education* (London 1763, first edn. 1758) p. 319.

33. Fawconer, *A Discourse*, p. 15.

34. See Louise Lippincott, *Selling Art in Georgian London: The Rise of Arthur Pond* (New Haven and London, 1983) pp. 32-3.

35. Marcia Pointon, 'Portrait Painting as a business enterprise in London in the 1780s', *Art History*, 7 (June 1984) p. 188; Edwards, pp. 187-8.

36. Vertue, II, p. 123. One of the most successful artistic examples of this process comes with the somewhat obscure portraitist Robinson, who ploughed some of his income into giving his daughter Anastasia a properly genteel education which enabled her to meet, captivate and marry the (admittedly highly eccentric and unconventional) Earl of Peterborough in 1714. See anon., *Life of Charles Mordaunt, Earl of Peterborough*, 2 vols. (London 1853) pp. 174-7.

37. Edwards, p. 190.

38. Vertue, III, pp. 34-5, 81.

39. According to Vertue (III p.120) Soldi had considerable business but overspent, developed a 'high mind and conceptions grandisses' and ended up in Fleet prison for debt. He was an example of a painter assuming too much and suffering as a result. Vertue goes on to lament 'the only singular affectation of thinking himself above the dignity of a painter. In his birth or parentage will be a check on his diligence...he would rather have world believe he does them honour when he paints for them'.

40. *Common Sense* no. 93 (11 November 1738), for example, assaulted the 'absurd and ridiculous Imitation of the French, which is now become the Epidemical Distember of the Kingdom...'.

41. *Monthly Review*, 14 (January-June 1756) p. 269.

42. The best overview of the theoretical dimensions of the court/country split is in Isaac Kramnick, *Bolingbroke and his Circle* (Cambridge, Mass. 1968).

43. For a survey of the relationship between the city and the country see Wrigley, 'A Simple Model' and Fisher, 'London as a Centre'. For a more literary/sociological view, Raymond Williams, *The Country and the City* (London 1975) pp. 61-109. For a good view of urban (as opposed to metropolitan) civilisation see P. Borsay, 'The English Urban Renaissance:

The Development of Provincial Culture c.1680-1760', *Social History*, 5 (1977), pp. 581-603 and 'Cities, Status and the English Urban Landscape', *History*, 67 (February 1982) pp. 1-12.

44. *The Country Gentleman's Companion: Letters...from a Gentleman in London, to his Friend in the Country, wherein he passionately dissuades him from coming to London* (London 1699) p. 14.

45. *Connoisseur*, no. 78, (24 July 1755, reprinted London, 1756).

46. Jeremy Collier, *A Short View of the Prophaneness and Immorality of the English Stage* (London 1698), quoted in Speck, *Society and Literature in England 1700-60* (London 1983) p. 91.

47. *Appleby's Journal* (9 October 1731).

48. J.H. Plumb, *Sir Robert Walpole*, (London 1956) vol.1 pp. XI-XII.

49. Joseph Addison, *The Spectator*, no. 126 (25 July 1711).

50. 'Memoirs of Thomas Jones', *Walpole Society* (London 1946-8) vol. XXII, pp. 29-30.

51. As the Abbé J. B. Leblanc noted during his visits — see the frequent references to the English adoration of almost anything on four legs in his *Lettres d'un François* (La Haye, 1745).

52. Lord Chesterfield, *Letters* (London, 19 April, OS 1749).

53. For a more detailed examination of this topic of language, see John Barrell, *English Literature in History, 1730-80: An Equal, Wide Survey* (London 1983) pp. 110-75.

54. Horace Walpole, *Letters*, ed. W. S. Lewis, 48 vols. (New Haven and London, 1937-83), vol. 9, p. 350, to Montagu, 31 March 1761.

55. Fawconer, *A Discourse*, p. 9.

56. *Torrington Diaries 1781-1794*, ed. C. B. Andrews (London 1935) vol. II, p. 149.

57. *Essay*, introduction, p. XII.

58. For examples see Bernard Denvir, *The Eighteenth Century, Art, Design*

and Society 1689-1789 (London 1983) pp. 83-7.

59. Above all with the failed Peerage bill of 1719, which would have placed severe restrictions on the creation of new members of the House of Lords. See Dorothy Marshall, *Eighteenth-Century England* (London 1962) pp. 116ff and E. R. Turner, 'The Peerage Bill of 1719', *English Historical Review*, 28 (1913) pp. 243-59.

60. D. Andrews, 'Aldermen and the big Bourgeoisie of London considered', *Social History*, 6 (1981) pp. 359-64; N. Rogers, 'Money, Land and Lineage, The big Bourgeoisie of Hanoverian London', *Social History* 4 (1979) pp. 437-54 and E.P. Thompson, 'Eighteenth-Century English Society: Class Struggle without Class?' *Social History*, 3 (1978) pp. 133-65. For argumentative background on the issue see L. Stone, 'Social Mobility in England 1500-1700', *Past and Present* 33 (1966) pp. 16-35, which maintains that there was little, and W.A. Speck 'Social Status in Late Stuart England', *Past and Present,* 34 (1966) pp. 127-9 which disputes this view. Speck also lays out the various arguments about eighteenth-century England very concisely in his *Society and Literature,* pp. 41-93.

61. J. H. Plumb, *The Growth of Political Stability in England, 1675-1725* (London 1967). See also Lewis Namier, *The Structure of Politics at the Accession of George III* (London 1957), esp. pp. 16-24, 134-57. W.A. Speck, *Stability and Strife: England 1714-60* (London 1977) pp. 143-66.

62. R. W. Malcolmson, *Popular Recreations in English Society 1700-1850* (Cambridge 1973) p. 118.

63. Quoted in E. P. Thompson, 'Patrician Society, Plebian Culture', *Journal of Social History* (1973-4) p. 395.

64. For which see George Stubbes, *A Dialogue in the Manner of Plato on the Superiority of the Pleasures of the Understanding to the Pleasures of the Senses* (London 1734).

65. *Connoisseur,* no.120 (30 May 1756) The article begins with what is, perhaps, one of the best definitions of taste in the period: 'If you ask...what is taste, they will tell you that "Taste is a kind of a sort of a...in short, Taste is Taste." '

66. This is quoted in E.W. Manwaring, *Italian Landscape in 18th Century England,* 2nd edn. (London 1965) p. 27; also in J. T. Boulton's introduction to Edmund Burke, *An Essay on the Sublime and the Beautiful* (London 1958) p. xxvii.

Chapter 2: Taste

1. The subject of taste has aroused interest in both general and literary historians at periodic intervals. This chapter, although it differs frequently from many of the interpretations that have been put forward at various dates, nonetheless owes a good deal to many of them. If there are few specific references to be made in the following pages then the following have nonetheless been found useful: E. N. Hooker, 'The Discussion of Taste from 1750-70 and new Trends in Literary Criticism', *Proceedings of the Modern Library Association of America* (June 1934), pp. 577-92. J. Stolnitz', "Beauty": some stages in the history of an idea', *Journal of the History of Ideas* vol. 22, no. 2 (April/June 1961) pp. 185-204. R. W. Babock 'The Idea of Taste in the 18th Century', *Proceedings of the Modern Language Association of America,* 50 (1935), pp. 922-6; A. O. Lovejoy, 'Nature as aesthetic norm', *Modern Language Notes,* vol. 42, no.7 (November 1927) pp. 444-5. K. E. Gilbert and H. Kuhn, *A History of Aesthetics* (New York 1939), pp. 233-67. Leo Lowenthal, *Literature, Popular Culture and Society* (Palo Alto 1961) pp. 52-108. John Pittock, *The Ascendancy of Taste* (London 1973) and Rothblatt, *Tradition,* chapter 6.

For bibliographies, see J. W. Draper, '18th Century English Aesthetics: a Bibliography',*Anglistische Forschungen*, no. 75 (Heidelberg 1931) and W. D. Templeman, 'Contributions to the Bibliography of 18th-Century Aesthetics', *Modern Philology*, 30, no. 3 (February 1933) pp. 309-16. See also H. V. S. and M. S. Ogden, 'A Bibliography of 17th-Century writings on the pictorial arts in English', *Art Bulletin*, 39 (1947) pp. 196-201 and also, *English Taste in Landscape*, pp. 5-15, 76-84. The monumental, but unfortunately untranslated, work by Johannes Dobai, *Die Kunstliteratur des Klassizismus und der Romantik in England, 1700-1840* (Bern 1974-7) can also be pillaged for both bibliographic and general details.

2. For an overview of Shaftesbury's aesthetics see J. A. Bernstein, 'Shaftesbury's Identification of the Good with the Beautiful', *Eighteenth Century Studies*, 10, no. 3 (Spring 1977) pp. 304-25. See also J. Stolnitz, 'On the Significance of Lord Shaftesbury in Modern Aesthetic Theory', *Philosophical Quarterly* (1961) vol. XI, pp. 9-113.

3. For an examination of this topic, see Ronald A. Knox, *Enthusiasm: A Chapter in the History of Religion with Special Reference to the Seventeenth and Eighteenth Centuries* (Oxford 1950).

4. *Leviathan, or the Matter, Form and Power of a Commonwealth, Ecclesiastical and Civil* (London 1651). See also John Bowle, *Hobbes and his Critics: a Study in 17th-Century Constitutionalism* (London 1951) and S. I. Mintz, *The Hunting of Leviathan: 17th Century Reactions to the Materialism and Moral Philosophy of Thomas Hobbes* (Cambridge 1962) pp. 63-147.

5. See Locke's *Essay concerning Humane Understanding* (Oxford 1894) vol. 1, pp. 471-85, vol. 2, 226-44, 341-62. The best survey of the English 18th-century philosophers is

probably D. D. Raphael, *British Moralists 1650-1800*, 2 vols. (Oxford 1969). See also R. W. Harris, *Reason and Nature*, chapter 2.

6. See G. Pitcher, *Berkeley* (London 1977) pp. 65-85, 110-24; I. C. Tipton, *Berkeley, the Philosophy of Immaterialism* (London 1974) pp.179-255 and C. D. Broad, 'Berkeley's denial of material substance' in *Locke and Berkeley, a collection of critical essays*, ed. C. B. Martin and D. M. Armstrong (London 1968) pp. 255-83.

7. Anthony Ashley Cooper, 3rd Earl of Shaftesbury, *Characteristicks of Men, Manners, Opinions, Times* (5th ed., Birmingham 1773). Shaftesbury's main discourse on morality is contained in vol. 2, Treatise IV, *viz* 'An Inquiry concerning Virtue, or Merit', pp. 5-176.

8. Francis Hutcheson, *A Short Introduction to Moral Philosophy, in three books; containing the Elements of Ethicks and the Law of Nature* (Glasgow 1747) p. 21.

9. Locke, *Essay,* section 4, 18/4 quoted in B. Willey, *The Seventeenth-Century Background* (London 1979) p. 253.

10. For a general survey of Hume's thought, see J. J. Richetti, *Locke, Berkeley and Hume* (Cambridge, Mass. 1983) pp. 183-263, and G. R. Cragg, *Reason and Authority in the 18th Century*, (Cambridge 1964) p. 125.

11. Adam Smith, *The Theory of Moral Sentiments* in *Works* (London 1812) vol. I, pp. 219-21.

12 David Hume 'On the Standard of Taste'; Chapter 23 of *Essays Moral, Political and Literary* (London 1741/2, repr. Oxford 1963) pp. 231ff.

13. On aesthetics generally in the early 18th century in England see M.C. Beardsley, *Aesthetics from Classical Greece to the Present: a Short History* (University of Alabama 1982) pp. 166-208.

14. For Pope see above all, *Essay on*

Criticism (1711) in *Complete Works* (London 1871), vol. 3. For Alexander Gerard, *An Essay on Taste* (3rd edn. 1780, reprinted Florida 1963) p. 250.

15. John Gilbert Cooper, *Letters concerning Taste* (London 1755) pp. 1-25. *Encyclopaedia Britannica*, essays on Taste, Beauty and Criticism.

16. Anon., *A Discourse Concerning the Propriety of Manners, Taste and Beauty* (London 1751) pp.1-2. Anon., *The Female Spectator* (London 1745) vol. 3, Book 15, pp.127ff.

17. Francis Hutcheson, *An Inquiry into the Original of our Ideas of Beauty and Virtue, in two volumes* (2nd edn. London, 1726) pp. 7-9.

18. Hume, 'On the Standard of Taste' in *Essays, Moral, Political and Literary* (London 1741/2) p. 232.

19. *Ibid.*, p. 234.

20. For the rules, see M. C. Beardsley, *Aesthetics*, pp.142-51, and P. Hazard, *European Thought in the Eighteenth Century* (London 1965) pp. 234-5.

21. Addison, *Spectator*, no. 291 (1712).

22. Hume, *Standard*, p. 237.

23. (Allen Ramsay), *The Investigator* (London 1762) essay 4 on taste, p. 55. Anon., *A Discourse...*, p. 6.

24. Gerard, *Essay*, p. 10.

25. Hume, *Standard*, p. 240.

26. *Ibid.*, p. 242-3.

27. The insistence on fairness in matters of social evaluation is a common theme in all writings, whether they be on taste, education or courtesy. The educational writer James Nelson, for example, insisted for this reason that manners should be more important than education or birth — 'Why? Because these are not in our Power to choose.' *An Essay on the Government of Children* (London 1763) p. 318.

28. Hume, *Standard*, p. 244.

29. *Ibid.*, pp. 244-5.

30. *Ibid.*, p. 251.

31. Anon., *A Discourse*, p. 11.

32. Thomas Sheridan, *British Education, or the Source of the Disorders of Great Britain* (London 1756) pp. 24-5.

33. *Encyclopaedia Britannica*, entry on Taste.

34. Marshall Smith, *The Art of Painting*, pp. 2-3.

35. John Gwyn (d.1786), *An Essay on Design, including Proposals for Erecting a Public Academy*. (London 1749) pp. 65-6.

36. Smith, *The Art of Painting*, p.15. William Aglionby, *Painting Illustrated in three Diallogues; Containing some choise Observations upon the Art; together with the Lives of the most Eminent painters from Cimabue to the Time of Raphael and Michael Angelo* (London 1685) preface.

37. J. Richardson, *An Argument in Behalf of the Science of a Connoisseur*, in *Two Discourses* (London 1719) pp. 33-4.

38. George Stubbes, *A Dialogue in the Manner of Plato* (London 1734) pp. 61-2.

39. Joseph Highmore, *Essays Moral, Religious, Political and Miscellaneous*, 2 vols. (London 1766) vol. 2, p. 87.

40. (Charles Bramston), *The Man of Taste, by the Author of the Art of Politics* (London 1733).

41. Richardson, *Science of a Connoisseur*, pp. 39-40.

42. C. du Fresnoy, *De Arte Graphica, translated...by Mr Wills, with notes miscellaneous and explanatory* (London 1754) note to line 24. See also: 'A Sermon on Painting preached before the Earl of Orford at Houghton', published in Horace Walpole, *Aedes..*, 'painting itself is innocent: no art, no Science can be criminal'.

43. John Phillips, *The Reformation of Images: the Destruction of Art in England 1535-1665* (Berkeley 1973) pp. 201-10.

44. George Salteran, *A Treatise against Images and Pictures in Churches* (1641) pp. 11-12.

45. Robert Wolseley, *Preface to Valentinian* (1685), printed in J. E. Spingarn, *Critical Essays of the 17th Century*, 3 vols. (Oxford 1908-9). For a general bibliography of works on the question of decency at the end of the 17th century see W. D. Templeman, 'Contributions'.

46. See, for example, Francis Haskell, *Rediscoveries in Art* (London 1976) p. 72.

47. J. G. Cooper, *Letters*, p. 55.

48. *Hist. Mss. Comm. Buccleuch-Whitehall*, vol. II, p. 695. For a more general account of Shrewsbury's stay in Rome, see T. C. Nicholson and A. S. Turberville, *Charles Talbot, Duke of Shrewsbury* (Cambridge 1930) pp. 143-61.

49. *Bodleian Mss. North b.17 f.27*, pictures sent to Arthur Moore 1710/11.

50. *A Descriptive Catalogue of a Collection of Pictures selected from the Roman, Florentine, Lombard, Venetian, Neapolitan, Flemish, French and Spanish Schools...* (belonging to Robert Strange) (London 1769).

51. John Gwyn, *London and Westminster Improv'd* (London 1766) pp. 26-7.

52. Alexander Browne, *Ars Pictoria; or, an Academy treating of Drawing, Painting, Limning and Etching* (1669). Prefatory poem signed J.H. and P. Fisher:
We know no form of Angels but from Paint,
Nor difference make of Devil, or of Saint,...
T'is then hop'd by the Painter at the least
He may assistant be unto the Priest.

53. *The Case concerning the setting up of Images, or painting of them, in Churches:- Thomas Barlow, late Bishop of Lincoln, upon the occasion of his suffering such images to be defaced in his diocese...published upon the occasion of a painting being set up in Whitechapel Church* (London 1714).

54. *Ibid.*, and *The Diary of Mary,* *Countess Cowper*, ed. C. S. Cowper (London 1864) p. 92, entry of 7 March 1716.

55. R. Paulson, *Hogarth, his Life, Art and Times* (New Haven 1971) vol. I, pp. 270-8. M. Jourdain, *The Works of William Kent* (London 1948) p. 38.

56. *A Letter from a Parishioner of St Clement Danes to...Edmund Ld. Bp. of London, occasion'd by his Ldsp's causing the Picture, over the Altar, to be taken down* (London 1725) p.10. See also the *Flying Post*, 4-7 September, 1725 and the *Postboy* and *Daily Journal*, 4 September.

57. *Ibid.*, introduction.

58. *Ibid.*, p. 7. The painting was eventually removed to a less conspicuous part of the church and destroyed by bombing in 1940.

59. (W. Hole) *The Ornaments of Churches considered, with a particular View to the late Decoration of the Parish Church of St Margaret Westminster* (Oxford 1761).

60. Thomas Newton, *Works* (London 1782) 'Life of Dr Newton, Bishop of Bristol, by himself' (preface).

61. J. Galt, *The Life and Works of Benjamin West* (London 1820) vol. 2, pp. 53-4.

62. For a general look at painting in churches in the 18th century, see B. F. L. Clarke, *The Building of the 18th Century Church* (London 1963) pp. 170-1, and see below, chapter five.

63. William Shenstone, 'On the Test of Popular Opinion' in *Works* (London 1764) vol. 2, pp. 8-12.

64. *Gentleman's Magazine*, 27 (1757) p. 591, letter dated 22 December.

65. Joseph Highmore, *Essays* vol. 1, p. 196.

66. *Penny London Post, or the Morning Advertiser*, 29 September — 2 October 1749, quoted in H. M. Atherton, *Political Prints in the Age of Hogarth* (Oxford 1974) p. 77.

67. *Old England, or, the Constitutional Journal*, 30 March 1745. Quoted in Atherton, *Political Prints* pp. 77-8, who goes on to give several examples of the government's sporadic and none too effective efforts to wipe out pornography.

Chapter 3: The Art Market

1. See for example, *Badminton Mss (The Red Book) no. 21*: 'a list of pictures sold by Mr Fletcher and valued by Mr Vosterman, Mr Kerseboom and Mr Wyck, approved of by Sr Peter Lely' (n.d. but presumably 1670s) the list gives 36 pictures valued at £300.1s.
2. See Alessandrio Luzio: *La Galleria dei Gonzaga venduta all'Inghilterra nel 1627-1628* (Milano 1913).
3. A great deal has been written about Charles' collections and their dispersal. For catalogues of the works and the names of the initial buyers, the *Walpole Society* (London 1970-2) vol. 43 gives a complete reprint. See also the introduction by Oliver Millar pp. xi-xxv and George Redford, *Art Sales: a History of Sales of Pictures & other Works of Art*, 2 vols. (London 1858) p. 22.
4. See Pepys' *Diary* for 19 November 1660, 21 November 1660, 26 December 1663, 18 April 1666.
5. Perhaps the most succinct comment of all was that of Hadrian Beverland: T'is easier to conquer Dunkirk than to get a good picture...' — *Hadriani Beverlandi Patrimonii sui Reliquae* (London 1711) introduction.
6. The sale of the Arundel collection took place on the 26 February 1684. See G .Hoet, *Catalogus of naamlijst van schilderijen met derselver prijsen*, 2 vols. (Amsterdam 1752) vol. I, p. 1. More of the pictures were sold in London in the 1720s, see Earl of Stafford sale, (nd) Stafford House, Petty France, Westminster. I am grateful to Francis Haskell for drawing my attention to the only extant

copy of the sale which is in the British Museum. See also David Howarth, *Lord Arundel and his Circle* (New Haven and London 1985) for the social and political setting of Arundel's collection. For sale of the Buckingham collection see J. Stoye, *English Travellers Abroad, 1604-67* (London 1952) pp. 92-4.

7. See F. Haskell, *Patrons and Painters, Art and Society in Baroque Italy* (London 1963) especially chapter 7. See also F. Haskell, 'The Market for Italian Art in the 17th Century', *Past and Present* (April 1959) pp. 48-59 and L. Stone, 'The Market for Italian Art', *Past and Present* (November 1959) pp. 92-4.
8. The laws in question seem to have been 3 Edw. IV.4 - 'certain merchandise not lawful to be brought into the Realm of England...from foreign parts to be uttered or sold...(int. al.) ...and painted ware' and *1 Rich. III.12* 'no merchant stranger shal import...painted glasses, painted paper, painted forces, painted images, painted cloths' see *The Act of Tonnage and Poundage and Book of Rates* (London 1682) p. 262.
9. *Calendar of State Papers: Treasury Books 1669-72*, 5 September 1672, p. 1303.
10. *Ibid.*, 1685-9, vol. 1, pp. 226, 269; vol. 2, pp. 602, 669.
11. *Ibid.*, 1681-5, 18 October 1681, p. 275; 1685-9, p. 487. vol. 2, p. 657.
12. Roger North was amongst those who picked up a few pictures in this way, although no other records of such sales seem to survive. For Roger North's purchases see his catalogue of pictures, *BM Add Mss 32504*, ff.1-74: 'Bought by D[udley] N[orth] at ye custome house for 2 gn. wch I pay'd: A Mdna after Van Dyke A Sacra Familia after a french print from Rafael Another from a print A offering of ye three kings after a print These are of very little value...had

good guilt frames, which pay'd ye price.'

North had a collection of nearly 200 pictures which he kept in his chambers in London, and then moved to his country seat at Rougham in Norfolk, which he modified to take a picture gallery. It seems that the pictures were sold in the 1740s, although the sale catalogue does not appear to have survived. Some few of the pictures may have passed into the Holkham collection, through the agency of John Blackwood, although it is impossible to discover which ones. I am grateful to Dr W. O. Hassell and Mr John Guinness for this information. See also the *Autobiography of Roger North*, ed. A. Jessop (London 1887) pp. xxiv-vi, xlv-lvii.

13. *Hist. Mss. Comm. 9th Report*, part 2, p. 34.

14. 11 May 1686, Lugt no. 8. Lugt states that there are two copies of this sale, one in the British Museum and one in the Ashmolean. As far as can be seen, the BM copy was destroyed, possibly during the war, and the Ashmolean copy is now in the Bodleian. For more on Manby see below p. 72.

15. There is a unique collection of early English sale catalogues from this period in the BM. For greater detail concerning them, see H. V. S. and M. S. Ogden, *English Taste in Landscape in the 17th Century* (Ann Arbor 1955) pp. 86-92 which briefly discusses early auctions.

16. *Cal. Treas. Bks. 1679-80*, p. 40, 30 April 1670. Williams received his 28 pictures and two marble heads on 31 July, p. 160.

17. *Journal of the House of Commons*, 3 April 1695, vol. 11, p. 292, para. 11 'Ways and Means for Raising Supply: ...a duty of 20 per cent ad valorem to be lain on all pictures imported...'.

18. *12 Wm. 3, 19 June 1701, Lords' Journal*, vol. 16, p. 758; 'An Act for granting to His Majesty several duties upon low wines...and continuing

several duties upon coffee, tea...pictures...', see also *6 Anne, Lords' Journal*, vol. 18, pp. 566-77.

19. Vertue III, p. 9. For an account of these catalogues, which is, however, partially inaccurate on the early developments, see Denys Sutton, 'Aspects of British collecting, part one', *Apollo*, 114, no. 237 (November 1981) pp. 298-339.

20. *8 Geo.1 4 Feb. 1721, Lords' Journal* vol. 21; renewed in *11 Geo.1 12 March 1724, Lords' Journal* vol. 22. To give an idea of the essentially artisanal attitude taken towards painting until late in the 17th century, the bill suggested in 1673, when it made its brief appearance in Parliament, was entitled 'Manufacturers (English) Bill - act for encouraging the manufacturers of England' (*Lords' Journal*, vol. 12, 7 June 1673).

21. *P. R. O. Cust. 3* series.

22. Greater details for the earlier period are given in J. Denucé, *Art exports in the 17th Century in Antwerp (Sources of the History of Flemish Art vol. 1)* (Antwerp 1931). Only one dealer, John Blackwood, has been noted operating in Spain, mentioned as a trader who also imported works from Holland. Edwards p.170. Blackwood held many sales, particularly in the 1750s.

23. There was the occasional sale of pictures from Spain, for example the one held by Cock in 1731, a transcript of which is in *V&A Mss* 86-00-18/9. Whether this one was genuine or not is however another matter — certainly the importation figures do not suggest that enough pictures arrived from Spain in this period to make a complete sale.

24. For details see A. Emiliani, *Leggi, Bandi e Provvedimenti per la Tutela dei Beni Artistici e Culturali negli Antichi Stati Italiani, 1571-1860* (Bologna 1978).

25. Horace Walpole's letters detail some of the buying activities of his father

in Italy, *cf.* especially *Letters* to Horace Mann, vols. 17 and 18, passim.

26. Vertue, II, p. 93. Jervas' account of the affair in which, according to Vertue, he threatened to have the Royal Navy blow up the Citta' Vecchia, is contained in a letter to the Bishop of Lichfield and Coventry, 24 February 1703, *Bodl. Ms Eng.Lett.* c.275 ff.18-19.

27. *Nollekens and his Times;* vol. 1, p. 212.

28. Jonathan Richardson, 'Argument in Behalf of the Science of a Connoisseur' in *Works* (London 1773, reprinted in Hildesheim 1969) p. 273.

29. For Pond, see Lippincott, *Selling Art.* For Smibert see H.W. Foote, *John Smibert, Painter*(New York 1969) and ed. Sir David Evans, *The Notebook of John Smibert* (Boston 1969).

30. J. Dennistoun, ed., *The Memories of Robert Strange,* 2 vols. (London 1855) vol. 1, p. 32.

31. K. E. Ingram, *Sources of Jamaican History, 1655-1838* (Zug, Switzerland 1976) vol. 2, pp. 946-7. See also entry in Sir William Musgrave, *Obituary prior to 1800...6* vols., ed. Sir George Armytage, *Harleian Society* (London 1899-1901) vols. 44-9.

32. According to the auctioneer Edward Millington this was done at the instigation of the Revd J. Hill; see his letter to Hill at Rotterdam, dated 25 June 1697, *BM Stow* 747 f.76.

33. *Notes and Queries* 7. 8. 477; 7.10.93. For Outroping see the *Oxford English Dictionary* and *Notes and Queries* 5.12.95.

34. Scottish Records Office, *Clerk of Penicuik* papers, GD18/4653.

35. See above, note 15.

36. *London Gazette,* no.2404, 24 November (announcement dated 18 October).

37. T. Borenius, with H. and M. Ogden: 'Sir Peter Lely's collection', *Burlington Magazine',* 83 (August 1943) pp. 185-9 and 84 (June 1944) p. 154. For fuller details of Lely sale see *BM*

Add. Mss. 16174 f.37v.

38. The most complete description of the French art market is contained in P. Savary, *Dictionnaire Universelle de Commerce* (Copenhagen 1762) under such terms as Hussieur-Priseur, Vente, etc. See also Krzystof Pomian, 'Marchands, Connoisseurs, et Curieux à Paris au XVIIIe siècle' in *Revue de l'Art,* 43 (1979) pp. 23-35. For further comparison, a very good summary of the Dutch art market appears in Clara Bille, *De Tempel der Kunst of het Kabinet van den heer Braamcamp* (Amsterdam 1961) pp. 236-8, while Michael Montias, in *Artists and Artisans in Delft* (Princeton 1982) pp. 183-219 deals with a specific study for a slightly earlier period.

39. For the outroper's rates see *Guildhall Small Mss Box 35/15* and 6/14. The rates for other auctioneers can be found in virtually every sale catalogue.

40. *London Gazette,* nos 2654 (5 May, Lugt no.95); 2678 (22 July); 2704 (22 October, Lugt no.111); 2721 (16 December); 2733 (26/7 January); 2748 (17 March, Lugt no.134); 2750 (23 March, Lugt no.135).

41. The last reference to Verryck is in a sale advertised in the *London Gazette,* 2923 for 21 November 1693.

42. *Hist. Mss. Comm. House of Lords Mss. p. 303.*

43. *Guildhall Small Mss.,* Box 35 no.15 dated June 1692.

44. *Ibid.,* Box 6 no. 14 dated 30 March 1710 and 6 June 1710.

45. See for example, Edwin Ward (?) *The Auction, or the Poet turn'd Painter* (n.d. but probably around 1695) and the anonymous *A Satire against painting in Burlesque Verse: Submitted to the Judicious by an Eminent Hand* (n.d. but copy in BM dated in m/s 20 March 1696/7).

46. Millington's address prefaces his auction dated 19-21 March 1689/90

(Lugt no.38).
47. For Millington see P. Ash 'Edward Millington' in *Estates Gazette* (6 Jan. 1962). On early auctions see Redford, *Art Sales*, pp. 23-7, and R. Parkinson, 'The first kings of Epithets' *Connoisseur* (April 1978) pp. 269-73.
48. Vertue, V, pp. 85-6.
49. Millington was still alive in 1704, Ash, 'Edward Millington.' His last recorded sale of pictures was on 4 May 1699 (Lugt no.170) but he stopped giving art sales regularly in 1693.
50. Redford, *Art Sales*, pp. 23-7.
51. *Notes and Queries*, series 7, no. 8, p. 384.
52. Vertue, II, p. 29.
53. ie. Bedford Gate, York St, Covent Garden, an address given on the sale catalogues and in M[arshall] S[mith]'s book *The Art of Painting, according to the Theory and Practice of the best Italian, French and Germane Masters* (London 1692).
54. Walton's recorded sales were 16 April 1688, Peter Lely (advertised in *London Gazette* no.2321); 24 January 1688/9, Earl of Arundel (L.G. 2409) 19 January 1691/2 Henry, Duke of Norfolk (L.G. 2730); 27 January 1691/2 Duke of Norfolk (L.G. 2734) 25 February 1691/2 John Riley (L.G. 2741); 7 April 1692 Riley continued (L.G. 2754). For the Lely sale see above note 35.
55. ed. E. M. Thompson, *The Correspondence of the Family of Hatton*, 2 vols., *Camden Society* (London 1878) letter dated 7 March 1691/2, vol. 2, pp. 171-2.
56. For Langford, for example, see *Biographica Dramatica* (1812) vol. 1, part 2, p. 444. Thomas Mortimer, *The Universal Director; or the Nobleman's and Gentleman's True Guide to the Masters and Professors of the Liberal and Polite Arts and Sciences, and of the Mechanic Arts, Manufactures...established in London and Westminster and their Environs*

(London 1763) part III, p. 92. Mortimer set himself up in a prolific business acting as a guide through the more complex by-ways that England's rapidly evolving society was developing; among his other works was an explanatory *Elements of Commerce* (London 1772) and *Every man his own Broker; or, a Guide to Exchange Alley* (London 1761).
57. *Catalogue of the dwelling House of the Rt. Hon. General (Wm.) Stuart, (deceased)* 14 April 1730 in Bodleian Library Johnson collection d778. The sale contained his pictures as well as those of the financial swindler John Law and Sir John Holland.
58. Papers examined were, *St James Evening Post; Postman; Postboy; Weekly Journal; Whitehall Evening Post; London Evening Post; Daily Postboy; Weekly Miscellany; Thursday's Journal; Flying Post; Evening Post; Daily Post; Churchman; Universal Spectator; Country Journal.*
59. R. Campbell, *The London Tradesman* (London 1747) p. 175.
60. *Alscot Mss.* Box 13: Ford to James West, 24 August 1741. West was appointed receiver of Oxford's estate and as a result prepared the sale of the art collection, considerable details of which can be found in the executor's accounts. A full contract for conducting the sale was made out for Christopher Cock on 20 September 1741.
61. There is solid evidence for it being used only once in the 1680-1760 period, at the Edwin sale of 1749/50, *V&A Mss.* 86-00-18/9, vol.1, pp.128-9. The term only begins to appear in auctioneering manuals towards the end of the 18th century.
62. Anon., *The Taste of the Town* (London 1731) p. 232.
63. *BM Lansdowne Mss.*, 1215 f.161.
64. W. T. Whitley, *Thomas Gainsborough* (London 1915) pp. 275-81.
65. *2 Esp. 572 1796.* See Joseph Bateman,

The Law of Auctions (London 1838) p. 341.

66. G. Burden, 'Sir Thomas Isham, an English collector in Rome in 1677-8' *Italian Studies* (1960) pp. 1-25.

67. E. K. Waterhouse, 'A Note on British collecting of Italian Pictures in the late 17th Century', *Burlington Magazine*, 60 (1960) pp. 54-8. See also *Exeter (Burghley) Mss* 51/9-10-18 in Northamptonshire records office.

68. R. W. Ramsay, *Studies in Oliver Cromwell's Family Circle* (London 1930) pp.79-117 passim. See also inventory of Fauconberg's paintings - 'A Note of Pictures taken in 9ber 1684' *BM Add Mss* 41255 ff.109-10.

69. H. Bunker Wright and H. C. Montgomery, 'The Art Collection of a Virtuoso in 18th Century England', *Art Bulletin* (1945) vol. 27 pp. 195-204, 'Inventory of Mr Prior's pictures taken the 18th October 1721', *BM Lansdowne Mss* 1050.

70. ed. J. J. Cartwright, *The Wentworth Papers* (London 1882). Letter to Lady Bathurst January 26. See also details of Raby's importation of pictures in *Cal. Treas. Books* (1713), January 26 1712/13, p. 93.

71. Schaub's collection appears to have attracted little attention until it was sold in 1758. About the only reference to its existence, and not a very flattering one, is by Walpole in a letter to Horace Mann dated 10 May (February?) 1758 *Letters*, vol. 21, p. 198-9. See also Vertue, V, 76.

72. Haskell, *Patrons and Painters*, pp. 299-310.

73. Daniel Defoe, *The Compleat English Gentleman;...edited for the first time from the author's autograph manuscript in the British Museum*, by Karl D. Buelbring (London 1890) pp. 33-4.

74. For this tour, which is probably one of the best documented in the first part of the century, see Edward Wright, *Some Observations made in Travelling through France, Italy, etc..., n 1720, 1721, and 1722*

(London 1730) as well as the mss collection of letters in *BM Stowe Mss* 750.

75. See their entries in the *Dictionary of National Biography;* see also Waterhouse, 'A Note on British collecting'.

76. I. Pears, 'Patronage and Learning in the Virtuoso Republic: John Talman in Italy 1709-12', *Oxford Art Journal*, 5, no.1 (1982) pp. 24-30.

77. ed. W. Coxe, *The Private and Original Correspondence of the Duke of Shrewsbury* (London 1821). Letter to Lord Somers, June 1704, p. 642; Somers to Shrewsbury 21 July 1704, p. 643 Somers to Shrewsbury, 5 October 1704, p. 644; Halifax to Shrewsbury, 24 July 1705, p. 652; Halifax to Shrewsbury, Autumn 1705 p. 655. *Hist. Mss. Comm. Montagu (Whitehall) II, ii,* vol. 45, pp. 662ff.

78. *Bodleian Mss Rawl. d. 1162* f.7: Kent notebook, August 1715, 'Bt for Ld Somers 2 of Albanos from Pallace Siacchete...cost 400 roman crowns...a fine landskip of Paul Bril...120 crowns...' Walpole, *Letters*, vol. 13, p. 214, notes the Saccheti collection on sale in Rome in 1740; in *Aedes* he notes it was bought by Pope Benedict XIV.

79. B. Rand, *The Life, Unpublished Letters and Philosophical Regimen of Anthony, Earl of Shaftesbury, Author of 'the Characteristics'* (London 1900) pp. 465-96.

80. R. W. Ramsay, *Studies...,* pp. 133-4.

81. *Cal. State Papers (Domestic) 1672,* p. 463, Southwell to Williamson, 9 August.

82. See note 79.

83. Pears, 'Patronage'; *Bodleian Mss Eng. Lett. e34* f.138, Talman to Madox, 5 July 1710.

84. Rand, *The Life,* p. 468, Shaftesbury to Croply 16 December 1712. For details of Shaftesbury's activities in London see *P. R. O. 30/24/46a/84.* See also E. Wind, 'Shaftesbury as a Patron of Art', *Journal of the War-*

burg and Courtauld Institutes, 2 (1938-9) pp.185-8 and B. Croce 'Shaftesbury in Italia' *Uomini e cosa della vecchia Italia* (Bari 1927), pp. 272-304. Edward Wright, *Some Observations,* p. 295-6 — about the Pallavicini collection in Rome, seen in 1720, he remarked 'some of the painting and sculpture have since been brought into England...', but gives no further details. Sir Robert Walpole's Marattis came from this collection (vide *Aedes*) but it is uncertain when they arrived.

85. M. F. S. Hervey, *The Life, Corre - spondence & Collections of Thomas Howard, Earl of Arundel* (Cambridge 1921) pp. 267-80, 382-95.

86. *Cal. Treas. Papers 1681-5* vol.1, p. 1415, 27 November 1684, 'list of 3 boxes and 2 packets of pictures for Charles Fox, paymaster General, laden at Antwerp by Henricius Lankrind'. For further references to Fox see Vertue, V, p. 64.

87. John Earl of Sunderland employed Thomas Jocson (Jackson?) in 1665 to buy pictures for him. What — if anything — was bought in this way is not known. There are three letters from Jocson in *BM Blenheim loan E5.4*, dated 13 June, 2 August and 12 December 1665.

88. One of the very few exceptions to this is the case of Nathanial Curzon, who commissioned the dealer William Kent to buy some 29 pictures for him in Italy in 1758. However it is likely that Kent, who held frequent auctions in London at this period, was also buying on his own behalf. See Leslie Harris, 'The Picture Collection at Kedleston Hall', *Connoisseur,* 198 no.797 (July 1978) pp. 208-17.

89. For Thomas Roe, see his *Letters from Constantinople* (London 1740). For the best example of the disadvantages of having a crooked agent, see the affair of the Duke of Beaufort and Mr Phillips, written up by S. Sitwell in 'The Red Book', in *Sing High, Sing Low* (London 1944) pp. 38ff. The

Red Book, which contains details of the legal case against Phillips is in the Mss of the Duke of Beaufort, Badminton House, Gloucs. A copy of the sale of the stolen pictures is in *V&A Mss* 86-00-18/9.

90. Lugt no. 8, 11 May 1686. Little is known of Manby as a painter, but there is one landscape by him in the Victoria and Albert Museum, for which information I am grateful to R. Parkinson.

91. Walpole, *Anecdotes of Painting in England,* ed. J. Dalloway and N. Wornum (London 1888) vol. 2, p. 129. Manby, who died in 1695, may have been a partner of the sculptor Edward Pierce in a picture dealing business after his sale. E. Croft-Murray and P. Hulton, *The British Museum: Catalogue of British Drawings* (London 1960) vol. 1, entry under Manby.

92. *A Catalogue of Original Pictures, Of several Excellent Masters, brought by Mr Closterman out of Italy* ... sold 26 December 1702. (Not in Lugt. A copy is to be found in the Getty Library, Santa Monica). The sale consisted of 89 pictures with the highlight being a *Virgin and Child* by Guido Reni.

93. Graham seems to have held at least three sales, with catalogues for two surviving. One (6 March 1711/2 is in *Hist. Mss. Comm. 43, Somerset and Buccleuch,* p. 204. A second (dated 12 March 1712/13) is in the *Chatsworth Mss,* 134.0. A letter from him to the Duke of Portland 'enclosing a catalogue' and dated 16 July 1713 is in PW2 HY 941 of the *Portland Mss.*

94. *Spectator,* no. 67, 17 May 1711.

95. Lord Burlington bought: F. Laura, *Landscape, with Fisherman drawing Nets* — £73.10s. , lot 31; Rosa of Tivoli, *Shepherd's Boy with Cattle* 17 gns, lot 46; Wouvermans, *Horses,* £16.13s.9d. lot 17; Gaspar Poussin, *Landscape with Building,* £35.4s.6d., lot 20. The Duke of

Portland bought Claude, *Landscape, Evening, Temple of Bacchus*, £210, lot 45. There were two Claudes in the Portland sale of 1722, the most complete annotated copy of the catalogue being at Chatsworth Mss 134.2. Both are described solely as 'Landscape and Figures'. The first, lot 137, went to the Duke of Bridgewater for £210 and the second to the Earl of Scarborough for £294. Whoever bought it, the painting next turns up in the Methuen collection and is now in the National Gallery of Canada, Ottawa as *The Temple of Bacchus*. It was engraved by Byrne in 1769. Other buyers at the Graham sale included Lord Rutland, Andrew Fountaine and Robert Child.

96. E. W. Manwaring, *Italian Landscape*, p. 64.

97. Badminton House Mss, *The Red Book.*

98. Vertue, III, 87, 95. J. Kenworthy Browne, 'Matthew Brettingham's Rome Account Book 1747-54' in *Walpole Society* (1983), vol. 49, pp. 37-132. The practice of hiring people to bid dated from the earliest of auctions, and was recommended by Charles Bertie to the Countess of Rutland for the 1682 Lely sale. *Hist. Mss. Comm. Rutland II*, letter dated 8 April 1682.

99. John Howard bought a wide variety of paintings at a number of sales in the first half of the century. It was probably he, rather than the connoissour Hugh Howard, who acted for the 2nd Duke of Devonshire at the 1722 Portland sale, and bought: lot 62 — Titian, *Holy Family*, £126 (Chatsworth no. 667 after Titian — *Holy Family with Infant St John and a Lamb*, sold Christies 21.5.1976); lot 64 — Michaelangelo Buonarotti, *Our Saviour and the Woman of Samaria*, £105; lot 74 — Pietro da Cortona, *Quintus Cincinnatus*, £200; lot 75 — P. Veronese, *Adoration*, £367 (In Devonshire House in the 1760s, now Chatsworth no 75, attr.

Veronese, *Adoration of the Magi).* He also on occasion acted for Lord Effingham, (see Plates 15 and 16).

100. The elder Colivoe appears to have died in 1727, as an obituary of "Isaac Collivous, painter" appears in the *Daily Post*, 25 March 1727. Between 1738 and 1750, according to surviving records, the younger Colivoe bought 40 pictures at sales, with an average value of £7. He was still working in the 1760s, but his attendance at auctions fell from the 1750s onwards, being confined almost exclusively to those of the dealer Blackwood, suggesting he may have had some sort of business arrangement with him. Smart, probably Captain George Smart, also worked at the less expensive end of the market, occasionally acting for the collector Jones Raymond. For details on Raymond, see Lippincott, *Selling Art*, pp. 61-3.

101. Vertue, II, p. 23.

102. 'In 1710 Hay did several pictures of (George Baillie of) Jerviswood as presents for various friends at the rate of £1.10s. each and 10/- for the frame' — *The Household Book of Lady G. Baillie 1692-1723*, ed. R Scott Moncrieff (Publications of the Scottish History Society, NS I, 1911) p. XXVII. I am grateful to Dr Rosalind Marshall of the Scottish National Portrait Gallery for information on Hay. See also Vertue, III, p. 125.

103. ed. J. Dennistoun. *The Memories of Robert Strange*, vol. 1. p. 32.

104. R. W. Goulding, *Catalogue of the Pictures belonging to the Duke of Portland* (London 1936) introduction p. xxx.

105. *Holkham Mss 730, 732, 737, 738.* I am grateful to Dr W. O. Hassell, formerly of the Bodleian Library, for this information. The Claude is the *Landscape with supplication of Marsyas*, still at Holkham Hall, *Liber Veritatis*, no. 95. (Plate 18).

106. Goulding, *Catalogue*, p. xxx.

107. *BM loan* 29/98-37.
108. ed. C. E. and R. C. Wright, *Diary of Humfrey Wanley* (London 1966) pp. 17, 21, 35, 42.
109. Hay Testament: Scottish Record Office CC8/8/116/2 proved 25 April 1757.
110. *Wanley Diary,* pp. 50, 56, 61, 64, 65. Many of the marbles bought in Italy were sold to the Earl of Pembroke.
111. See above, chapter two.
112. Plumb, *Walpole,* vol. 1, pp. 85-7; Margaret Stuffman, 'Les Tableaux de la collection de Pierre Crozat,' *Gazette des Beaux Arts,* 6th period, 72 (1968) pp. 28-9; Lesley Lewis, *Connoisseurs and Secret Agents in 18th Century Rome* (London 1961) pp. 91-143.
113. *Dictionary of National Biography:* Christopher Layer. *Report of the Lords' Committee empowered by the House of Lords to examine Christopher Layer* ... (London 1723).
114. Diary of Rawlinson, *Bodleian Mss Rawl* d1181 vol.2, p.353, 24 April 1721 (OS). Hay, his wife and Smibert attended a wedding with Rawlinson. Hay's connection with Smibert was continuous; they were in Rome together in 1716 and 1722 and Smibert painted Hay's portrait in 1728. Smibert was also questioned about the Layer conspiracy, and gave evidence at the trial. He was questioned again about the identity of Mrs Hay — the wife of Colonel John, not Andrew — but was reluctant to give evidence, claiming that his appearance at the Layer trial had already damaged his career. *Cal. State Papers (Domestic)* 35- 52/23,44.
115. *Cal. State Papers (Domestic)* 35 65/43. Undated but certainly pre-May 1724.
116. *Cal. State Papers (Domestic)* 35 52/21. Hay's wife was in Scotland at the time.
117. *Hist. Mss. Comm. Portland Mss.* vol. 6, pp. 11-17, 19 February 1725/6
118. *Wanley Diary,* pp. 88, 91 and addendum 20 February 1720/1.

119. Preface to 1759 *Catalogue of Harleian Mss.* Hay was asked to go and see the Mss of (amongst others) Bernard Montfaucon, the Cistercian monastery of Clairvaulx, the Duke of Savoy, the monastery of Bovio in Pisa, St Basil's monastery in Rome. Many of the Mss Hay was not meant to buy, only to examine, suggesting that Harley, perhaps out of necessity, put considerable faith in his expertise in these matters. Hay appears to have been in Venice before: he was asked to 'remember the fragments of Greek Mss you left with the bookseller who bought Maffeo's library'. While there he was also required to get 'a catalogue of Mr Smith's library'.
120. Oxford sale day 2 (heads) lot 33, by Dahl, bought for £1.13s by Maddis. This is the only record of Hay attending an auction sale as a buyer, acquiring 6 pictures and a drawing by Richardson. However, it does appear that he may have acquired some pictures in England for resale. In the 1724 Ancaster sale, lot 18, a *Circumcision* by Rembrandt, corresponds to the 1744/5 sale, day 1, lot 47 sold to Spencer, seen in 1751 by Walpole at Wimbledon, subsequently moved to Althorp and now in the Washington National Gallery (see Plate 20).
121. *Wanley Diary,* 25.1.21/2; 17.4.22; 20.4.22.
122. C. H. and M. S. Collins-Baker, *The Life and Circumstances of James Brydges, Duke of Chandos* (Oxford 1949) p. 79 note 1.
123. A catalogue of this sale of prints is in the British Museum, dated 1738.
124. Hay held sales in 1738, 39, 41, 42/3 and 44/5.
125. 1742/3 sale, day 2 lot 43: Maratti — *Virgin and Christ,* £63.10s. 6d. bt. by Mr Davy.
126. LORD BURLINGTON: (1725/6 sale) Ochiali, *View of Florence,* (lot 9) 18 gns; anon., *Genius of Poetry, Moliere and Lully,* (lot 16) £5.15s.;

Le Mere, *Diogenes throwing his Dish away*, (lot 34) £31.10*s*; Panini, *Arch of Constantine* (lot 55) £40 (possibly one of a pair now at Chatsworth — Vanvitelli *Arches of Constantine and Titus*, Chatsworth no. 473) (see Plate 22); Trevisani, *Virgin* (lot 63) £26. (1738 sale) *G. Poussin, two large landscapes* (day 1 lot 36) £4.4*s*.6*d*. SIR ROBERT SUTTON: (1725 sale) Ferg and VanderCabel, *Basso relievo, figures and ruins* (lot 36) £25.5*s*. DUKE OF DEVONSHIRE: (1725 sale) Trevisani, *St Catherine* (lot 33) £22; Poelenburg, *Flight into Egypt* (lot 54) £20 (Chatsworth no. 487); Panini, *View of the Coliseum* (lot 56) £30 (Chatsworth no.473, Vanvitelli) (see Plate 21). ROBERT WALPOLE: (1725/6 sale) Old Patell, *Flight into Egypt, Landscape and Ruins* (lot 31) £11.6*s*.; Velásquez, *Innocent X* (lot 37) 11 gns (Washington, National Gallery) (see Plate 23); Poelenburg, *Our Saviour, Joseph and Mary* (lot 50) £37.16*s*; Romanelli, *Hercules and Omphale with Nymphs* (lot 62) £44.2*s*. (see Plate 25) Pietro da Cortona, *Abraham, Hagar and Sarah* (lot 73) no price (Moscow, Rumjatzeff Museum See Plate 26). SIR ROBERT FURNESE: (1725/6 sale) G. Poussin, *Landscape and Figures* (lot 57) £63. LORD JAMES CAVENDISH: (1725/6 sale) G. Poussin, *Landscape and Figures* (lot 44) £35.14*s*; (1738 sale) N. Poussin, *Holy family and Architecture* (day 1 lot 74) £37.5*s*.6*d*.; (1742/3 sale) Guido Reni, *Holy Family, a cartoon* (day 2 lot 34) £3.5*s*. (1744/5 sale) Ochiali, *View of the Ripetta at Rome* (day 1 lot 45) £29.18*s*. 6*d*. Ghisolfi, *View of the Campo Vaccino* (day 2 lot 34) £7.10*s*. Maratti, *Venus amongst White Roses* (day 2 lot 42) £21.0s. LORD MALPAS *later* CHOLMONDELEY:(1725/6) Swaneveldt, *Landscape and figures, large* (lot 23) 23 gns; Old Patell, *Architecture and Landscape* (lot 38) £17.6*s*.6*d*.; Bolognese, *Hagar and Ishmael* (lot

39) 17 gns; Borgognone, *A Battle* (lot 53) £23.12*s*. 6*d*.; F. Miele, *Landscape and figures* (lot 67) £80; Teniers, *The Temptation of St Anthony* (no lot number) 16 gns; (1742/3 sale) G. Poussin, *Landscape and Figures* (day 1 lot 47) £18.10*s*.6*d*. The Poussin, Patell, Swaneveldt, Bourgognone and Bolognese appear in an inventory of the late 1740s account of Lord Cholmondeley's pictures, *Cheshire Records Office* DCH/X/15/12.

127. However, day 1 lot 47 of the 1744/5 sale, 'The circumcision of our Saviour, a very high finished picture with 14 figures, by *Rembrandt*, in his best manner, 1661', bought by Crisp for Mr Spencer (V&A Mss) £55.13*s*., now in the Washington National Gallery (see note 120). Same sale, day 1 lot 40, 'The flight into Egypt on copper by *Claude Lorrain*', bought by Barnard for the Duke of Rutland, 17 gns, is in the Rutland collection at Belvoir Castle (see Marcel Rothlisberger *Claude Lorrain*, London, 1961) no. 234/p.502. Same sale, day 2 lot 46, 'A Landscape, with the story of Orion and Diana, in the clouds, very capital, by *Nicholas Poussin*', bought by the Duke of Rutland for £31.10*s*. and sold to Reynolds in 1758 for £53.11*s*., was later sold to Calonne and is now in the Metropolitan Museum, New York, (see Francis Brown, *Sir Joshua Reynolds' Collection of Pictures*, unpublished Phd., Princeton 1987, see Plate 24. 1739 sale lot 54? Rembrandt, *Woman bathing in a Stream*, is in the London National Gallery.

128. *Scot's Magazine*: obituary vol.16, p. 500, October 1754.

129. Letters in *Clerk of Penicuik Mss*, Scottish Record Office, GD18/4665/1-2.

130. I am grateful to Alastair Smart of the Scottish National Portrait Gallery for this information.

131. Vertue, III, p. 125. See also *Testament*,

supra note 109.

132. *P. R. O. Prob 11/861/477* will made 9.8.1744, proven December 1760. Witnessed by Mary Langford. Mention of debt of John Wellbeloved, a frequent buyer at Paris' sales. Paris' assets seem to have been £80 in cash, £80 of debts owed to him, £300 in India bonds, all left to his wife, and 'a small estate in Sussex' which cost £190, left to his brother. Abraham Langford, Paris' auctioneer, was appointed executor.

133. Vertue, V, p. 13.

134. Warwickshire County Records Office, *Lucy papers*, L6.

135. *P. R. O.Cal. State Papers (Domestic)* Sp 35-75/35.

136. cf note 97.

137. Cambridge University Library, *Cholmondely (Houghton) papers* C(H) Correspondence 1968 de Roussel to Walpole, 15 April 1733.

138. For virtually all these, the only surviving records are in *V&A* 86-00-18/9.

139. 1741/2 sale day 2 lots 48-9, Poussin, *The Triumph of Bacchus* £230, *A Sacrifice*, its companion £252. Blunt nos 136-8 — *Bacchanals for the Chateau de Richelieu*, sold at Delmé sale 1790, and bought by Lord Ashburnham, then sold again in 1850. *Triumph of Pan* is now in the London National Gallery and the *Bacchus* is in the Nelson Gallery-Atkins Museum of Art in Kansas City (see Plates 27-8).

140. The Duke of Bedford bought 11 pictures from Paris' auctions, the Earl of Cholmondeley 7.

141. See note 129.

142. 10 June 1738, Scottish Record Office, *Clerk of Penicuick Mss* GD/18/4665/2.

143. *Potier sale*, Paris 1757, 'Rémy pour l'Angleterre', lots 1-4, 10, 20, 22, 32, 36, 51, 89, 96bis, 103, 104, 108, 113 and 141 (copy in BN cabinet d'estampes).
Tallard sale, 1756, lot 40, Corregio, *Le Martyre d'une sainte, premier*

tems'. estimated at 150 livres. Sold to Grignard, Huissier-priseur, for 60 livres and resold to Bragge for 84 livres (4.18s.,). Tallard apparently had it from the Crozat collection. *Bragge sale*, 1757, day 2, lot 66, to Barnard for £4.14s.6d. *Barnard (Hankey) sale* 1799, day 1 lot 29, sold to Woodburne for 17 gns. Perhaps *A gentleman leaving Town (Phillips 28.4.1803)* lot 6 — *Martyrdom of St Justiniani*.
Tallard sale lot 65 — Guido Reni, *'Virgin holding infant receiving a Cross presented by St John; St Joseph on one Side, Hand on a Book,* on wood 14"x 10", Remy pour Dr Bragge, est. 400 livres', sold for 450 (£26.5s.). *Bragge sale* 1757 day 1 lot 68 sold to Barnard £55.13s. Thereafter lost. Both of these pictures are described in highly favourable terms in *London and its Environs Described* (London 1761) vol. I, p. 281.

144. *Floris Drabbe sale,* Leyden, 1 April 1743, lot 29 *Vanderwelde* Een Capitaal stuk vol Scheepen 203 guilders bought by Harsebroek 'voor Globber, englesch kunstkooper,' see annotated copy of sale catalogue in BN cabinet d'estampes.

145. See annotated copy in *V&A* Mss.

146. The effect of these movements between dealers had on prices can be seen by the movement of Poussin's *Moses Sweetening the Waters of Maribah.* This passed from one Dr Hickman to the dealer-painter Knapton, who sold it to the dealer John Blackwood for 150 guineas. He sold it at auction to Royden for 250 gns and in 1755 it was bought by Lord Harcourt for £50. Sold in 1948, it is now in the Baltimore Museum of Fine Art — *Harcourt papers*, ed E. W. Harcourt, (ND) vol. 3, p. 233.

147. Northamptonshire County Records Office, *Booth papers* D-50/1, *P. R. O.* Copy of Bragge's will made 23 February 1777, and proved 6 June 1777. Bragge left to one Salthrop

'My fine picture of *Angostini Car-
raci after Annibale* of the dead
Christ with the blessed Virgin in a
Swoond'.

148. John Boydell, in his 1769 catalogue
of his engravings, said he had en-
graved two works from Bragge's col-
lection: *Holbein*, 'A Country Attor-
ney and his Clients', the original of
which was later sold to Mrs French;
Laura, 'Apollo as Herdsman', sold as
lot 35 on day 2 of his sale in 1778.
Several pictures by Gaspard Dughet
that were at some stage owned by
Bragge were also engraved.

149. The last reference to a sale by Bragge
is in 1763, see National Gallery,
Phillips-Roberts Mss 10254.

150. *A Catalogue of the ... Collections of
... Pictures of Dr Bragge ... selected
from the Finest Cabinets in Europe,
with that Taste and Judgement pecu-
liar to so Acknowledged a Connois-
seur...*, Langford 5 February 1778.
The Ottoboni collection is referred to
as being on sale by Walpole in a let-
ter to Richard West, Rome 7 May
1740, *Letters* , vol. 13, p. 214.

151. See note 127. See also catalogue of
1754 sale of pictures, with Horace
Walpole's additions in the British
Museum and the *Catalogue of pic-
tures of Dr Newton* in the Courtauld
Institute.

152. For more on this topic, see below,
chapter seven.

153. Another was engraved by Arthur
Pond.

154. Walpole, *Letters,* vol. 18, p. 355, 11
December 1743.

155. *The Family memoirs of the Rev.
William Stukeley*, Surtees Society
(London 1880), vol. 3, p. 5: 'Dr Mil-
ward carried me to Cock's auction
room where is a most magnificent
show of paintings to be sold by auc-
tion ... they are the pictures of Sir
Robert Walpole, under the fictitious
name of Mr Robert Bragge. I have
seen 'em at Sir Robert's house. Thus
fares it with power and grandeur ...'
(4 May 1748). The sale, not registered

in Lugt, took place on 5/6 May
1748. The only existing copy of the
sale, with annotations, is in the
Bodleian. There were 125 lots, of
which 60 were sold for a total of
£851.11*s*.6*d*. Other sales of the
Walpole collection took place in
1748/9 and 1750/1.

156. *Notes and Queries* 2/1/p.151 sug-
gests that this was written by
Bragge, rather than about him, but
this is probably a result of a misread-
ing of a mss addition in the BM
copy.

157. The structure of law which sur-
rounded art selling in France meant
that the dealer could only rarely hold
sales on his own account and could
not run auctions. As a result he was
held back from the large profits that
such operations offered to his En-
glish counterparts but at the same
time gained the enormous benefit of
being less tainted with an over-close
connection with money and was able
more often to pose as disinterested.
See K. Pomian, 'Marchands, Con-
noisseurs'.

158. Anon., *A Satire against Painting in
Burlesque Verse.*

159. See note 56.

160. Samuel Foote, *Taste* (first edn.
1752) in *The Dramatic Works of
Samuel Foote* (London 1781) vol. 1.

161. Conolly, *The Connoisseur, or Ev-
eryman his Folly* (London 1736).

162. William Hayley, *The Two Connois-
seurs* (London 1736).

163. John Gwyn, *London and Westmin-
ster Improv'd*, p. 71.

164. TB, *A Call to the Connoisseurs*, p.
24.

165. Burke to Barry, 26 August 1767,
Letters, vol. 1, pp. 322-4.

166. *Correspondence of the Family of
Hatton*, Hatton to unknown corre-
spondent, 28 January 1692, vol. 2, p.
169.

167. *Letters*, vol. 18, pp. 373-4, to Mann
22 March 1742: 'I have made a few
purchases at Lord Oxford's sale. The
things sold dear; the antiquities for

above £5,000, which yet, no doubt, cost him much more, for he gave me the most extravagant prices ...' and vol. 21 p.199, again to Mann '[Schaub's] collection was indubitably not worth £4,000, it has sold for near eight ...'

168. *Letters*, vol. 23, p. 210 to Mann 6 May 1770.

169. *Ibid.*, vol. 24, p. 441, to Mann 11 February 1779. For further information on art prices after 1760 see Gerald Reitlinger, *The Economics of Taste*, vol.1, 'The Rise and Fall of Picture Prices, 1760-1960' (London 1961) pp. 3-25.

170. See note 139; for a general account of the popularity of Poussin in England in this period, see Ellis Waterhouse, 'Poussin et l'Angleterre jusqu'en 1744' in ed. A. Chastel, *Nicholas Poussin* (CNRS Paris 1960) vol. 1, pp. 283-95.

171. Schaub sale, day 3 lot 53. A 1760 inventory of the Ashburnham collection notes the picture as being by Corregio without giving any valuation while a 1793 inventory mentions only that it 'was called so' at the Schaub sale. Transcripts of both inventories are in the Getty Library, Santa Monica.

172. cf, for example, the sketch of Mead by Thomas Birch in *BM add. mss* 6269 f.282.

173. *Philipps-Roberts MS* 10254 ff99-102.

174. The only copy of this sale, which fortunately is annotated, is in the print room of the Rijksmuseum, Amsterdam. The sale was held by Langford on 1 March 1764. On the whole Harenc, who occasionally appears to have bought pictures for the Duke of Rutland, purchased only works of middling value. The highlights of his collection were A. Carraci, *The Piazza of Bologna* £112, Bragge sale 1750 day 2 lot 73, untraced in his own sale; Guido Reni, *A Magdalen* £73.10s. same sale, day 2 lot 69, sold 1764 day 1 lot 75 for £22.11s. 6d.; Le Brun, *Moses and the Brazen Ser-*

pent, £80, Rawdon sale, 1744 day 1 lot 54, not traced in 1764 sale now in the Bristol Art Gallery. Le Sueur, *Assumption of the Virgin,* bought Bragge sale 1743/4 day 1 lot 57, £27.5s. sold 1764 day 3 lot 79 for £94.7s; F. Mola, *Landscape with Hercules and Dejanira,* bought Jeckyll/Paris sale 1740 day 2 lot 46, sold 1764 day 2 lot 79, £74.11s.; and Teniers, *A large Landscape with the Parting of Abraham and Lot,* day 1 lot 80, £10.2s. As will be discussed in greater detail below (chapter 6) the choice of artists fell easily into an accepted and conventional pattern.

175. Annotated copy of sale catalogue at Christies, 7/8 June 1799, Lugt no. 5936.

Chapter Four: Painters

1. Alexander Browne, *Ars Pictoria*, p. 25.

2. Once more, little of this was novel, except the intensity with which it was insisted upon and the degree of success it obtained. The ideas English polemicists adopted went back at least to Alberti; for which see A. Blunt, *Artistic Theory in Italy, 1450-1600* (London 1973) pp. 48-57.

3. Richardson, An Essay on the Theory of Painting (London 1715) p. 29.

4. *Ibid.,* p. 31

5. The relatively few gentlemen who painted professionally include Joseph Highmore, who abandoned a career as a lawyer to take up the brush; Vertue, III, p. 17, and Thomas Flatman (1663-88) who managed both occupations simultaneously.

6. *Hist. Mss. Comm. Egmont Diary,* vol. 1, pp. 224-5, 23rd February 1731/2.

7. Those knighted were Peter Lely, John Baptist Medina, Godfrey Kneller, James Thornhill and Joshua Reynolds.

8. For Reynolds successful social career see E. K. Waterhouse, *Reynolds* (London 1941) pp. 13-18. See also Nicholas Penny, 'An Ambitious Man; The Career and the Achievement of Sir Joshua Reynolds' in *Reynolds*, Royal Academy of Art Exhibition Catalogue (London 16 Jan.-31 March 1986) pp. 17-42.

9. R. Wittkower, 'The Artist' in ed. J. L. Clifford, *Man vs Society in Eighteenth Century Britain* (Cambridge 1969) pp. 70- 84.

10. Lippincott, *Selling Art,* pp. 19-54 and passim.

11. John Galt, *Life and Works of Benjamin West,* vol. 2 p. 3.

12. *St James Chronicle,* 8 May 1798.

13. H. Colvin, *Biographical Dictionary of British Architects, 1600-1840* (London 1978) pp. 26-36 and see also F. Jenkins, *Architect and Patron* (Oxford 1961) pp. 40-66.

14. Richardson, *The Theory of Painting,* p. 31.

15. The buying activities of a large number of doctors can be traced in a large number of sales catalogues of the period, especially in the *V & A* Mss 86-00-18/9 series compiled by Richard Houlditch.

16. See R. M. Nichols and F. A. Wray, *A History of the Foundling Hospital* (London 1935) pp. 249-64 and B. Nicolson, *The Treasures of the Foundling Hospital* (Oxford 1972) pp. 20-32.

17. G. Holmes, *Augustan England: Professions, State and Society 1680-1730* (London 1982) pp. 166-235 gives a good account of the changing professional fortunes of the medical profession. Exact parallels between the two cannot be drawn as nowhere in the painters' progress was there anything which mirrored the growing importance of medical empiricism that was embodied in the slowly improving position of the surgeons as opposed to the more intellectually-oriented physicians.

18. For a good analysis of Richardson's notion of 'scientific' connoisseurship (which perhaps strays in attributing a too modern interpretation of science to his use of the word) see Carol Gibson-Wood, 'Jonathan Richardson and the Rationalisation of Connoisseurship,' *Art History,* 7, no.1 (1984) pp. 38-56.

19. For Lebrun on the physiological principles of history painting, see *Expressions des Passions de l'Ame representées en plusieurs Têtes gravées d'après les Dessins de feu M. Lebrun par J. Audran* (Paris 1727). For further on this see P. Marcel, *Charles Lebrun* (Paris 1909) pp. 114-28, and the notes to exhibits 130-5 in the catalogue of the exhibition *Charles Lebrun* ed. J. Thuillier (Versailles 1963). Both English and continental artists frequently supplemented their incomes by illustrating medical texts. Some doctors – such as William Cheselden in 1720 – came to the artists to learn how to draw while others, such as William Hunter, replied by teaching the painters about anatomy.

20. For which see P. O. Kristeller: 'The Modern System of the Arts,' in *Journal of the History of Ideas,* 12 (1951) pp. 496-527 and 13 (1952) pp.17-46. See also John Barrell, *The Political Theory of Painting from Reynolds to Hazlitt: The Body of the Public* (New Haven and London, 1986) pp. 7-18.

21. For the best account of Streeter see E.F. Croft-Murray, *Decorative Painting,* vol. 1, pp. 44-6, 226-7. See also T. Borenius, 'Robert Streeter,' *Burlington Magazine,* 84 (January 1944) pp. 2-12 and *do.* 'The Serjeant-Painters,' *ibid.,* 84 (April 1944) pp. 80-2. The reference to 'Streeter of all paintings' comes in Buckeridge, *Art of Painting,* p. 4

22. For a general survey of the influx of foreigners, see M. Whinney and O. Millar: *English Art, 1625-1714* (Oxford 1957) chapter 8, C. H. Collins Baker, *Lely and the Stuart Portrait*

Painters (London 1912) vol. 2, *pas-sim*. For Hondius and Cradock, see Vertue, I, pp. 26, 79-80; II, pp. 74, 94, 123.

23. One example of this is John Van Wycke, who made a tidy income selling animal paintings to the country gentry, whose taste for such works was so disapproved of by the urban cognoscenti (see Chapter one) Vertue, III, p. 141.
24. One of the best examples of this is Arthur Pond, in Lippincott, *Selling Art* pp. 31-55 and 95-126.
25. Joseph Burke, *English Art 1714-1800* (Oxford 1976) p. 293.
26. Vertue, III, p. 134; for Smibert see Evans *John Smibert*, and Foote, *John Smibert*.
27. R. Rolt, in *A New Dictionary of Trade and Commerce* (London 1756) also identifies drapery, heraldry, ship and floorcloth painters as distinct subdivisions of the trade.
28. The best surviving example is a coach from around the start of the 18th century, the Lord Mayor's coach, which is painted in the style of Kneller. It is currently in the care of Whitbread Plc at their head office in London.
29. Edwards, p. 37.
30. *Ibid.*, p. 111.
31. J. Larwood and J. C. Hotten, *English Inn Signs* (London 1951) pp. 21-2.
32. Edwards, p. 117.
33. J. Pye, *The Patronage of British Art, An Historical Sketch* (London 1845) p. 99 quotes complaints in the *St James Chronicle* on 20 July 1764. See also *The Spectator* no 28, 2 April, 1711. See also J. T. Smith, *Nollekens and his Times, comprehending a Life of that celebrated sculptor and memoirs of several contemporary Artists*, 2 vols. (London 1829, reprinted 1920) vol. I, pp. 22-3.
34. R. Campbell, *The London Tradesman* (London 1747) pp. 103-4.
35. W. T. Whitley, *Artists and their Friends in England, 1700-1799*, 2 vols. (London and Boston 1928) vol.

1, pp. 330-6.
36. According to *P. R, O. Cust 3*, exports of paint were worth well over £3,300 p.a. by 1750. From 1730 the colourman Keating was specifically advertising his products for the export market, see *London Evening Post* 15 October 1730. For experimentation in colours and manufacture see R. Dossie, *The Handmaid to the Arts*, 2 vols. (London 1758); J. Hoofnail, *New Practical Improvements...and Observations on some of the Experiments of the Honourable and Judicious Robert Boyle, esq.* (London 1738); R. D. Harley, *Artists' Pigments c.1600-1835: A Study in English Documentary Sources* (London 1970).
37. Campbell, *The London Tradesman*, p. 104.
38. For a good coverage of theatrical painting see S. Rosenfeld, *Georgian Scene Painters and Scene Painting* (Cambridge 1981) specially pp. 79-85.
39. 1700-65. See Edwards, pp. 19-21.
40. For example, John Talman, writing from Rome to Henry Newton (18 November 1711) to organise a campaign to stop Marco Ricci winning the commission to paint the dome of St Paul's: 'Yis cupola...will be ye scandal of painting and an eyesore to all discerning men. Rizzi of Venice everyone knows to be no more yan a scene painter...' *(Bodl MS Eng. Lett.* E34 f231).
41. W. O. Englefield, *History of the Painter-Stainers' Company* (London 1922) pp. 81-2.
42. Lely was made free of the Painter-Stainers' company in 1647 and asked it for an apprentice in 1652. See Oliver Millar's introduction to *Sir Peter Lely: Catalogue of an Exhibition at the National Portrait Gallery* (London 1978) pp. 10, 18-20.
43. Englefield, *Painter-Stainers' Company*, p. 161. City of London, Guildhall Library Mss PS 5667-9 'Minutes of the Painter-Stainers' Company',

f.370.
44. *Mss PS Guildhall* 5667-9 f.333. The company did, however, attempt to enforce regulations on apprenticeship in 1698 (f.347) and had a final fight with the Heralds' Company in 1738 (f.506).
45. For Thornhill and Reynolds see Englefield, *Painter-Stainers' Company*, p. 162, 181. For the Heralds' comments p. 158.
46. Although the number of London's trade painters clearly increased throughout the century, the number of apprentices registered at the Company steadily fell, from a high point of 468 for the decade 1671-80 to only 229 in the 1731-40 period. See *Painter-Stainers' Minutes.*
47. The engravers were however kept very much in a subordinate position, limited to six associate members and forbidden to vote at general assemblies, Bruntjen, *John Boydell*, p. 54, footnote 30.
48. For greater detail see S. C. Hutchison, *The History of the Royal Academy, 1768-1968* (London 1968) pp. 26-41.
49. William Aglionby, *Painting Illustrated*, preface.
50. *Theory of Painting*, pp. 24-6.
51. *The Idler*, no. 45 (24 Feb. 1759).
52. W. Gilpin, *Observations on parts of the Counties of Cambridge, Norfolk, Suffolk and Essex... in two tours, the former made in the year 1769, the latter in the year 1773* (London 1809) p. 38. Burke said of Reynolds, 'His portraits remind the spectator of that invention of History and the amenity of Landscape', James Prior, *Memoir of the Rt. Hon. Edmund Burke*, 2 vols. (London 1826) pp. 189-90.
53. Nos. 240 and 248.
54. R. Folkenflik, in his introduction to the edited volume *The English Hero, 1660-1800* (Newark 1982) pp. 25-34.
55. Campbell, *The Compleat Tradesman*, p. 96; *Gentleman's Magazine* (1762) vol. 32, pp. 247-8 'On the De-

fects of London, A Letter from an Italian to his Friend in Naples'. A more serious assault on the arts in England is in Jean-André Rouquet, *The Present State of the Arts in England* (London 1755) which drew an indignant response in the *Monthly Review* 13 (1755) p. 399.
56. As Hogarth put it 'Portrait painting is the chief branch (of the art) by which a man can promise himself a tolerable lively hood and the only one by which a money lover [can] get a fortune'. See Michael Kitson, Hogarth's "Apology for Painters" *Walpole Society* (1966-8) vol. 49, p. 100. Whinney and Millar, *English Art*, pp. 171-2, cites Lely in the 1640s as starting with landscapes and history and turning to portraits as no one wanted them, while Pye, *Patronage of British Art*, pp. 36-7 also mentions Giles Hussey in the following century as another who followed the same route.
57. In *Sculptura*. The passage is quoted in William Sandby, *The History of the Royal Academy of Arts*, 2 vols. (London 1862) vol. 1, pp. 19-20.
58. Mentioned in *Cal. Treas. Books 1681-85*, 7 June 1681 p. 170. The reference to Foubert's 'Royal Academy', is in *Cal. Treas. Papers 1697*, p. 167.
59. Robert Strange, *Memories*, vol. 1. p. 26; E R. Dibdin, 'Liverpool Art and Artists in the Eighteenth Century', *Walpole Society* (1917-18) vol. 6, pp. 65-6. For the Foulis Academy, see David and Francina Irwin, *Scottish Painters at Home and Abroad 1700-1900* (London 1975) pp. 83-97.
60. For this reason some critics disapproved of the SEAMC's project of awarding prizes to the best painters, on the grounds that the decisions were reached in a way that encouraged excess originality: 'Considering the present State of History Painting amongst ourselves, we cannot expect to meet with Originals of any value,

or excellence. We must be content, at first, with *Copies* of our best Originals: and only expect a Piece that will please by the happy *likeness* it may have to the Performances of more able Hands ... your present method, Gentlemen, in my *humble opinion*, will never answer your laudable Design, of carrying History Painting to any degree of Perfection...' Anon, *A Letter to the Members of the Society for the Encouragement of Arts, Manufactures and Commerce, containing some Remarks on the Pictures to which the Premiums were adjudged; with some cursory Observations on History Painting...* (London 1761).

61. Reynolds, *Discourses on Art* ed. Robert R. Wark (San Marino 1959) first discourse, delivered 2 January 1769, p. 15.

62. For a general survey of the French academic ideal see Quentin Bell, *The Schools of Design* (London 1963) pp. 1-20; N. Pevsner, *Academies of Art, Past and Present* (Cambridge 1940) pp. 86-101 and F. B. Chambers, *The History of Taste* (New York 1932) pp. 105-36.

63. Reynolds, *15th Discourse.* pp. 265-82, delivered 10 December 1790.

64. Quoted in Whitley, *Artists and their Friends*, vol. 1, p. 27.

65. See R. Paulson, *Hogarth*, vol. 1, pp. 270-8.

66. Kitson, 'Hogarth's "Apology"', p. 107.

67. The Schaub Corregio — *Sigismunda weeping over the Heart of Tancred* — which so enraged Hogarth was sold to Sir Thomas Seabright for £404.5s. (day 1, lot 59). *London Chronicle* 2-4 May 1758. According to F. Antal, it was in fact by Furini. For this, and Hogarth's debt to the continent see his article 'Hogarth and his Borrowings', *Art Bulletin* 29 (1947) 36-48; see also Edgar Wind, 'Borrowed Attitudes in Hogarth and Reynolds', *Journal of the Warburg and Courtauld Institutes*, 2 (1938-9) pp. 182-5,

and Hilde Kurz, 'Italian Models of Hogarth's Picture Stories', *Ibid.*, 15 (1952) pp. 136-68.

68. Rivalry with the French was frequently used by apologists to spur the English into action, but in this case the English scarcely lagged behind. Exhibitions were held in France in 1699, 1704 and 1725 but were not held regularly until 1747. More importantly from the financial rather than the prestige point of view was the fact that the English artists had no alternative outlet such as the Italian or Dutch market days when their wares could go on general show.

69. B. Nicolson, *The Treasures of the Foundling Hospital*, pp. 20-31.

70 D. Hudson and K. Luckhurst, *The Royal Society of Arts, 1754-1954* (London 1954) p. 37.

71. Edwards, introduction pp. XXVII-XXVIII and footnote: preface to 1762 catalogue. See also John Gwyn, *London and Westminster Improv'd*, p. 24, where he says that the exhibition 'became a scene of tumult and disorder ...the room was crowded with menial servants and their acquaintances; this prostitution of the fine arts undoubtedly became extremely disagreable to the Professors themselves, who heard alike, with indignation, their works censured or approved by Kitchen maids or stable boys...'

72. Edwards, introduction p.XXVI. For the 1761 exhibition the catalogue was sold for a shilling and could be used time and again to gain entry to the rooms. The year after this method was changed, with the catalogue being given free and a one shilling admission ticket being charged instead. ·

73. *Ibid*, introduction pp. XXVIII-XXIX and footnote.

74. *Ibid.*

75. *Ibid.*, p. XXVIII and footnote.

76. The various bodies involved in these disputes have, on the whole, been

treated generously by historians. For
the Foundling Hospital, see Nicol-
son, *Foundling Hospital,* and R. H.
Nichols and F. A. Wray, *A History.*
See also L. Cust, *History of the So-
ciety of Dilettanti* (London 1898) pp.
51-8, Algernon Graves, *The Society
of Artists of Great Britain and the
Free Society* (London 1907) espe-
cially pp. 295ff. Hudson and Luck-
hurst, *Royal Society* chapters 1-3 and
finally D. G. C. Allan, 'The Society
of Arts and Government', *Eigh-
teenth Century Studies* 7, no. 4
(1974) pp. 434-52.

77. D.G.C. Allan, *William Shipley,
Founder of the Royal Society of Arts*
(London 1968) especially pp. 40-96.

78. Kitson, 'Hogarth's "Apology"'p. 105.

79. Both the SEAMC and the Dilettanti
were castigated by Hogarth for their
attempts to interfere, and for once
Hogarth seems to have spoken for
more people than himself. As he put
it, 'This society of castle builders [ie
the SEAMC] has the same ideas as
[the Society of Dilettanti]. They wish
first to persuade the world, that no
genius can deserve notice without
being first cultivated under their own
direction...' John Ireland, *Hogarth
Illustrated from his own Manuscripts,*
3rd edn. (London 1812) vol. III, p.
82. Robert Strange, who later be-
came ferociously hostile to the Royal
Academy, disagreed on this matter.
Writing of the talks with the Society
of Dilettanti, he said: 'On the part of
the majority of the leading artists. I
was sorry to remark motives, appa-
rantly limited to their own views and
ambition to govern, diametrically op-
posed to the liberality with which we
were treated. After various meetings,
the Dilettanti finding that they were
to be allowed no share in the govern-
ment of the Academy, or in appropri-
ating their own fund, the negotiations
ended'. Robert Strange, *An Inquiry
into the Rise and Establishment of
the Royal Academy of Arts* (London
1775) p. 62. One of the constant fea-

tures of all the comments hurled dur-
ing the fights in this period was the
accusation of megalomania, and a
desire to frustrate the best interests
of the artists for the sake of personal
gain.

80. Anon., *The Conduct of the Royal
Academicians, while Members of
the Incorporated Society of Artists
of Great Britain* (London 1771) pp.
13-14. See also Robert Strange, *An
Inquiry,* pp. 64-5.

81. The best account of the dispute from
the point of view of the Academi-
cians is in Edwards, introduction pp.
xxx-xxxix. (Plates 43 and 44) Ac-
cording to this version, the toppling
of the original committee in 1767
was not simply a question of politi-
cal infighting but was instead a real
battle of merit versus mediocrity. As
he puts it, the meeting that saw the
first substantial attack on the Com-
mittee in that year 'introduced sever-
al very inferior artists into the places
of the most respectable of those from
whom the Society....received their
origin and support....This sudden
revolution satisfied no-one except
those of the cabal with whom the or-
der originated...' , p. xxxii.

82. According to Edwards, p. xxx, the
dispute was 'in a great degree occa-
sioned by the loose and unguarded
manner in which the charter was
composed'. Certainly, as the opposi-
tion described *(The Conduct of the
Royal Academicians)* working out its
ambiguities required all the skills of
government legal officials.

83. Anon, *Abstract of the Instrument
and Laws of the Royal Academy of
Arts in London* (London 1797) pp.
3-4.

84. *Ibid.,* p. 3 'All Academicians shall...
not be members of any other Society
of Artists...' If this ruling did not suc-
cessfully exclude all the old enemies,
then those enemies claimed other
methods could — for example, they
maintained that the rule (p. 23) that
all pupils at the Academy had to

have a piece of work approved by the committee before being admitted was used to keep them out by arbitrarily declaring their work inadequate. (*The Conduct* pp. 42ff).

85. Anon., *The Laws and Regulations for the Students, Rules and Orders of the Schools and Library and for the Exhibition* (London 1797) p. 10.

86. 'Memoirs of Thomas Jones', *Walpole Society*, pp. 23-4.

Chapter Five: Patronage

1. For a good, if slightly whimsical, discussion of this, see J. P. Stein, 'The Monetary Appreciation of Paintings,' *Journal of Political Economy*, 85, no 5 (1977) pp. 1021-35.

2. For the politics of nostalgia, see Kramnick, *Bolingbroke and his Circle*.

3. Walpole, *Anecdotes*, vol. 2, pp. 426, 585, 643, 700.

4. For a favourable interpretation of Charles' collection, see Aglionby, *Painting Illustrated*, dedication. *A Catalogue and Description of King Charles I's Capital Collection of Pictures, Limnings, Statues, Bronzes, Medals and other Curiosities* — was compiled by Vertue and edited and published by Walpole in 1756. The comments on it appeared in the *Monthly Review*, 15 (July-December 1756) p. 278.

5. For which see G. Clark, *The Later Stuarts, 1660-1714* (Oxford 1976) pp. 6-8, 58, 86-7, 102-3.

6. For Charles attempts to gather what remained in England of his father's collection, see *Hist. Mss. Comm. 7*, pp. 88-93; *Cal. State Papers 1669-1672*, pp. 300, 916, 1081, 1251; *Cal. Treas. Books, 1660-1667*, p. 50. For pictures from abroad see D. Mahon, 'Notes on the Dutch Gift to Charles II', *Burlington Magazine*, 91 (December 1949) pp. 349-50, and 92 (January 1950) pp. 12-18.

7. Croft-Murray, *Decorative Painting* vol. I pp. 236-42.

8. C. H. Collins-Baker, 'Lely's financial relations with Charles II,' *Burlington Magazine*, 20 (October 1911-March 1912) pp. 43-5.

9. *Cal. Treas. Books 1693-1696*, p. 1068.

10. *Ibid.*, 1702 pp. 598, 1022, 1035, 1172.

11. Collins Baker, 'Lely's Financial Relations'.

12. J. D. Stewart, 'Records of Payment to Kneller and his Contemporaries', *Burlington Magazine*, 113 (January 1971) p. 31.

13. *Wren Society*, vol. 6 (Oxford 1929) pp. 77-79: 'The Memorial of Sir James Thornhill, Knt., the History Painter, August 24, 1717'.

14. *Hist. Mss. Comm. Rutland*, III, pp. 138-9, 24 Sept 1784.

15. E. Wind, 'Julian the Apostate at Hampton Court', *Journal of the Warburg and Courtauld Institutes*, 3 (1939-40) pp. 127-37.

16. In Croft-Murray, *Decorative Painting*, however, there are mentions of private gentlemen who adorned their walls with allegorical displays celebrating the Hanoverians, or at least the political principles the Hanoverians represented. See, for example, the 'Glorification of George I' painted by John Vanderbank for an unknown patron at 11 Bedford Row, London, and now destroyed, vol. I, p. 260.

17. Vertue, III, p. 79.

18. *Hist. Mss. Comm. Egmont Diary*, vol. III, p. 275, 28 October 1743: 'When Sir Godfrey Kneller died [Dahl] expected to be courted to succeed him as principal painter to the king; but places at court are not given away unasked for; besides, he refused to draw the Duke of Cumberland when two years old, desiring the Lord who was sent to ask it, to tell his Majesty that not having had the honour to paint him or his Royal Consort, he was unwilling to begin

with a child. The King took it so ill that he immediately gave the vacant place to Mr Jervis, a far inferior artist...'.

19. The best, and one of the few, accounts of Jervas occurs in Vertue, who thought little of his abilities. See Vertue, III, pp. 1-5, 15-17, 97-124.
20. Vertue, II, p. 124.
21. Vertue, III, p. 54.
22. George provided the academy with apartments in Somerset House and presented the Society of Artists with £100 but apparently did little else. Edwards, pp. XXXVII-XXXVIII.
23. See above, Chapter two.
24. H. M. Colvin, '50 New Churches', *Architectural Review*, 107 (1950) pp. 189-96.
25. Robert Brown (d. 1753) did a considerable amount of work on the 50 new churches, including St Andrew's Holborn, St Andrew's Undershaft and St Botolph's, see E. Croft-Murray *Decorative Painting*, vol. 1, pp. 263-4.
26. For Thornhill's decoration of St Pauls' see *ibid.*, vol. 1, pp. 73-4, 271. For Whitehall and Windsor, painted by Verrio, *ibid.*, vol. 1 pp. 57, 239, 241.
27. See above, pp. 45-7.
28. Casali appears to hold the record for this later group with three altar pieces, for the Foundling Hospital (1739), St Margaret's Westminster (1758) and the Roman Catholic Church in Lincoln's Inn Fields (1762), *ibid.*, Croft-Murray, vol. 2, pp. 182-3. Amiconi worked on Emmanuel College, Cambridge in 1734 and Cowdray House chapel, vol. 2, p.164. Hogarth produced an altarpiece for St Mary Redcliffe, Bristol, in 1755, vol. 2, p. 222, and Hayman likewise for Cusworth Park, Yorkshire in 1752, vol. 2, p. 219.
29. Examples of this are almost innumerable. See, for example, Aglionby, *Painting Illustrated*, dedication; Richardson, *Science of a Connoisseur*, pp. 44ff and Buckeridge, *The*

Art of Painting, dedication.
30. Samuel Johnson, *The Idler*, no. 45, 24 February 1759. He was joined in his opinion by Hogarth, who concluded that portrait painting would always be dominant — 'The artists and the age are fitted for one another', Ireland, *Hogarth Illustrated*, vol. III, p. 73.
31. One such is J. H. Muntz, 'who resided for a time with the late Lord Orford', Edwards, p. 15.
32. An exception was Lord Tilney, who was an enthusiastic patron of Andrea Casali. There were eight Casali works in the Wanstead House sale (lots 194, 228-30, 296, 362-4).
33. R. Trumbach, *The Rise of the Egalitarian Family* (New York, 1978) pp. 120-30; see also Girouard, p. 15.
34. The great 'at homes', for which special London houses were built, are described in Girouard, *English Country House*, pp. 195-9. In 1719, equally, the Duke of Newcastle could advertise in the *Original Weekly Journal* (18 July) that, on his retreat from the capital to the country, he would keep open house. However, such displays of hospitality were becoming rarer.
35. Such as John Vanderhagen, on the staff of the Earl of Derby at Knowsley in 1702 at £20 a year (*Lancs RO*, Knowsley Mss DDK15/24) or William Bell in the Delavel family between 1770 and 1775 (R. E. G. Cole, *History of Doddington* (Lincoln 1897) p. 170. For the topic generally, see J. Steegman, *The Artist and the Country House* (London 1949) and J. Harris, *The Artist and the Country House* (London 1979) pp. 222-346 passim.
36. Shaftesbury's thoughts on the matter can be found in the 'Judgement of Hercules,' in *Characteristics*, vol. III, pp. 347-91. See also B. Croce, 'Shaftesbury in Italia', pp. 272-309. The painting, by Paolo de Matteis, is now in the Ashmolean museum, Oxford. Another patron who entered

into the spirit of things with gusto was John Talman, for which see Pears, 'Patronage and Learning in the Virtuoso Republick'.

37. Galt, *Life of Benjamin West*, vol. II, p. 12.
38. *Ibid.*, vol. II, p. 26.
39. ed. J. J. Cartwright, *The Wentworth Papers* (London 1892) letter dated 27 November 1711.
40. *Ibid.*, 21 March 1712.
41. 'The explanation of ye Painting in ye Oval of the Great Hall at Blenheim, by James Thornhill', *B.M. Add. Mss. 61354* (g1-20/38). 'Sir Godfrey Kneller's — of his sketch for an historical or Allegorical picture...' *BM Add. Mss.* 61355.
42. *B.M. Add. Mss.* 61355.
43. The work was abandoned because of the great fight between the Duchess of Marlborough and Queen Anne, who had originally offered to pay but then changed her mind. The oil sketch passed into the hands of Dr Mead and was sold in 1754 (day 2, lot 15) for five guineas to the painter/dealer John Ellis. It was then sold to the Duke of Newcastle, who sold it to Lord Pelham and by 1800 it was in Marlborough House in London. It is now in Blenheim Palace.
44. *B.M. Add. Mss.* 61354 (G1-20/42).
45. Vertue, III, p. 79.
46. Edwards, p. 50.
47. *Ibid.*, p. 111.
48. Galt, *Life and Works of Benjamin West*, vol. 2, pp. 9-10.
49. *The Autobiography and Correspondence of Mary Granville, Mrs Delaney ...* edited by *the Rt Hon. Lady Llanover*, 6 vols. (London 1861-2) vol. 2, 28 Jan. 1748, p. 487. Delaney had been promoting Barber for some time; writing to Mrs Dewes in 1745/46 she gives the following details: 'Mr Barber has just finished another picture of me in enamel, which Mr Bristow says is better done than any he saw of Zink's, indeed I think it very finely enamelled, and I hope it will bring him into good business.

Lord Masareen sits to him on Monday, and Mr Bristow has promised to prevail, if possible, with Lord and Lady Chesterfield, to sit to him, and that will bring him into fashion. He is an industrious man, and deserves to be encouraged...'

50. Vertue, III, p. 95.
51. Talman letters to Newton, 5 July 1710, f.136. See also Jourdain, *The Works of William Kent*, pp. 25-44.
52. *Reminiscences of Henry Angelo*, ed. Lavers Smith, 2 vols. (London 1904) vol. 1, pp. 90ff, which states Penny was sent at the expense of the gentry of Knutsford.
53. Vertue, III, p. 93.
54. Lionel Cust, *The Society of Dilettanti*, pp. 42-58.
55. Galt, *Life and Works of Benjamin West*, vol. 2, pp. 10ff.
56. Vertue, II, p. 133.
57. For Kneller, see J. D. Stewart, *Sir Godfrey Kneller and the English Baroque Portrait* (Oxford 1983) pp. 65-8; for Lely, R. B. Beckett, *Lely* (London 1951) pp. 17-21 and Anna Jameson, *Court Beauties of the Reign of Charles II* (London 1872); For Wright, Collins-Baker, *Lely and the Stuart Portrait Painters*, vol. 1, pp.186-7, 192. The pictures were seen by Evelyn, 31 July 1673. There were 22 portraits, of which 20 were badly damaged in World War II and apparantly destroyed; Riley's activities were noted by Luttrell, *Diary*, vol. I, p. 415 October 1687; For Bardwell's eight Mayors of Norwich (1746-65) see *A Companion to St Andrew's Hall in the City of Norwich*, 2nd ed. (Norwich 1812).
58. Edwards, pp. 5-6.
59. *Ibid.*, pp. 26-7.
60. Rouquet, *Present State*, quoted in Denvir, *Art and Design*, p. 121.
61. *Hist. Mss. Comm. Egmont Diary*, vol. III, p. 126, 15 April 1740.
62. *The Diary of John Baker, Barrister*, ed. Philip C. Yorke, (London 1931) 21 November 1771, p. 226.
63. Vertue, I, p. 32.

64. Smith, *Nollekens and the Artists of his Time* , vol. 1, pp. 87-8.
65. Mortimer, *The Universal Director*, introduction.
66. Information about prices can be found scattered through the pages of Vertue. The artificiality of rates can be demonstrated by comparing commission prices with resale values – at the Lely sale, for example, few of his works fetched more than five pounds and even pictures that were not portraits dropped considerably in value. According to Viscount Perceval, Dahl had the indignity of seeing pictures he had sold to the Earl of Oxford for 30 guineas go at the Oxford sale in 1739 for 39/-. Prices charged were also vast by continental standards; Maratti, for example, was paid only around 150 scudi (about £40) for a full-length portrait — see Haskell, *Painters and Patrons*, p. 17.
67. Vertue, I, p. 125.
68. Walpole, *Anecdotes*, vol. 2, p. 632.
69. ed. S. H. A. Hervey, *The Diary of John Hervey*, pp. 159-65.
70. John Ingamells and Robert Raines, 'Catalogue of the Paintings, Drawings and Etchings of Philip Mercier', *Walpole Society*, (1976-8) vol. 46, pp. 4-6.
71. Trevor Fawcett, 'Eighteenth Century Art in Norwich', *Walpole Society* (1976-78) vol. 46, pp. 71-90.
72. M. Kirby Talley, 'Thomas Bardwell of Bungay, Artist and Author 1704-1767', *Walpole Society*, vol. 46, pp. 95-112.
73. E. R. Dibdin 'Liverpool Art and Artists' pp. 12-91.
74. Fawcett, *Art in Norwich*.
75. *Ibid.*
76. Collins-Baker, *Lely and the Stuart Portrait Painters*.
77. Vertue, I, pp. 82, 105-6.
78. Vertue, III, p. 79; see also Lippincott, *Selling Art*, pp. 36-8.
79. E. K. Waterhouse, *Painting in Britain 1530-1790* (London 1978) pp. 230-1.
80. Vertue, II, p. 133. For John Michael

Wright's cousin see Walpole, *Anecdotes*, vol. 2, p. 474.
81. W. Foister, 'British Artists in India, 1760-1820', *Walpole Society* (1930-31) vol. 19, pp. 1-88. For Kettle and Humphrey, see pp. 51-7. See also Mildred Archer, *India and British Portraiture 1770-1825* (London 1979) pp. 66-97 and 186-203.
82. For Smibert, see above, chapter two. See also W. Dunlap, *History of the Arts of Design in the United States*, 2 vols. (New York 1834) pp. 17-28, 30, 167-8.
83. What little information there is on such people can most easily be found in E. K. Waterhouse, *Dictionary of English 18th Century Painters*.
84. Oliver Goldsmith, *The Vicar of Wakefield*, pp. 82-83.
85. J. Ayres, *English Naive Painting* (London 1980) pp. 151-7. For another account of travelling painters, see *Gentleman's Magazine*, 12 (1742) p. 434. For an account of the lesser urban painter, James Bunk, see Edwards, p. 32, where he is inserted as the author 'deems it necessary to notice those who have contributed their feeble efforts toward supporting a spirit of enrichment and decoration among the inferior virtuosi'. The continued existence of such people was ascribed by Hogarth to simple economics: 'A certain number of portrait painters, if they can get patronised by people of Rank, may find employment, but the majority, even of these, must either shift how they can amongst their acquaintance, or live by travelling from town to town like gypsies'. *Hogarth Illustrated*, vol. 3, p. 89.
86. Gwyn, *An Essay on Design*, preface.
87. Charles Lamotte, *An Essay on Poetry and Painting* (London 1730) 'an Appendix concerning Obscenity,' p. 184.
88. *An Essay on Poetry and Painting* pp. 8-9.
89. Aglionby, *Painting Illustrated*, dedication.

90. 'Generosus,' *The Nature of Patronage and the Duty of Patrons* (London 1732). For comparisons with literary patronage, see P. Rogers, *The Augustan Vision* (London 1978) pp. 76-86 and M. Foss, *The Age of Patronage: The Arts in England 1660-1750* (London 1971) pp. 162ff and, best of all, P. J. Korshin, 'Types of 18th Century Literary Patronage', *Eighteenth Century Studies*, 7, no.4 (1974) pp. 453-73.

91. The most striking example of this was the AntiGallican Society formed, according to Edwards, after the peace of Aix-La-Chapelle in order to encourage an early Buy-British campaign. Edwards continues: 'and though it must be confessed that these societies did not direct their attention to the arts in particular, yet their patriotic example greatly stimulated their countrymen to exert their talents in those productions which were before almost unknown in Great Britain'. (Introduction, p. x).

92. Richardson, *Science of a Connoisseur*, pp. 49-50.

93. Du Fresnoy, *de Arte Graphica...*, translated by *Mr. Wills*, dedication, p. I.

94. Matthew Decker, *Essay on the Decline of Foreign Trade* (Dublin 1749) pp. 181ff.

95. Richard Hurd, *Dialogues on the Uses of Foreign Travel considered as part of an English Gentleman's Education, between Lord Shaftesbury and Mr Locke* (2nd ed., London 1764) p. 60. Not everybody agreed with this comforting idea, however; see for example Chesterfield, *Letters*, London, 7 February OS. 1749.

Chapter Six: Collectors and Collections

1. 'The Doctors of the Church', valued at £3,500 by West and Cipriani in 1779 and sold to the Empress Catherine. It is still in the Hermitage, Leningrad. (cf. Pepper, *Guido Reni*, no.98, p. 250). For Walpole see *Aedes*, and Plumb, *Sir Robert Walpole*, pp. 85-7.

2. For Newcastle see 1711 inventory of his goods at 'Welbeck, Haughton, Bolsover Castle, Nottingham Castle, Wimple and Dover St Westminster' in *PRO Prob 5/37*. For the Earl of Bristol see ed. S. H. A. Hervey: *The Diary of John Hervey, 1st Earl of Bristol with Extracts from his book of Expenses* (Wells 1894).

3. For Harenc see above, chapter 3. For Burke (1729-97) see *Letters*, vol. 2, pp.7-8: to Barry 19 July, 1768: 'We have bought a pretty house and estate...with the house I was obliged to take the seller's collection of pictures...'. See also Carl B. Cone 'Edmund Burke's Art Collection', *Art Bulletin*, 29 (1947) pp. 126-151.

4. For the Duke of Rutland (1696-1779) see Esther Moir: *The Discovery of Britain, The English Tourists 1540-1840* (London 1964) p. 71. Lady Victoria Manners, 'Notes on the Pictures at Belvoir Castle', *Connoisseur* (June 1903), pp. 67-75, Christopher Hussey, 'Belvoir Castle, Rutland' *Country Life*, 6 December, 1956, pp. 1284-90; 13 December, pp. 1402-5; 20 December, pp. 1456-9; 27 December, pp. 1500-3.

5. For West (1704-72) see *Alscot Mss*, account books of James West detailing expenditure on cleaning, repairing and framing as well as purchases in sale catalogues.

6. 1641-1702. See K. J. Garlick: 'a catalogue of pictures at Althrop', *Walpole Society* (1974-6), vol. 45, introduction.

7. For the early history of collecting, see Denys Sutton, 'Early Patrons and Collectors', *Apollo*, November 1981, pp. 282-97 and Susan Foister: 'Paintings and other works of Art in 16th Century English Inventories' *Burlington Magazine*, 123 (1980) pp. 273-82.

8. Girouard, *English Country House*, pp. 101-2.
9. For the use of the term 'repository' with reference to English collections of curiosities, see Michael Hunter: 'The Cabinet Institutionalised: The Royal Society's "Repository" and its background', in ed. O. Impey and A. MacGregor, *The Origins of Museums: The Cabinet of Curiosities in Sixteenth and Seventeenth-Century Europe* (Oxford 1985) pp. 159-68, especially, p. 168. For virtuoso collecting see Houghton, *The English Virtuoso;* Arthur MacGregor, 'The Cabinet of Curiosities in Seventeenth Century Britain' in *The Origins of Museums*, pp. 147-58 and for the 18th century succession, J. M. Levine, *Dr Woodward's Shield, History, Science and Satire in Augustan England* (London 1977).
10. Waterhouse: 'A Note on British Collecting', Borenius, 'The Sale...'.
11. For Beaufort, see chapter 3. For Povey see deed of sale of Books, Manuscripts and Pictures of Thomas Povey esq., of St Martins' in the Fields, to William Blathwayt, and schedule. Gloucester Records Office *Dyrham papers*, D1799/E247 dated 8 November 1693/4.
12. (James Wright), *Country Conversations: Being an Account of some Discourses that happened in a Visit to the Country last Summer, on divers Subjects...* (London 1694) p. IV.
13. Mark Girouard, 'The Power Houses', 1st Slade lecture, Oxford, 1976.
14. ed. Cartwright, *The Wentworth Papers*, p. 26.
15. Alexander Pope, 'On the Use of Riches', in *Complete Works* (London 1881) vol. 3, first published as Epistle four of *Moral Essays* (London 1731).
16. For example see (James Bramston), *The Man of Taste.*
17. Pope, 'Use of Riches'.
18. Richardson, *An Essay on the Whole Art of Criticism* in *Two Discourses*

(London 1719) pp. 15-16.
19. *A Call to the Connoisseurs*, p. 29.
20. Richard Blome, *The Gentleman's Recreation* (London 1686), entry on painting. William Sanderson, *Graphice, the Use of the Pen and Pencil, or, the most Excellent Art of Painting, in two parts* (London 1658) p. 24ff. Sanderson recommends that portraits of one's wife should be placed upstairs in private rooms for fear of arousing adulterous thoughts in the mind of 'an Italian-minded guest'. John Elsum, *The Art of Painting*, pp. 82-7.
21. Banbrigg Buckeridge, *The Art of Painting*, dedication.
22. See James Kennedy's *Description of the Antiquities and Curiosities in Wilton-House* (London 1769), reprinted in Frank Herrmann, *The English as Collectors, A Documentary History* (London 1972) pp. 97-9.
23. *A Letter on the Nature and State of Curiosity as at present with us* (London 1736) p. 23.
24. By Mary Webster, in 'Taste of an Augustan Collector: The Collection of Dr Richard Mead,' *Country Life*, 148 (1970) p. 765ff.
25. Having part of a collection devoted to heads of eminent men was quite common — both the Earls of Oxford and of Halifax, for example, had sizeable portions of their collections in this category. However, the proportion of politicians and soldiers was generally far higher than in Mead's, and the quality of the paintings less good. Such paintings were generally there for their representation rather than for their artistic quality and consequently tended to be either inexpensive or copies. It was only when the repute of portraits began to rise in artistic terms that this changed, and here, perhaps, Mead might be seen as innovatory. If collecting portraits was a conceit, paying lip-service to the idea that illustrious predecessors could have a

moral effect through their image, then it was one dearly held onto, even if not always acted upon. John Sheffield, Duke of Buckingham, for example, remarked about his gallery 'there also....I have so many portraits of famous persons in several kinds, as enough to excite ambition in any man less lazy, or less at ease, than myself' (*Works*, vol. 2, p. 218).

26. The best account of Mead is A. Zuckerman: *Dr Richard Mead (1673-1754) a biographical study* (Univ. of Illinois PhD 1965). See also R. H. Meade: *In the Sunshine of Life: a biography of Richard Mead* (Philadelphia, 1974). For Watteau see M. Eidelberg: 'Watteau Paintings in England in the early 18th Century', *Burlington Magazine,* 117 (September 1975) pp. 576-81 and R. Raines, 'Watteau and "Watteaus" in England before 1760', *Gazette des Beaux Arts* (Février 1977) pp. 51-64.

27. The art collection of the 2nd Earl of Egremont is one of the best documented of the first half of the century. Not only is there a full inventory of Egremont House, taken shortly after the Earl's death in 1763, but also a detailed list of purchases, with prices paid and the source. In addition to this there are frequent references to Egremont in auction catalogues before 1749, when this second manuscript begins. *Petworth Mss.*, 6267, 5742, 5743, 5749. For the auctions see *V&A Mss.* 86-00-18/19. Many paintings were sold at Christies on 7/8 March 1794 in an anonymous sale, while more went on 21 May 1892 and 26 November 1892. (Spellings as in Mss).
VENETIAN PAINTERS: Canaletto; Giorgione; Marieschi; Old Palma (2); Schiavone; Solario; Tintoretto; Titian (2); P. Veronese (2); BOLOGNESE PAINTERS; Albano (3); A. Carracci (1 and 1 copy); Cignani; Franceschini; Correggio; Guercino (5); Lanfranc; Sirani (2); del Sole (2). ROMAN PAINTERS: Bassano (3); Brandi;

Chiari (3); Pietro da Cortona; Lucatelli (5); Maratti (2); Mola; Panini (9); Trevisani; Viviano; Zuccharo. FLORENTINE SCHOOL: Andrea del Sarto (2); Bronzino; Carlo Dolce; Leonardo; Vasari; Zuccharelli. DUTCH ARTISTS: Backhuysen; Berghem; Bloemart; Cuyp (4); Hackert; Hobbima (2); Moucheron; Rembrandt; Ruysdael; Vander-Heyde; Vanderwelde; Van Eckout; Van Goen (4); VanHorst; Van Huysum; Vliega; Wynants (2). FLEMISH ARTISTS: Both (2); Brill; Brower; Matsys; Miel (2); Mompert (7); Peters; Poelenbergh; Synders (2); Tillemans; Teniers (9); VanderMeulen (3) de Vos. FRENCH PAINTERS PRESENT: Bon Boulogne; Sebastian Bourdon (3); Boyer; Chardin; Claude (2); La Hyre; Le Sueur (2); Millet (3); G. Poussin (3); N. Poussin (2); S. Vouet (2).

28. 3 February 1758 lot 56 sold Christies 15.6.1850 lot 12.

29. £126, Bragge sale 24 Jan., 1754; still at Petworth (Plate 55).

30. Anonymous sale 29 July 1762, £105.

31. £81.18*s.* Furnese sale 3.2.58 (Petworth Mss). This painting is not, however, down as being bought by Egremont in the V&A *Mss* manuscript version of the Furnese sale catalogue.

32. £99.15*s.* Bragge 1756, day 1 lot 71. Still at Petworth (Plate 56).

33. John de Pesters sale 3.4.1756 lot 31 £241.10*s.* Still at Petworth (Plate 57).

34. Bought for £186.18*s.* at Bragge's sale in 1753, lot 75. Location unknown.

35. Seven paintings of Guido Reni (1575-1642) fetched more than £100 at auction, the maximum being £328 paid for a *Madonna and Child* at the Schaub sale by Richard Grosvenor (Sold Christies 4 July 1924 — see D. S. Pepper, *Guido Reni* (New York 1984) p. 257, catalogue 115 note 1a/b.) According to Pepper, it is a

copy. Maratti was described by
Chesterfield (18 November 1748) as
'the last eminent painter in Europe', a
view to which many of his contem-
poraries would have subscribed.

36. The reputation of the painting was,
however, shortlived. By 1770 there
appears to have been some concern
that it was a copy; see for example
Walpole's visit to Bulstrode in 1770,
Walpole Society (1927-8) vol. 16, p.
68 where he describes it as 'the copy
of Raphael's Holy Family at Ver-
sailles...'.

37. Rembrandt was, perhaps, typical of
the aesthetic confusion of the period.
On the one hand his works could
fetch extremely high prices, but he
could still be dismissed by the likes
of Chesterfield: 'I love la belle nature;
Rembrandt paints caricatures' (*Let-
ters* 10 May 1751). For general in-
formation about Dutch paintings in
England in this period, culled from
the sale catalogues in the *V&A Mss.*,
see Frank Simpson, 'Dutch paintings
in England before 1760', *Burlington
Magazine*, 95 (February 1943) pp.
39-42. See also *Rembrandt in 18th
Century England*, ed. C. White, D.
Alexander, E. D'Oench, Yale Center
for British Art exhibition catalogue
(1983); Seymour Slive, *Rembrandt
and his Critics 1630-1730* (The
Hague 1953).

38. Walpole, *Aedes*, introduction.

39. James Barry, *An Enquiry into the
Real and Imaginary Obstructions to
the Acquisition of the Arts in Eng-
land*, in *Works* (London 1809) vol. 2,
p. 199. See also Reynolds' thoughts
on the matter in *The Idler*, 20 Octo-
ber 1759.

40. A good and concise account of 18th
century European collecting is in F.
H. Taylor, *The Taste of Angels; A
History of Art Collecting from
Rameses to Napoleon* (Boston
1948), especially pp. 302-12 on
Christina of Sweden, pp. 330-400 on
French collectors and pp. 500-31 on
Prussia and Russia.

41. John Elsum: *The Art of Painting af-
ter the Italian Manner* (London
1704) p. 82ff.

42. Dezallier D'Argenville: 'Lettre sur le
choix et l'arrangement d'un cabinet
curieux,' in *Mercure de France*, juin
1727, p. 1295. Reprinted in E. Piot:
Le Cabinet d'un Amateur (Paris
1861-2) pp. 163-78.

43. C. F. Joullain: *Réflexions sur la
Peinture* (Paris 1786) pp. 99-106.

44. See, for example, the lists of works
sold by Peter Stent listed by Alexan-
der Globe in *Peter Stent, London
Printseller c.1642-65* (Vancouver
1985).

45. (William Graves) *Sculpura-Histori-
ca-Technica; or the History and Art
of Engraving* (London 1747) preface
p. IV. In saying this Graves was, by
mid-century, repeating a common-
place. In 1698/9, for example
Richard Powys was writing to
Matthew Prior: 'Having now taken a
House, I am entering into the trouble
and expence of furnishing of it. Pic-
tures, if good, are very dear, if bad,
they are the worst furniture I can
have, but good prints make as hand-
some a show...', *Hist. Mss. Comm.
Bath Mss*, III, p. 330 (Letter dated
March 23/April 2 1698/9).

46. *Letters*, vol. 23, p. 465 to Mann, 6
May 1770.

47. Sanderson, *Graphice*, p.15.

48. Gwyn, *An Essay on Design*, p. 44.

49. Richardson, *Science of a Connois-
seur*, p. 53.

50. Buckeridge, *The Art of Painting*,
dedication.

51. Colen Campbell, *Vitruvius Britanni-
cus, or, the British Architect, in two
volumes* (London 1715, reprinted
New York 1967) is full of patriotic
remarks about English architecture
and architects.

52. Bernard Mandeville, *The Fable of
the Bees*, 2 vols. edited by F. B.
Kaye (Oxford 1924) vol. 1, pp. 108-
24, 181-5; vol. 2 preface, pp. 51-3,
75-6, 126-7 (first published London
1714). See also M. M. Goldsmith,

'Private Vices, Public Virtues: Bernard Mandeville and English Political Ideology in the early 18th Century', in *Eighteenth Century Studies* (1975-6), vol. 9 pp. 477-511.

53. Fawconer took a completely opposite stance to Mandeville, for which see his *Discourse on Modern Luxury*, passim. For a general survey of the idea of luxury, see the excellent book by John Sekora, *Luxury, the Concept in Western thought from Eden to Smollett* (Baltimore 1977).

54. *A Letter on....Curiosity*, p. 14.

55. Buckeridge, *The Art of Painting*, dedication.

56. Turnbull, *A Treatise on Ancient Painting*, p. 121.

57. Such an opinion coincided closely with the idea that there was also a right and wrong way of patronage, for which see above, chapter 4.

58. Speck, *Society and Literature*, p. 47.

59. *A Letter on....Curiosity*, p. 53.

60. (Thomas Martyn), *The English Connoisseur* (London 1766), preface pp. II-III. For the sources of this important work, see Frank Simpson, 'The English Connoisseur and its Sources' in *Burlington Magazine*, 93 (1951) pp. 355-6. For those who followed his advice, see John Harris, 'English Country House Guides,1740-1840', in *Concerning Architecture, Essays on Architectural Writers and Writing presented to Nikolaus Pevsner*, ed. John Summerson (London 1968) pp. 58-74. See also John Vaughan, *The English Guide Book, c.1780-1870, An Illustrated History*, (Newton Abbot 1974).

61. Vertue, III, pp. 2, 5, 42.

62. See the *Gentleman's Magazine*, 28 (March 1758) p. 141.

63. ed. Paget Toynbee: 'Horace Walpole's journals of visits to country seats, etc.' in *Walpole Society* (1927-8) vol. 16, pp. 9-80 and Lord Oxford's tours through various parts of Britain in *Hist. Mss. Comm. 29 (Portland Mss.)* vol. 6, pp. 65-191 passim.

64. *Bodleian Library Mss Rawl* a 178

f211. Who Scawen was is not clear, but one Robert Scawen appears in Venice in 1692, writing to Sir William Trumbull about the possible purchase of pictures there. *Hist. Mss. Comm. (Downshire Mss)*, I, p. 411.

65. The best general coverage of the growth of the English tourist industry in this period is Esther Moir, *The Discovery of Britain: The English Tourists 1540-1840* (London 1964) pp. 58-76.

66. *Ibid.*, pp. 59-62.

67. *Torrington Diaries*, vol. I, p. 53. The costs of a country tour can be gauged by examining a journal, possibly by the third Viscount Grimston, which details the varying expenses — A Northern Tour from St Albans, 1768, *Hist. Mss. Comm. (Earl of Verulam Mss)* pp. 229ff.

68. *Torrington Diaries*, vol. I, p. 231.

69. He also adopted a system of entry by ticket, and was promptly besieged by people considered quite unsuitable. See W. T. Whitley, *Art in England 1800-1828* (Cambridge 1921) pp. 108-10.

70. This fact is mentioned in Walpole, *Aedes*, for the entry under the Gallery. See also the letter to Horace Mann dated 18 June 1751 in *Letters*, vol. 3, p. 60. Compare also the inventory of 1736 — 'A Catalogue of the Right Honble Sir Robert Walpole's Collection of Pictures' in Pierpoint Morgan Library, New York, which lists 114 pictures at Houghton, 149 in Downing Street, 64 in Grosvenor Street and 78 in Chelsea. Many of the London pictures were sold between 1748 and 1751 after Walpole's death. While the great collection of Maratti were at Houghton, and appear to have been specifically bought for the house, the London collections included the Poussin of 'Moses Striking the Rock' (*Blunt* no. 23) and of 'Scipio's abstinence' (*Blunt* no. 181), two Claudes (*Roth* no. 5 and 99) and

the Velásquez of 'Innocent X' (Washington).

71. The collection began moving to Corsham after Sir Paul Methuen died in 1757 and his estate passed to his cousin, Paul Methuen. The portion that was left in the capital was transferred to the country by Paul Cobb Methuen after 1795, see Tancred Borenius, *A Catalogue of the Pictures at Corsham Court* (London 1939) pp. X-XI. Compare also the inventories for the London house, contained in Martyn, *The English Connoisseur*, vol. 2, pp. 17-37 with that in John Britton, *An Historical Account of Corsham Court, in Wiltshire, the Seat of Paul Cobb Methuen, esq., with a Catalogue of his Celebrated Collection of Pictures* (London 1808).

72. Martyn, *The English Connoisseur*, vol. 1, pp. 28-30 (Chatsworth) and pp. 41-51 (Devonshire House). The view is backed up by William Gilpin, in his *Observations....made in 1772, on several parts of England, particularly the Mountains and Lakes of Cumberland and Westmoreland* (London 1788) vol. 2, p. 221 'There are few pictures in the house'. By the mid-19th century, however, the situation had changed radically and Chatsworth had taken on more of its modern appearance — Waagen, *Treasures of Art of Great Britain* (London 1854) vol. 3, p. 344.

73. See the inventories of various dates from the 1730s onwards that are in the *Alscot Mss.* box 13.

74. Sampson Gideon (1699-1762), a financier of Portuguese Jewish descent whose son was made Lord Eardley. Inventory in Martyn *The English Connoisseur*, I, p. 12; *London and its Environs Described*, I, p. 271-4. The collection stayed in the family when it sold Belvedere and moved to Bedwell park and passed to Sir Culling Eardley. Portions, however, were sold at Christies 30 June 1860; 6 June 1868; 14 June 1929. Gideon

was a frequent buyer at auction sales. Among his purchases was 'Snyders and his Wife and Child by Long Jan' (Orford sale 1751, day 2, lot 66, 84 stg) now attributed to Van Dyke; 'Morillios Flight into Egypt' (1756 Mendez sale lot 46) now Detroit Institute of Art; and 'Rembrandt painting an Old Woman' (Schaub sale, 1758, day 2 lot 98), now Cologne.

75. Sir Gregory Page; *London and its Environs Described,* vol. I, pp. 315-22; Martyn *The English Connossieur,* vol. I, pp. 90ff. Page was a second baronet and reputed to be the wealthiest commoner in the kingdom. He died in 1775 and his house was torn down in 1788: 'the princeley magnificence of his residence, his park and his domestics surpassed everything in point of grandeur that had been exhibited by a citizen of London since the days of the munificent Sir Thomas Gresham and almost equally the Italian merchants of the ducal house of Medicis. (Mss of Sir Henry Dryden, quoted in *Country Life* 4 July 1947, letter of F. H. Page-Turner). The collection was bought by Van Heythusen at the beginning of the 1780s apart from some minor works which went to the Cator family, see W. Buchanan *Memoirs of Painting with a Chronological history of the importation of pictures by the Great Masters into England since the French Revolution* 2 vols. (London 1824) I, p. 321. Other fragments sold 8 May 1783 (Lugt 3573). As John Brushe notes in his essay on Wricklemarsh, Page was an enthusiast for Dutch painting and particularly favoured Vanderwerff (Wricklemarsh and the Collections of Gregory Page, *Apollo,* November 1985, pp. 364-71.)

76. Reprinted in F. H. Taylor, *The Taste of Angels: A History of Art Collecting from Rameses to Napoleon* (Boston 1948) pp. 451-2.

77. General John Guise, d.1765; Martyn,

The English Connoisseur, II, pp. 49ff. His pictures were left in his will to Christ Church, Oxford, where many still are. See his entry in the *Dictionary of National Biography* and the introductions to the two catalogues of the Christ Church collection by Byam Shaw: *Drawings by Old Masters at Christ Church, Oxford*, 2 vols. (Oxford 1976) and *Catalogue of Paintings at Christ Church, Oxford* (Oxford 1967).

78. Andrew Coltee Ducarel, Antiquarian and librarian of French descent, 1713-85. 29 pictures sold 30 November 1785 (Lugt 3954).

79. Chauncey, 1706-77, collection dispersed at the sale of pictures of Charles and Nathanial Chauncey, 26 March 1790.

80. Presumably Joshua Ward, quack doctor to the poor and the monarchy, 1685-1761. The best account of his life is in *Dictionary of National Biography*.

Chapter Seven: The Connoisseur and Connoisseurship

1. Sir Thomas Elyot, (ed. H.H.S. Croft) *The boke named the Governor* (London 1880) p. 44.

2. John Evelyn, *Sculptura, or the History and Art of Chalcography and Engraving in Copper* (London 1755) dedication to Robert Boyle.

3. W. E. Houghton, 'The English Virtuoso in the 17th century', *Journal of the History of Ideas,* 3 (January-April 1942) pp. 51-73, and 190-219.

4. Smith: *The Art of Painting,* chapter 6, 'Objections to Painting Answered'.

5. J. L. Costeker: *The Fine Gentleman* (London 1973) preface.

6. John Locke, *Some Thoughts concerning Education* (London 1693), section 191, pp. 243-4.

7. Turnbull, *A Treatise on Ancient Painting*, p. 108

8. *Autobiography of Mrs Delaney,* vol.1, to Anne Granville, 7 June 1734.

9. See the list of such people in Manwaring, *Italian Landscape* p. 7.

10. See above, pp. 143.

11. For a general bibliography on educational writings in this period see S. H. Atkins, *Printed Material on Education* (University of Hull, 1970). William Salmon, *Polygraphice, or the Arts of Drawing, etc.* (8th edn. 1701) preface. Sanderson, *Graphice* (London 1658) p. 28. William Higford, *Institutions, or Advice to his Grandson* (1658) pp. 90ff.

12. (Mary Astell?) *An Essay In defence of The Female Sex* (London 1696) pp. 21, 37.

13. Lippincott, *Selling Art*, pp. 38-40.

14. Vertue, V, 63.

15. Cf. Samuel Johnson *The Idler* 35 (16 December, 1758) 'I am the unfortunate husband of a buyer of bargains ... it is impossible to make her pass the door of a house when she hears *goods selling by auction*'. See also above, p. 65.

16. Cosmetti, *The Polite Arts, Dedicated to the Ladies* (London 1767) p. 16. 'When you view a painting, take particular care not to go, like ignorant people, excessively near ... but approach gradually, then recede a little ... it is what connoiseurs call, finding the proper light of a painting'.

17. Some details about the Duchess of Portland, who was the heiress of the 2nd Earl of Oxford, can be found in Goulding, *Catalogue of the Pictures of the Duke of Portland*, For Lady Betty Germaine see Walpole's visits in *Walpole Society*, 16 (1927-8) pp. 40, 55-8. Her finest pictures, Leonardo's 'laughing boy with a plaything in his hand', passed to Sir William Hamilton, then to William Beckford. See O. E. Deutsch 'Sir William Hamilton's Picture Gallery, *Burlington Magazine,* (1943) p. 37. There is a noticeable contrast between the minor impact made by female English collectors and French

examples like the Comtesse de Verrue and Madame de Pompadour, both of whom played a major role in determining the evolution of taste.

18. George Stubbes, *A Dialogue in the Manner of Plato*, dedication to Frederick, Prince of Wales, pp. III-IV.
19. The most complete exposition of this idea can be found in Richardson's 'Theory of Painting', in *Works*. Once again, the ideas were scarcely new, being basically reiterations of notions first put forward by Leonardo, for which see Blunt, *Artistic Theory*, p. 51.
20. Gwyn, *An Essay on Design*, p. 37.
21. (TB) *A Call to the Connoisseurs* p. 5.
22. *Ibid.*, p. 9.
23. Highmore, *Essays*, vol. II, pp. 85-6.
24. *A Call to the Connoisseurs*, p. 10.
25. *Weekly Register*, 112 (3 June, 1732).
26. Daniel Webb, *An Enquiry into the Beauties of Painting* (London 1760) p. 18.
27. Richardson, *The Science of a Connoisseur*, pp. 217-22.
28. Chesterfield, *Letters*, 27 September 1749 OS.
29. Perhaps the most clear-cut way in which aesthetic interests paralleled and even mimicked wider concerns is in that of originals and copies. Just as rapidly increasing wealth increased the number of people with the resources to appear to be gentlemen, so a rapidly expanding art market raised the risk that copies of paintings would be passed off as originals. In both cases the concerned were keen not only to find a way of telling the real and fake apart, but were equally interested in providing some sort of proof that it could indeed be done. As with the case of fake gentlemen, aesthetic theories were faced with the problem of why a copy of a painting was not as good as the original if no-one could tell that it was only a copy — a philosophical problem that periodically reappears every time a museum

discovers that it has paid a large mount of money for a fake. The prime line of defence in both social and artistic cases was to insist that ultimately the deception cannot succeed; that, as Addison put it, 'an imitation of the best authors is not to compare with a good original'. (*Spectator*, no.160) Jonathan Richardson, taking the matter a little further, concluded similarly and decided that if a copy is taken for an original, then this is the fault of the viewer, and indicates either his malformed taste or his lack of attention ('Of Originals and Copies', in *Art of Criticism*, pp. 150-220).

30. Richardson, *Essay on the Art of Criticism*, pp. 22-3.
31. John Sheffield, Duke of Buckingham, 'On Criticism' in *Complete Works* (London 1753), vol. 2, p. 207.
32. TB, *A Call to the Connoisseurs*, p. 22.
33. *Female Spectator*, vol. 3, p. 133.
34. For Schaub and Guise, see Vertue, I, pp. 9-11, 14; III, p. 152. For Walpole's opinion see *Letters*, vol. 4, p. 124.
35. J. Richardson (jnr.), *Richardsoniana* (London 1776), vol. I, p. 336.
36. *Hist. Mss. Comm.(Egmont Diary)*, vol. I, pp. 224-5, 23 February 1731/2; Vertue, III, p. 83.
37. Oliver Goldsmith, 'The Citizen of the World', *The Public Ledger*, 6 May 1760.
38. Ramsay, *The Investigator*, p. 55.
39. J. T. James, *The Italian Schools of Painting, with Observations on the Present State of the Art* (London 1820) pp. V-VI.
40. Collins-Baker, *Lely and the Stuart Portrait Painters*, vol. 1, p. 146. As a result of this expertise he was called in to advise others, such as the 1st Duke of Beaufort, see above, chapter 3.
41. For Jervas see Vertue, III p.16. For Kent see Michael I. Wilson, *William Kent: Architect, Designer, Painter, Gardener 1685-1748* (London 1984)

pp. 22-38.

42. *Hist. Mss. Comm. Duke of Buccleuch at Montagu House*, Mss II pt. 2, pp. 746-99.

43. The little information available on the Rose and Crown club is to be found in Vertue, VI, pp. 32-6.

44. Occasionally, it appears that paintings coming up to auction were specifically exhibited so that a wider public could see them; cf. the advertisement in the *Evening Post* for 23 August 1720 for the sale of a 'collection of pictures lately brought from Rome, in which is that famous picture of Tintorett, now to be seen in Somersett house'. The work was moved to St Martin's Lane for the sale, which was conducted by Cooper. No further trace of it has survived.

45. *An Idea of the Perfection of Painting from the principles of Art and by Examples conformable to the Observations which Pliny and Quintilian have made upon the most celebrated Pieces of the Ancient Painters, paralleled with some works of the most famous modern Painters ... rendered English by J. E.* (London 1668).

46. *The History of Painting, Sculpture, Architecture, Graving and of those who have excelled in them in three books, containing the Rise, Progress, Decay and Revival; with an account of the Production of the best Artists...and how to distinguish the true and regular Performances* (London 1699). For a list of works published in English, see the Ogdens, 'Bibliography'.

47. *The Painter's Voyage of Italy: In which all the most famous paintings of the most eminent Masters are Particularised, as they are preserved in the several Cities of Italy: chiefly related to their Altar-Pieces, and such other paintings as are ornamental in their Churches: and also many choice Pictures, kept as Jewels, in the Palaces of particular Persons ...written originally in Ital-*

ian *by Giacomo Barri... Englished by W. L.* (London 1679).

48. Richardson, in the *Science of a Connoisseur*, pp. 84-5 gives a list of 11 books he recommends for the apprentice connoisseur. Of these only one is in English.

49. Father Bernard de Montfaucon, *The Travels from Paris thro' Italy in 1698, 1699, 1700, containing an Account of many Antiquities* (London 1712, 1725).

50. Richardson, *An Account of some of the Statues, Bas-Reliefs, Drawings and Paintings in Italy, etc, with Remarks...* (London 1722).

51. John Macky, *A Journey through England, in Familiar Letters* (London 1714), *A Journey through the Austrian Netherlands* (London 1728). John Breval, *Remarks on several Parts of Europe: relating chiefly to the Antiquities and History of those Countries through which the Author has travelled* (London 1726, revised version 1738). James Russel, *Letters from a young Painter abroad to his Friends* (London 1750).

52. Buckeridge, *The Art of Painting.*

53. Walpole not only produced the *Anecdotes*, the *Aedes* and the *Catalogue of the pictures of Charles I*, he also published a *Catalogue of the Collection of Pictures of the Duke of Devonshire, General Guise and the late Sir Paul Methuen* (London 1760) and a *Catalogue of the Curious Collection of pictures of G. Villiers...Also a Catalogue of Sir P. Lely's Collection ... (and) a description of Easton Neston* (London 1758).

54. James Kennedy, *A New Description of the Pictures, Statues, Bustos, Basso-Relievos and other Curiosities at the Earl of Pembroke's House at Wilton* (Salisbury/London 1758).

55. *London and its Environs Described, containing an Account of Whatever is most Remarkable for Grandeur,*

Elegance, Curiosity or Use, in the City and in the Country 20 Miles around it, 6 vols. (London 1761).

56. *The English Connoisseur.*

57. There were a huge number of copyists operating in London throughout this period. Some, such as Mrs Brown in chapter four, have already been noted. The painter Gouge copied Guido's *Joseph and Potiphar's Wife* for Viscount Perceval *(Hist. Mss. Comm. Egmont Diary*, II, p. 192) while George Lucy sent back paintings from Rome to his family in Warwickshire in the 1750s *(Lucy Papers)*. According to Nathanial Wanley, Isaac Fuller 'could put upon Sr Peter Lely one of his pieces for an incomparable picture of M. Angelo'. *(BM Lansdowne 814 ƒ95*, letter dated 11 July 1701). Some of the better copyists were also tempted into outright forgery.

58. For Strange, see his *Memories*. For Boydell see Sven Bruntjen, *John Boydell 1719-1804: A Study in Art Patronage and Publishing in Georgian London* (New York 1985), esp. pp. 16-46. An early attempt to mass-produce high quality prints for a wide audience came with Le Blond's 'picture office' in the early 1720s, which offered engravings of Caracci and Raphael. It went bankrupt fairly speedily. Both Guise and Viscount Perceval were on the board. See *Hist. Mss. Comm* . 7, pp. 247b.

59. Compare, for example, works such as *A Critical Review of the Pictures ... exhibited at the Great Room in Spring Gardens* (London 1766) or *Candid Observations, on the Principle Performances now exhibiting at the New Room of the Society of Artists, Near Exeter Change. Intended as a Vade Mecum to that Exhibition* (London 1772) with the works of French critics of the same period. The best collection of English exhibition criticism is deposited in the W. S. Lewis Library, Farmington, Connecticut. See also Helena

Zmijewska, *La Critique des Salons en France du temps de Diderot 1759-89* (Warsaw 1980).

60. *Aedes*, pp. 76-80.

61. François-Bernard Lépicié, *Catalogue Raisonné des Tableaux du Roi avec un abregé de la vie des peintres* (Paris 1752).

62. *Ibid.*, vol. II, pp. 197-234.

63. *Ibid.*, vol. II, pp. 232-3.

64. L. Lipking, the *Ordering of the Arts in Eighteenth-century England* (Princeton 1970) pp. 127-45.

65. The published account thus contrasts strongly with an earlier, 1735, catalogue which is constructed by order of artist rather than in a room-by-room guide.

66. It was still, nonetheless, a relatively new technique; in a similar work on the Palais Royal by Dubois de Saint-Gelais published in 1727, the paintings are listed, neatly but arbitrarily, by alphabetical order of the painter's Christian name — *Description des tableaux du Palais Royal, avec la Vie des Peintres à la tête de leurs ouvrages*, (Paris 1727).

67. cf. Francis Haskell and Nicholas Penny, *Taste and the Antique* (London 1971) pp. 99-100.

68. *The Gentleman's and Connoisseur's Dictionary of Painters. Containing a complete Collection, and Account, of the most distinguished Artists, who have flourished in the Art of Painting, at Rome, Venice, Naples, Florence, and other Cities of Italy; In Holland, Flanders, England, Germany or France; from the year 1250, when the Art of Painting was revived by Cimabue, to the year 1767; including above Five Hundred Years, and the Number of Artists amounting to near one Thousand Four Hundred....by the Rev. M. Pilkington* (London 1770). It may be noted that in the earlier works the conception of art began with the ancients, with much of the description concentrating on the classical period. Henry Bell's *On*

the Origin of Painting (1728), for example, starts with the Flood and works through the Egyptians, Chinese, Greeks, Romans and Trojans before reaching Cimabue. By the time of Pilkington a more 'Renaissance-oriented' approach had become the norm.

69. *Ibid.*, preface, p. v.
70. *Ibid.*, preface, p. vi.
71. *Ibid.*, p. 269.
72. See Peter Fullerton, 'Patronage and Pedagogy: the British Institution in the early Nineteenth Century,' *Art History*, 5 (1982) pp. 59-72.

Bibliography

Primary Sources

Manuscript

Alscot Park, Stratford upon Avon
Papers of James West

Badminton House, Gloucestershire
Papers of the Earls and Dukes of Beaufort

Cambridge, University Library
Cholmondely Mss, series (H) correspondence of Robert Walpole

Chatsworth House, Derbyshire
Papers of the Dukes of Devonshire

Chichester, West Sussex Records Office
Petworth Mss

Chester, Cheshire Records Office
Inventory of Lord Cholmondely's pictures DCH/X/15/12

Edinburgh, Scottish Records Office
Clerk of Penicuik Mss GD 18 4665 letters of Andrew Hay
CC8-8-116-2 Testament of Andrew Hay

Gloucester, Gloucestershire Records Office
Dyrham Mss (series D1799)

Holkham Hall, Norfolk
Coke Mss

London, British Museum
Add Mss 6269 Birch Papers
Add Mss 9125 Coxe papers: inventory of the pictures at Blenheim Palace
Add Mss 16174 Accounts of the sale of pictures of Sir Peter Lely
Add Mss 32504 Notebook of Roger North (1701)
Add Mss 41255 'a note of pictures taken in 9'ber 1684' (Viscount of Fauconberg)
Add Mss 44024 Account book of Nathanial Hone
Add Mss 61355 'Sir Godfrey Kneller's — of his sketch for an Historical or Allegorical picture'
Add Mss 61354 'The Explanation of ye painting in ye Oval of the Great Hall at Blenheim, by James Thornhill'
Blenheim Loan E.5.4 letters of the Earl of Sunderland

BM Loan 29 papers of the Earls of Oxford
Lansdowne Mss 1050 'Inventory of Mr Prior's pictures, taken the 18th October, 1721'
Lansdowne Mss 1215 Notice on Auctions
Stowe Mss 747 letter of Edward Millington
Harleian Mss 6344 a description of the pictures at Buckingham House
Sloane Mss 1985 a description of the pictures and manuscripts of Hadrian Beverland

London, Greater London Council Record Office
Acc 1128/107-177 inventory of the pictures of Robert Child and a listing of his pictures bought in Holland

London, Guildhall Library
Small Mss boxes 6, 35 papers relating to the outroper's office
MS 5667-9 minute books of the Painter-Stainers' company

London, National Gallery
Philipps-Roberts MSS 10254

London, Public Record Office
Prob 5/37 inventory of the goods of John Holles, Duke of Newcastle
Cust 3 register of imports and exports, 1693-1774
Prob 11 will of Samuel Paris, proved December 1760
 will of Robert Bragge, proved July 1777
SP 35 Calendar of State Papers (Domestic), George I and George II

London, Victoria and Albert Museum
MS 86-00-18/19 (J. Houlditch) Transcripts of Auction sales, 1711-58

Maidstone, Kent Record Office
Lisle Mss (U1500)

Northampton, Northamptonshire Records Office
Booth Mss
Exeter (Burghley) Mss

Nottingham, University of
Papers of the Dukes of Portland

Oxford, Bodleian Library
MS Eng. Lett. e.275 letter of Charles Jervas
MS Eng. Lett. e.34 letter book of John Talman
MS North b.17 accounts of Arthur Moore
MS Rawl a.178 letter of Thomas Povey
MS Rawl d.1162 notebook of William Kent
MS Rawl d.1161 diary of Thomas Rawlinson

Warwick, Warwickshire Record Office
Lucy papers (L6)

Printed Collections

Calendar of State Papers (Domestic) 1660-1704

Calendar of State Papers (Treasury Books) 1660-1702

Calendar of State Papers (Treasury Papers) 1720-28

The Journal of the House of Lords, 1670-1766

The Journal of the House of Commons, 1670-1766

Historic Manuscripts Commission

7th report: Papers of Sir Harry Verney

Mss of the House of Lords

Papers of the Earl of Egmont (1879)

9th report: *Calendar of the House of Lords* (1883)

13th report: *Mss of the Duke of Portland*, vols. 1-10 (1891-1931)

14th report: *Mss of the House of Lords*, vols. 1-12 (1900-77)

Mss of the Duke of Rutland, vols. 1-4 (1888-1905)

Mss of the Duke of Buccleuch at Montagu House, vols. 1-3 (1899-1903

Diary of Viscount Perceval, afterwards 1st Earl of Egmont vols. 1-3 (1920-3)

Mss of the Marquis of Downshire (1924-40)

Primary Printed Sources

ANON *Abstract of the Instrument of Institution of the Royal Academy of Arts in London* (London 1797)

ANON *The Act of Tonnage and Poundage and Book of Rates* (London 1682)

AGLIONBY, William *Painting Illustrated in three Diallogues; containing some choise Observations upon the Art; together with the Lives of the most eminent Painters from Cimabue to the Time of Raphael and Michael Angelo* (London 1685)

ANGELO, Henry *Reminiscences of Henry Angelo*, ed. Lavers Smith 2 vols. (London 1904)

ASTELL, Mary (?) *In Defence of the Female Sex* (London 1696)

BARLOW, Thomas *The Case concerning the setting up of Images, or Painting of them, in churches: —Thomas Barlow, late Bishop of Lincoln, upon the occasion of his suffering such Images to be defaced in his Diocese Published upon the occasion of a Painting being set up in Whitechapel Church* (London 1714)

B, T *A Call to the CONNOISSEURS, or DECISIONS of SENSE, with respect to the PRESENT STATE of PAINTING and SCULPTURE and their several PROFESSORS in these KINGDOMS, Together with a REVIEW of, and an EXAMINATION into, their comparative MERITS and EXCELLENCIES. Intended to vindicate the GENIUS and ABILITIES of the ARTISTS of our COUNTRY from the MALEVOLENCE of the pretended CONNOISSEURS or interested DEALERS* (London 1761)

BARRI, Giacomo *The Painter's Voyage of Italy: In which all the most famous paintings of the most eminent Masters are Particularised, as they are preserved in the several Cities of Italy: chiefly related to their Altar-Pieces, and such other paintings as are ornamental in their Churches: and also many choice Pictures, kept as Jewels, in the Palaces of particular Persons... written originally in Italian by Giacomo Barri... Englished by W(illiam) L(odge)* (London 1679)

BARRY, James *The Works of James Barry*, 2 vols. (London 1809)

BEVERLAND, Hadrian *Hadriani Beverlandi Patrimonii sui Reliquae* (London 1711)

BLOME, Richard *The Gentleman's Recreation* (London 1686)

BOYDELL, John *Catalogue raisoné d'un recueil d'estampes d'après les plus beaux Tableaux qui soient en Angleterre* (London 1769/79)

(BRAMSTON, James) *The Man of Taste, by the Author of the Art of Politicks* (London 1733)

BREVAL, John *Remarks on several Parts of Europe: relating chiefly to the Antiquities and History of those Countries through which the Author has travelled* (London 1726, revised version 1738)

BRITTON, John *An Historical account of Corsham Court in Wiltshire, the Seat of Paul Cobb Methuen, esq., with a Catalogue of his celebrated collection of Pictures* (London 1808)

BROWNE, Alexander *Ars Pictoria: or an Academy treating of Drawing, Painting, Limning and Etching, to which are added thirty Copper Plates...* (1669)

BUCHANAN, W. *Memoirs of Painting with a Chronological history of the importation of pictures by the Great Masters into England since the French Revolution* , 2 vols. (London 1824)

BUCKERIDGE, B(anbrigg) trans. of (Roger de Piles) *The Art of Painting, with the Lives of the Painters...To which is added, an Essay towards an English School* (London 1706)

BURKE, Edmund *The Letters of Edmund Burke*, ed. T. W. Copeland (Cambridge and Chicago 1958)

———— *A Philosophical Enquiry into the Origin of our Ideas of the Sublime and Beautiful* (London 1757)

BYNG, J. Viscount Torrington *Torrington Diaries* ed. C. B. Andrews (London 1935)

ANON *The Conduct of the Royal Academicians, while Members of the Incorporated Society of Artists of Great Britain* (London 1771)

COLLIER, Jeremy *A Short View of the Prophaneness and Immorality of the English Stage* (London 1698)

CONOLLY— *The Connoisseur, or Everyman his Folly* (London 1736)

COOPER, Anthony Ashley, 3rd Earl of Shaftesbury *Characteristicks of Men, Manners, Opinions, Times, Etc, in Three Volumes* (5th Edition, Birmingham, 1773)

COOPER, John Gilbert *Letters concerning Taste* (London 1755)

COSTEKER, J. L. *The Fine Gentleman; or, the Complete Education of a young Nobleman* (London 1732)

ANON *The Country Gentleman's Companion; Letters ... from a Gentleman in London, to his Friend in the Country, wherein he Passionately dissuades him from coming to London* (London 1699)

COWPER, Lady Mary *The Diary of Mary, Countess Cowper*, ed. C. S. Cowper (London 1864)

D'ARGENVILLE, Dezallier *'Lettre sur la Peinture', Mercure de France* (juin 1727) p.1295

DECKER, Matthew *An Essay on the Decline of Foreign Trade* (Dublin 1749)

DEFOE, Daniel *An Essay upon Projects* (London 1697)

———— *The Compleat English Gentleman; ... edited for the first time from the Author's autograph Manuscript in the British Museum by Karl D. Buelbring (London 1890)*

DELANEY, Mrs Mary *Autobiography and Correspondence of Mary Granville, Mrs Delaney, with interesting Reminiscences of King George III and Queen Charlotte*, ed. Lady Llanover, 6 vols. (London 1861-2)

ANON *A Discourse concerning the Propriety of Manners, Taste and Beauty* (London 1751)

DOSSIE, Robert *The Handmaid to the Arts* (London 1758)

DUBOIS DE SAINT-GELAIS L. F. *Description des tableax du Palais Royal, avec la Vie des Peintres à la tête de leurs ouvrages* (Paris 1727)

EDWARDS, Edward *Anecdotes of Painters who have resided or been born in England, with critical Remarks on their Productions* (London 1808)

ELSUM, John *The Art of Painting in the Italian Manner* (London 1704)

ELYOT, Sir Thomas *The Boke named the Governour*, ed. H. H. S. Croft (London 1880)

EVELYN, John *Sculptura, or the History and Art of Chalcography, and Engraving in Copper* (London 1755)

FAWCONER Samuel *A Discourse on modern Luxury* (London 1765)

FOOTE, Samuel *The Dramatic Works of Samuel Foote*, 4 vols. (London 1763-81)

FREART DE CHAMBRAY, R. *An Idea of the Perfection of Painting from the Principles of Art and by Examples conformable to the Observations which Pliny and Quintilian have made upon the most celebrated Pieces of the Ancient Painters, paralled with some Works of the most famous Modern Painters...* rendered English by J[ohn] E[velyn]

FRESNOY, Charles du *de Arte Graphica, translated ... by Mr. Wills, with notes Miscellaneous and Explanatory* (London 1754)

'GENEROSUS' *The Nature of Patronage and the Duty of Patrons* (London 1732)

GERARD, Alexander *An Essay on Taste* (3rd ed, 1780)

(GILPIN, William) *An Essay upon Prints* (London 1768)

GILPIN, William *Observations relative chiefly to Picturesque Beauty ... made in 1772, on several parts of England, particularly the Mountains and Lakes of Cumberland and Westmoreland*, 2 vols. (London 1788)

GOLDSMITH, Oliver *The Citizen of the World; in The Public Ledger (London 1760)*

———— *The Vicar of Wakefield* (London 1766)

GRAVES, William *Sculptura-Historia-Technica, or, the History and Art of Engraving* (London 1747)

GWYN, John *An Essay on Design, including Proposals for erecting a Public Academy* (London 1749)

———— *London and Westminster improved, illustrated by Plans, to which is prefix'd, a Discourse on Public Magnificence, with Observations on the State of the Arts and Artists in this Kingdom* (London 1766)

HAYLEY, William *The Two Connoisseurs* (London 1760?)

HIGFORD, William *Institutions, or Advice to his Grandson* (1658)

HIGHMORE, Joseph *Essays Moral, Religious, Political and Miscellaneous* 2 vols.

(London 1766)

HOBBES, Thomas *Leviathan: or the Matter, Form and Power of a Commonwealth, Ecclesiastical and Civil* (London 1651)

HOET, G. *Catalogus of Naamlijst van Schilderijen met derselver prijsen,* 2 vols. (Amsterdam 1752)

HOGARTH, William *The Analysis of Beauty. Written with a View of fixing the fluctuating ideas of Taste* (London 1753)

(HOLE, W.) *The Ornaments of Churches considered, with a particular view to the late decoration of the parish Church of St Margaret Westminster* (Oxford 1761)

HUME, David *Essays Moral, Political and Literary* (London 1741/2)

HURD, Richard *Dialogues on the uses of Foreign Travel considered as part of an English Gentleman's Education, between Lord Shaftesbury and Mr Locke* (2nd ed. London 1764)

HUTCHESON, Frances *An Inquiry into the Original of our Ideas of Beauty and Virtue, in two volumes* (2nd ed., London 1726)

————— *A short Introduction to Moral Philosophy in three books, containing the elements of Ethicks and the Law of Nature* (Glasgow 1747)

————— *A System of Moral Philosophy, in three Books* (London 1755)

IRELAND, John *Hogarth illustrated from his own Manuscripts,* 3 vols. (1791-3, 1812)

JOHNSON, Samuel *Lives of the English Poets, and a Criticism of their Works* (Dublin 1781)

————— *The Idler*

————— *The Rambler*

JONES, Thomas 'Memoirs of Thomas Jones', *Walpole Society* vol. 32 (London 1946-8)

JOULLAIN, C.-F. *Reflexions sur la Peinture* (Paris 1786)

ANON *The Journey of Dr Bongout and his Lady to Bath, performed in the year 177-* (London 1778)

KENNEDY, James *A New Description of the Pictures, Statues, Bustoes, Basso-Relievos and other Curiosities at the Earl of Pembroke's House at Wilton* (Salisbury/London 1758)

LAMOTTE, Charles *An Essay on Poetry and Painting, with an Appendix concerning Obscenity* (London 1730)

ANON *The Laws and Regulations of the Students, Rules and Orders of the Schools and Library and for the Exhibition* (London 1797)

LEBLANC, J. B. *Lettres d'un François* (La Haye 1745)

LÉPICIÉ, François-Bernard *Catalogue Raisonné des Tableaux du Roi avec un abregé de la vie des peintres* (Paris 1752)

ANON *A Letter from a Parishioner of St Clement Danes to...Edmund, Ld Bp of London, occasion'd by his Ldsp's causing the Picture, over the Altar, to be taken down* (London 1725)

ANON *A Letter to the Members of the Society for the Encouragement of Arts, Manufactures and Commerce, containing some Remarks on the Pictures to which the Premiums were adjudged; with some Cursory Observations on History Painting* (London 1761)

LOCKE, John *An Essay concerning Humane Understanding* (2 vols. Oxford 1894)

————— *Some Thoughts concerning Education,* ed. J. L. Axtell (Cambridge 1968)

ANON *London and its Environs Described, containing an Account of Whatever is most remarkable for Grandeur, Elegance, Curiosity or Use, in the City and in the Country 20 miles around it,* 6 vols. (London 1761)

MACKY, John *A Journey through England, in Familiar Letters* (London 1714)

————— *A Journey through the Austrian Netherlands* (London 1728)

MANDEVILLE, Bernard *The Fable of the Bees,* ed. F. B. Kaye, 2 vols. (Oxford 1924)

MARTYN, Thomas *The English Connoisseur,* 2 vols. (London 1766)

MILLAR, John *Observations concerning the Distinction of Ranks* (London 1771)

MILLER, James *The Man of Taste* (London 1735)

MONTFAUCON, Father Bernard de *The Travels from Paris thro' Italy in 1698, 1699, 1700, containing an Account of many Antiquities* (London 1712, 1725)

MORE, Hannah *On the Modern System of Female Education* (London 1797)

————— *Thoughts on the Manners of the Great* (London 1788)

MORTIMER, Thomas *The Universal Director; or the Nobleman's and Gentleman's true Guide to the Masters and Professors of the Liberal and Polite Arts and Sciences, and of the Mechanic Arts, Manufactures established in London and Westminster,* 3 vols. (London 1763)

NELSON, James *An Essay on the Government of Children, under three general Heads: viz, Health, Manners and Education* (London 1763)

NEWTON, Thomas *The Works of Thomas Newton, Bishop of Bristol* (London 1782)
NORTH, Roger *The Autobiography of Roger North*, ed. A. Jessop (London 1887)
PARROTT, Richard *Reflections on various Subjects* (London 1752)
PEPYS, Samuel *The Diary of Samuel Pepys*, ed. R. Latham and W. Matthews, (Berkeley 1970)
PHILPOT, Stephen *Essay on the Advantage of a Polite Education joined with a Learned one* (London 1747)
PILKINGTON, M. *The Gentleman's and Connoisseur's Dictionary of Painters. Containing a complete Collection, and Account, of the most distinguished Artists, who have flourished in the Art of Painting, at Rome, Venice, Naples, Florence, and other Cities of Italy; In Holland, Flanders, England, Germany or France; from the year 1250, when the Art of Painting was revived by Cimabue, to the year 1767; including above Five Hundred Years, and the Number of Artists amounting to near one Thousand Four Hundred...* (London 1770)
PLANNER, John *The Town and Country Auctioneer's Guide* (London 1797)
POPE, Alexander *Complete Works* (London 1871)
ANON *The present State of Learning, Religion and Infidelity in GREAT BRITAIN; Wherein the Causes of the present Degeneracy of Taste and Increase of Infidelity, are Inquired into and accounted for...Published by a sincere Friend to RELIGION and VIRTUE* (London 1732)
(RAMSAY, Allan) *The Investigator* (London 1762)
RAMSAY, William *The Gentleman's Companion, or, a Character of true Nobility and Gentility* (1672)
ANON *Report of the Lord's Committee empowered by the House of Lords to examine Christopher Layer...* (London 1723)
REYNOLDS, Sir Joshua *Discourses on Art*, ed. Robert R. Wark (San Marino 1959)
RICHARDSON, Jonathan *An Account of some of the Statues, Bas-Reliefs, Drawings and Paintings in Italy, etc, with remarks* (London 1722)
————— *Argument in behalf of the Science of a Connoisseur*, in *Two Discourses* (London 1719)
————— *Essay on the Theory of Painting* (London 1715)
————— *An Essay on the Whole Art of Criticism as it relates to Painting*, in *Two Discourses* (London 1719)
RICHARDSON, Jonathan, jnr. *Richardsoniana*, 2 vols. (London 1776)
ROE, Sir Thomas *Letters from Constantinople* (London 1740)
ROLT, R. *A New Dictionary of Trade and Commerce* (London 1756)
ROUQUET, J. A. *The Present State of the Arts in England*, (London 1755)
RUSSEL, James *Letters from a young Painter abroad to his Friends* (London 1750)
SALMON, William *Polygraphice, or the Art of Drawing Engraving...Varnishing...and Dying* (London 1672)
SALTERAN, George *A Treatise against Images and Pictures in Churches* (1641)
SANDERSON, William *Graphice, the Use of the Pen and Pencil, or, the most excellent Art of Painting, in two parts* (London 1658)
ANON *A Satire against Painting in Burlesque Verse, submitted to the Judicious by an Eminent Hand* (1696/7?)
SAVERY, P. *Dictionnaire Universelle de Commerce* (Copenhagen 1762)
SHEFFIELD, John, Duke of Buckingham *Complete Works*, 2 vols. (London 1753)
SHENSTONE, William *Works*, 2 vols. (London 1764)
SHERIDAN, Thomas *British Education, or the Source of the Disorders of Great Britain* (1756)
SMITH, Adam *The Theory of Moral Sentiments*, in *Works* (London 1812)
SMITH, J. T. *Nollekens and his Times, comprehending a Life of that celebrated Sculptor and Memoirs of several contemporary Artists*, 2 vols. (London 1829, reprinted 1920)
S(MITH), M(arshall) *The Art of Painting according to the Theory and Practice of the best Italian, French and Germane Masters* (London 1692)
STANHOPE, Philip Dormer, Earl of Chesterfield *Letters of the Earl of Chesterfield to his Son* (London 1929)
STRANGE, Robert *An Enquiry into the Rise and Establishment of the Royal Academy of Arts* (London 1775)
————— *Memories of Robert Strange*, ed. J. Dennistoun, 2 vols. (London 1855)
STUBBES, George *A Dialogue in the Manner of Plato on the superiority of the Pleasures of the Understanding to the Pleasures of the Senses* (London 1734)

STUKELEY, W. *The Family Memoirs of the Revd. W. Stukeley and the Antiquarian and other Correspondence of W. Stukeley, R. & S. Gale*, ed. W. C. Lukis, 3 vols. (Durham, Surtees Society 1882-7)

TURNBULL, George *A Treatise on Ancient Painting* (London 1740)

VERTUE, G. 'The Notebooks of George Vertue', *Walpole Society*, vols. 18, 20, 22, 24, 26, 29 (Oxford 1930-47)

WALPOLE, Horace *Aedes Walpoliana: or a Description of the Collection of Pictures at Houghton Hall in Norfolk* (London 1767)

———— *Anecdotes of Painting in England; with some Account of the principal Artists; and incidental Notes on other Arts*, ed. Dalloway and Wornum, 3 vols. (London 1862)

———— *A Catalogue of the Collection of Pictures of the Duke of Devonshire, General Guise and the Late Sir Paul Methuen* (London 1760)

———— *A Catalogue of the Curious Collection of Pictures of G. Villiers...; Also a Catalogue of Sir. P. Lely's Collection...(and) a Description of Easton Neston* (London 1760)

———— Journals of visits to Country Seats', ed. Paget Toynbee, *Walpole Society*, vol. 16 (1927-8) pp. 9-80

———— *The Letters of Horace Walpole*, ed. W.S. Lewis, 48 vols. (New Haven and London 1937-82) pp. 9-80

WANLEY, H. *The Diary of Humfrey Wanley*, ed. C. E. and R. C. Wright (London 1966)

(WARD, Edwin) *The Auction, or the Poet turned Painter* (1695)

WEBB, Daniel *An Enquiry into the Beauties of Painting* (London 1760)

WRIGHT, Edward *Some Observations made in Travelling through France, Italy, etc...* (London 1730)

(WRIGHT, James) *Country Conversations; being an Account of some Discourses that happened in a Visit to the Country last Summer, on divers Subjects...* (London 1694)

Secondary Printed Sources

ALLAN, D. G. C. 'The Society of Arts and Government, 1754-1800', *Eighteenth Century Studies*, 7 no. 4 (1974) pp. 434-52

———— *William Shipley, Founder of the Royal Society of Arts* (London 1968)

ANDREWS, D. 'Aldermen and the big bourgeoisie of London considered', *Social History*, 4, no. 3 (1981) pp. 359-64

ANTAL, C. F. *Hogarth and his Place in European Art* (London 1962)

———— 'Hogarth and his Borrowings', *Art Bulletin*, 29 (1947) pp. 36-48

ARPINO, G. and LECALDANO, P. *L'Opera completa di Rembrandt van Rijn* (Milano 1969)

ASH, P. 'Edward Millington', *Estates Gazette*, 6 January 1962

ATHERTON, H. M. *Political Prints in the Age of Hogarth* (Oxford 1974)

ATKINS, S. H. *Printed Material on Education* (University of Hull 1970)

AYRES, J. *English Naive Painting* (London 1980)

BABCOCK, R.W. 'The Idea of Taste in the Eighteenth Century', *Proceedings of the Modern Language Association of America*, 50 (1935) pp. 922-6

BARRELL, John *English Literature in History, An Equal, Wide Survey* (London 1983)

———— *The Political Theory of Painting from Reynolds to Hazlitt: The Body of the Public* (New Haven and London 1986)

BEARDSLEY, M. C. *Aesthetics from Classical Greece to the Present: a Short History* (University of Alabama, 1982)

BELL, Quentin *The Schools of Design* (London 1963)

BERNSTEIN, J. A. 'Shaftesbury's identification of the Good with the Beautiful', *Eighteenth Century Studies*, 10, no. 3 (1977) pp. 304-25

BILLE, C. *De Tempel der Kunst of het Kabinet van den Heer Braamcamp* (Amsterdam 1961)

BLUNT, A. *Artistic Theory in Italy, 1450-1600* (London 1973)

———— *The Paintings of Nicholas Poussin, a Critical Catalogue* (London 1966)

BOISCLAIR, Marie-Nicole *Gaspard Dughet 1615-1675* (Paris 1986)

BORENIUS, T. *A Catalogue of the Pictures at Corsham Court* (London 1939)

———— 'Sir Peter Lely's collection', *Burlington Magazine*, 83 (August 1943) pp. 185-9, and 84

(June 1944) p.154

————— 'Robert Streeter', *Burlington Magazine* 84 (January 1944) pp. 2-12

————— 'The Sergeant-Painters', *Burlington Magazine* 84 (April 1944) pp. 80-2

BORSAY, P. 'Cities, Status and the English Urban Landscape', *History*, 67 (February 1982) pp. 1-12

————— 'The English Urban Renaissance: The Development of provincial Urban Culture, *c.* 1680-1760', *Social History*, 5 (May 1977) pp. 581-603

BOWLE, J. *Hobbes and his Critics: a Study in Seventeenth Century Constitutionalism* (London 1951)

BRAUER, G. C. *The Education of a Gentleman: Theories of Gentlemanly Education in England, 1660-1775* (New York 1959)

BRIGANTI, Giuliano *Pietro da Cortona, o della Pittura Barocca* (Firenze 1982)

BROAD, C. D. 'Berkeley's denial of material substance' in ed. Martin, C. B. and Armstrong, D. M., *Locke and Berkeley, a Collection of Critical Essays* (London 1968) pp. 255-83

BROWN, Francis *Sir Joshua Reynolds' Collection of Pictures* (Princeton Phd. 1987)

BROWNE, J. K. 'Matthew Brettingham's Rome account book, 1747-1754', *Walpole Society* vol. 49 (1983) pp. 37-132

BRUNTJEN, Sven, *John Boydell 1719-1804: A Study in Art Patronage and Publishing in Georgian London* (New York 1985)

BRUSHE, J. 'Wricklemarsh and the Collections of Gregory Page', *Apollo* (November 1985) pp. 364-371

BURDEN, G. 'Sir Thomas Isham, an English Collector in Rome in 1677-1678', *Italian Studies* (1960) pp. 1-25

BURKE, Joseph *English Art, 1714-1800* (Oxford 1976)

CARRITT, D. 'Mr Fauquier's Chardins', *Burlington Magazine*, 116 (September 1974) pp. 502-9

CARTWRIGHT, J. J. (ed.) *The Wentworth papers, 1705-1739* (London 1883)

CHAMBERS, F. B. *The History of Taste* (New York 1932)

CLARK, G. *The Later Stuarts, 1660-1714* (Oxford 1976)

CLARKE, B. F. L. *The Building of the Eighteenth Century Church* (London 1963)

COATES,A. W. 'Changing attitudes to Labour in the mid-Eighteenth Century', *Economic History Review*, 2nd series, 11 (1958-9) pp. 35-51

COLE, R. E. G. *History of Doddington* (Lincoln 1897)

COLLINS-BAKER, C. H. *Lely and the Stuart Portrait Painters*, 2 vols. (London 1912)

————— 'Lely's financial relations with Charles II', *Burlington Magazine*, 20 (October 1911-March 1912) pp. 43-5

COLLINS-BAKER, C. H. & M. S. *The Life and Circumstances of James Brydges, Duke of Chandos* (Oxford 1949)

COLVIN, H. M. *Biographical Dictionary of British Architects, 1600-1840* (2nd ed., London 1978)

————— 'Fifty New Churches', *Architectural Review*, 107 (1950) pp. 189-96

CONE, Carl. B. 'Edmund Burke's Art Collection', *Art Bulletin* 29 (1947) pp. 126-51

CORFIELD, P. J. *The Impact of English Towns, 1700-1800* (Oxford 1982)

COXE, W. *Private and Original Correspondence of Charles Talbot, Duke of Shrewsbury, with King William, the Leaders of the Whig party and other distinguished Statesmen* (London 1821)

CRAGG, G. R. *Reason and Authority in the Eighteenth Century* (Cambridge 1964)

CROCE, B. 'Shaftesbury in Italia', *Uomini e cose della Vecchia Italia* (Bari 1927) pp. 272-309

CROFT-MURRAY, E. F. *Decorative Painting in England 1537-1837*, 2 vols. (London 1962-70)

CROW, Thomas E. *Painters and Public Life in Eighteenth-Century Paris* (New Haven and London 1985)

CUST, L. and Colvin, S. *The History of the Society of Dilettanti* (London 1898)

DAICHES, D. *A Critical History of English Literature*, 3 vols. (London 1960)

DENUCÉ, J. *Art Export in 17th Century Antwerp, the firm Fouchoudt, Sources of the History of Flemish Art* vol. 1 (Antwerp 1931)

DENVIR, B. *The Eighteenth Century: Art, Design and Society 1689-1789* (London 1983)

DIBDIN, E. R. 'Liverpool Art and Artists in the Eighteenth Century', *Walpole Society*, vol. 6, (1917-18) pp. 12-91

DOBAI, J. *Die Kunstliteratur des Klassizismus und der Romantik in England, 1700-1840*, 3 vols. (Bern 1974-7)

DRAPER, J. 'Eighteenth Century English Aesthetics: a Bibliography', *Anglistische Forschungen* 75,

(Hiedelberg 1931)

EIDELBERG, M. 'Watteau Paintings in England in the early Eighteenth Century,' *Burlington Magazine*, 117 (1975) pp. 576-82

EMILIANI, A. *Leggi, Bandi e Provvedimenti per la tutela dei Beni Artistici e Culturali negli Antichi Stati Iltaliani 1571-1860* (Bologna 1978)

ENGLEFIELD, W. O. *History of the Painter-Stainers' Company* (London 1932)

EVANS, Sir David, *The Notebook of John Smibert* (Boston 1969)

EVANS, Joan, *The History of the Royal Society of Antiquaries* (Oxford 1956)

FAWCETT T. 'Eighteenth Century Art in Norwich,' *Walpole Society*, vol. 46 (1976-8) pp. 71-40

FISHER, F. J. 'London as a centre for conspicuous consumption', *Transactions of the Royal Historical Society*, 4th series, 30 (1948) pp. 37-50.

FLEMING, J. 'Messrs Robert and James Adam, Art Dealers', *Connoisseur*, 144 (1959) pp. 168-71

FOISTER, S. 'Paintings and other works of art in Sixteenth Century English Inventories', *Burlington Magazine*, 123 (1980) pp. 273-82

FOISTER, W. 'British Artists in India, 1760-1820', *Walpole Society*, vol. 19 (1930-1) pp. 1-88

FOLKENFLIK, R. ed., *The English Hero, 1660-1800* (Newark, 1982)

FOOTE, H. W. *John Smibert, Painter* (New York 1969)

FORD, B. 'Thomas Jenkins, Banker, Dealer and Unofficial English Agent', *Apollo* 99 (1974) pp. 416-25

FOSS, M. *The Age of Patronage: The Arts in England 1660-1750* (London 1974)

GALT, J. *The Life and Works of Benjamin West*, 2 vols. (London 1820)

GARLICK, K. J. 'A Catalogue of Pictures at Althorp', *Walpole Society*, vol. 45 (1974-6)

GILBERT, K. E. and Kuhn, H. *A History of Aesthetics* (New York 1939)

GIROUARD, M. *Life in the English Country House* (London 1978)

GOLDSMITH, M. M. 'Private Vices, Public Virtues: Bernard Mandeville and English Political Ideology in the early Eighteenth Century', *Eighteenth Century Studies*, 9 (1975-6) pp. 477-511

GOULD, Cecil *The Paintings of Correggio* (Ithaca 1976)

GOULDING, R. W. *Catalogue of the Pictures belonging to the Duke of Portland* (London 1936)

GRAVES, A. *The Society of Artists of Great Britain, 1760-91; The Free Society of Artists, 1761-1783* (London 1907)

————— *Art Sales from early in the Eighteenth Century to early in the Twentieth*, 3 vols. (London 1921)

HALE, J. R. *England and the Renaissance* (London 1954)

HARCOURT, E. W. (ed.) *The Harcourt Papers* (n.p., n.d.)

HARRIS, J. 'English Country House Guides, 1740-1840', *Concerning Architecture, Essays on Architectural Writers and Writing presented to Nikolaus Pevsner*, ed. J. Summerson (London 1968)

————— *The Artist and the Country House* (London 1979)

HARRIS, L. 'The Picture Collection at Kedleston Hall', *Connoisseur*, 198 (1978) pp. 208-17

HARRIS, R. W. *Reason and Nature in Eighteenth Century Thought* (London 1968)

HASKELL, F. 'The Market for Italian Art in the Seventeenth Century', *Past and Present* (April 1959) pp. 48-59

————— *Patrons and Painters; Art and Society in Baroque Italy* (London 1963)

————— *Rediscoveries in Art* (London 1976)

HASKELL, F. and Penny, N. *Taste and the Antique* (London 1971)

HAZARD, P. *European Thought in the Eighteenth Century* (London 1965)

HERMANN, F. *The English as Collectors, a Documentary History* (London 1972)

HERVEY, M. F. S. *The Life, Correspondence and Collections of Thomas Howard, Earl of Arundel* (Cambridge 1921)

HERVEY, S. H. A. *The Diary of John Hervey, 1st Earl of Bristol with Extracts from his Book of Expenses* (Wells 1894)

HOLMES, G. *Augustan England: Professions, State and Society, 1680-1730* (London 1982)

HOOK, J. *The Baroque Age in England* (London 1976)

HOOKER, E. N. 'The Discussion of Taste from 1750-1770 and new Trends in Literary Criticism', *Proceedings of the Modern Language Association of America* (June 1934) pp. 577-92

HOUGHTON, W. E. 'The English Virtuoso in the Seventeenth Century', *Journal of the History of Ideas*, 3 (1942) pp. 51-73; 190-219

HOWARTH, D. *Lord Arundel and his Circle* (New Haven and London 1985)

HUDSON, D. and Luckhurst, K. *The Royal Society of Arts, 1754-1954* (London 1954)

HUSSEY, C. *English Gardens and Landscapes, 1700-1750* (London 1967)

HUTCHISON, S. C. *The History of the Royal Academy, 1768-1968* (London 1968)

INGAMELLS, J. and Raines, R. 'Catalogue of the Paintings, Drawings and Etchings of Philip Mercier', *Walpole Society*, vol. 46 (1976-78) pp. 1-70

INGRAM, K. E. *Sources of Jamaican History*, 2 vols. (Zug 1976)

IRWIN, David and Francina *Scottish Painters at Home and Abroad, 1700-1900* (London 1975)

JENKINS, F. *Architect and Patron: A Survey of Professional Relations and Practice in England from the Sixteenth Century to the Present Day* (Durham 1961)

JOURDAIN, M. *The Works of William Kent* (London 1948)

KITSON, Michael 'Hogarth's "Apology for Painters"', *Walpole Society*, vol. 49 (1966-8) pp. 46-111

KORSHIN, P. J. 'Types of Eighteenth Century Literary Patronage', *Eighteenth Century Studies*, 7, no. 4 (1974) pp. 453-73

KRAMNICK, Isaac *Bolingbroke and his Circle* (Cambridge, Mass. 1968)

KRISTELLER, P. O. 'The Modern System of the Arts', *Journal of the History of Ideas*, 12 (1951) pp. 496-527; vol. 13 (1952) 17-46

KURZ, Hilde 'Italian Models of Hogarth's Picture Stories,' *Journal of the Warburg and Courtauld Institutes*, 15 (1952) pp. 136-68

LARWOOD, J. and Hotten, J. C. *English Inn Signs* (London 1951)

LAWSON, J. and Silver, H. *A Social History of Education in England* (London 1973)

LEVINE, J. M. *Dr Woodward's Shield, History, Science and Satire in Augustan England* (London 1977)

LEWIS, L. *Connoisseurs and Secret Agents in Eighteenth Century Rome* (London 1961)

LIPKING, L. The *Ordering of the Arts in Eighteenth Century England* (Princeton, 1970)

LIPPINCOTT, L.W. *Selling Art in Georgian London: The Rise of Arthur Pond* (London 1983)

LOCKYER, R. *Buckingham: The Life and Political Career of George Villiers, First Duke of Buckingham, 1592-1628* (London 1981)

LOVEJOY, A. O. 'Nature as Aesthetic Norm', *Modern Language Notes*, 42, no. 7 (1927) pp. 444-50

LOWENTHAL, L. *Literature, Popular Culture and Society* (Palo Alto, 1961)

LUGT, F. *Repertoire des Catalogues de Ventes Publiques interessant l'art ou la Curiosité*, 3 vols. (The Hague 1938)

LUZIO, A. O. *La Galleria dei Gonzaga venduta in Inghilterra nel 1627-8* (Milano 1913)

MAHON, D. 'Notes on the Dutch Gift to Charles II', *Burlington Magazine*, 91 (1949) pp. 349-50; 92 (1950) pp. 12-18

MALCOLMSON, R. W. *Popular Recreations in English Society, 1700-1850* (Cambridge 1973)

MANNERS, Lady Victoria 'Notes on the Pictures at Belvoir Castle', *Connoisseur* (June 1903) pp. 67-75

MANWARING, E. W. *Italian Landscape in Eighteenth Century England* (2nd ed. London 1965)

MARCEL, P. *Charles LeBrun* (Paris 1909)

MARR, G. S. *The Periodical Essayists of the Eighteenth Century* (London 1924)

MARSHALL, Dorothy *Eighteenth-Century England* (London 1962)

MCKENDRICK, N. ed. *The Birth of a Consumer Society: The Commercialisation of Eighteenth Century England* (London 1982)

MEADE, R. H. *In the Sunshine of Life: A Biography of Richard Mead* (Philadelphia 1974)

MILLAR, O. 'Inventory and Valuation of King Charles I's Collection', *Walpole Society*, vol. 43 (1970-2)

MINTZ, S. I. *The Hunting of Leviathan: Seventeenth Century reactions to the Materialism and Moral Philosophy of Thomas Hobbes* (Cambridge 1962)

MIREUR, H. *Dictionnaire des Ventes d'Art XVIII-XIXme siècles*, 7 vols. (Paris 1901-12)

MOIR, E. *The Discovery of Britain: The English Tourists, 1540-1840* (London 1964)

MUSGRAVE, Sir William *Obituary prior to 1800, as far as relates to England, Scotland and Ireland. Compiled by Sir W. Musgrave... and entitled by him, 'A General Nomenclature and Obituary'*, ed. Sir G. J. Armstrong, *Harleian Society*, vols. XLIV-XLIX, (1899-1901)

NAMIER, L. *The Structure of Politics at the Accession of George III* (London 1957)

NICHOLS, R. H. and Wray, F. A. *A History of the Foundling Hospital* (London 1935)

NICOLSON, B. *The Treasures of the Foundling Hospital* (Oxford 1972)

NICHOLSON, T. C. and Turberville, A. S. *Charles Talbot, Duke of Shrewsbury* (Cambridge 1930)

OGDEN, H. V. S. & M. S. 'A Bibliography of 17th Century Writings on the Pictorial arts in English', *Art Bulletin*, 39 (1947) pp. 196-201

————— *English Taste in Landscape in the Seventeenth Century* (Ann Arbor 1955)

PARKINSON, R. 'The First Kings of Epithets', *Connoisseur* (April 1978) pp. 269-73

PARRY, G. *The Golden Age Restor'd: The Culture of the Stuart Court, 1603-42* (Manchester 1981)

PAULSON, R. *Hogarth: His Life, Art and Times*, 2 vols. (New Haven and London 1971)

PEARS, I. 'Patronage and Learning in the Virtuoso Republic: John Talman in Italy, 1709-12', *Oxford Art Journal*, 5, no. 1 (1982) pp. 24-30

PENNY, Nicholas 'An Ambitious Man; The Career and the Achievement of Sir Joshua Reynolds', *Reynolds,* Royal Academy of Art Exhibition (London, January-March 1986)

PEPPER, D. S. *Guido Reni* (New York 1984)

PEVSNER, N. *Academies of Art, Past and Present* (Cambridge 1940)

PHILLIPS, J. *The Reformation of Images: The Destruction of Art in England, 1535-1665* (Berkeley 1973)

PIOT, E. *Le Cabinet d'un Amateur* (Paris 1861-2)

PITCHER, G. *Berkeley*, (London 1977)

PITTOCK, J. *The Ascendency of Taste* (London 1973)

PLUMB, J. H. *The Growth of Political Stability in England, 1675-1725* (London 1967)

————— *Georgian Delights* (London 1980)

————— *Robert Walpole*, 2 vols. (London 1956)

POMIAN, K. 'Marchands, Connoisseurs et Curieux à Paris au XVIIIesiècle', *Revue de l'Art*, 43 (1979) pp. 23-36

PORTER, R. *English Society in the Eighteenth Century* (London 1982)

POSNER, D. *Annibale Carracci: A Study in the Reform of Italian Painting around 1500*, 2 vols. (London 1971)

POYNTON, M. 'Portrait Painting as a Business Enterprise in London in the 1780's', *Art History*, 7 no. 2 (1984) pp. 187-205

PYE, J. *Patronage of British Art, An Historical Sketch* (London 1845)

RAINES, R. 'Watteau and "Watteaus" in England before 1760', *Gazette des Beaux Arts* (février 1977) pp. 51-64

RAMSEY, R.W. *Studies in Oliver Cromwell's Family Circle* (London 1930)

RAND, B. *The Life, Unpublished Letters and Philosophical Regimen of Anthony, Earl of Shaftesbury, Author of the 'Characteristicks'* (London 1900)

RAPHAEL, D. D. *British Moralists, 1650-1800*, 2 vols. (Oxford 1969)

REDFORD, G. *Art Sales: A History of Sales of Pictures and other Works of Art*, 2 vols. (London 1888)

REED, M. *The Georgian Triumph* (London 1984)

REITLINGER, G. *The Economics of Taste* (London 1961)

RICHETTI, J. J. *Locke, Berkeley and Hume* (Cambridge, Mass. 1983)

ROBERTSON, J. G. *The Genesis of Romantic Theory* (Cambridge 1923)

RODGERS, B. *Cloak of Charity: Studies in 18th Century Philanthropy* (London 1949)

ROGERS, N. 'Money, Land and Lineage: The Big Bourgeoisie of Hanoverian London', *Social History*, 4, no. 3 (1979) pp. 437-54

ROGERS, P. *The Augustan Vision* (London 1978)

ROSENFELD, S. *Georgian Scene Painters and Scene Painting* (Cambridge 1981)

ROTHBLATT, S. *Tradition and Change in English Liberal Education* (London 1976)

ROTHLISBERGER, M. *Claude Lorrain: The Paintings*, 2 vols. (London 1961)

SEKORA, J. *Luxury, The Concept in Western Thought, from Eden to Smollett* (Baltimore 1977)

SIMPSON, F. 'The English Connoisseur and its Sources', *Burlington Magazine*, 93 (1951) pp. 355-6

————— 'Dutch Paintings in England before 1760', *Burlington Magazine*, 95 (1953) pp. 39-42

SITWELL, S. *Sing High, Sing Low* (London 1944)

SLIVE, S. *Rembrandt and his Critics, 1630-1730* (The Hague 1953)

SPECK, W. A. 'Social Status in Late Stuart England', *Past and Present*, 34 (1966) pp. 127-9

————— *Society and Literature in England, 1700-1760* (Dublin 1983)

————— *Stability and Strife: England 1714-60* (London 1977)

SPRAGUE ALLAN, B. *Tides in English Taste (1619-1800)* (New York 1969)

STEEGMAN, J. *The Artist and the Country House* (London 1949)

STEIN, J. P. 'The Monetary Appreciation of Paintings', *Journal of Political Economy*, 85 no. 5 (1977) pp. 1021-35

STEWART, J. D. 'Records of Payment to Kneller and his Contempories', *Burlington Magazine*, 113 (1971) pp. 30-3

STOLNITZ, J. ' "Beauty", some Stages in the History of an Idea', *Journal of the History of Ideas*, 22, no. 2 (1961) pp. 185-204

———— 'On the Significance of Lord Shaftesbury in Modern Aesthetic Theory', *Philosophical Quarterly*, 11 (1961) pp. 97-113

STONE, L. 'The Market for Italian Art in the 17th Century', *Past and Present* (November 1959) pp. 92-4

———— 'Social Mobility in England, 1500-1700', *Past and Present*, 33 (1976) pp. 16-35

STOYE, J. W. *English Travellers Abroad, 1604-1667; Their Influence in English Society and Politics* (London 1952)

STUFFMAN, M. 'Les Tableaux de la collection de Pierre Crozat', *Gazette des Beaux Arts*, 6th period, 72 (1968) pp. 11-135

SUTTON, D. 'Aspects of British Collecting, part one', *Apollo*, 14, no. 237 (1981) pp. 282-339

TALLEY, M. Kirby 'Thomas Bardwell of Bungay, Artist and Author 1704-1767', *Walpole Society*, vol. 46 (1976-8) pp. 91-163

TAYLOR, F. H. *The Taste of Angels: A History of Art Collecting from Rameses to Napoleon* (Boston 1948)

TEMPLEMAN, W. D. 'Contributions to the Bibliography of Eighteenth Century Aesthetics', *Modern Philology*, 30, no. 3 (1933) pp. 309-16

THOMAS, P. W. 'Two Cultures? Court and Country under Charles I', in ed. Conrad Russell, *The Origins of the English Civil War* (1973) pp. 168-93

THOMPSON, E. M. *Correspondence of the Family of Hatton, being chiefly Letters addressed to Christopher, first Viscount Hatton, AD 1601-1702*, 2 vols. (London, Camden Society 1878)

THOMPSON, E. P. 'Eighteenth Century Society: Class Struggle without Class?' *Social History*, 3, no. 2 (1978) pp. 133-65

———— 'Patrician Society, Plebian Culture', *Journal of Social History*, 7 (1973-4) pp. 384-405

THUILLIER, J. *Charles Lebrun* (Versailles 1963)

———— *l'Opera Completa di Poussin*, (Milano 1974)

TIMBS, J. *Club Life of London: with Anecdotes of the Clubs, Coffee Houses and Taverns* (London 1866)

TIPTON, I. C. *Berkeley, the Philosophy of Immaterialism* (London 1974)

TRUMBACH, R. *The Rise of the Egalitarian Family* (New York 1978)

TURNER, E. R. 'The Peerage Bill of 1719', *English Historical Review*, 28 (1913) pp. 243-59.

USTICK, W. L. 'Changing Ideals of Aristocratic Character and Conduct in Seventeenth Century England', *Modern Philology*, vol. 30 (1932) pp. 147-66

WATERHOUSE, E. K. 'English Painting and France in the Eighteenth Century', *Journal of the Warburg and Courtauld Institutes*, 15 (1952) pp. 122-35

———— 'A Note on British Collecting of Italian Pictures in the late Seventeenth Century', *Burlington Magazine*, 102 (1960) pp. 54-8

———— *Painting in Britain, 1530-1790* (London 1978)

———— 'Poussin et l'Angleterre jusqu'en 1744', ed. A. Chastel, *Nicolas Poussin*, vol. 1 (Paris 1960) pp. 283-95

———— *Reynolds* (London 1941)

WEBSTER, M. 'Taste of an Augustan Collector: The Collection of Dr Richard Mead', *Country Life*, 147 (1970) pp. 249-51; 148 (1970) pp. 765-7

WHITE, C., ALEXANDER, D. and D'OENCH, E. eds. 'Rembrandt in 18th century England,' *Yale Center for British Art Exhibition Catalogue* (1983)

WILLEY, B. *The Seventeenth Century Background* (London 1934)

WILLIAMS, R. *The Country and the City* (London 1975)

WILLIAMSON, G. C. *English Conversation Pieces*, (London 1931)

WIND, E. 'Borrowed Attitudes in Hogarth and Reynolds,' *Journal of the Warburg and Courtauld Institutes*, 2 (1938-9) pp. 182-85

———— 'Julian the Apostate at Hampton Court', *Journal of the Warburg and Courtauld Institutes*,

3 (1939-40) pp. 127-37
——————— 'Shaftesbury as Patron of Art', *Journal of the Warburg and Courtauld Institutes*, 2 (1938-9) pp. 185-8
WHINNEY, M. and MILLAR, O. *English Art, 1625-1714* (Oxford 1957)
WHITLEY, W. T. *Art in England, 1800-1828* (Cambridge 1921)
——————— *Artists and their Friends in England*, 1700-1799, 2 vols. (London 1928)
——————— *Thomas Gainsborough* (London 1915)
WITTKOWER, R. 'The Artist', in ed. J. L. Clifford, *Man vs. Society in Eighteenth Century Britain* (Cambridge 1968) pp. 19-54
WRIGHT, H. B. and MONTGOMERY, H. C. 'The Art Collection of a Virtuoso in Eighteenth Century England' *Art Bulletin*, vol. 27 (1945) pp. 195-204
WRIGLEY, E. A. 'A Simple Model of London's Importance in changing English Society, 1650-1750', *Past and Present*, 37 (1967) pp. 44-50
ZMIJEWSKA, H. *La Critique des Salons en France du temps de Diderot 1759-89* (Warsaw 1980)
ZUCKERMAN, A. *Dr Richard Mead (1673-1754) a Biographical Study* (Univ. of Illinois Phd., 1963)

Index

Note: Page numbers in *italics* refer to illustrations.